BRUSSELS

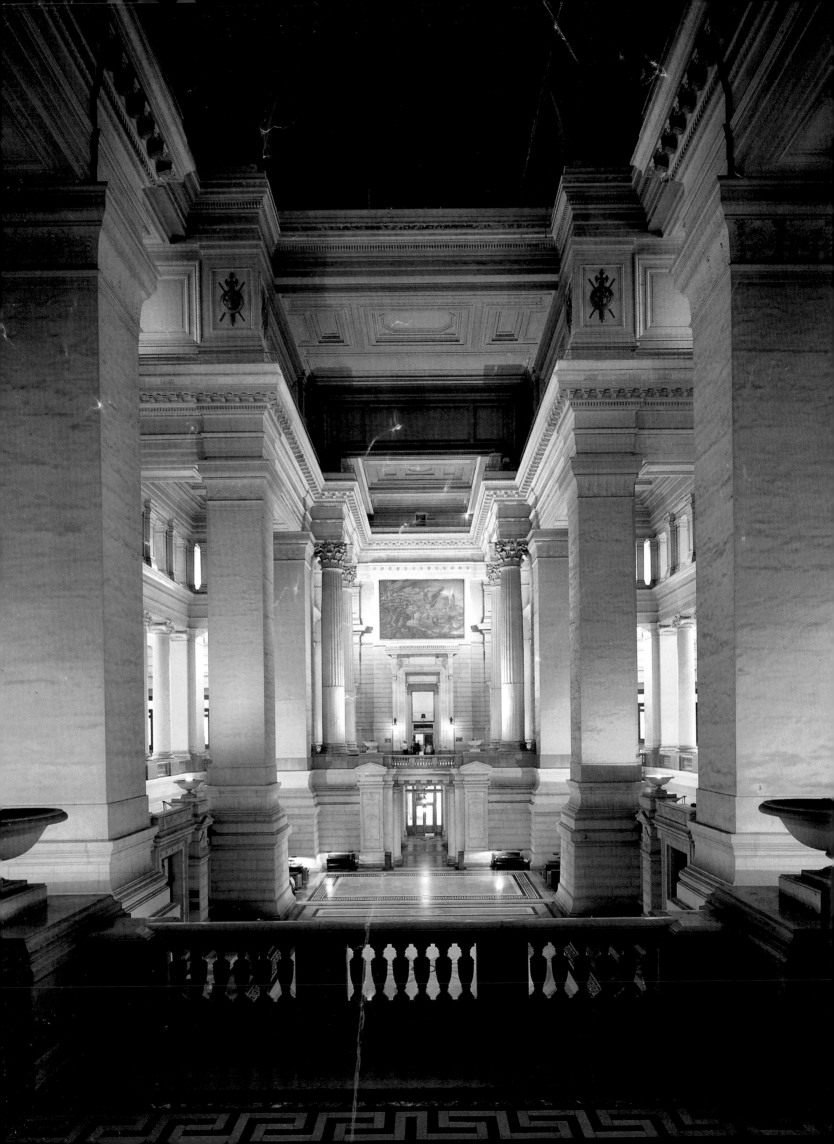

BRUSSELS

FIN DE SIÈCLE

Edited by
Philippe Roberts-Jones

EVERGREEN

EVERGREEN is an imprint of Benedikt Taschen Verlag GmbH

© for this edition: 1999 Benedikt Taschen Verlag GmbH
Hohenzollernring 53, D–50672 Köln

original French edition published by Flammarion
© Flammarion, Paris, 1994
under the title "Bruxelles fin de siècle"
© ADAGP, Paris, 1994 for the works by Adolphe Crespin,
James Ensor, Willem Paerels, Armand Rassenfosse, Fernand
Schirren, Léon Sneyers, Léon Spilliaert, James Thiriar, Jules
Van Biesbroeck and Privat Livemont
With the collaboration of: Paul Aron, Françoise Dierckens,
Michel Draguet, Serge Jaumain and Michel Stockhem

English translation: Sue Rose, Wembley
Cover design: Catinka Keul, Cologne

Printed in France
ISBN 3–8228–7023–4

Contents

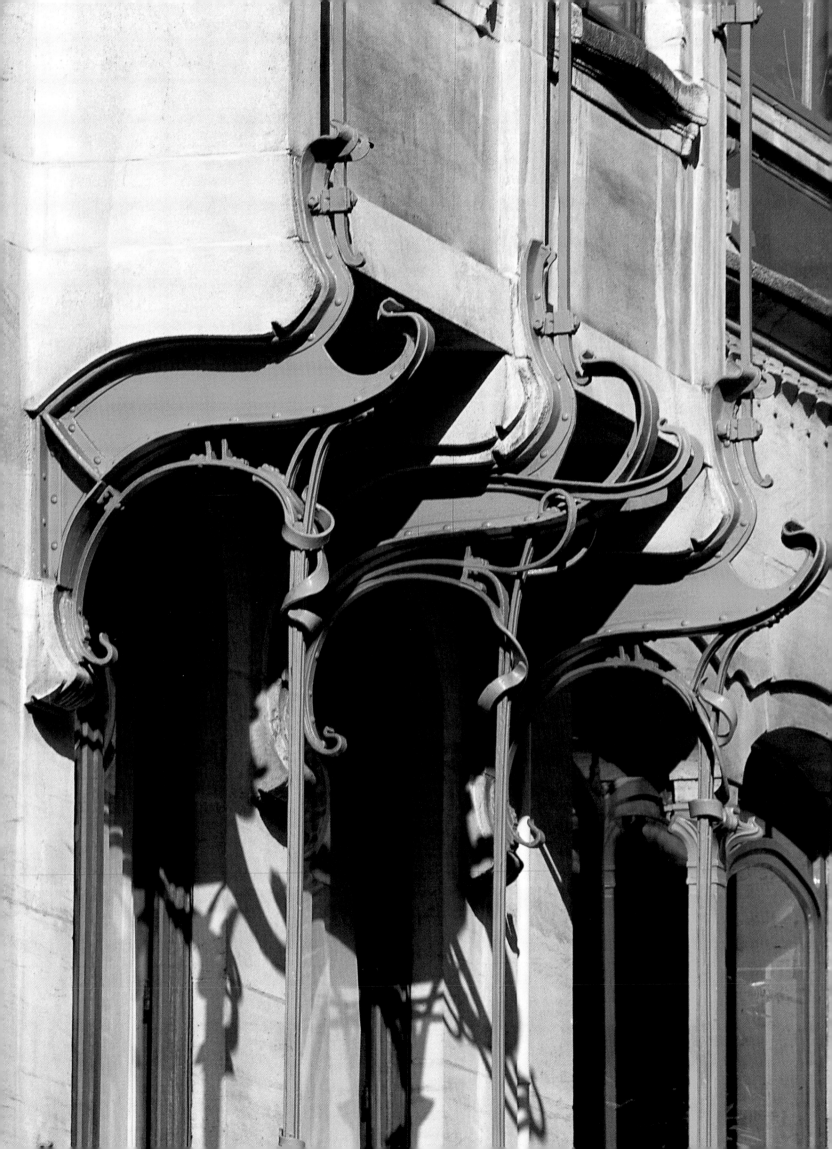

Brussels, *fin-de-siècle* crossroads

The gentle sweep of a curve, the scrolling and unscrolling of a line, a phrase, a curl of smoke rising like a thought, can create an impression of grace and lightness, but can also conjure up a feeling of indolence, facility or perversity, like the coils of a viper. The *fin-de-siècle* style, dominated by the curved line, was often associated with these latter impressions, and not without justification. The decadents revelled in their label and did their utmost to live up to it; the symbolists took pleasure in melancholy, in an evanescent romanticism, in which the only sign of life is the surging flight of the dragonfly. Sensual freedom went beyond the heady pleasures of audacity and degenerated into Satanism. All this is true, but these symptoms apart, this period was an exciting time of great change: Lautrec and his posters, Redon and his imaginary world, Cézanne and his mountains, Van Gogh and his sunflowers, Gauguin and Noa-Noa! The *fin-de-siècle* years had their antidotes, among them Art Nouveau; language moved from hazy languor to sharp clarity, times were changing, and there were the countless exhibitions, designs, and festivities of the Belle Epoque. And, in Mallarmé's words, it was always "Today, virgin, alive and beautiful".

The curves occasionally met and intertwined, creating an unexpected effect, a new and exciting graphic style; sometimes the curve ended in a whiplash. This was the case in Brussels, and the designer was Victor Horta, an inspired architect who transformed the distribution of living areas into a sequence of space and light. His use of curves imparted a natural rhythm and energised the relationship between interior and exterior. In the Hôtel Solvay, a masterpiece of architectural exuberance in terms of design, space, form, light and decoration, built in 1895, his concern for comfort led to the installation of a ventilation system, a type of air-conditioning before the term was ever invented. Horta thus combined functionalism and aesthetic appeal to create the ultimate in style.

Although Belgium, with Brussels as its capital, did not become an independent nation until 1830, its various provinces had been united under various regimes

Victor Horta: façade of house and studio, 23–25 Rue Américaine (1898–1901). Now the Musée Horta.

for centuries. The very name of Belgium was not new. Without going back as far as Julius Caesar, Philip the Good was called "*conditor belgii*"[1] by Justus Lipsius in the fifteenth century. Brussels and the surrounding province of Brabant were situated at the centre of these regions. The area owed its richness and diversity largely to the fact that it was the crossroads between two cultures, Latin and Germanic. But other circumstances – historical, political, economic and intellectual – had also favoured its expansion over the centuries. Brussels' current role as a national and European administrative centre traces its origins back to a distant past.

In the tenth century, Charles of France, the younger son of Louis IV and Duke of Lotharingia, took up residence in Brussels. Five centuries later, Philip the Good set up his court there. From the mid-fifteenth century, Brussels was virtually the capital of the Burgundian State; it had around 30,000 inhabitants and boasted a distinctive skyline with its Hôtel de Ville and its Cathedral of Saint Michel. In 1555, Charles V chose to announce his abdication in the great hall of the Coudenberg Palace.

In the Middle Ages, Brabant boasted one of the most substantial centres of civic authority in the West. It also housed one of the oldest intellectual establishments in the Christian world: the University of Louvain, founded in 1425. At the same time, trade was flourishing – the woollen industry was already thriving by the end of the thirteenth century – and reached new heights in the industrial era. However, the province safeguarded its areas of natural beauty, the lofty beeches of the Soignes Forest contrasting with the gently rolling landscapes of Pajottenland. Soignes attracted the attention of Jacques d'Arthois in the seventeenth century and that of Hippolyte Boulenger in the nineteenth. Pajottenland formed the setting for the parables and animated scenes painted by Bruegel the Elder, who settled in Brussels in 1563. Three centuries later, it served as a backdrop for Eugène Laermans' social comment.

The flowering of the arts in Brabant was truly remarkable. Many examples come to mind: the international renown of the fifteenth- and sixteenth-century wooden altarpieces; the Gothic town halls of Brabant and the architecture of the Jesuit churches; the woodprints made in the monastery of Groenendael around

1450; the tapestry workshops of Brussels, which supplied neighbouring countries and were commissioned in 1560 by Pope Leo X to weave the *Acts of the Apostles* after cartoons by Raphaël.

Painting proved to be the dominant artistic language. The Brussels school came into its own in the fifteenth century with the advent of the Tournai artist Rogelet de la Pasture, known as Rogier van der Weyden. His authoritative personality compelled recognition. An extremely lively studio welcomed foreign artists, trained students and exerted an influence far beyond Brussels' city limits. At the same time, the artist Hugo van der Goes from Ghent had been admitted as a lay brother to the Roode Kloster priory, on the outskirts of the city, and was painting his last works there. Brussels was therefore highly influential in the century of the Flemish Primitives. Then came Bernard van Orley, court painter of Margaret of Austria. The city was restored to supremacy with Bruegel, who painted his chief masterpieces there. Antwerp, a great commercial metropolis, reigned supreme in the seventeenth century with Rubens, Van Dyck, Jordaens and Jan Bruegel. The Archduke Leopold William, Governor General of the Netherlands and a leading collector, invited David Teniers, a young, prolific and highly-acclaimed artist, to Brussels as keeper of his picture gallery in 1651.

The eighteenth century was a period of sleepy charm. But in the nineteenth century, Brussels and Antwerp witnessed a revival in painting; the art had been sustained and enriched over the centuries by the guilds' technical expertise, teaching, and continued respect for the subject. In 1855, the Parisian journalist Edmond About acknowledged this revival of Belgian national identity when he stated, "The Belgian exhibition is the most sensational after our own." Seven years later, at the international exhibition in London, the art historian Thoré-Bürger declared, "The Belgian school has taken the English and everyone else by surprise."[2] In Brussels, the Stevens brothers revived the native realist movement in 1848; in 1868, the Société Libre des Beaux-Arts was founded there, and, in 1884, the internationally renowned Cercle des Vingt. Brussels, the capital of a nation, became the hub of its artistic life.

The *fin-de-siècle* years were filled with myriads of new sounds and colours. The rise of various nationalistic movements was followed by the geographic repartition of the West, and this enlarged the continent's horizons. Colonial initiatives were going from strength to strength in the great nations of the time – England, France or Germany. Alive to the spirit of the times, Leopold II was quick to lend a sympathetic ear to the bold plans of the explorer Stanley and thus contrived, despite Belgium's relative weakness, to carve out an empire for himself in the heart of Africa. Little understood by the citizens of Brussels, who were interested only in short-term gain, the ruler and his African ambitions were greeted with hostility rather than encouragement. However, Leopold's personal fortune was assured from that time onwards, and other countries, aware of the potential riches of the Congo, could barely conceal their envy. One caricature depicted Leopold II as a keeper of wild animals, declaring, "Just take a look at my bear."[3] 'Belgian jokes', in Paris or elsewhere, are no new phenomenon.

Belgium is indebted to its king, not only for fifty years of colonial resources, but also for a sense of grandeur, that has not always been much appreciated. The king transformed the small coastal town of Ostend into a seaside resort frequented by the whole of Europe. In Brussels, he commissioned buildings and town planning programmes and created broad thoroughfares, open spaces, and monuments, from the Avenue de Tervuren to the Jardin du Roi and the Arche du Cinquantenaire; and he often dipped into the privy purse to contribute to the expenses. Such grandiose projects distracted his attention from the grave social problems that were afflicting his country. His King's Speech of 1886, in which he stressed the need for reform, may have come in response to the pressure of events, but he should be commended for his obvious resolve and the generous spirit of his words.

The period remained curiously oblivious to working-class demands and Marxist ideas. Imprisoned in the straitjacket of convention, Belgians long remained unfamiliar with issues such as those raised by Sigmund Freud. The artistic world proved more sensitive, and the concerns of the proletariat were better understood by artists than by politicians. In 1850, Courbet created a general scandal by showing "that a stone breaker was equal to a prince", to quote one of his few supporters.[4] In Belgium, from 1848, the realist painters also condemned injustice and, by the end of the century, the most eloquent and most successful works were being

produced in Brussels. The sculptor Constantin Meunier endowed the worker with dignity and nobility; in 1896, Octave Mirabeau praised his art when Meunier exhibited in Bing's gallery, L'Art Nouveau, in Paris. Eugène Laermans' *Evening of the Strike* (1893) is today a very powerful image of legitimate protest. The painting moves us by the power of its visual language, which is not 'naturalistic' but the product of an exacerbated realism. In this respect, it forms part of a major trend in nineteenth-century Belgian art which, in the work of Guillaume Vogels or Henri Evenepoel, foreshadowed the advent of Expressionism, a movement whose first Belgian exponent was James Ensor.

Ensor was a man possessed, a revolutionary painter immersed in his fantasies. His colours have an idiosyncratic violence and his fantastic vision of a universe is peopled with fallen angels and masks. Aggressive and misunderstood, he was a loyal supporter of the Brussels Cercle des Vingt. His role as a precursor was not recognised abroad until after his death, when an American art historian, citing *The Tribulations of St Anthony* (1887), remarked that, at that point in his career, Ensor was probably the most audacious of all living artists.[5]

The climate of the times was better suited to the innovations and subtleties of Symbolism. Félicien Rops' 1879 illustrations to Barbey d'Aurevilley's *Les Diaboliques* caused one Parisian critic to observe, "This is a new sensation in art."[6] Rops' sulphurous reputation spread throughout Europe. Symbolism had many faces. For the poet Charles Van Leberghe it was "the *frisson* of things, the eddying breeze"; for Maurice Maeterlinck it was "the great treasures of the unconscious".[7]

Maeterlinck, the author of *Pelléas et Mélisande*, was born in Ghent and won the Nobel Prize for literature in 1911. In 1894, André Gide wrote, "We have at present no writers in France who can come close to Maeterlinck."[8] *Les Serres Chaudes* show him to be a precursor of Apollinaire and the Surrealists. Take, for example, the lines, "There is an ambulance in the midst of the harvest" and "Elsewhere the moon had scythed down the oasis". Along with Ibsen, Strindberg

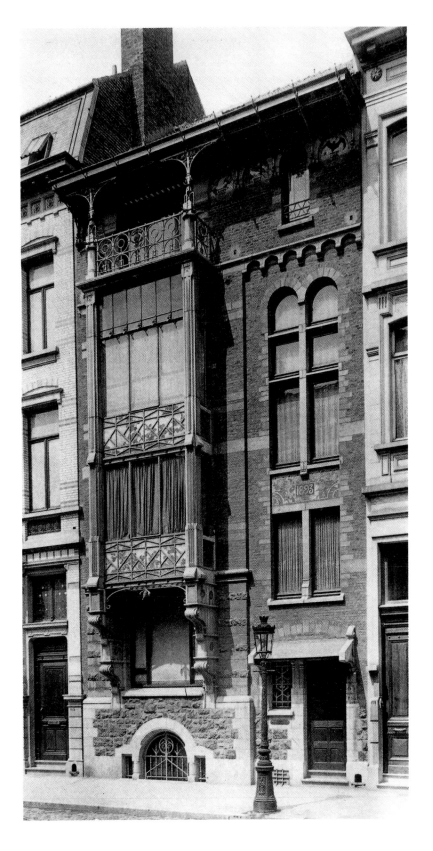

Paul Hankar: façade of house, 71 Rue Defacqz. Period photograph. Brussels, Archives d'Architecture Moderne.

RIGHT PAGE: James Ensor: *Woman Eating Oysters*, 1882. Oil on canvas, 207 x 150 cm. Antwerp, Koninklijk Museum voor Schone Kunsten.

OPPOSITE: Fernand Khnopff: *With Grégoire Le Roy. My Heart Weeps for Days Long Past*, 1889. Design for the frontispiece of: G. Le Roy, *Mon cœur pleure d'autrefois* (Paris, 1889), 1889. Pencil and coloured pencil on paper, 14.5 x 9 cm. Private collection.

ABOVE: Félicien Rops: *The Circus Entertainer*, 1879. Drawing with watercolour highlights, 22 x 15 cm. Brussels, Musée Communal d'Ixelles.

RIGHT PAGE: James Ensor: *Portrait of Émile Verhaeren*, 1890. Oil on wood, 23.7 x 18.5 cm. Brussels, Musée de la Littérature, Bibliothèque Royale Albert Ier, Cabinet Verhaeren, No 51.

or Shaw, Maeterlinck was also a great pioneer of *fin-de siècle* theatre. His *Oiseau Bleu* was, like *Pelléas*, a resounding international success. It was staged by the leading directors of the time: Konstantin Stanislavsky, Max Reinhardt, and the French actor-producer Lugné-Poë. *Pelléas* was set to music by Gabriel Fauré, Claude Debussy, Arnold Schoenberg and Jean Sibelius. Maeterlinck's writings aroused great interest. His language was innovative and unconventional, its measured pace, discursive style, and occasional awkwardness created a strange intensity.

The poet Émile Verhaeren was equally radical. In *Les Villages Illusoires,* he writes:

Long as endless threads, the long rain
Interminably, all the long grey day,
Lines the green panes with its long grey threads,
Infinitely, the rain
The long, long rain
The rain.
…

Mallarmé recognised in Verhaeren a "great new poet", describing, in a *Toast*, his "joy in the magnificent, in the/true-to the-point-of-poignancy-and-tenderness,/ in the strange, the turbulent,/the serious that together are bestowed,/through human genius, by his/Verse".[9]

Symbolist painting found a remarkable exponent in Fernand Khnopff. His haughty manner concealed an introverted narcissistic nature; his motto was 'One's self alone'. The images that he created are both precise and distant, subtle and memorable. His originality lay in his choice of subject rather than his mode of expression. Xavier Mellery, who taught Khnopff, commented, "The artist who can make us forget colour and form in favour of emotion will have attained the highest goal."[10] If emotion is the primary requisite of art, Khnopff refined its effect to the point of enigma. By contrast, the vision of William Degouve de Nuncques was "full of amazed and reflective childhood".[11]

These and many other artistic approaches were brought together by the Cercle des Vingt, a polymorphous group which, in 1884, began its series of annual exhibitions; the artists exhibited included Whistler, Cézanne, Monet, Renoir, Gauguin, Van Gogh, Burne-Jones and Seurat. By its concerts, lectures, and its journal *La Libre esthétique*, Les Vingt transformed Brussels

into a centre for the avant-garde. Octave Maus, lawyer and patron of the arts, musician and music-lover, and his friends Edmond Picard, Emile Verhaeren and Théo van Rysselberghe, waged a "thirty-year battle for art". It was an outstanding period of musical activity: from Wagner to Debussy, from César Franck to Guillaume Lekeu, from operas at the Théâtre Royal de la Monnaie to the Concerts Populaires, from Vincent d'Indy and Georgette Leblanc to the magical virtuosity of the violinist, Eugène Ysaÿe.

The *fin-de-siècle* spirit and Art Nouveau style are associated in Brussels with architecture and decoration, with Victor Horta, Paul Hankar and Henry van de Velde. Van de Velde founded the School of Arts and Crafts in Weimar in 1908, which in 1919 became part of the Bauhaus. Art Nouveau, although it reigned supreme for a while, was not without its critics, and it should be remembered today that its opponents spoke in the name of tradition. In 1908, an ageing art lover in Anatole France's *L'Ile des pingouins* commented, "Disgustingly flabby, bulbous protuberances can be seen hanging down over the façades: they call these Art Nouveau motifs …"[12] The Belgian contributors to Art Nouveau were among the most influential; they include Horta, Maeterlinck, Verhaeren, Khnopff, van de Velde, Ysaÿe, Vogels and Ensor. They were supported by the intellectual and progressive members of an affluent bourgeoisie. Art cannot survive in society without support. Art Nouveau laid claim to the status of 'total art' and comprised both decorative and architectural elements.

At the end of the nineteenth century, there was a great deal of cultural cross-fertilisation between nations. Brussels was not a backwater but a centre. Lautréamont, Rimbaud and Mallarmé published their works there. Félicien Rops took Paris by storm, while Théo van Rysselberghe brought his genius as a portraitist to bear on French Neo-Impressionism. The Cercle des Vingt embraced the decorative arts, welcoming Walter Crane in 1891. Willy Finch founded the Finnish school of ceramics in Helsinki. Khnopff was a triumphant success at the Vienna Secession in 1898. The Austrian Josef Hoffmann built Stoclet House in Brussels; it was decorated with mosaics by Gustav Klimt. European unity was, in short, a reality till nationalism tore it apart in 1914.

Philippe Roberts-Jones

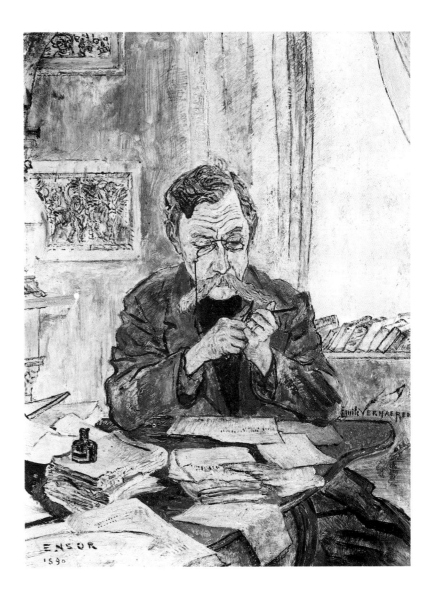

1830–1870
The city and the arts:
from independence
to realism

A new state

Belgium has a colourful past and a rich tradition. It was born in August 1830 of a romantic revolution, in which the Dutch occupiers were driven out. Legend has it that the uprising was sparked off by the performance of an opera, *La Muette de Portici*, at the Théâtre Royal de la Monnaie. A wave of insurrections was sweeping Europe; the distinguishing feature of the Belgian revolution was the differences in sensibility, culture and economic development between the Flemish rural North and the French-speaking industrial South. Independence was achieved by a French-speaking Catholic bourgeoisie hostile to the Protestant aristocracy of the house of Orange-Nassau, which had ruled the country since Napoleon's defeat at Waterloo in 1815. The desire for freedom was inseparable from the economic ambitions of the French-speaking elite, which immediately set about industrialising the country.

The Belgian identity that emerged in 1830 was the product of a pragmatic consensus. Belgium sought to protect its borders and establish its unity by means of a liberal constitution, promulgated on 11 February 1831, and a monarchy (Saxe-Coburg-Gotha) accepted by all the leading powers. The constitution favoured the progressive ideas and guaranteed individual rights, but

it gave the vote to a tiny minority of the population – 1% in 1830, 5% in 1880 – qualified by property holdings. Belgian had won its independence, but had to rein in its external ambitions; the European powers insisted that the young state remain neutral. Belgium, standing at the heart of Europe, functioned as a keystone, maintaining the balance of the other nations. The birth of modern Belgium owed as much to the desire of the British to isolate France as to the inability of the Netherlands to reunite what had been torn asunder by the Reformation. This led to the emergence of a state whose self-image was compounded of modernity and conservatism and innovation and tradition.

Throughout the nineteenth century, the new Belgian nation could afford neither a strong central government nor a unity imposed by authoritarian means. It was a small state rich in natural resources. There was coal (an indispensable source of energy for industrial growth), various minerals, slate, stone and loam, and vast forests that provided the wood needed for mining, building and heating. In such a small country, industrialists were never far from these resources, and access was soon improved by the development of communications.[1]

A prosperous country, Belgium built its economic growth on a situation shared by the whole of Europe: the low cost of labour – and resultant mass poverty – led to industrial expansion, in which the bourgeoisie, which had flourished since independence, invested heavily. Belgium rapidly became one of the wealthiest countries in Europe, and Marx was quick to see it as a "paradise of continental liberalism". The policies of the new state were pragmatic. Employment in Belgium had been badly hit by the closure of the Dutch market in 1830 and the establishment of a toll on the Escaut river. The construction of one of the most extensive rail networks in the world, the first on the continent, and of a large number of roads, not only promoted economic growth, but made Belgium – and Brussels – the hub of modern Europe.[2] The state also assisted industry and agriculture by taking protectionist measures and by regulating the money supply (the National Bank was created in 1850). During this initial period, from 1830 to 1850, Belgium experienced an industrial and commercial recovery. From the mid-nineteenth century, the state emerged as a champion of free trade

Share certificate issued by the Compagnie Générale de Chemins de Fer et de Travaux Publics. Private collection.

PREVIOUS PAGES: Guillaume Low: row of town houses in eclectic style, Rue aux Laines (1903–1905).

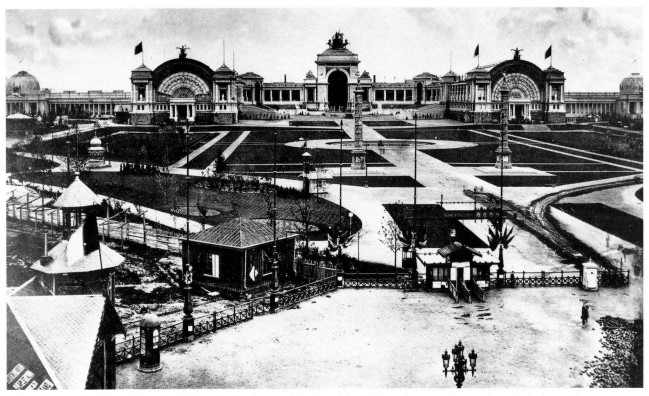

General view of buildings designed by Gédéon Bordiau for the celebration of the fiftieth anniversary of independence. Only the pavilions were permanent; the arcade and galleries were made of wood and stucco. Photograph by Damanet, 1880. Brussels, Archives du Palais Royal.

principles. A Liberal Party reformer from Liège, Walther Frère-Orban (1812–1896), was instrumental in passing laws that facilitated the free circulation of goods. The most famous of these was the abolition of the *octrois* (local import taxes). This eliminated the tolls that were stifling the cities, promoted trade and lowered prices. Central government also assisted industrial growth by taking control of a key sector for production costs: transport. This policy, advocated by a rapidly expanding bourgeoisie, was adopted by both the Liberal Party and the Catholics.

The triumph of free trade coincided with a period of great prosperity: The period 1850–1875 was marked by intense growth. Belgium was seen as the most industrialised country in the world after England.[3] However, the social cost was enormous.[4] The situation of the urban and rural poor inspired artists and writers to bear witness to their poverty and enlist in the struggle for reform that occupied the remainder of the century.

Culture and national identity

In this newly recognised country the formation of national identity was considered one of the key functions of the arts. In his King's Speech of 1865, Leopold II demanded that culture should serve to aggrandize the nation, thereby giving political expression to a concern that had prevailed since independence. A distinctive cultural identity was needed to create a sense of national unity. The debate about national art continued throughout the century: the writers who wanted to set themselves apart from Paris joined forces with the painters who saw Rubens' brilliance or the Flemish Primitives' sensitivity as the expression of a rich, self-sufficient, national school. The fiftieth anniversary of independence became the occasion for an initial survey of Belgian art, and revealed the desire to establish a national identity.

From 1830, this need for self-affirmation found expression in a romantic hostility to academism.[5] A baroque sensibility emphasising tactile sensuality was

the Belgian response to the rationalism of the school of David; Neo-Classicism was considered an alien import. This northern trend emerged in Antwerp, a city with a rich past, in Malines, and in Liège; it reappeared amid the turmoil of the romantic movement. The year 1830 marked the triumph, at the Brussels Salon, of a brand of Romanticism that was deeply entrenched in the Antwerp Academy; its leading practitioner was Gustave Wappers. Against the neoclassical principles developed by the followers of François-Joseph Navez – a pupil of David and director of the Brussels Academy – were set history paintings in which heroes were portrayed in flamboyant brushwork. Figures like Louis Gallait and Antoine Wiertz rejected 'the classical' as alien. They sought to affirm the national tradition by drawing on the tradition of seventeenth-century Flemish painting: large-scale, virtuoso canvases in which the tormented forms bear witness to the artist's passionate subjectivity.

Bearing witness to the past, art consolidated national values in its choice of subject, while its technique too derived from time-honoured tradition. In the field of literature, the national iconography found expression in the historical novel, which flourished between 1815 and 1850. During this period, writers systematically celebrated all the major events in the history of the Belgian provinces since the Middle Ages. Examples include *Philippine de Flandres ou les Prisonniers du Louvre* by Moke, and *La Cour du duc Jean IV* by Saint-Genois. Keen to create its own distinctive identity, the intellectual elite sought to escape the profound influence exerted by France. This led to a preference for German, British and American models; French literary movements were deemed excessively bold, indeed immoral. This policy of imitation made for strong growth in the printing industry, but afforded French critics a rather negative image of Belgian literary works. Keeping themselves aloof from new trends, Belgian writers all too often resorted to nationalism as a means of acquiring a sense of legitimacy.

Adopting the principles of the Saint-Simonian movement, whose influence was felt among the nation's guiding spirits, Romanticism actively helped to create

Paul Bonduelle: Masonic temple, interior, 79 Rue de Laeken (opened in 1910).

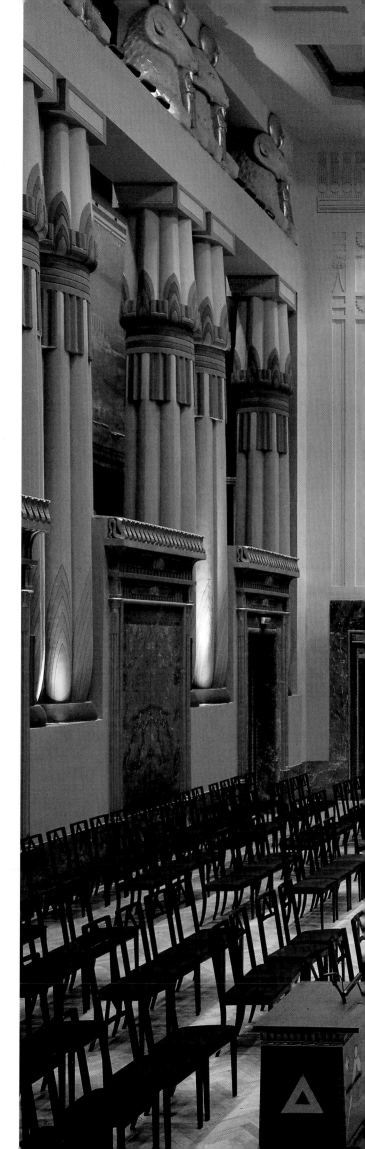

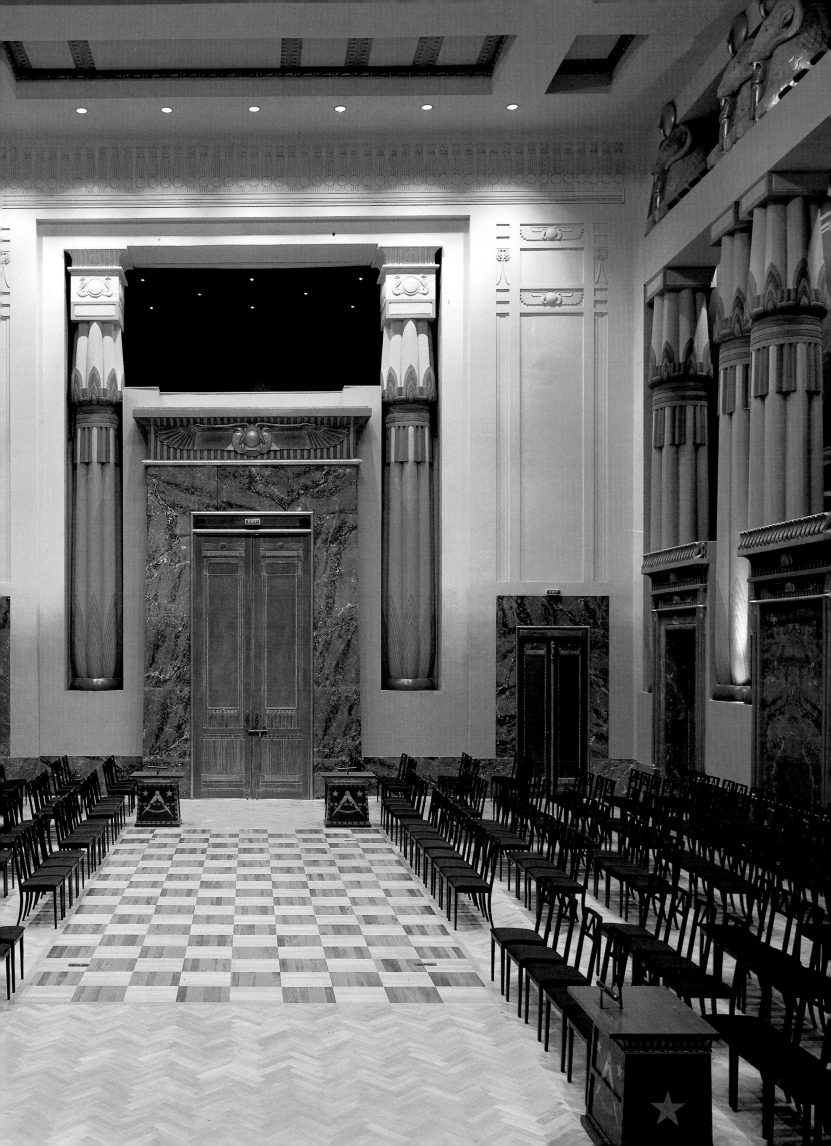

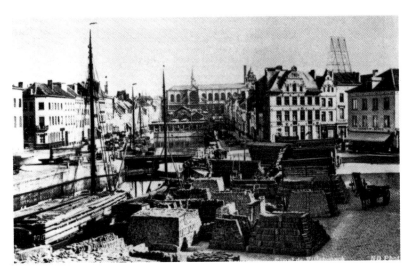

The canal: merchant's dock circa 1900. Period photograph. Brussels, Archives de la Ville.

a world in which industry was regarded as the chief vehicle of progress. From Neo-Classicism to Romanticism, the Belgian school of pictorial art was recognisable by its focus on reality; this found expression in attention to detail and a strong emphasis on the tactile. The desire to represent reality was gradually supplemented by a need to testify to the experiences of life. Developing out of Realism, Positivism and Naturalism, Modernity made its presence felt as early as the 1870s.

The city: its role and significance

Brussels reaped the benefit of the new state's achievements and became the symbol of its success. Situated at the heart of the country, Brussels was the centre of river, road and, later, rail networks, which favoured its commercial and industrial growth. It was also a highly-reputed international financial centre: capital flooded in from all over Europe, while domestic initiatives were taken to ensure the country's rapid industrialisation. Keen to promote national industry, the Société Générale and the Banque de Belgique both chose Brussels as the site of their head offices.

The presence of many small businesses manufacturing a wide range of products and the interpenetration of studios and houses have often obscured the fact that, in the nineteenth century, Brussels and its

suburbs were already the country's main industrial centre. Brussels was also the most densely populated city. The steep population graph did not flatten out until the following century: the population soared from 140,000 inhabitants in 1831 to around 230,000 in 1846, reaching half a million by the end of the century. The adjoining communes benefited from this growth which brought in its wake the town-planning programmes that gave the capital its modern appearance. The opposite was true, however, for the city centre.[6] Built to accommodate institutions, administrative offices and prestigious buildings, it witnessed the gradual exodus of most of its industries and inhabitants. The poorest classes followed the factories into the suburbs in the north west, while the wealthiest moved to the verdant new *communes* in the east of the city.

Brussels was the centre of national activity because it was the home of the royal family, the political infrastructure, the leading institutions and the head offices of large companies. It was also the city symbolically chosen by the Liberal Party for its first conference in 1846. Thirty-nine years later, the formal creation of the Belgian Labour Party also took place in Brussels. One consequence of this was that the politics of the Brussels *communes* acquired national significance. All parties sought places on the Municipal Council which, throughout the nineteenth century, remained a bastion of liberalism. With little concern for social problems – until the end of the century Brussels had no public housing policy – this liberalism displayed a militant anticlericalism directed against a Catholic tradition dating from the Reformation. The aid given by the city to the Free University of Brussels should be seen in this context. The University was founded in 1834 to offset the influence of the Catholic University of Louvain, which had been rebuilt after Independence. Brussels Free University exerted a decisive influence. A large number of political and cultural luminaries of the turn of the century supported the principle of free enquiry, and shared an anticlericalism that shaped the liberal struggle and fostered the Masonic ideal. On similar grounds, the Brussels authorities supported the development of a neutral state education system and took charge of the secular burials which, in 1880, represented over a quarter of all funerals in Brussels.

The changing face of a capital

> Belgium is a magnificent art book, whose chapters, fortunately for the reputation of the provinces, are widely distributed, but whose preface is Brussels and Brussels alone.[7]

Eugène Fromentin stayed in Brussels in 1875, and clearly stated the city's position relative to the rest of the country. Its function as royal capital and seat of the main institutions led to the construction of new buildings, while various urban development programmes modified the layout of the city. Three problems arose: the transformation of the city centre, a link between the upper and lower parts of the city, and planning the city's expansion. New industrial and working-class districts were built in the north, and new residential districts in the west.

Between 1851 and 1913, the frontiers of Brussels were moved at least ten times: the area covered by the capital more than doubled from 415 hectares in 1830 to 1,046 hectares on the eve of World War One. Large thoroughfares were cleared at the very heart of the city. Brussels extended towards the west, where work on the Léopold district (which became part of Brussels in 1854) resulted in some rectilinear boulevards. These acted like a magnet for the upper middle classes who abandoned the noisy working-class streets of the centre for attractive houses in the more tranquil districts of the upper part of the city. The construction of Rue du Trône, Rue de la Loi and Avenue Louise – a stately boulevard leading out to the Bois de la Cambre and fertile soil for Art Nouveau at the end of the century – continued this eastern expansion. The paths through the wood, designed by the landscape architect Edouard Keilig, became a popular place to walk for the residents of Brussels, as did the Avenue Louise where, from 1869, the first horse-drawn omnibus on rails plied its trade.

King Leopold II, whose reign began in 1865, was deeply interested in town-planning and keen to promote the growth of his city even before he came to the throne.[8] His desire to enhance the prestige of the

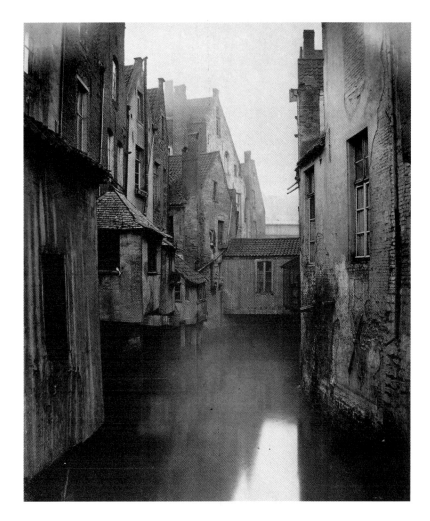

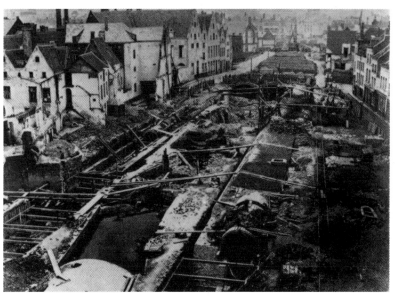

Top: The River Senne before it was covered over. Period photograph taken by the Ghémar brothers. Brussels, Archives de la Ville.

Opposite: The River Senne in the process of being covered over. Period photograph. Private collection.

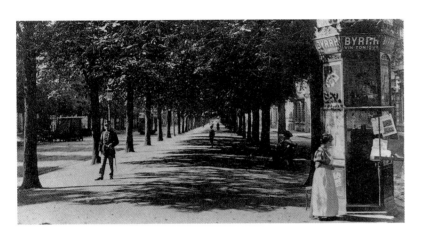

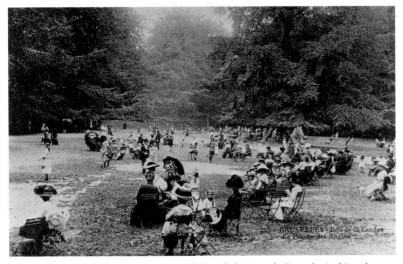

Avenue Louise, postcard. Period photograph. Brussels, Archives de la Ville.

Bois de la Cambre: Pelouse des Anglais, postcard. Period photograph. Brussels, Archives de la Ville.

capital led to a number of changes. His first priority was to transform Brussels into a modern city. Vast building projects drastically altered its appearance; homes received a fresh water supply in 1854, the sewerage system was built between 1840 and 1870 and, most importantly, the Senne was covered over and the central boulevards built (1867–1871). These last two large-scale projects responded to the need to improve the capital's public health and sanitation and accommodate an ever-increasing population.[9]

The boulevards, opened in 1871, provided a new route for commercial and private traffic between the

Gare du Nord and the new Gare du Midi completed two years previously. This replaced the traditional East-West route which crossed the Montagne de la Cour, the Rue de la Madeleine and led to the old Poultry Market. Squares on these boulevards were decorated with sculpture, and many new buildings arose: arcades (Passage du Nord in 1882), hotels (Métropole in 1870), auditoriums (the Alhambra in 1874), and cafés brought the city to life. The cafés were the haunt of young people who met to discuss literature, painting and music. The Café Sésino, which opened in 1872, was a meeting place for the members of the review *La Jeune Belgique*. The department stores built in the city centre were visited by colourful throngs of people. Places of entertainment stood alongside business centres. The Bourse was built between 1871 and 1873 by the architect Léon Suys, who was responsible for laying out the ring boulevards. This lavishly-decorated neoclassical building, very Parisian in style, brought to Brussels French sculptors like Albert Carrier-Belleuse or Auguste Rodin, who could not find work in France because of the Franco-Prussian war[10].

Although it is customary to talk about the "Haussmanisation" of the city with reference to the transformation of Paris by Baron Haussmann, the Brussels municipality refused to impose constraints on its architects similar to those which had created the unified appearance of the great Parisian boulevards. Brussels elected instead to stimulate their creativity by organising, in 1872, a competition for the façades of investment properties: apartment blocks with business premises on the ground floor. The blocks were not a great success and caused the bankruptcy of their French developer in 1878.

The year in which Leopold II came to the throne, the engineer Victor Besme proposed a "general plan for the extension and embellishment of the city and suburbs of Brussels". A plan of some kind was necessary because the city had now extended beyond its city walls. Besme envisaged the creation of a new twenty-seven kilometre-long city-limit, that would encompass suburbs like Schaerbeek, Saint-Gilles, Ixelles or Saint-Josse-ten-Noode, which had once been rural

RIGHT PAGE: Alban Chambon, Hôtel Métropole, 1893. Place de Brouckère.

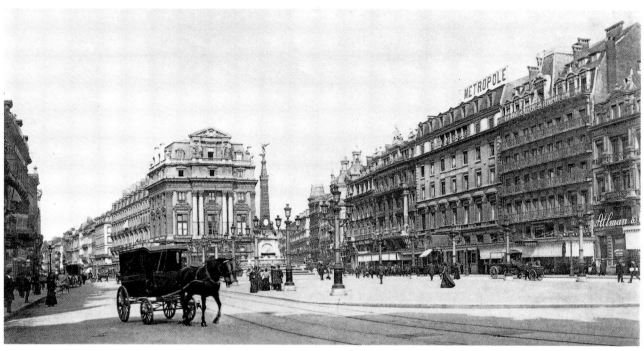

Place de Brouckère. Period photograph. Brussels, Archives de la Ville.

communes. The plan kindled the king's interest. He became involved in – and contributed financially to – various projects designed to improve the appearance of the city by creating impressive vistas and public parks: the Jardins du Roi to preserve the view from Avenue Louise across the ponds known as the Etangs d'Ixelles (1873), the park of Saint-Gilles-Forest (1875), the Avenue de Tervuren (1892), and the purchase of land in Tervuren between 1865 and 1900 to give the city more room to breathe. The city expanded as districts were razed to the ground, transformed, restyled, reconstructed around large thoroughfares, and interspersed with squares containing public buildings, gardens, and statues. In these new areas, town houses sprang up alongside artists' studios. Some of the studios did thriving business. Those on the Rue de la Charité founded in 1874, were famous for their huge panoramas, which found purchasers throughout Europe.[11]

New buildings reflecting the prevailing tastes and needs of the capital adorned the radically altered face of the city: arcades, churches, barracks, administrative offices, studios, hospitals, schools, hotels, and so on. The year 1866 saw the beginning of what, for seventeen years, was the biggest construction site in Europe:

the Palais de Justice designed by the architect Joseph Poelaert. Strangely enough, the scale of the building met with general approval; the Palais de Justice was seen as an accurate reflection of the grandeur of the nation. The building dominates the Brussels skyline: Its ornate grandiosity is emphasised by its artificial elevation. The Place Royale, the site of the equestrian statue of Godfrey de Bouillon by Eugène Simonis, was linked to the church of Sainte-Marie – by the Rue Royale in 1827. In 1872, it was extended to provide a breathtaking view of the Palais de Justice. On the same street, a formal garden decorated by statues representing the medieval guilds was laid out in 1890, opposite the church of Notre-Dame-du-Sablon.

Since independence, sculpture had become a political tool for those who wanted to consolidate national unity by ensuring that the lessons of history were displayed around the city. Monumental or small-scale, public or private, sculpture was increasingly widespread. During the 1870s, the ornamentation of new buildings and the restoration of sculpture on old buildings provided work for many artists. In Brussels, the Bourse, the church of Notre-Dame-du-Sablon, the Hôtel de Ville and the façade of the university were

among the major projects. Throughout the century, the state, provinces and towns embarked on a policy of commissioning: a decorative and educational function was attributed to sculptures featured on façades, in squares, and in public buildings. It became a universally accessible language. This "mania for statuary" reflected the self-satisfaction of the bourgeoisie at the time. It escalated to such an extent that one critic commented, "Before there were not enough statues in the squares; now there are not enough squares for the statues".[12]

In 1875, Gédéon Bordiau sketched out the plan for the construction of the north-eastern district with its series of gardens which, twenty years later, were to be a favourite site for the Art Nouveau architects. In 1880, for the festivities celebrating the fiftieth anniversary of Belgian independence, he designed two exhibition halls – which were to become the Musée Royal de l'Armée et d'Histoire Militaire and an industrial arts museum – linked by a semicircular colonnade. The monumental central arch of the colonnade crowned the vista of the Rue de la Loi, marking the beginning of the future Avenue de Tervuren. This was built in 1897, for the World Exhibition held in Brussels. The façades of the two exhibition halls displayed their metal framework, which was placed on a neoclassical foundation. The central arch was not completed until 1905 by Charles Girault. Once again, intervention by King Leopold II was a decisive factor; at the beginning of the twentieth century, the ruler invested the proceeds of his colonial policy in the completion of the town-planning programme begun the previous century.

One of the key consequences of these large-scale building projects was to oust the workers from the capital's prestigious areas. Driving the predominantly Flemish working class out to the suburbs, Brussels established itself as a French-speaking city.[13] This led to an increasingly marked division of the urban districts. The bourgeoisie could be found in the wealthy districts to the east of the pentagon formed by inner Brussels; the working-class districts, still displaying the mix of residential accommodation and industrial

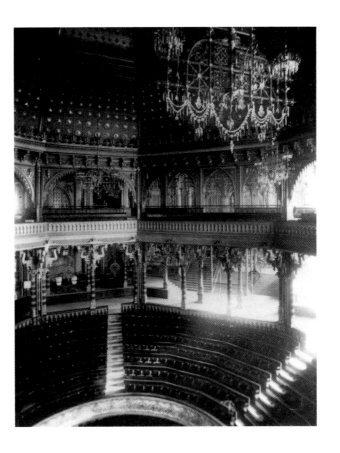

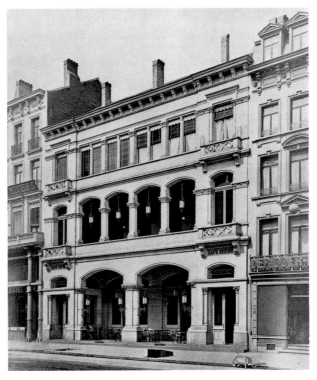

TOP: Alban Chambon: Théâtre de la Bourse (1885) destroyed by fire in 1890. Period photograph. Brussels, Archives d'Architecture Moderne.

OPPOSITE: Désiré de Keyser: Café Sésino, Boulevard Anspach (1875, since demolished). Period photograph, Brussels, Archives de la Ville.

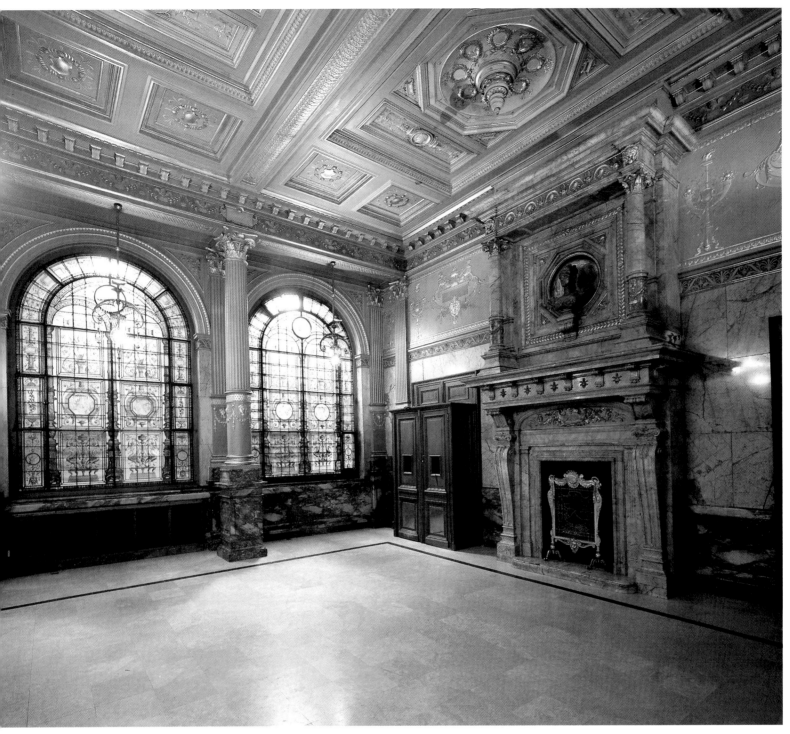

Alban Chambon: Hôtel Métropole, Place de Brouckère (1893).

buildings that had formerly characterised the city centre, were now situated to the west of the large boulevards. Many important companies took up residence along the canal, in particular in Molenbeek, where factories like the Atelier François Pauwels or the Atelier Cail et Halot, specialising in railway equipment, boilers and steam machinery, employed several hundred workers. This high density of working-class people with their wretched homes was to earn the commune the nickname of the "Belgian Manchester".

The programme to improve health and sanitation in the Notre-Dame-aux-Neiges district, between the Palais de la Nation, the Rue Royale, the present Avenue du Botanique and the Avenue des Arts, caused a mass exodus of the working-class population. Charles Buls, the burgomaster who succeeded Jules Anspach in 1880, was probably referring to this project when he wrote in *L'Esthétique des villes*: "The architects of grandiose plans never consider the suffering caused to the poor and meek whom they crush under the debris of the homes that have been destroyed by the demolition worker's pick."[14]

The developers cut through the heart of the city, laying out a network of roads affording long vistas, particularly towards the Colonne du Congrès. Charles Buls fought to preserve the picturesque aspect of the

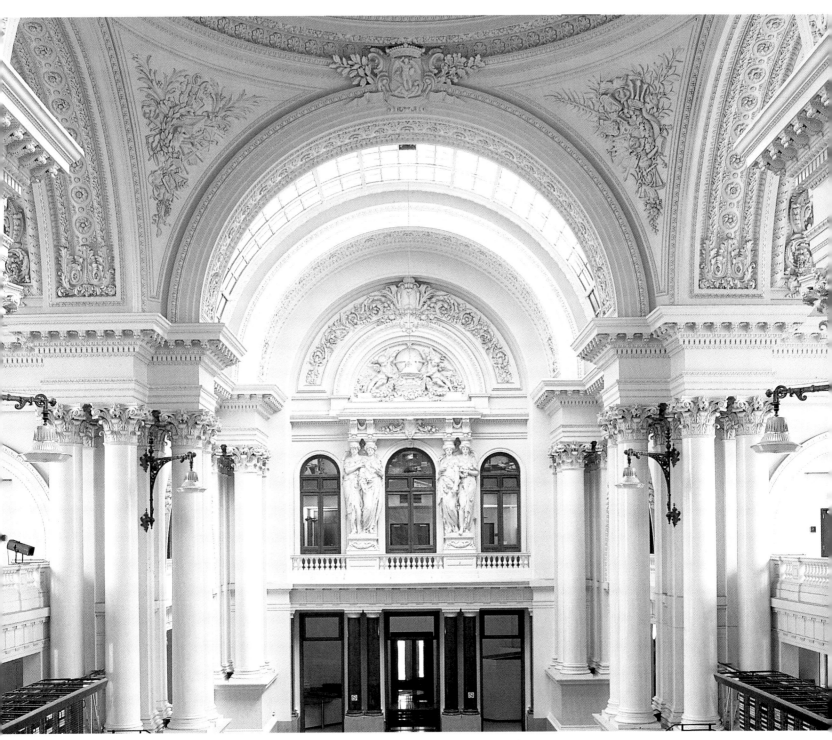

Léon Suys: Bourse, Boulevard Anspach (1868–1873).

city, suggesting that instead of levelling the land, they should exploit the uneven terrain; he wanted to restore winding roads and allow people the delight of coming upon period buildings by chance rather than making them the focus of attention. Buls failed in his attempt to prevent the demolition of the Saint-Roch district (1897–1898), deemed necessary to link the upper and lower parts of the city, and resigned in 1899.

During the reign of Leopold II, over 200 projects to remodel the expanding district below the Place Royale were submitted for approval. The king often intervened personally. He supported Henri Maquet's plans for the creation of a curving street (the future Rue du Couden-

berg) and the construction of a plateau on which the Palais des Beaux-Arts (the present Musée d'Art Ancien) was erected. There, in 1884, the people of Brussels flocked to the first Salon of the Cercle des Vingt. This "cultural acropolis", officially named the Mont des Arts by Maquet in 1903, accommodated the museum extension, a library and the national archives. For the World Exhibition in 1910, a park was laid out on the waste land formerly occupied by the Saint-Roch district. In the 1910s, the neighbouring district, the 'Putterie', also disappeared, replaced by Horta's Gare Centrale and the railway junction linking the Gare du Nord to the Gare du Midi, which was finally opened in 1952.

In his town-planning ventures, the king often clashed with burgomasters and city councils, who were jealous of their independence. As populations rose, and local tax incomes with them, some of the once small *communes* embarked on the construction of prestigious town halls.[15] Jules Jacques van Ysendijck, the architect of two of these buildings, in Anderlecht (1879) and Schaerbeek (1887), drew his inspiration from the town halls of Brussels and Louvain; by the nineteenth century these had come to symbolize civic freedom. Van Ysendijck combined Gothic and Flemish Renaissance influences to create his own personal style; his architecture is colourful and picturesque in its wealth of ornamentation. The impressive decoration of the Saint-Gilles Town Hall by Albert Daumont, opened in 1904, was realised by some of the most prominent names in the capital.[16]

Eclecticism and bourgeois taste

In the mid-nineteenth century, Brussels seemed at the height of its glory. The art of compromise practised by its bourgeoisie was reflected in its tranquil prosperity. This was not affected by the revolutionary events of 1848. Marx was expelled, while the exiled Metternich was welcomed. Brussels preferred the peaceful life. Music became a popular bourgeois pursuit and was enjoyed by a fashionable society hungry for culture and amusement. Brussels' musical life placed the city, in 1860, somewhere between a major capital and a small provincial town. Ambition alternated with complacency to the great satisfaction of a bourgeoisie which was developing somewhat unadventurous tastes.

The symphonic and operatic events organised by the three major musical societies in the city – the Concerts du Conservatoire, the Grande Harmonie and the Association des Artistes-Musiciens – were of variable interest.

Concerts by soloists accounted for the lion's share of musical life in Brussels. Popular composers were often programmed, but the Association des Artistes-Musiciens made some genuine discoveries and introduced Wagner and Verdi. On the other hand, societies like the Cercle Artistique et Littéraire, founded in 1844, introduced Brussels to chamber music, engaging virtuosi who attracted wider audiences to this intimate genre. Piano recitals were particularly well-attended.

LEFT PAGE, TOP: Rue de la Régence, view of the Palais de Justice. Period photograph. Brussels, Archives de la Ville.

LEFT PAGE, BOTTOM: the Mont des Arts, circa 1910. Period photograph. Brussels Archives de la Ville.

BELOW: Albert Dumont: Saint-Gilles Town Hall, 6 Place Van Meenên (1900–1904). Photograph in *L'Emulation*, 1906.

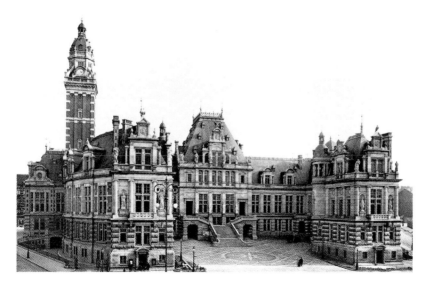

The repertory of the Théâtre Royal de la Monnaie was like that of the majority of European opera houses: an apparently disparate mixture of major works and facile crowd-pullers. Italian bel canto, grand opera and French opéra-comique alternated on the Brussels stage.

In architecture, individualism and bourgeois prosperity led to an eclectic use of styles, a trend exacerbated by the capital's successive urban developments. Three major trends could be identified: classical, romantic, and eclectic. Classical showed Greek and

OPPOSITE: Maurice Van Ysendijck: Schaerbeek Town Hall, Salle des Mariages, Place Collignon (1884–1887).

BELOW: Maurice Van Ysendijck: Schaerbeek Town Hall (1884–1887). Period photograph. Brussels, Bastin & Evrard collection.

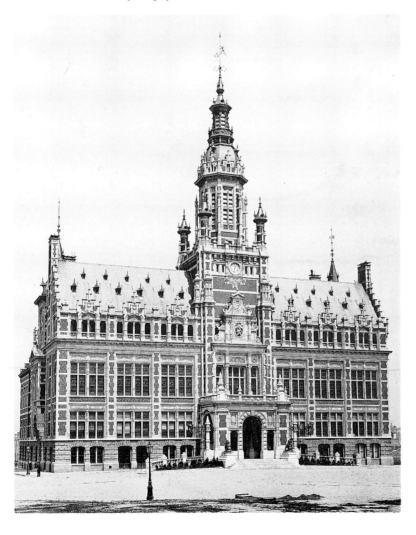

Roman influences and the romantic style involved a revival of medieval architecture. Eclecticism was seen by the editors of the *Journal de l'Architecture* as an immense stock of exciting new combinations. An important movement in the 1850s-1860s, eclecticism reached its height in the following decade. The under-privileged classes had been severely hit by the economic crisis of 1870, but the defeat of the French at the Battle of Sedan and the fall of the French Second Empire were a source of great national pride to the bourgeoisie and found expression in the Flemish Neo-Renaissance style.

This style emerged in the context of the rebirth of national art; its sixteenth- and seventeenth-century architectural models had superficially combined classical forms with a use of space that was Gothic in spirit. Belgian architects freed themselves from these weak classical influences to give free rein to their imagination. In the 1870s, Brussels sported a colourful appearance, with façades realised in many different styles and a variety of materials: brick, glass, stone, ironwork, and panelling. These diversified visual effects contrasted sharply with the austerity of the Theresian style, imported in the eighteenth century by the Austrian regime. Among the inventors of Art Nouveau, some, like Paul Hankar, were to retain a lasting fondness for the colourful Neo-Renaissance vision of life.

Architecture, whether private or public, illustrated the nation's strength. The restoration of monuments celebrating a glorious past went hand in hand with the construction of new buildings symbolic of the new nation. The vast town-planning programme that spanned the century cemented the links between style and function. All over the city, hospitals, prisons, churches, barracks, galleries, theatres, and parks were built, their function emphasised by an appropriate style.[17] Style acquired a moral value that verged on the excessive. For example, with its grandiose dimensions, the Palais de Justice by Joseph Poelaert can be seen as an embodiment of the ambiguous nature of eclecticism. The encyclopaedic universalism to which it aspires tends toward a panoramic use of space, in which ornament confers an exemplary dignity. The building towers over the city like Justice over a submissive humanity. The ornamentation creates a didactic and moral Elysium, in which eclecticism emerges as the symbol of the established order.

The monumental rhetoric generated by eclecticism was also applied to the interior of buildings. No threshold marked the transition between public and private areas. The use of glass made it possible to view the interior as a covered exterior. This lack of differentiation between different areas offered architects a sense of freedom that the use of the latest industrial techniques enhanced: Iron and glass completely revolutionised architecture and encouraged architects to ignore the traditional stylistic vocabulary. The conventions associating a particular style of ornament with a

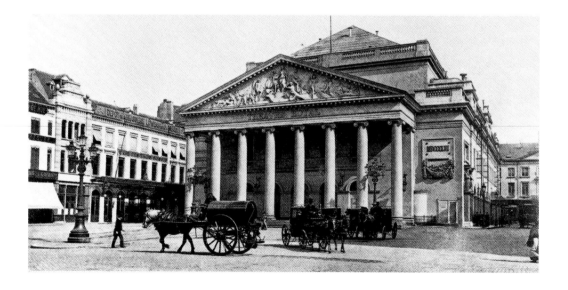

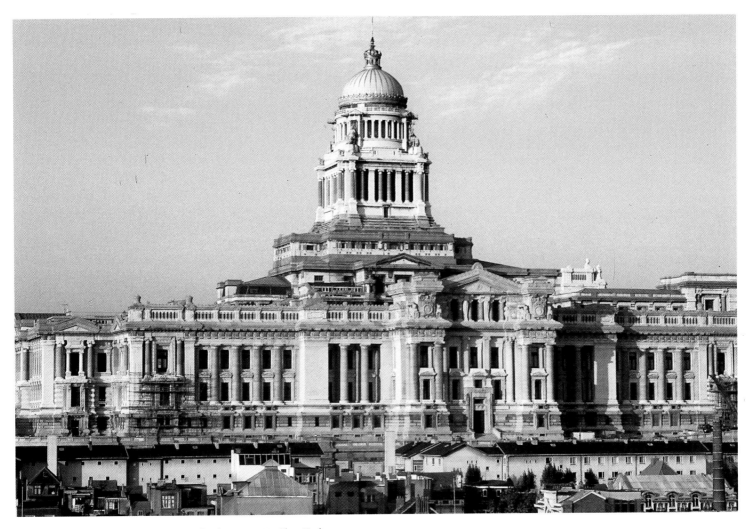

Above: Joseph Poelaert: Palais de Justice, façade, 1866–1883. Place Poelaert.

Left: Théâtre Royal de la Monnaie. Period photograph. Brussels, Archives de la Ville.

Below: Paul Hankar: design for the Spoelberch housing development, 1894. Watercolour. Brussels, Archives d'Architecture Moderne.

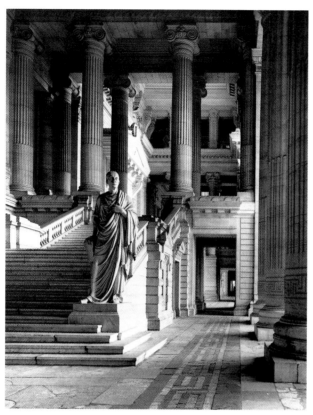

Joseph Poelaert: Palais de Justice, colonnade of the two philosophers, Place Poelaert (1866–1883).

particular form of construction were ignored. Artists freely raided the resources of both form and ornament; along with the classical heritage, out went ideal models.

The beginnings of critical realism

Belgium's political, economic, cultural and social equilibrium was founded on the steady growth of a young country. The prospects seemed unlimited. Revolutionary activity had already sown the seeds of unrest in various places in Europe, causing people to challenge the bourgeois social order. In France in particular, the emergence of the working class was perceived as a threat. And new artistic movements were coming into existence, asserting the need to anchor creative output in contemporary reality.

In Belgium, this desire for modernity initially found expression in painting. A preoccupation with depicting real life had formed one of the characteristic features of the Belgian school since Neo-Classicism. From 1848 onwards, a new generation endeavoured to represent a reality in which social injustice went hand in hand with moral hypocrisy. Thus Alfred Stevens, who made a name for himself in Second Empire Paris as a portraitist of women, his brother Joseph, and Charles de Groux displayed a new awareness of social problems; they depicted poverty-stricken countryside, wandering beggars and the ravages of alcoholism. The presentation of Gustave Courbet's *The Stone Breakers* at the Brussels Salon in 1851 had strengthened the resolve of a new school keen to depict the customs, ideas and failings of its time. This revolution overturned academicism and associated artistic ability with the capacity to produce an accurate portrayal of real life, whether the subject was a social event or timeless nature. This immanent realism came to be regarded as the only style worthy of attention.

During these years, social criticism was still disorganised and lacking in any true programme, whether aesthetic or political. In 1847, in Brussels, a small group of painters and writers formed the Société des Joyeux. This was a movement that hurled the works of Courbet, Duranty and, later, Flaubert in the face of established convention. Members of this student group, which had close ties with the Free University of Brussels, included the young Félicien Rops and Charles de Coster; they attacked the establishment and received ideas, championed freedom of thought, attacked Catholic bigotry, and promoted ugliness to the rank of an aesthetic notion. Several journals came to the defence of the younger generation, whose works continued to be rejected by the Salon, or, if they were accepted, displayed to their disadvantage. They included *L'Uylenspiegel, Journal des ébats artistiques et littéraires*, which was founded in February 1856 and only ceased publication in 1864. Among its contributors were the writer Emile Leclerq, de Coster and Rops. It offered a sounding board for progressivist ideology and a forum for artistic protest. From it, in 1867, came the most important literary work of the period, and the only one to enjoy lasting popularity, although less in Belgium than abroad: *La Légende et les aventures héroïques, joyeuses, et glorieuses d'Ulenspiegel et de Lamme Goedzak au pays de Flandres et ailleurs* (1866) by Charles de Coster,

illustrated by Félicien Rops and others. This baroque work used both epic and novelistic registers, transforming the grandiose scenes favoured by historical novelists with its pointed irony. De Coster thus supported the moral and political aims of the realists while transcending the formal boundaries by which they were constrained. De Coster died in poverty and obscurity in 1879; only with the emergence of a new generation did his genius receive the appreciation it deserved.

In the 1850s, young painters influenced by Realism flocked to the Atelier Libre Saint-Luc, which had been founded in 1846: Louis Artan, Charles de Groux, Félicien Rops, Constantin Meunier and Camille van Camp formed close friendships there and discussed new art. Theories appealed to them less than the quest for a technique imbued with Flemish spirit so powerfully exemplified by de Coster.

The new Belgian realism thus marked a return to the models of the seventeenth century. Land and seascapes became the vehicle for a "national" art, characterised by impasto and vigorous technique. Light delineated objects and emphasised the harmony of natural scenes intended to reflect the country's tranquillity and wealth. The robust brushstrokes showed the Flemish temperament aspiring to a powerful and expressive style. Gradually, Realism compelled recognition as a national art, no longer associated with the representation of the past, but with the sensibility and character of the people.

Open-air painting first emerged as a response to the intellectualism that had prompted the previous generation to tackle vast historical subjects. The work of Théodore Fourmois in the 1850s was decisive. Landscape painting diverged from established formulae to restore the importance of light in depicting changes of mood, rather in the manner of the Barbizon painters. This return to landscape reflected a long national tradition and a romantic spirit. In its wake, the gradual decline of academic commonplaces was inevitable.

Under the guise of a realism which drew as much on contemporary works by Corot, Daubigny or Rousseau as upon a "national" tradition – and a national tradition was the inspiration of the Barbizon school[18] – the landscape artists manifested the need for a return to nature. This was soon interpreted as a rejection of the industrialisation process that had raised Belgium to the status of a great power. The solitude of wind-blown seascape or the pastoral ideal was not devoid of melancholy. Camille Lemonnier's expression "souls awakening among the quivering leaves" was a summons to exile from the ever-expanding cities. Hippolyte Boulenger, a seriously ill young painter suffering from depression took refuge in the forest village of Tervuren, not far from the gates of Brussels. There he gave free rein to a landscape art that was less concerned with the mimetic representation of the natural world than with the free translation of intense and immediate feeling. His pulsating colours added a pre-expressionist dimension to this brand of realism. Boulenger's vision was sentimental, focusing exclusively on expressive effect. Accepted for the Brussels Salon in 1866, Boulenger was at the origin of the revival of landscape painting in Belgium. The Tervuren school, of which he was the only true exponent, offers the Belgian equivalent of the highly successful Barbizon school.[19]

In the field of literature, the first break with bourgeois conformism was initiated by writers in contact with French Second Empire exiles, who had emigrated to Brussels because their political affinities were with progressivist liberalism. This outside influence, and the distance they put between themselves and nationalism, enabled these writers to emulate in literature the achievements of the realist painters.

The battle fought by the painters and sculptors cannot be dissociated from that of the writers, even though, during the 1870s, literature had appeared to be marking time in comparison to the visual arts. The development of the realist novel owed a great deal to Eugène van Bemmel, who edited *La Revue trimestrielle* (1854–1869). Following in the wake of the Société des Joyeux, young writers were creating a new image of Belgium in their works: They were interested in the poor, in the tragedy of failed artists, in unhappy love affairs experienced by people from social strata which had hitherto been ignored by the novel. The downfall of the heroine in *Une fille du peuple* (1874) by Emile Leclercq portrayed the misfortunes of a girl from the 'lower depths'; but this was not merely an objective report. Leclerq's aims were like those of his artist friends, de Groux, Hermans, and Stevens, when they depicted stray dogs or the poor: He wanted to provoke a 'healthy reaction' in his bourgeois readers.

No significant work appeared between the publication of *La Légende d'Ulenspiegel* by de Coster and the first issues of *La Jeune Belgique*, in 1881. But it was during this period that social and moral conditions altered imperceptibly, leading to the prolific creativity that marked the last twenty years of the century. It took the form of a slightly belated naturalism relative to its counterpart in literature.

From the Société Libre des Beaux-Arts to L'Essor

In the 1860s, the new generation came up against the hostility of academic circles. On 1 May 1868, the Société Libre des Beaux-Arts was founded in Brussels to defend the new realist credo. Its manifesto did not really break with tradition. The "free and individual interpretation of nature"[20] was the timeless principle underpinning artistic rebirth. In addition to Louis Dubois, who became its mouthpiece[21], the Société Libre reunited former members of the Atelier Libre Saint-Luc, artists who, like Rops, Artan or Dubois, had been frequenting the studio on the Rue aux Laines since 1860. They were joined by almost all the realist artists who, in Brussels and the provinces, were working in this style. Certain figures, keen to maintain their independence, notably Henri de Braekeleer and Hippolyte Boulenger, refused to join the new group. The activities of association were later described by some as unionist; the artists asserted their freedom by rejecting the hierarchy of genres and seeking the right to exhibit their recent works freely. In December 1868, the Société Libre organised its first exhibition in the premises of the Belgian daily newspaper *La Chronique* in the Galerie du Roi. From the start, the group aimed to be international. Works by Courbet, Millet, Rousseau and Daubigny were presented to the Brussels public, and were enthusiastically greeted by young writers like Camille Lemonnier, who soon espoused the cause of naturalism.

The following year, Realism made its appearance in the Brussels Salon in the form of French artists like

Louis Artan: *Night*, 1871. Oil on paper mounted on canvas, 133.5 x 53.5 cm. Brussels, Musées Royaux des Beaux-Arts de Belgique.

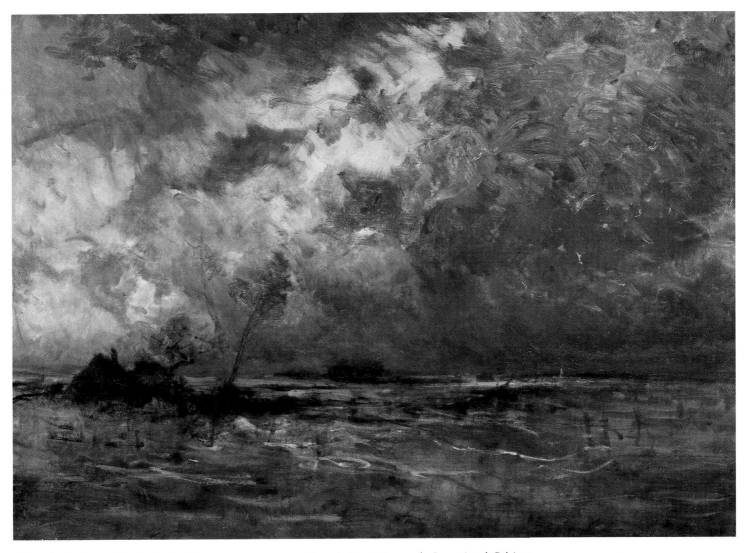

Hippolyte Boulenger: *The Flood*, 1871. Oil on canvas, 102 x 144 cm. Brussels, Musées Royaux des Beaux-Arts de Belgique.

Boudin, Corot, Daubigny, Daumier and Courbet, and Belgians such as Groux, Stobbaerts and de Braekeleer. The movement went from strength to strength; King Leopold II purchased canvases by young artists such as Artan and Meunier. Firmly rooted in the landscape tradition of the former Low Countries, Realism came into its own in the early 1870s, and several exhibitions organised in 1872 and 1873 confirmed its vitality. Some of these were charitable events. One was the comprehensive survey of contemporary art organised by the Cercle Artistique et Littéraire, which opened in May 1872. In either case, Realism compelled recognition as a national movement in its own right.[22]

Ideas took shape and caught up with trends prefigured only in painting. Artists and writers were now expected to be wholly contemporary.[23] On 15 December 1871, the foundation of the review *L'Art Libre* by Camille Lemonnier gave artists and writers a vital platform for the formation of an avant-garde which was to win international fame. In its second issue, the review

published the manifesto of the Société Libre. Deeply hostile to academism, the leading lights of *L'Art Libre* nevertheless gave free rein to a patriotic sentimentalism still informed by the romantic ideal. This was particularly evident in the field of literature. Despite prestigious contributions by Houssaye, Champfleury, Heredia and Mallarmé, the journal folded in December 1872. It was succeeded by *L'Art Universel* in February 1873. A fortnightly journal edited by Lemonnier, it prided itself on being receptive to international influences and reflecting the many and varied forms of modernity. The journal's coherent approach was particularly clear in the field of pictorial art: The work of Stevens, de Groux, Boulenger, Dubois, Heymans, Corot and Millet took pride of place. The several interesting etchings provided by Rops evinced a talent for engraving that attracted the enthusiastic attention of Barbey d'Aurevilly, Verlaine, Mallarmé and Péladan; he was an illustrator of genius. Rops' scandalous erotic plates soon overshadowed his work as a landscape

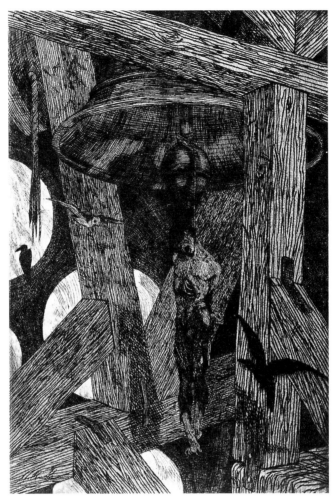

Félicien Rops: *Hanged Man*, 1867. Illustration for Charles de Coster, *La Légende et les aventures héroïques, joyeuses, et glorieuses d'Ulenspiegel et de Lamme Goedzak*. Etching, 20.2 x 13.6 cm. Brussels, Van Loock collection.

artist. A visionary, he demonstrated the multifaceted nature of a modernity that took the universe as its inexhaustible field of enquiry: literary or intuitive, sensitive or demoniac, sublime or picturesque.

At the Brussels Salon of 1875, a canvas by Charles Hermans entitled *At Dawn* confirmed the triumph of the species Realism championed by the Société Libre des Beaux-Arts. The moralising subject presented on the scale of a history painting was not, on this occasion, criticised for breaching the hierarchy of genres. It illustrated the trend for social comment that was bringing Realism closer to Naturalism. Artists had begun to adopt a critical attitude to social inequalities and failings.

Around 1875, financial difficulties apparently led to the dissolution of the Société Libre des Beaux-Arts. Rops' energetic activities led to the formation of a new circle, La Chrysalide, whose first exhibition opened its doors in Brussels in November 1876. Continuity was assured, as the new group included many former members of the Société Libre: Baron, Meunier, Artan and Rops (who designed the invitation card). La Chrysalide continued to target the Academy, but received public support nonetheless; a large number of works were sold. La Chrysalide was orientated more towards Realism than toward the brand of Naturalism that was challenging materialistic bourgeois society. In its exhi-

bitions 1876, 1878, and 1881, the emphasis, as Victor Reding noted in *La Fédération artistique*, was on impressions and imitations of nature.[24] The original members were joined by younger artists who were soon to make a name for themselves in the Cercle des Vingt: Vogels, Ensor, Finch and Pantazis.

Nature was central to the concerns of the young avant-garde in literature and the visual arts. In its manifesto published in November 1875, *L'Artiste* sought to exclude social considerations from the objectives of the Belgian realist movement.[25] Issues of technique therefore defined the movement. It sought the intensity of a visual exploration emancipated from all academic conventions, in a style of painting no longer dominated by the subject and its narrative function. Defining the aim of the movement, Lemonnier himself agreed with this retrospectively:

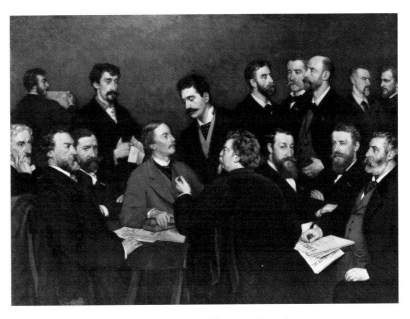

Edmond Lambrichs: *Portraits of the Members of the Société Libre des Beaux-Arts*, n. d. Oil on canvas, 175 x 236 cm. Brussels, Musées Royaux des Beaux-Arts de Belgique.

> To make strong healthy paintings, without rhetoric or formulae; to return to the true sense of painting, which is loved not for its subject but for its rich physicality, like a precious substance or a living organism; to paint nature as it is, frankly and faithfully, free of established systems and techniques.[26]

This emphasis on strength and health was intended to strengthen the younger artists' resolve to pursue modernity despite the "pundits of routine", in a society doomed to decline and decadence. Striving to paint "lovingly and honestly" whatever it saw, this style reached its acme in the fields of portraiture and landscape, by respecting what Lemonnier believed were painting's fundamental elements: nature, the individual and colour. Thus, Louis Artan distinguished himself as a painter of seascapes, glorifying light in thick swirls of paint. In his works, the atmosphere is coloured by finely-nuanced shifts in feeling. His austere taste focuses attention on painting itself. In his works, we feel the enthusiasm that made him lose himself in the world he was contemplating, seeking expressive power in the tactility of his brushwork, if necessary at the expense of his ostensible subject.

In the late 1870s, the realist painters, gathered under the banner of the Société Libre des Beaux-Arts, gradually moved towards a freer technique and a more instinctive and vigorous style of painting. No longer concerned to produce an objective rendering

of the subject, painters aspired to express emotion in the fluid movement of light and patches of plain colour. The critics were quick to note the sensuous brushwork informing the vivid colours of this Belgian style of Realism.

Crude and robust in the work of Artan or Rops, delicate and mannered in the work of Alfred Stevens, colour appeared, in its very physicality, the founding principle of Realism. It was not necessarily associated with light. Although similarities with French Impressionism exist, the path taken by Belgian artists was substantially different.

The emphasis placed on technique did not mean that the subject was neglected. For some, the idea of a "return to nature" constituted a critique of urban life. For others, like Rops and his artist friends on the banks of the Meuse, it was connected with the pleasure they took in society life. Far from the city, artists wished to re-establish contact that a natural environment which was completely indifferent to the artifices of social intercourse: the obligations, relationships and games of public life. This was soon accompanied by a desire for a return to the origins, for timeless values. Taking refuge in the countryside, in the tranquil vil-

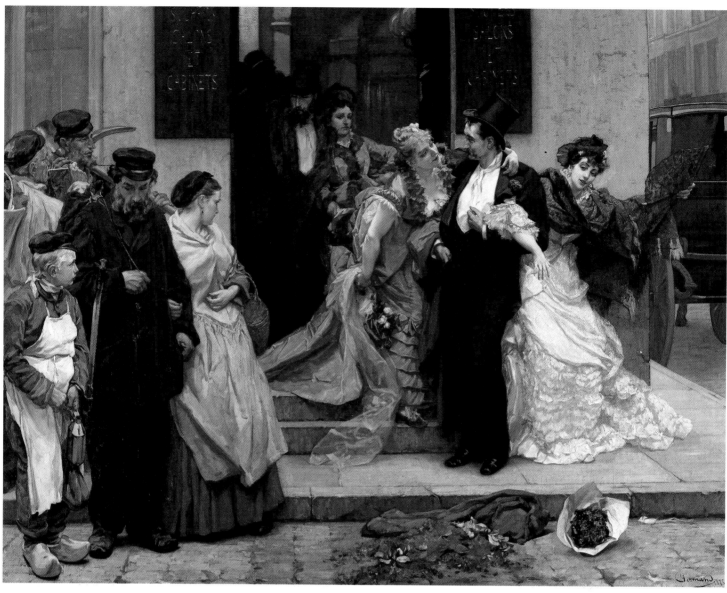

Charles Hermans: *At Dawn*, 1875. Oil on canvas, 248 x 317 cm. Brussels, Musées Royaux des Beaux-Arts de Belgique.

RIGHT: Alfred Stevens: *India Comes to Paris: the Exotic Curio*, n. d. Oil on canvas, 73.7 x 59.7 cm. Amsterdam, Vincent van Gogh Museum.

lages of Flanders or Wallonia, was one way of escaping the growth of industrial society.

One artist stood out against this background: Constantin Meunier. Like Millet in France and Charles de Groux in Belgium, he explored a social dimension which, in 1878, was emphasised by his discovery of the crisis-ridden collieries of Liège. Trained in painting and sculpture, Meunier had not yet discovered this "savage people, who lurked in the shadows until he opened the gates of art to them", in Lemonnier's words. His work was suffused with a hazy atmosphere that cast a veil over the translucent air and endowed empty space with a luminous opacity. Even before taking the dignity of labour as his theme, Meunier's affinity for that world of precarious existences was manifest, not in his sub-

jects, but in his divided brushwork and the physicality with which he invested space.

Alongside the Société Libre des Beaux-Arts and La Chrysalide, L'Essor – a circle of pupils and former pupils of the fine arts academies established in 1876 – organised some major exhibitions, which presented works by the avant-garde alongside the more conservative representatives of the Brussels scene. Until 1891, the date of its dissolution, L'Essor enjoyed remarkable public success, cemented by royal patronage. Providing an umbrella for a wide variety of different creative trends, L'Essor brought a variety of artistic circles together; the result was a "happy medium",[27] covering academic convention with a thin veneer of modernism.

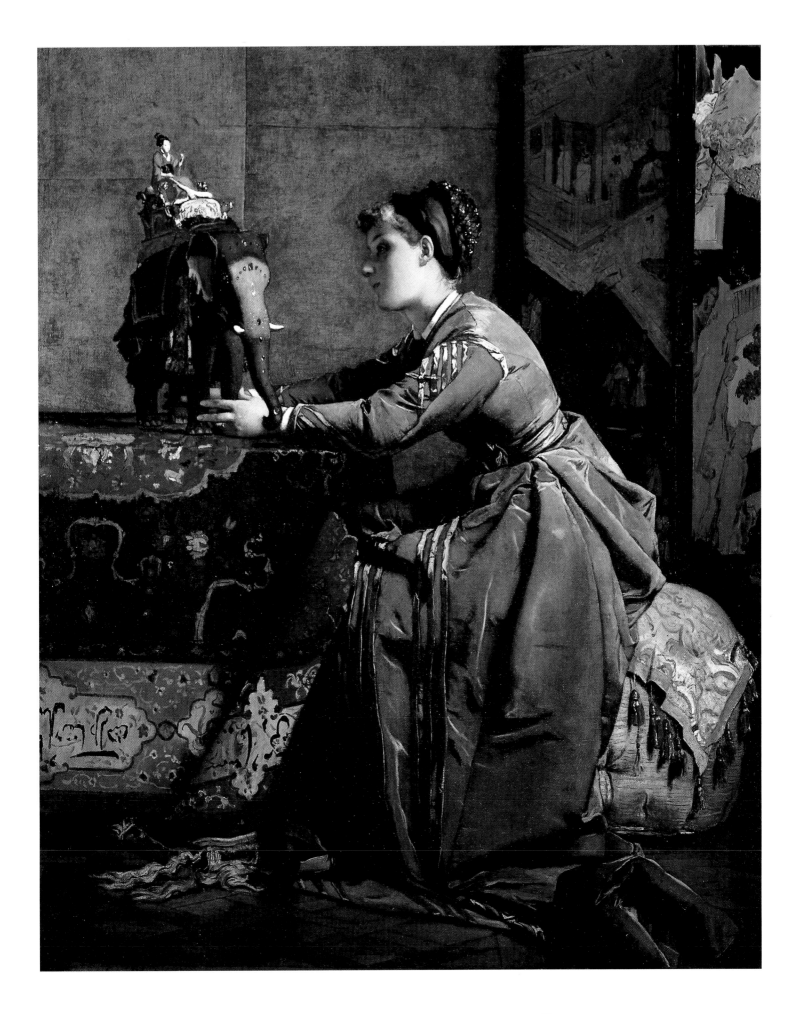

Sculpture and reality

Painting had led the way; sculpture had tended to bring up the rear. Associated more with the world of politics and the civic authorities on whom they depended, the sculptors were reluctant to immortalise vulgar subjects in marble. Aware of their educational mission, they remained committed to 'big' subjects and traditional styles, though, following the example of Rude, the study of nature had become increasingly popular in the studios.

'Statue mania' continued; squares and parks were decorated with countless pieces of sculpture in which academism combined with Saint-Sulpician mysticism. For economic reasons, experimental projects tended to be made in clay. The Liège artist Léopold Harzé sculpted several large groups in clay. One of these, *Liège Market* (1859), depicted a group of some 100 people and combined close attention to detail with a desire to show life in the streets. The keynote of his work was not the scientific precision championed by Zola, but a provincial sentimentality imbued with popular folklore. Gradually, classical references, consolidated by the traditional journey to Italy, were replaced by models chosen for their contemporaneity. The world of physical labour became a focus of artistic attention. In his monument to *John Cockerill*, exhibited in 1870 and 1871, Armand Cattier accompanied the statue of the industrialist with four allegories of work: lifelike portrayals of a miner, a mechanic, a puddler and a blacksmith. A new vision, free of classical reference, became the norm. The individualisation of figures perturbed many critics, who suspected casts taken directly from the model. Artists preferred clay and bronze to marble, as they were easier to work and facilitated the rendering of fine detail, different volumes; they were also capable of registering spontaneous impressions. The lost-wax process enabled the sculptor to capture the most fleeting emotions in bronze. The art of delineating volume gave way to a modulation of light in which successive volumes gave rise to complex passage work. This new art, buttressed by the discovery of Falguière, Mercié, Carrier-Belleuse, Carpeaux and Rodin, was supported by the Société Libre des Beaux-Arts and by La Chrysalide. Its realist exponents were Charles van der Stappen, Jef Lambeaux, Julien Dillens, Thomas Vinçotte, Paul de Vigne and Léon

Julien Dillens: *Sphinx-Enigme*, 1875. Bronze, 90 x 100 cm. Ghent, Museum voor Schone Kunsten.

Mignon. Their portraiture was expressive and individualised down to the very least detail. Their depiction of the nude was deemed unconventional and even shocking, like this woman by Dillens entitled *Enigme*, the unusual and faithful rendering of a sickly constitution was found positively repellent. Dillens was challenging the classical ideal, whose profound influence could still be seen in the work of van der Stappen, Vinçotte or de Vigne; he wanted his work to reflect contemporary life. Lambeaux, too, portrayed in sculpture the ragged casualties of an industrial society. In academic genre scenes, the real was present only to confer pathos; the new realist scenes were the more subversive in that sculpture made of them 'icons' of social injustice.

Brussels: between Paris and Bayreuth

Modernity in music coincided with the advent of Wagnerism. In March 1860, Richard Wagner arrived in Brussels from Paris, hoping that an invitation from the Théâtre Royal de la Monnaie would earn him some money. Despite the public success of his two concerts, in which he conducted excerpts from *Der Fliegende Holländer*, *Lohengrin* and *Tannhäuser*, he was still penniless when he left.

His visit nevertheless had a profound influence on several supporters of the new generation. One such was Adolphe Samuel, winner of the Prix de Rome, a pupil of Fétis and Mendelssohn, a friend of Berlioz, and professor of harmony at the Brussels Conservatory. He favoured progress in music and politics alike; he provided the masses with access to concert-going by launching an initiative that complemented the music curriculum available in a growing number of schools. Following the example of Jules Pasdeloup, founder of the Concerts Populaires in Paris in 1861, Samuel founded the Société des Concerts Populaires de Musique Classique in Brussels in November 1865. The society began a long career, in which the name of Wagner gained particular lustre. Subscribers rubbed shoulders with guests from the working classes: labourers, soldiers and children filled the auditorium for each concert.

Brussels notables made it a point of honour to contribute money to this undertaking, which ran to some ten concerts a year. The orchestral programmes combined originality with edification; there were overtures, complete symphonies, and chamber music transcribed for orchestra. Many of the works performed were Brussels premières. Samuel had a marked preference for German music, particularly Beethoven and Mendelssohn. Interesting repertory in performances by leading virtuosi made these Concerts Populaires exciting events. The soloists included the German pianist Louis Brassin, who became professor of piano at the Brussels Conservatory and helped to promote Wagner's music.

At La Monnaie, new productions became more ambitious. In 1861, Gounod attended the Brussels

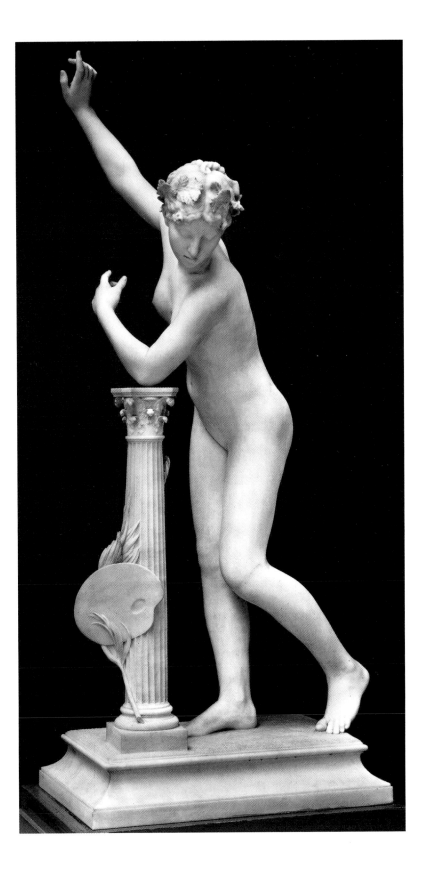

Paul de Vigne: *Immortality*, 1881 or late 1883. Marble, 187 x 64.5 x 81 cm. Brussels, Musées Royaux des Beaux-Arts de Belgique.

première of *Faust*. With *Philémon et Baucis* (1862), *Mireille* (1865), *Roméo et Juliette* and *La Colombe* (1867), he became one of the most popular composers in the repertoire. Meyerbeer was also performed: six months after the Parisian première, *L'Africaine* was performed in Brussels to unprecedented acclaim. The Brussels public liked not only grand opera but bel canto: the fashionable society of Brussels adored tenors and divas.

Jules Henry Vachot was appointed director of La Monnaie in 1869, and, at Brassin's instigation, invited the young conductor Hans Richter to Brussels. A future hero of Bayreuth, battling to ensure that the integrity of the score was respected, Richter presided over the rehearsals of *Lohengrin*; the première, in March 1870, caused a sensation. Wagnerism combined ancient legends with new music, and fuelled the hopes of a bourgeoisie for whom culture was an instrument of social progress; it found its true home in Brussels and enthused an entire generation. The modernity embodied in *Lohengrin* was a phenomenon that transcended the Belgian context. Wagnerians flocked in from Paris, where such an event was unthinkable; in the aftermath of the Franco-Prussian war, Wagner was perceived as the voice of 'German arrogance'.

The importance now accorded to music in Brussels society manifested itself in various large-scale events that took place at intervals throughout the century. When the Gare du Midi, designed to impress Parisian visitors, opened in 1869, Adolphe Samuel worked wonders: Around 1,500 musicians took part in the first complete performance in Belgium of Handel's *Messiah*. The audience numbered some 8,000 people. It proved an exemplary success. Throughout the century, the proliferation of music societies revealed the bourgeoisie's love of music.[28] Music formed one of the pillars of bourgeois education. Audiences and performances alike increased, and thus encouraged the appearance of specialist periodicals. 1855 saw the first issue of *Le Guide musical*. Initially a local journal, by the end of the century this publication had made a name for itself as the most important musical weekly in the French language, outclassing the Parisian weekly *Le Ménestrel*.

Interest in the Flemish movement emerged in music as it did in painting and architecture. Peter Benoit, a composer of major choral works, launched various initiatives in favour of Flemish national music; these were generally received sympathetically in Brussels, where his follower Arthur Wilford had settled.

In the 1870s, great leaders took over from the great pioneers. Brussels' musical life reached a watershed with the arrival of François-Auguste Gevaert and Joseph Dupont. César Franck, whose influence was exerted from Paris, was another key figure.

Gevaert started out as a composer, but made his name as an academic musicologist. His Parisian triumph, *Georgette ou Le Moulin de Fontenoy,* and the success of *Quentin Durward*, performed at the Opéra-Comique in 1858, consolidated his fame. From that period onwards, he also applied his considerable talents to historical research, and indulged in rancorous polemics with his fellow countryman Fétis in the columns of the Parisian *Gazette musicale*.

When he became head of the Brussels Conservatory in 1871, Gevaert, basking in the glory of his previous position as musical director of the Paris Opéra (1867–1870), reigned supreme over the Belgian music scene. Devoting himself to music theory at the expense of his compositional career, he gave the Conservatory a new lease of life; he was ruthless in his choice of professors. Confident of his authority and enjoying the support of the king, he could now rely on his staff and focus his attention on the Conservatory's concert programme. The re-formed orchestra made a name for itself in the symphonic repertoire, from Mozart to Schumann. But great works by Handel and Bach were also performed, with a fresh concern for authenticity, despite the various cuts, arrangements and *tempi* sanctioned by Gevaert, who shared the prevailing taste for eclecticism. This concern was furthered by the Conservatory's Musée Instrumental, founded in 1877, whose mission was to give ancient instruments a new lease of life, if necessary by restoring them. The Conservatory concerts made use of the museum's woodwind, brass, violas d'amore and harpsichords whenever possible.

In 1873, Joseph Dupont was engaged by La Monnaie as conductor of the Concerts Populaires, a position he held for twenty-six seasons. He knew exactly which card the institution should play. He wanted to counterbalance the revivals at the Conservatory from the past (mostly the recent past) and introduce the Brussels public to modern music in general, and Wagner's in particular, more quickly than was possible at La Monnaie. In 1877, in the excitement following

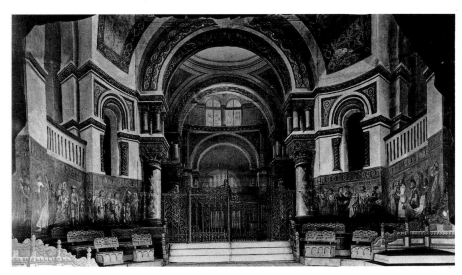

Stage set for *L'Africaine* by Giacomo Meyerbeer (Act I), performed at the Théâtre Royale de la Monnaie in 1865. Period photograph. Brussels, Archives du Théâtre Royale de la Monnaie.

the inauguration of the Bayreuth Festival, two concerts devoted exclusively to Wagner were organised. Others followed: "the Wagnerian disease", as it was known in Paris, was spreading.

Alongside Wagner's increasingly popular music, the Concerts Populaires also welcomed high-calibre contemporary pieces played by renowned performers. The best Belgian music (Vieuxtemps, Mathieu, Auguste Dupont, Franck, Raway, Blockx, Huberti) was performed alongside French music (Berlioz, Saint-Saëns, Bizet, Massenet and Godard). The German and Slavic schools were also 'naturally' well represented; not only the romantic composers, but 'contemporary' composers like Liszt, Brahms, Raff, Dvorak, Tchaikovsky and Anton Rubinstein. A perceptive conductor, talented orchestrator, and 'moderate' Wagnerian, Joseph Dupont left his mark on his times.

Meanwhile, César Franck's Parisian reputation was reaching new heights. A virtuoso pianist brought up in Liège, Franck had lived in the French capital since he was a teenager, and was a pupil of Reicha. He soon came to the notice of Liszt, who encouraged the publication of his *Trios* written in 1841. Having failed in his career as a pianist, he had distinguished himself by 1870 as a celebrated professor and organist. In 1859, he was appointed organist at the Church of Sainte-Clotilde, where he played the famous Cavaillé-Coll. In 1871, with Saint-Saëns and others, he founded the

National Society of Music, which was to play a decisive role in reforming French music. Succeeding his teacher François Benoist as organ professor at the Paris Conservatory in 1872, he more or less unwittingly transformed his organ course into a composition class. He had already given private lessons to two of the best French composeres of the time: Duparc and Castillon.

News of the successes of his symphonic and chamber compositions eventually reached Belgium. His piece *Les Eolides* was performed at the Concerts Populaires and the *Quintet in F Minor for Piano and Strings*, first performed in 1880 in Paris by Saint-Saëns with a Belgian quartet, was soon after performed in Belgium too. The turn-of-the-century mania for Franck's music had begun.

At La Monnaie, the exploration of Wagner's works did not continue long. *Tannhäuser*, introduced in 1872–1873, was the biggest box-office success of the following season. Between 1872 and 1875 conductors came and went, no doubt reading the runes. Despite the advent of a Wagnerian conductor in the person of Joseph Dupont, the spread of Wagner's music was hindered by the arrival, in 1875, of the directorial team of Stoumon and Calabresi. This triumvirate reigned until 1885. Spurred on by Dupont to create an excellent company, Stoumon and Calabresi were able to win the unconditional support of the city of Brussels, which

Stage set for *Sigurd* by Ernest Reyer (Act IV, Scene I), world première given at the Théâtre Royale de la Monnaie in 1884. Period photograph. Brussels, Fievez collection.

they later exploited to extend their dominion beyond what was warranted.

Stoumon and Calabresi loathed Wagner. They - preferred lighter new pieces by Guiraud, Paladilhe, Massé, Dubois, Mathieu or Stoumon himself. Until 1880, the outstanding events at the Monnaie were all Latin operas by Latin artists – *Carmen, Aïda, Paul et Virginie, Cinq-Mars, La Guzla de l'émir, Le Timbre d'argent* – played by an increasingly accomplished orchestra.

The year 1881 marked the beginning of a new era, that of the "déçus de l'Opéra": composers rejected by the Paris Opéra. Indeed, extra-musical events had already led to certain French works being premièred in Brussels; the famous *Fille de Madame Angot* by Lecocq was given its first performance at the Alcazar in 1872. After that, musical imperatives prevailed. Eminent French composers rejected by reactionary directors of the Paris Opéra at the Palais Garnier were given a warmer welcome in Brussels. Massenet was the first, with his *Hérodiade*. On 19 December 1881, after night-long queuing in the Place de la Monnaie, the audience heard a sparkling cast give the first performance of the work. Queen Maria Henrietta and her retinue, the government, and Brussels dignitaries shared the boxes with the leading French composers: Saint-Saëns, Reyer, Godard, Joncières and Guiraud. The evening was a resounding success. Twenty weeks later, Massenet closed the season at La Monnaie by conducting the fifty-fifth performance of *Hérodiade*.

The success of *Hérodiade* cemented the Brussels-Paris axis, but performances of Wagner continued. Italian opera too, was well-represented: Boito's *Mephistofele* received thirty-four performances in 1883. The impact of *Parsifal* in 1882, and the production at La Monnaie in January 1883, two weeks before Wagner's death, of an eagerly-awaited *Ring Cycle* performed by many of the singers in the Bayreuth company, and numerous press campaigns, had kept alive the Wagnerian flame. Ernest Reyer, Berlioz's successor as music critic of the *Journal des Débats*, arrived in Brussels with an opera in which the names of the main characters – Sigurd, Günther, Hagen, Irnprit, Ramuer, Brunehild, Hilda, Uta – reveal the composer's preference for Nordic myth over Latin clarity.

The long-awaited *Sigurd* became one of the most frequently performed French operas in France over the next sixty years; the triumphant première took place on 7 January 1884. The cast was sensational and included one of the great voices of the turn of the century: Rose Caron.[29] A great musical occasion, the première of *Sigurd* was performed before *le-tout-Paris*, who soon became accustomed to taking the 'train to La Monnaie'.

With the first performance in French, on 7 March 1885, of *Die Meistersinger* Brussels gained still greater

renown as the capital of Wagnerism outside Germany. Indeed, some of the most important interpreters and adapters of Wagner's music were Belgian. Maurice Kufferath, already a devotee of Wagner at the age of twenty, had gradually taken control of the *Guide Musical*, which had until then been rather traditionalist. A discriminating man of letters with a flair for spotting new talent, a sworn enemy of the mediocre, and a courageous polemicist, he tirelessly interpreted Wagner's music for his readers. In France, his only rival was Adolphe Jullien. The French translations of Wagner's libretti by Victor van Wilder (Victor Wilder when in France) were considered definitive. In Paris, the young singer Ernest van Dyck excelled in Wagnerian roles; Emile Blauwaert's performances of these roles were much praised by Peter Benoit. In April 1883, a Wagner concert conducted by Dupont at the Concerts Populaires provided a showcase for a trio of fine singers: Rose Caron, van Dyck, and Blauwaert. Bluwaert was due to star in the 1891 Wagner festival after his brilliant Gurnemanz in the 1889 *Parsifal* when he suddenly died. He was buried on a cold February day in a small cemetery near the gates of Brussels; an orchestra out of sight of the tomb played the Faith and Grail themes from *Parsifal*. Thereafter, Brussels lived and died to the sound of Wagner.

Top: Armand Rassenfosse: *Portrait of César Franck*, n.d. Lithograph with crayon highlights, 17.6 x 14.5 cm. Private collection.

Opposite: Rose Caron in *Salammbô* by Reyer (1889–1890). Brussels, Fievez collection.

1870–1893
A new
generation:
modernity

Jan Toorop: *After the strike*, circa 1888. Oil on canvas, 65 x 76 cm.
Otterlo, Rijksmuseum Kröller-Müller.

Economic crisis and uncertainty

The period of intense economic growth that Belgium
had enjoyed since its independence came to a halt
with the crisis of 1874. The markets closed in the
aftermath of the Franco-Prussian war. The recession
worsened when the United States stopped ordering the
coal and steel needed for building its national railway
network. Belgium depended heavily on international
trade, and the result was a long depression that lifted
only in 1895.

The agricultural sector was also in severe difficul-
ties; the market had been flooded by large quantities
of American wheat. Many unemployed farm workers
headed for the industrial centres, but these had been
hit hard by the recession and were unable to absorb
them. The recession directly affected the working
classes, resulting in pay cuts and escalating unemploy-
ment; many families were plunged into poverty with-
out the protection of any form of unemployment
benefit.

The depression came to a crisis in the 1880s. In-
creasingly severe unemployment led to demonstrations
by unemployed workers in the winter of 1884–1885.
Soon sporadic strikes broke out in the Borinage region
and, in March 1886, a workers' upspring broke out in
Liège and spread like wildfire through Hainaut and
the nation's main industrial centres. This revolt led to
pitched battles between workers and the army. The
political establishment had not seen the trouble brew-
ing and was badly shaken. The insurrection also gener-
ated a wave of deep sympathy in libertarian artistic
circles. Ensor, Toorop, Picard and Verhaeren mani-
fested their support for the workers' cause. Two years
before, in a pamphlet about the crisis, Eudore Pirmez
had written: "The situation of the landowners and the
capitalists is pitiable; they are the ones who are suffer-
ing. There are no complaints from the workers!"[1]

After 1886, working class conditions could no
longer be ignored. The King's Speech offered clear
evidence of this; on several occasions, he returned to
the injustices undermining the country. The establish-
ment resolved on a few unadventurous welfare mea-
sures. It implemented a Labour Commission, which
compiled an initial report on working conditions. The
report recommended the passing of laws such as the
creation of industrial and labour councils, the abolition
of the truck system, and the non-transferability and
immunity from seizure of wages. These measures
merely brought Belgium into line with laws that had
been in force in Germany and France for several
decades.

When the crisis began in 1886, the Catholic party
had been in power for two years. It continued to ad-
minister the nation's affairs single-handed until World
War One, but now had to contend with the appear-
ance of a new political force, the Belgian Labour Party,
which was established in 1885 in the wake of demands
for universal suffrage. The Labour Party succeeded in
federating many groups of workers, but had to wait
until 1894 before attaining a seat in parliament. In
the meantime, it organised co-operatives, unions, and
charitable associations. The construction of the
Maison du Peuple in Brussels numbers among the
Labour Party's achievements. It also gave the architect

Victor Horta the chance to demonstrate the full range of his talents.

The Labour Party was Brussels-based. Its development was influenced by its membership, many of whom were artisans and activists disinclined to revolutionary violence. Another and highly important contingent was made up of bourgeois intellectuals. An intelligentsia had formed in the capital, which had become a centre of ideological debate. The debate was enlivened by the many foreign thinkers fleeing European conservative regimes, and by the existence of the Brussels university, where progressive notions held sway.

During this period, the city continued to expand: If we compare the number of professionals working in Brussels in the mid- and late nineteenth century, we perceive a sharp increase in the standard of living. A new urban life arose; small businesses had sprung up, along with the numerous inns, cafés, restaurants, and theatres.

The working classes in Brussels were particularly vulnerable. Severely affected by the economic recession, they were also the victims of a town-planning policy that drove them out towards the new suburbs.

Architecture and eclecticism

The development of a national style was the touchstone of Belgian cultural life during the third quarter of the century. Sculpture had to be edifying; literature was dominated by the fashion for historical novels, while the Flemish tendency to conservatism formed an obstacle to the creation of a national style of painting. In the 1870s, 'national style' in architecture required a break with eclecticism, which had been described as

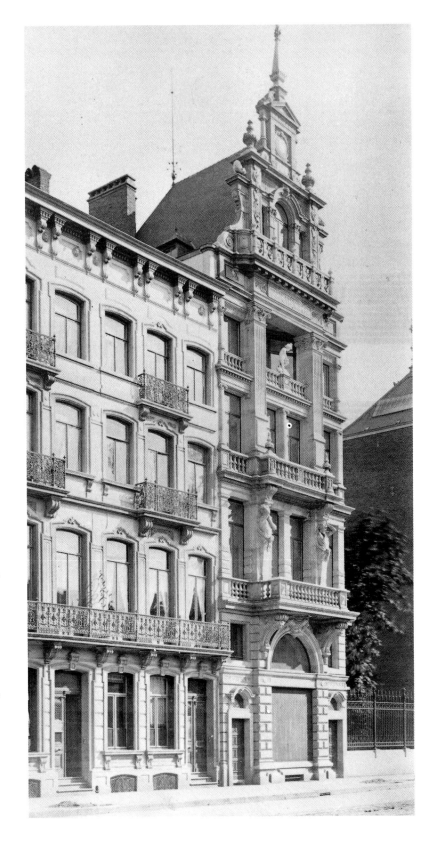

Henri Beyaert: Maison des Chats, 1–3 Boulevard A. Max (1874–1876). Period photograph. Brussels, Archives de la Ville.

FOLLOWING PAGES

LEFT, TOP: Alphonse Balat: Musées Royaux des Beaux-Arts (1875).

LEFT, BOTTOM: Alphonse Balat: Palais Royal, main staircase, 1868.

RIGHT: Octave van Rysselberghe: house, 10 Rue Faider (1882).

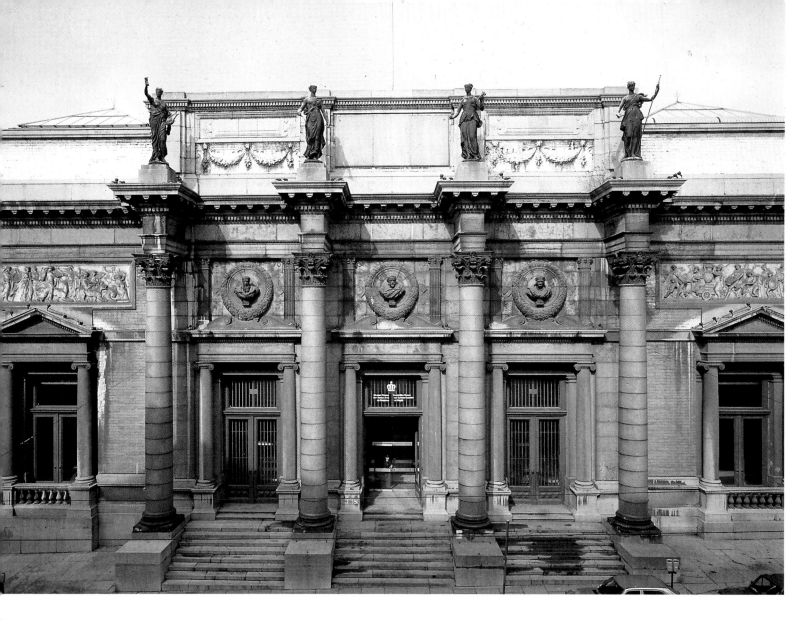

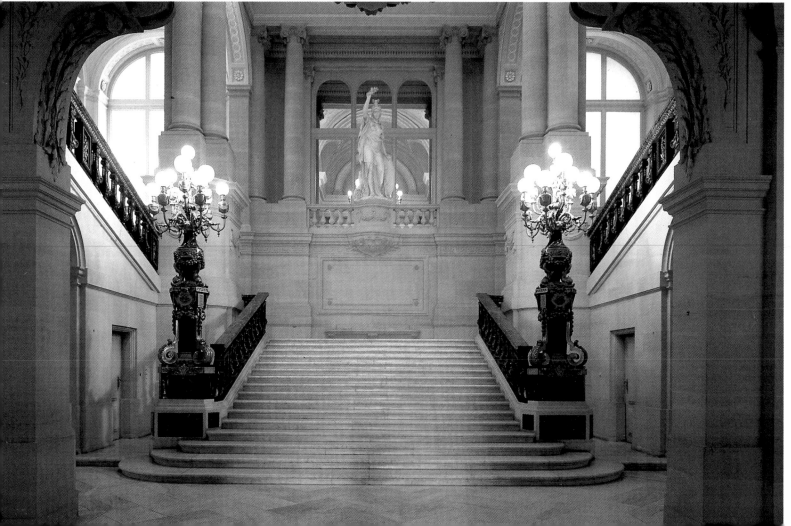

"carnival architecture" and "a veritable Babel".[2] The Flemish Renaissance, regarded as a golden age for the Netherlands, was the obvious source of inspiration. It clearly influenced the Belgian pavilion designed by the architect Emile Janlet for the World Exhibition held in Paris in 1878. Satisfying a taste for movement, colour and picturesque appeal regarded as peculiarly Belgian, it is thought by some to have given rise to Art Nouveau in Belgium

The Flemish Neo-Renaissance style continued to thrive until the outbreak of war in August 1914; its leading exponent was Henri Beyaert. When, in 1875, he won the façade competition organised by the city of Brussels with his Maison des Chats, the review *L'Emulation* heralded his design as "the embodiment of Flemish thought, sixteenth-century in character, yet invested with *sentiment*, the *spirit* of our century, in other words, expressed with greater elegance than Vredeman de Vries would have done."[3] This elegance derived from his earlier work in an eclectic neo-Louis XV style, laden with ornamentation. Beyaert did not confine himself to architecture; he also worked in interior design. His interest in archaeology, like that of his model Viollet-le-Duc, went well beyond reconstruction to become an act of the imagination, as witness his restoration, in the 1860s, of the Porte de Hal, a severely damaged remnant of Brussels' second city wall.

The Maison des Chats on Boulevard Anspach, marked an important stage in his career. The façade initially calls to mind those of the houses in the nearby Grand'Place, but Beyaert's intricately decorated gable above the austere frame of the façade was eclectic in inspiration. On the third floor, he eliminated part of the façade to create a loggia, whose effect is all the more spectacular because it was echoed on the lower floors by larger balconies overhanging the street. This type of interplay, softened by the use of curved lines that enliven the entire façade, later found an echo in the work of Horta. In the late 1870s, Beyaert designed the Place du Petit Sablon, endowing Brussels with one of its most attractive ornaments. This square might have remained no more than a plot of grass dotted with statues and enclosed by a simple railing; instead, it became a splendid formal garden with paths and lawns, verdant hollows, a sloping terrain and an ornamental pond. The strict pattern of the stone columns

and the railings is subverted by the fact that each boasts a different design. There is no doubt that Beyaert's ornamental invention and consummate craftsmanship exerted a profound influence on Paul Hankar, who collaborated on this project. The time Hankar spent in Beyaert's studio (1879–1892) left him with a marked taste for wrought-ironwork.

Beyaert was so famous that in 1883, when fire ravaged the Palais de la Nation, he was commissioned to undertake the repairs and to enlarge the semicircular chamber. In 1888, he designed the Hôtel Hanrez on the Chaussée de Charleroi. At this very same time, it would seem, Horta, probably introduced by Hankar, was serving a short but beneficial apprenticeship in Beyaert's studio.

Beyaert proudly acknowledged the use he made of Flemish Renaissance style. His quest for an individual style of architecture, his meticulous attention to the function of the building, his choice of materials, and his liking for ornamentation integral to the architectural structure prefigures the achievements of Art Nouveau.

In 1888, Horta wrote a piece about the Théâtre Flamand, built four years earlier by Jean Baes, Rue de Laeken, for *L'Emulation*. Describing Baes' work as "impressionist", he emphasised the way in which the design was tailored to suit the building specifications, which had themselves been dictated by safety considerations. The tiers of external balconies were highly picturesque, but they made possible the rapid evacuation of each level. Unusually for a theatre, the auditorium was illuminated by a vast circular skylight which made it possible to mount daylight events. In the foyer, indicated on the façade by the three huge first floor windows, the iron framework was exposed; its overtly functional aspect contrasted with the interior decoration – tiling, wrought-iron chandeliers, sgraffiti and frescoes – which revealed the influence of Flemish Renaissance style.

Eclecticism epitomised the blend of conformism, originality, archaism and innovation elevated to the status of national values in the Belgium of Leopold II. Four architects found royal favour: Alphonse Balat, Henri Maquet, Alexandre Marcel and Charles Girault. In 1866, Balat was commissioned by the king to renovate the Brussels' Palais Royal. Leopold must have approved of the understated grandeur of the Palais

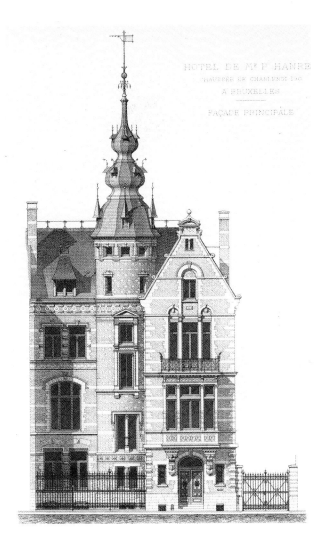

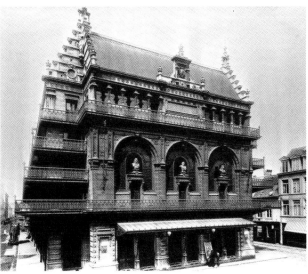

d'Assche (today the seat of the Conseil d'Etat) built between 1856 and 1858. In this building, Balat had created a striking contrast between the plain stone surfaces and the lavishly-ornamented window frames. At the Palais Royal, Balat designed the façade overlooking the garden, the Grande Galerie, the ballroom and the marble room, but it was the main staircase that caught the attention of his contemporaries. Balat's inspiration was French architecture of the second half of the eighteenth century, particularly Ange-Jacques Gabriel's *grand projet* at Versailles. However, the ambiguous light sources, the use of mirrors to disrupt the perception of space, and the plain stone facings setting off the delicately carved ornamentation that articulates the building's structure, were hallmarks of Balat's work.

Balat combined his taste for classical structure with a flair for colour. He liked to contrast the whiteness of stone with the rich colours of granite and marble. This can be seen at the Palais des Beaux-Arts, begun in 1875. Balat aspired to an ideal form that was not dictated by the architecture of the past. Unlike the "passionate romanticism" of Poelaert, Balat's deployment of space in the Palais des Beaux-Arts did not merely provide a dramatic setting for the ornamentation. Balat insisted on a classical structure even though the use of modern techniques would have given him greater freedom. As Horta pointed out in his *Mémoires*, "Balat's work can be recognised by its overall effect, but its details, unlike those of Poelaert, are impersonal."[4]

Eclecticism saw out the century. Its popularity was owed to its free approach to construction, combined with convention in its quest for a national art that would reflect the established order of a proud, arrogant and influential bourgeoisie. While challenging the very concept of style, eclectic architecture met the requirements of a social minority, some of whom had started to question their position during the economic crisis of the 1870s.

Top: Henri Beyaert: Hôtel Hanrez (demolished), 190 Chaussée de Charleroi (1890). Engraving. Reproduced in *Travaux d'architecture par Henri Beyaert*, n. d. Neirinck, Brussels. Brussels, Archives d'Architecture Moderne.

Bottom: Jean Baes: Théâtre Royal Flamand, 146 Rue de Laeken (1887). Period photograph.

In Brussels, the bourgeoisie had not been directly affected by the recession. The triumphalism of the previous years continued, while new sectors, particularly the chemical industry, had appeared on the scene. But the country had seen the rise of a new middle class whose numbers had increased with the nation's wealth. This class, whose culture testified to the efficacy of the education system, had no access to political power, which was still based exclusively on property qualification. The fact that a large number of recent university graduates were confined to the fringes of the political system created a feeling of frustration which caused some of the young bourgeoisie to gravitate towards the more militant groups being organised within the labour movement. On a cultural level, they were hostile to the values of the previous generation. The emergence of the naturalist trend has been justifiably associated with this social inequality, generated by a period of past prosperity that was deaf to the demands now engendered.[5]

The naturalist novel

The literary world registered the social developments described above in its own way. The generation of realist writers, the majority of whom were from modest backgrounds and regarded writing as a hobby, was succeeded by authors born in the 1860s for whom writing was a profession. These writers turned towards France and supported the naturalist movement.

The first sign of this was the series of artistic and literary reviews – *L'Art libre* (1871–1872), *L'Art universel* (1873–1875) and *L'Artiste* (1875–1880) – which came to the defence of the realist painters. In the columns of these periodicals, Camille Lemonnier campaigned in favour of Zola's *L'Assommoir* and *Germinal*. Several followers of Zola contributed to them, including Paul Alexis, Henry Céard and Joris-Karl Huysmans. This alliance paved the way for the close relationship between Brussels and Paris of the *fin-de-siècle* years. Less well-known French authors – like Léon Cladel – also received an enthusiastic welcome from the Belgians. It was not surprising that Cladel, the master of the regionalist novel, should have been received so warmly in Belgium, where the genre enjoyed great success after the popularity of naturalism *a là* Zola had waned.

The editorials soon gave way to novels. Camille Lemonnier, nicknamed the "maréchal des lettres", was the first professional writer to make a name for himself. Having made his début as a Salon critic, he decided to study various social milieux and, in 1880, he published the first naturalist novel, *Un Mâle*, in the periodical *L'Europe*, of which he was editor. As with almost all his books, it caused a considerable scandal. Public disapproval brought with it support from Parisian colleagues, particularly Daudet and Huysmans, and Lemonnier's young Belgian admirers also rallied to the cause.

The sensuality of *Un Mâle* and the brutality of its characters constituted a clear break with realism. The novel describes the secret affair between the poacher Cachaprès and Germaine, the granddaughter of a wealthy farmer. But as passion swells in the heart of the woodsman, it dies out in that of the beautiful Germaine, who wants to marry a local farmer. Cachaprès prowls around the farm until one day he is shot and mortally wounded. Pursued by the police, he takes

himself off to die in the bushes, deep in the heart of the forest, which, unlike Germaine, has never betrayed him. The work is both lyrical and naturalist; the hero's emotions reflect a state of nature. The determinism of the novel stems from the aesthetics of Zola, but the work was dedicated to Barbey d'Aurevilly – an author whose idealism and mannered prose appealed more to Lemonnier than Zola's unadorned style. Lemonnier's stylistic aspirations are reflected in his lengthy descriptions abounding in musical and pictorial metaphors. Many artists were inspired by this work.

Lemonnier followed this with *L'Hystérique* (1885), a psychological study of a neurotic woman captivated by a charismatic priest, *Happe-Chair* (1886), a working-class novel set in the steel-making region in the heart of Belgium, and *La Fin des Bourgeois* (1892), which charted the history of a family in the style of Zola's *Les Rougon-Macquart*. He also tackled a psychological novel (*Claudine Lamour*, 1893) before immersing himself in "naturalism" (*L'Ile Vierge*, 1897).

The other great Belgian naturalist novelist was Georges Eekhoud who, although less prolific than Lemonnier, produced a more coherent oeuvre; indeed, his themes recur obsessively. Eekhoud was interested in people on the fringes of society: the poor, criminals, the *lumpenproletariat,* prostitutes and homosexuals. This lower middle-class man from Brussels wore pince-nez and led a very sedate life, but was a revolutionary libertarian, who made no secret of his sympathies for controversial causes such as anarchism, the Flemish movement and, after the Great War, pacifism.

In *La Nouvelle Carthage,* published in Brussels in 1888 and reprinted in 1893 in a substantially enlarged version, Eekhoud depicted his native town in naturalist style. The author, whose grandmother's maiden name was Euphrasie Paridaens, gave the hero of his novel, set in Antwerp, the name Laurent Paridael. Laurent's story is similar to that of other Eekhoud heroes, all of whom rebel against their adopted milieu. But *La Nouvelle Carthage* offers a wide-ranging survey

Charles van der Stappen: *Ompdrailles*. Pedestal by Victor Horta, 1895–1897. Jardin du Roi. Monument in homage to Léon Cladel's novel *Ompdrailles ou le Tombeau des Lutteurs.*

of society and a bold criticism of Belgian capitalism. In justly celebrated pages, Eekhoud describes the stench around the factory, the noxious effect of acids and the pollution of working-class homes; he shows the helpless courage of honest folk, who simply want to earn enough to live on; he describes the sinister environment of the ports and the forced emigration to the Americas of Flemish or Walloon villagers reduced to penury. Artists like Eugène Laermans were inspired by the visionary power of these scenes, the prose counterpart of Emile Verhaeren's *Villes tentaculaires*.

Eekhoud's influence on painters – Henry de Groux's *Gansryders*, for example, is indebted to Eekhoud's first novel, *Kees Doorik* (1882) – was not unusual. Until the end of the century and for some time thereafter, Belgian literature enjoyed a special relationship with painting.

Since the mid-nineteenth century, French literature had placed great emphasis on pictorial inspiration. From the transpositions of Gautier to those of Flaubert, from the lives of artists written by Balzac or Zola to the lively descriptions of the Salons, pictorial art played an important role in the literary imagination, reaching its apogee in the work of Proust. In Belgium, too, painters found a place in literature, but in Brussels, particular importance was accorded to the great Flemish schools of art: to the Primitives for their mysticism and their representations of popular life, and to the Baroque painters, particularly Rubens and Jordaens, whose colourful scenes are animated by a fierce energy. For many writers, painting symbolised their national identity and enhanced their sense of legitimacy. By alluding to great artists famous throughout the Francophone world, they were capitalised on a reputation which no other local symbol could provide. Painting enabled them to situate themselves in a local cultural context that enjoyed a wide international audience. Bruegel's *Le Massacre des innocents*, drawn from St Matthew, reappeared in a story written by the young Maeterlinck, still very close to his model, but which prefigures the themes of *Les Aveugles*. Its further influence can be traced through *La Mort aux berceaux* (1897) by Eugène Demolder, to a minor work by Franz Hellens (the pseudonym of Frédéric van Ermengem), *Massacrons les innocents*, and to a series of texts written after 1914. Using art in literature thus assumes a partic-

ular importance in Belgium. Verhaeren's early poems are dedicated "To Rubens' Flemish citizens". Rops' friend and son-in-law, Eugène Demolder, was regarded as the master of the genre. *La Route d'émeraude* (1899) contained scenes inspired by the paintings of Jordaens, Rembrandt and Dutch genre painters. In *Le Royaume authentique du grand saint Nicolas* (1896), he created an amusing portrait of his friend James Ensor in the guise of Saint Fridolin. There are many such examples. Lemonnier cited Bruegel's *The Proverbs*. Albert Giraud wrote:

> I dream of a chamber theatre,
> With shutters painted by Breughel,
> Fairy palaces by Shakspear [*sic*],
> And amber-coloured backdrops by Watteau.[6]

Realist descriptions of contemporary society undoubtedly featured in the naturalist novel, the genre was not impervious to other influences. The "decadent" aesthetic was another component; indeed, the naturalist tradition of the "case study" paved the way for psychological analyses. It was a short step from describing the decline of a family to focusing on neurotic disorders, and many authors took that step. Eekhoud was already fascinated by sexual non-conformism, and Lemonnier by the depiction of bourgeois frustrations: their followers, the 'minor naturalists', exacerbated this tendency. In *Les Béotiens*, Henri Nizet described with relish the utter mediocrity of a Brussels man of letters. Henri Eslander reproduced the storyline of *Un mâle* in *Rage charnelle* (1890), highlighting its necrophiliac and sensual aspects; finally, in *Gueule rouge* (1894), Marius Renard attempted to write a Walloon *Germinal*.

The novel had no monopoly of such themes. An urban poetry began to emerge at the end of the century, which seemed set to compete with the naturalist novel. Verhaeren revolutionised the genre in this way: *Les Campagnes hallucinées* (1893) and *Les Villes tentaculaires* (1895) were the first attempts to create an impersonal lyricism that sympathetically charted the exodus from field to city, and celebrated in urban growth the destruction of the old world and the construction of a new society.

The journals of the literary renaissance

In the 1880s, a series of cultural and literary reviews appeared, among them *La Jeune Belgique* (1881–1897), *L'Art moderne* (1881–1914), *La Revue moderne* (1882–1883), *La Société nouvelle* (1884–1897). These, along with some twenty other, less important, magazines, marked the literary debut of a generation of writers born between 1850 and 1860. These young writers consistently sought to escape the demands of society and to devote themselves exclusively to their muse. The 'art for art's sake' aesthetic emerged as a new form of romanticism: the 'Moderns' versus the 'Ancients'.

In *Pauvre Belgique!* Baudelaire ironically characterised the supporters of realism: "Generally in this case, the man of letters has another occupation. Usually clerical."[7] It was precisely this image that the 1880s movement wanted to put behind it. They spoke of their elders with unconcealed animosity: "There are some twenty of them, the flotsam of the literature and art of the past, lawyers or teachers during the week, writers on Sundays; they remind me of some artistic home guard, full of disdain for the regular army."[8] The rift marked by the 1880s was, then, primarily the result of sociological changes. As Ywan Gilkin wrote, "Although I was pointed towards the career of a lawyer, I was personally determined to become a poet [...]."[9] Authors had become "professional writers" and set themselves apart from "Sunday writers". They looked to the great figures of Modern France, modelling themselves on Baudelaire, Hugo and Flaubert.

The first issue of the most important literary review of the time appeared on 1 December 1881. Founded by Albert Bauwens and Maurice Marlomont, but soon edited exclusively by the latter under his pseudonym Max Waller, *La Jeune Belgique* presented a certain ambiguity. Its title could be interpreted in nationalistic fashion, as borne out by its motto "soyons nous" (let us be ourselves). But it also referred to the famous romantic review, *La Jeune France*, and another French review of the same name, published between 1881 and 1888.

Eugène Laermans: *The Emigrants*, 1894. Oil on canvas, 150 x 211 cm. Brussels, Musées Royaux des Beaux-Arts de Belgique. Painting inspired by Georges Eckhoud's *La Nouvelle Carthage*.

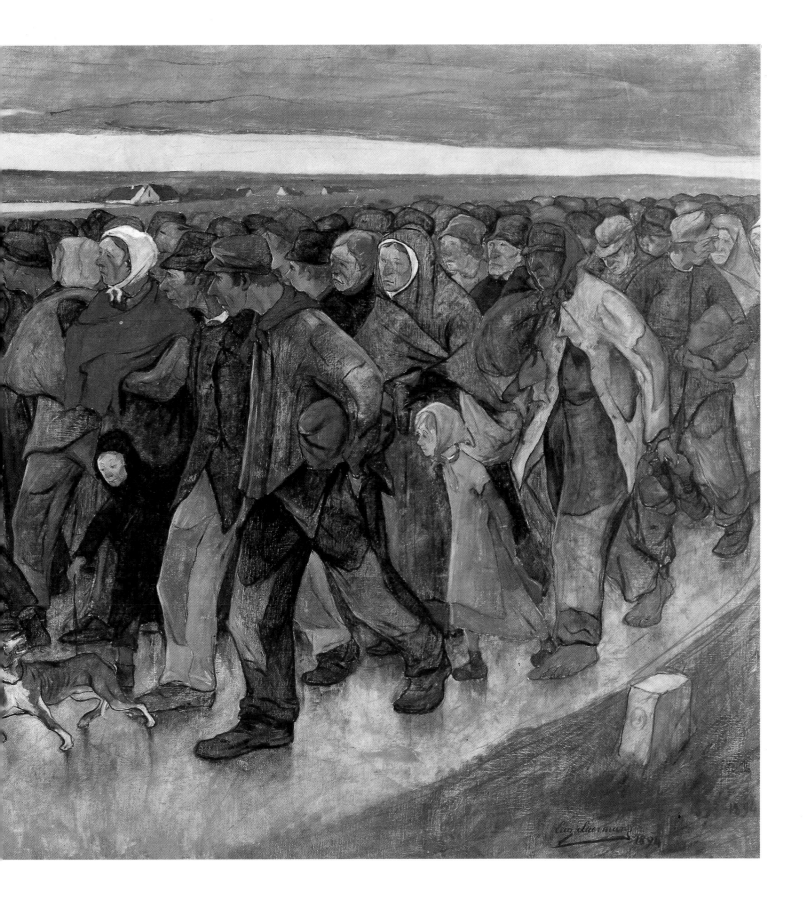

In fact, the widely-used expression "mouvement de la Jeune Belgique" had two meanings that should be identified if we are to understand the advent of modernity in Belgium. One referred to a social and cultural climate that gave rise to a series of movements (naturalism, symbolism, decadentism, etc.) encapsulating *fin-de-siècle* attitudes: anti-bourgeois rebellion, pessimism (influenced by the tutelary figure of Schopenhauer), the fusion of the arts inspired by Wagner, the lingering utopian ideal, the re-evaluation of earlier creative experiments and the aspiration to popular art. It was to this corpus of innovations that Maeterlinck and Verhaeren refer when they were describing the Belgian literary scene or their own personal spiritual agenda to foreign friends. In the 1880s, the expression became common parlance, and when the French *Revue encyclopédique Larousse* asked Edmond Picard, editor of *L'Art moderne*, to write an article about Belgium, they asked him as a representative of the "mouvement de la Jeune Belgique", notwithstanding the fact that he had tirelessly opposed the notion of art for art's sake championed by the review of that name!

La Jeune Belgique, effectively brought together the leading exponents of contemporary artistic modernity, publishing work by symbolist poets (Maeterlinck, Verhaeren, van Lerberghe), a Neo-Parnassian poet (Albert Giraud), and naturalist novelists (Eekhoud and Lemonnier). No other Belgian literary review was able to boast such a glittering array of contributors. Appearance in *La Jeune Belgique* became a rite of passage for the avant-garde writer. But the journal was also a forum for conflicts. The rifts, exclusions, and excommunications recorded in its pages sometimes with dire consequences. Verhaeren and Maeterlinck, its two most illustrious members, were both expelled, albeit for different reasons. *La Jeune Belgique* was a key rallying point for young authors, and played an important role in legitimising 'the literary career' in Belgium. But it was ultimately unable to come to terms with the innovations represented by the symbolist movement. The symbolists broke with the journal because its Parnassian or classical standpoints soon appeared backward-looking in the face of Mallarmé's revolutionary poetics.

The aesthetics of *La Jeune Belgique* and the symbolist response

The students and former students who had joined forces to found *La Jeune Belgique* formed a team, rather than a school. They made no secret of their sympathies for a moderate form of naturalism, but most of them devoted themselves to poetry and did not come out in favour of one particular poetic style. Their hesitation was understandable: In France, the time for sweeping declarations had past. Romanticism had fizzled out and the Parnassian movement had begun to savour too much of academism for the nonconformist younger generation. For Max Waller, at that time the only school worthy of the name was "that of the personality". This was in line with the wide-ranging cult of the individual that had, since the 1870s, left its mark on painting and, less obviously, on sculpture. During their late-afternoon meetings at the Café Sésino, Waller and his friends wanted primarily to create a literary coterie where they could discuss art and give vent to their feelings of impatience and independence. The prospect of joining forces with various poetic factions between which the distinctions remained unclear was not an attractive one. In November 1882, when Waller bought out the first proprietor, he made it a vehicle for promoting artistic activity for its own sake. This was in conscious defiance of the established critics and of the tendency to judge beauty in utilitarian terms. *La Jeune Belgique* became a hive of activity: publications, lectures, public events and agitprop events followed one another in close succession.

In April 1883, the judges responsible for awarding the five-yearly literature prize was divided over which writer should receive the award and no honour was bestowed. In response, *La Jeune Belgique* organised a grand banquet in honour of Camille Lemonnier, to begin the public process of renewal.

These young writers were initially influenced by their reading. They devoured Leconte de Lisle, Baudelaire and Hugo. With insatiable curiosity, they communicated their discoveries to each other. One of these was a mysterious work found among the unsold books of a local bookseller, an extensive extract of which appeared in *La Jeune Belgique* on 5 October 1885: *Les Chants de Maldoror* by Lautréamont. Maurice Maeter-

linck was to describe later, while denouncing it, the deep impression made on him by its "inexpressible beauty", those "electric and unexpected correspondences, phosphorescent metaphors in the flaming dark of the unconscious".[10] However, in the eyes of the young poets, fixed forms (sonnets, rondels, and so on) continued to offer distinct advantages. The corrections they made to each other's work showed that they were attentive to the precise use of words and metre.

Many texts revolved around the self-image these poets had formed. They saw themselves in the guise of the clown, the Pierrot, the exile. The poetic vocation was often perceived as a martyrdom, as in Albert Giraud's poem *Les Croix:*

> Beautiful lines are crosses
> On which the Poets bleed
> Blinded by bearded vultures
> That fly like on the wings of dread
> [...]
> They depart this life, hair straight,
> Far from the crowd's foolish din,
> The setting sun over their heads
> Like crowns on the heads of kings!
> Fine lines are their crucifix![11]

Max Waller was no less bitter, though his tone is ironic:

> To write lines, childish lines
> To laugh, and laugh, and laugh again,
> Like a Pierrot to peck at the jasmine-
> Flower, and gather its scent;
>
> To hammer out lines like weapons,
> Pointed and pitilessly sharp,
> Or atone for one's obsession,
> By counting out rosaries of tears,
>
> This is the ultimate good
> The rest is journalism;
> The golden stanza is like a prism
> In which the whole firmament shines [...].[12]

The themes here illustrated by the poets of *La Jeune Belgique* also appear almost unchanged in the work of their symbolist colleagues. The Parnassian perception of the artist, in fact, led seamlessly into that of the *fin-de-siècle* author. In fact, for the followers of Mallarmé

Fernand Khnopff: *The Kiss*. Drawing for the frontispiece of Max Waller's *Le Baiser*, 1883. Indian ink and Conté on paper, 23.6 x 16.2 cm. Private collection.

the poetic revolution focused less on meaning than on formal innovation.

In one of his few theoretical writings, devoted to the painter Fernand Khnopff, Emile Verhaeren aptly defined the nature of the symbolist response:

> The move towards symbolism at first happened almost unwittingly, then was slowly intensified in a direct reaction against naturalism. The latter stood for the fragmentation of description, painstaking microscopic analysis. There was no summarising, no integration, no generalising. One studied corners, anecdotes, and individuals; the whole school was founded on the science of the day and, as a result, on positivist philosophy.
> Symbolism will do the opposite. Naturalism is nurtured by the French philosophy of Comte and Littré, symbolism by the German philosophy of Kant and Fichte. This is completely logical. In symbolism, the fact and the world become nothing more than a pretext for ideas; they are

Fernand Khnopff: *A Crisis*, 1881. Oil on canvas, 114 x 175 cm. Private collection.

treated like appearances, condemned to unending vari-
ability and appear, in the last analysis, as mere dreams
produced by the brain. They are determined by ideas that
adjust to them or conjure them up; naturalism made room
for objectivity in art, symbolism reinstates subjectivity
to an even greater degree. The idea is imposed in all its
tyranny. This is therefore an art of thought, reflection,
composition, and will. It has nothing in common with
improvisation, with that type of literary 'rutting', which
transported the pen through vast, inextricable subjects.
Every word, every syllable is weighed, analysed, and
judged. And to reach the goal: Each sentence has to be
regarded as a living thing in its own right, independent,
existing by virtue of its words, upstanding, prone, pedes-
trian, runaway, dazzling, lustreless, energetic, limp, run-
ning and stagnant: an organism, a creation, body and soul
drawn out of one, and if, [*sic*] perfectly created, certainly
more immortal than its creator.
Such is literary symbolism.[13]

Quite apart from differences in talent, it was precisely
this new sense of poetic rhythm, this awareness of lan-
guage and abandonment of earlier models that made
it possible to differentiate between the use of the "hot-
houses" image in Ywan Gilkin's work, still deeply
influenced by *Les Fleurs du mal*, and the work of the
symbolist poets:

> In winter gardens, strange florists
> Furtively sow repellent plants,
> Whose stems begin to writhe like nests
> Of drowsy snakes by muddy ponds
> […]
> Gardeners of the perverse, how I resemble you!
> In the precocious mind where my seed was sown,
> The poison of my lines begins to bloom.[14]

This hostile attitude to nature is also found in Maeter-
linck's work, which, at that time, still took the form of
regular stanzas:

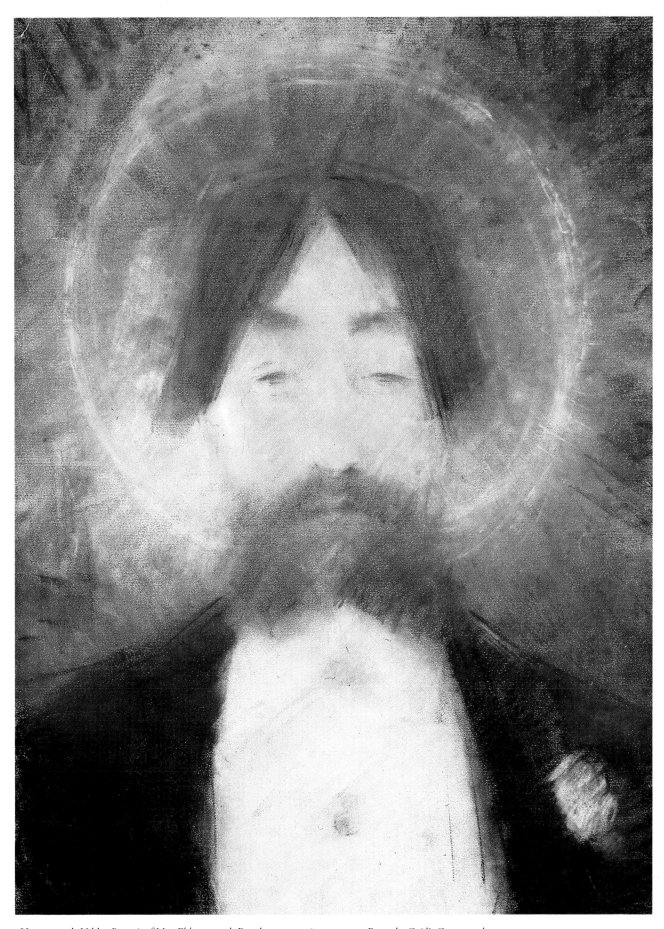

Henry van de Velde: *Portrait of Max Elskamp*, n. d. Pastel on paper, 60 x 42.7 cm. Brussels, Crédit Communal.

Under the blue crystal lid
Of my weary melancholy,
My evanescent sorrows
Gradually grow still:

Symbolic vegetation,
nenuphars of pleasure
Slow palms of my desires;
Limp creepers on dark moss.[15]

The same image is found in Maeterlinck's most daring work, though the rhythms and power of his similes are quite transformed:

O hothouse in the heart of the forest!
With your doors forever closed!
So much grows beneath your dome!
And how you resemble my soul!

The thoughts of a hungry princess,
Of a sailor bored in the desert,
Brass bands at the asylum wall.[16]

It is impossible to stress too highly the importance, now disregarded, of technical issues. Verhaeren's treatment of the line remained distinctive. When distancing himself from *La Jeune Belgique*, he confided to his friend Georges Khnopff, the younger brother of the painter, that he had deliberately published irregular lines in *Les Soirs* (1888), distorting the alexandrine as well as the syntax to conjure up the loss of reason. Albert Giraud's famous attack, accusing him of performing a "scalp dance" with language and of writing like a "flamboyant monkey", was, in fact, directed at Verhaeren's prosodic innovations.

In the same fashion, Max Elskamp confided to his friend, the artist Henry van de Velde: "I would like to find a new language which has not been prostituted by the profession [...]."[17] In 1892, his collection *Dominical* unleashed some violent criticism from the defenders of classicism. They could not find words harsh enough for Elskamp's "childishness" and "senility" (Valère-Gille). For Elskamp, the need for innovation was part of a more profound, almost mystical, quest for what Paul Gorceix called "the analogical image", capable of giving the reader an insight into the poet's inner life. Elskamp sought this new language in popular songs and deliberately awkward turns of

Maurice Maeterlinck. Period photograph. Ghent, Maeterlinck Foundation, Stadsarchief.

phrase. He was particularly interested in syntax: He endeavoured to disrupt word order in favour of an enhanced expressiveness. The result is sometimes mannered, but displays a rigor that has not, as yet, been sufficiently appreciated by modern critics. Moreover, by incorporating into his work objects of working-class life and art, Elskamp was able to bring to poetry a wealth of new material. His subtle fusion of the metaphysical and the material is graphically represented in his books; he made his own woodcuts and printed the volumes himself.

The question of form also affected other genres. The first edition of *Bruges-la-Morte* by Georges Rodenbach carried the subtitle "novel" – which many publishers omit – to emphasise the fact that it formed part of the debate on the status of the symbolist novel. The author wanted to write a narrative, a "passionate study", as he says in his foreword, but also to paint an "urban landscape", a setting that enfolded the event "in a poetical aura". It is uncertain which genre – poetry or novel – the work belongs to, and it is precisely this ambiguity that Mallarmé praised in a letter to the author dated 28 June 1892. He saw it as the realisation of the "contemporary endeavour by readers [...] to transform the poem into a novel, the novel into a poem".[18] The immense success of *Bruges-la-Morte* owed much to the stylistic consequences of this play on genre ambiguity.

A short story by Charles van Lerberghe, entitled *Sélection surnaturelle* (1900), was virtually an allegory of close attention to the text in its physical form. The typically decadent hero, a melancholy Hamlet, searches among the words of the language for those that best reflect his state of mind. During a sea trip, the Prince de Cynthie gradually disposes of crude words, concrete terms, verbs of movement, and the hardware of pronouns, articles and conjunctions. Even 'God' is thrown overboard. The vessel gradually becomes lighter as the heavy lexicon disappears. One last verb, small and trembling, finally speaks to the soul of the prince: "I aspire." Van Leberghe's attention to language and awareness of the ideological trends of his time gave Belgian symbolism its greatest poetical achievement. Some ten years in the making, *La Chanson d'Eve* was published in 1904. Van Lerberghe here carried mastery of the symbolist poetic genre to unprecedented heights. Captivated, Gabriel Fauré set it to music.

La Chanson d'Eve comprises four parts, loosely inspired by the figure of Eve: Premières Paroles, La Tentation, La Faute and Crépuscule. It is not possible to summarise the work: it remains an inexpressible quest, a lyrical description of the act of appropriating the world culminating in the union – life and death commingled – of humanity and Panic nature. The stages of the young girl's initiation are reflected in their rhythms. The contemplative rhythm of the beginning is succeeded by the faster tempi of desire and sensuality, until the day comes to an end, and with it the transient life of the endlessly renascent song:

> The lilting soul of Eve expires,
> It fades out in the light;
> Returning with a smile
> To the world it lyricised.
>
> Again it is the soul that dimly
> Dreams, a murmuring voice,
> The frisson of things, an eddying breeze
> On waterside and plain;
> It floats amid the roses, is
> The divine breath of spring.
>
> In vague chords intermingle
> Softly the beating of wings,
> The music of the stars,

> The petal fallen from the flower;
> Into the universal sound
> It melts softly; and thus ends
> The song of Eve.[19]

The painters too were searching for the foundations of a visual language increasingly independent of surface appearance. The traditional techniques were now to be placed at the service of unbridled subjectivity. Despite the fact that Belgian painting during the 1880s had been firmly committed to modernity and had, through the activities of the Société Libre des Beaux-Arts and La Chrysalide, already formed its own tradition, literature was now the model.

Fernand Khnopff: frontispiece for Georges Rodenbach's *Bruges-la-Morte*, Flammarion, Paris, 1892. Brussels, Musée de la Littérature, Bibliothèque Royale Albert Ier.

Charles van Lerberghe: *The Beauteous Mélusine*, drawing taken from his *Journal*, vol. V. Brussels, Musée de la Littérature, Bibliothèque Royale Albert I^{er}.

RIGHT: Théo van Rysselberghe: *Portrait of Octave Maus*, 1885. Oil on canvas, 90.5 x 75.5 cm. Brussels, Musées Royaux des Beaux-Arts de Belgique.

Writers and painters maintained their alliance until well into the 1880s. Journals flourished: the formation of *La Jeune Belgique* and the *L'Art moderne* in 1881 was followed by that of *La Wallonie*, founded in Liège by Albert Mockel in 1886. They provided the visual arts with a prominent platform and an exciting forum for ideas from all over Europe.

The formation of the Cercle des Vingt

When, at the instigation of the lawyer and journalist Victor Arnould, *L'Art moderne* was first published on 6 March 1881, *L'Artiste* had just folded. The succession was clear. The editorial board was comprised of Eugène Robert, Edmond Picard, Octave Maus, and soon Emile Verhaeren. While Octave Maus took care of organisational matters and wrote on music, Edmond Picard was an authoritative theoretician of modern art with a social message. Keeping abreast of the latest cultural developments, *L'Art moderne* was soon filled with enthusiasm for a new artistic circle.

In late 1883, several painters broke away from L'Essor, regarded by some as too bourgeois in spirit and excessively rigid in its rules. The Cercle des Vingt was formed by a handful of artists – originally fewer than twenty: Théo van Rysselberghe, Frantz Charlet, Fernand Khnopff, Jean Delvin, Paul du Bois, Willy Schlobach, Jef Lambeaux, James Ensor, Willy Finch, Frans Simon, Théo Verstraete, Charles Goethals, Pericles Pantazis, Guillaume Vogels and Gustave Vanaise.[20] Its organisation was remarkable for its flexibility. The group aimed to exhibit freely – without a selection committee – and to invite artists from all over the world who shared their modern approach. Maus, who had become the group's secretary, defined its aim: "[…] we shall make every effort to restore our poor bourgeois nation to its rightful place".[21]

Advertised for several weeks in *L'Art moderne*, the first exhibition of Les Vingt opened on 1 February 1884 at the Palais des Beaux-Arts in Brussels. Each artist's works were hung together, forming a coherent ensemble. Les Vingt also organised a series of concerts and lectures, which took place in the exhibition halls.

On 9 February 1884, at a lecture organised as part of the exhibition, Picard stressed the close ties between the new group and the Société Libre des Beaux-Arts,

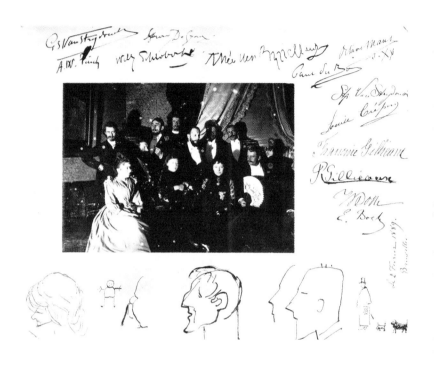

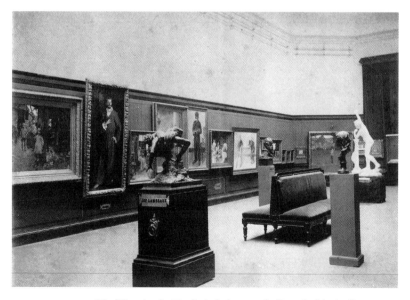

The 'Vingtistes', 1889. Period photograph. Brussels, Musées Royaux des Beaux-Arts de Belgique, Archives d'Architecture Moderne.

Exhibition hall at the Salon des Vingt of 1884, Palais des Beaux-Arts, Brussels. Period photograph. Brussels, Musées Royaux des Beaux-Arts de Belgique, Archives de l'Art Contemporain. (Fonds O. Maus, Vanderlinden donation.)

La Chrysalide and L'Art Libre. Realism and the study of nature formed the basis of this modernity – the "true art" – championed by *L'Art moderne* and promoted by Les Vingt.[22] Art, he insisted, needed to be firmly rooted in reality and aware of its social responsibility; in this way it could morally elevate its audience by its use of emotion.

There was a high turnover in the membership of the Cercle des Vingt. In the early years, some of the most conservative members resigned after virulent attacks by critics otherwise supportive of Les Vingt. The vacant positions were fiercely contested. In 1885, Isidore Verheyden, Jan Toorop and Guillaume Charlier were elected; in 1886, Anna Boch and Félicien Rops; in 1887, Henry de Groux; in 1889, Georges Lemmen, Henry van de Velde and Auguste Rodin; in 1890, Robert Picard, one of Edmond's sons. In 1891, it was the turn of George Minne and Paul Signac. Although two Frenchmen had been admitted, most of the "vingtistes" made no secret of wanting the circle to remain exclusively Belgian. This national bias was clearly seen in 1886 when Whistler submitted his candidacy. Vogels and Ensor advocated a policy of backing up-and-coming local artists rather than admitting a foreign celebrity who had already influenced Finch, van Rysselberghe and Khnopff.

Friendly relations with Paris formed one of the key points of Octave Maus' policy. The search for appropriate collaborators led to personal relationships being forged, which soon blossomed into friendship. Emile Verhaeren, Eugène Boch, Théodore de Wyzewa, Paul Signac and Théo van Rysselberghe served as 'liaison officers'. The latter diligently supported Maus throughout the career of Les Vingt and of La Libre Esthétique. Thanks to their exploratory activities, 130 guests from all over the world and all aesthetic walks of life visited Brussels. The guests of Les Vingt constituted a cast-list of modernity in the arts; it included not only the celebrities of the time, such as Fantin-Latour, Bracquemond, Gervex, Frémiet, Liebermann, Sargent and Whistler, but also movements in the process of winning recognition in their own countries. Thus, Les Vingt welcomed the Impressionists Monet (1886, 1889), Renoir (1886, 1890), Sisley (1890–1891), Morisot (1887) and Caillebotte (1888). In 1886, they conceived an enthusiasm for Neo-Impressionism, inviting Seurat (1887, 1889, 1891 and 1892), Signac (1888), Pissarro

LE SALON DES XX

— Vois-tu, mon fils, les frères Siamois dont on t'a si souvent parlé : ils doivent être à présent très vieux, car ils n'ont plus de cheveux !...

Details from a satirical page about the Salon des XX in *Le Patriote illustré*, 2 February 1890. Brussels, Musées Royaux des Beaux-Arts de Belgique, Archives de l'Art Contemporain. The caricature, in the style of Seurat's *Parade*, mocks Les Vingt. The sculptures depicted are by George Minne.

(1887, 1889, 1891), Dubois-Pillet (1888, 1893), Luce (1889, 1892) and Cross (1889, 1893). As well as high-profile modern movements, Les Vingt welcomed as yet unknown artists like Lautrec (1888, 1890, 1892 and 1893), Gauguin (1889 and 1891) and Van Gogh (1890 and 1891). While in Brussels, Van Gogh sold his *Vignes rouges* (*Red Vines*) to Anna Boch, the only canvas purchased during his lifetime.

In short, the Cercle des Vingt welcomed the entire avant-garde with all its aesthetic diversity, clashes of opinion and commitments. With its annual exhibition and the support of reviews that continued the debate in their pages, Les Vingt made Brussels a "sounding board" for the Parisian aesthetic revolutions. Brussels became the hub of European modernity.

Meanwhile, the ferment within Belgium continued. In January 1887, six artists, including the young Henry van de Velde, founded *L'Art indépendant* in Antwerp.

Supported by Max Elskamp, the Antwerp circle modelled itself on its counterpart in Brussels and invited several of its members, along with members of L'Essor and the Antwerp circle, Als Ik Kan. The scandal created by the exhibition – and particularly by Rops' *Pornokratès*, which had already caused a stir in Brussels – led to the dissolution of the group. In 1892, Elskamp and van de Velde breathed new life into the initiative by founding, again in Antwerp, the Association pour l'Art. The following year, it focused on the decorative arts, reflecting a tendency that was already in evidence at the final exhibition of Les Vingt.

The difficulties faced by provincial artistic circles were in some measure recompensed by the following achieved by Les Vingt abroad. In Paris, Les Trente mounted their first exhibition in December 1887 at Georges Petit's gallery in the Rue de Sèze, modelling themselves on the Brussels circle and inviting van Strydonck, Khnopff, Rops, van Rysselberghe and Charlier for the occasion. In the Netherlands, Vogels and Toorop were asked by the Société du Panorama of Amsterdam to mount an exhibition of Les Vingt works. In 1889, a selection of Belgian artists, including Boch, de Groux, de Regoyos, Dubois, Finch, Lemmen, Rops, Schlobach, Toorop, van Rysselberghe, van Strydonck and Vogels were presented to the Amsterdam public. With this success under his belt, Toorop offered to repeat the experiment in 1892. This new event, mounted at the Kunstring in The Hague, was the first major Neo-Impressionist exhibition in the Netherlands, showing work by Lemmen, Pissarro, van Rysselberghe, Signac, Seurat and van de Velde.

Aided by personal connections, Les Vingt exerted its influence over every European movement attempting to break with conventional practices – what the Germanic countries called the *Sezession*. Khnopff, known in England for his columns in the review *The Studio*, and in Austria and Munich thanks to his appearances (with Minne) at the Sezession exhibitions, strongly influenced Klimt and von Stuck. Van de Velde, internationally acclaimed for his teaching activities, was instrumental in founding the Bauhaus.

From the beginning, Les Vingt had always eschewed cliquish attitudes, taking for their own the agenda announced in 1881 by *L'Art moderne*. Historically, however, it did show a marked preference for certain movements which, in its view, were the embodiment of modernity. The first of these was Impressionism, closely followed by Neo-Impressionism in the late 1880s. Then came Symbolism and the revival of the decorative arts which, in 1893, led to the dissolution of Les Vingt and the formation of La Libre Esthétique.

If there is a common link here, it is surely the desire, inherited from the realists and naturalists, to remain firmly enrooted in the real world. Impressionism and Neo-Impressionism perceived reality in terms of visual sensation, whose inner meaning some members of Les Vingt, influenced by positivist thought, endeavoured to express through scientific language. Examining the bases of visual perception, the painters challenged the very notion of reality. This facilitated a 'natural' transition from Realism to Symbolism. No longer an objective visual representation of nature, the image became a means of questioning reality, of looking below the surface and extracting a basic principle, defined as beauty. The symbolist approach was not exclusively a product of the notion of ideality developed by the supporters of Péladan. It was based on a questioning of sense-data and a determination to go beyond illusion in order to produce an image of reality imbued with meaning. With Symbolism, the image became less intelligible, while the quest for new meaning was itself shaped by the concept of social progress discussed in progressivist circles. Aware of the role played by art in social reform, the avant-garde soon turned to the decorative arts. Metaphysical and optical preoccupations were set aside, and reality came to be identified with the physical presence of everyday objects.

Naturalism and ideality: Meunier and reality

The naturalist vision, which slowly came to prominence during the 1870s, was not without a tincture of utopian idealism. Constantin Meunier's sculpture gave physical expression to this marriage of reality and ideality. After discovering the world of manual labour in the early 1880s, he gradually abandoned painting in favour of sculpture. As he did so, his work became increasingly realist. By 1884, the austerity and expressive distortions of Meunier's style had acquired real authority. These powerful figures with their pre-

expressionist overtones were frequently condemned as incomplete, a criticism also directed at Ensor and the Impressionists. Meunier did not attain true recognition until 1896, with his exhibition at Bing's art gallery in Paris. In Belgium, only Picard and *L'Art moderne* came to his defence. In 1885, the five works that Meunier exhibited at Les Vingt demonstrated his predilection for depicting working-class-figures: the puddler and stevedore overturned traditional heroic conventions to extol the nobility of industrial labour. In 1886, he began to produce large-scale statues. *The Hammerman* (1886), *Woman Ramming* (1887) and *Stevedore* (1900) bear witness to this idealisation of the world of labour. *Fire-damp* (1889) and *Woman of the People* (1893) are stinging criticisms of the miserable living conditions of the proletariat. This tension between ideal and reality haunted Meunier throughout his life. He wanted both to give vent to his feelings about the *status quo* and create a spiritual ideal based on the nobility of labour. In this respect, his large posthumous group, *Monument to Labour*, was a synthesis of his artistic preoccupations. By the turn of the century, his work was universally admired, and he was regarded as the master of social realism in Berlin, Dresden, Vienna and Brussels.

Realism: between impression and expression

In 1884, 1886 and 1888, Whistler, by then internationally famous, exhibited at Les Vingt. His influence on Vogels, Finch, Toorop, Charlet, van Rysselberghe, de Regoyos and Khnopff was immediate and profound. Even before French Impressionism arrived in Brussels, the young painters had noted in the *Symphony in White* and other *Nocturnes* a masterful use of the musical qualities of the palette. The sense of unity was enhanced in Whistler's paintings by his use of light, an interplay of perfectly harmonious tone, shade, line and form. With his symphonic compositions, Whistler paved the way for an impressionism that transcended realism:

> It does not matter if this art is deceptive, if this light is contrived. We freely accept these superb unrealities, convinced that the artist should not be slavishly confined to the competent reproduction of what he sees. Everything must be filtered through his mind and coloured as he feels or imagines it.[23]

Among the young Belgian painters averse to harsh sunlight and keen to portray the light filtered by fog, drizzle or snow was Fernand Khnopff. Khnopff sought in mystery the essential truth beneath the

Constantin Meunier: *Fire-damp*, 1888–1889. Bronze, 150.5 x 212 x 110 cm. Brussels, Musées Royaux des Beaux-Arts de Belgique.

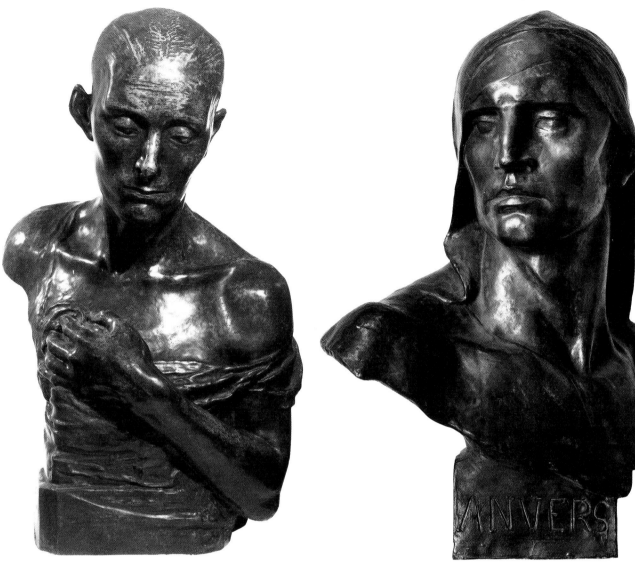

Constantin Meunier: *Woman of the People,* 1893. Bronze, 72 x 43.8 x 34.5 cm. Brussels, Musées Royaux des Beaux-Arts de Belgique.

Constantin Meunier: *Bust of a Stevedore*, 1896. Bronze, 59 x 38 x 39.5 cm. Brussels, Musées Royaux des Beaux-Arts de Belgique.

veneer of illusion. The dim light, the monochromatic palette, the dense atmosphere, and the use of musical harmony in his landscapes reveal the presence of the imperceptible in this going beyond even that subjective reality regarded as part of Belgian tradition.

Les Vingt's attachment to realism had been clear since its first exhibition. In the 1880s, realist lyricism became "expressionism". Guillaume Vogels, a follower of Boulenger, established himself as the master of a new type of landscape painting, in which a fluid rendering of light is combined with dense impasto. Fond of seasonal effects – rain, snow and fog – he transformed the illusion of nature into a vast sweep of coloured expanses that obliterated precision of line, local colour, perspective and volume. Instead of a view of reality, he created an internalised image of nature, a world of impressions "made up of subtle nuances, devoid of harshness, charming in its very negligence,

which miraculously conveys the sparkling of light, the day's radiance, the pallor of dusk, and the shimmer of sunshine on water. It creates the reassuring impression of fresh air, invigorating and delightful in its chill touch".[24] Here reality became "a reverie of nature, rather like a lazy description of distant events, a gently lulling music whose vague, indistinct harmonies voluptuously intermingle".[25]

In 1885, Ensor, Finch, Toorop and Vogels were seen as revolutionaries, not so much for the subjects they tackled as for the audacity of their increasingly pronounced "tachiste" technique. Colour became identified with light, rather than sunlight; Ensor soon emerged as the most committed exponent of this technique, in which light is the true subject of the canvas, and he was generally considered the leader of this new trend in painting. In both his landscapes and his interiors, the use of light gave the image meaning, here

instilling a joyful sense of movement, there wreathing a body in a melancholy nimbus. His spontaneous brushwork produced an unfinished effect which many critics – even within *L'Art moderne* – felt was not conducive to the "correct interpretation of nature". The subversive character sometimes attributed to Ensor, and, more generally, to Les Vingt, was, at this stage, merely the application of a freedom of expression, which had its origins in realism.

In 1885, Ensor's visual innovations were described as "impressionist" although his desire for free expression could not realy be equated with an analytic exploration of light. He remained part of a local tradition which regarded colour, boldly laid on the canvas, as a vehicle for the emotions. Lighter colours naturally occur in landscape painting, as the reflection of atmospheric variations, and this is evident in Théo van Rysselberghe's graceful style, in Finch's measured impasto, in Pantazis' musical harmonies, and the effects conjured by Toorop.

Taking advantage of the fact that Monet and Renoir were both being exhibited at Les Vingt, *L'Art moderne* replied, in February 1886, to accusations of Impressionism levelled at the Belgian landscape school in an article comparing the Belgian tradition to the Parisian avant-garde.[26] It was clear, the article stated, that none of the "vingtistes" was trying, like Monet, to convey the impression of light using pure colour. The Belgians were following in the footsteps of Boulenger and Artan. They had an intuitive feel for light, and their use of colour ignored optical combinations;[27] in their freedom of expression, they saw the canvas not as a window but as a screen on which feelings, emotions and impressions could be projected.

The national agenda was clear. In Belgium, the challenge to academic convention was based on a tradition of free expression divorced from any theoretical aim. French Impressionism nevertheless made its presence felt in Belgium. It favoured a distinctly lighter tone and transformed the ochres, earth shades and greys that had been so long in favour. Ensor, having graduated from the Brussels Academy, had retired to the family house in Ostend; he now emerged as one of the most original artists within Les Vingt. The palette of *Woman Eating Oysters*, painted in 1882 and exhibited at Les Vingt in 1886 after rejection by the Belgian Salon and L'Essor, broke new ground. He cap-

italised on the experience he had gained since 1880 in his seascapes, whose lighter colours and greater musicality were nonetheless reliant upon impasto. His bourgeois interiors of 1882 glow with radiant shades that enabled him to condense his graphic style, making the scenes more immediate. These pictures transcended evanescent illusion to become perceptive, even sorrowful, interrogations of reality. The mood remained intimate in the stuffy silence of the closed bourgeois household, but was soon to explode in a riot of acid colours. Ensor stood out both as the leader of a nonconformist and stormy avant-garde and as the principle target of the critical establishment. Between the painter and the world around him – starting with Les Vingt, who did not really understand him – relations were strained.

Belgium did not regard Impressionism as a revelation, but rather as the ratification of a local tradition

James Ensor. Period photograph. Archives CERAM.

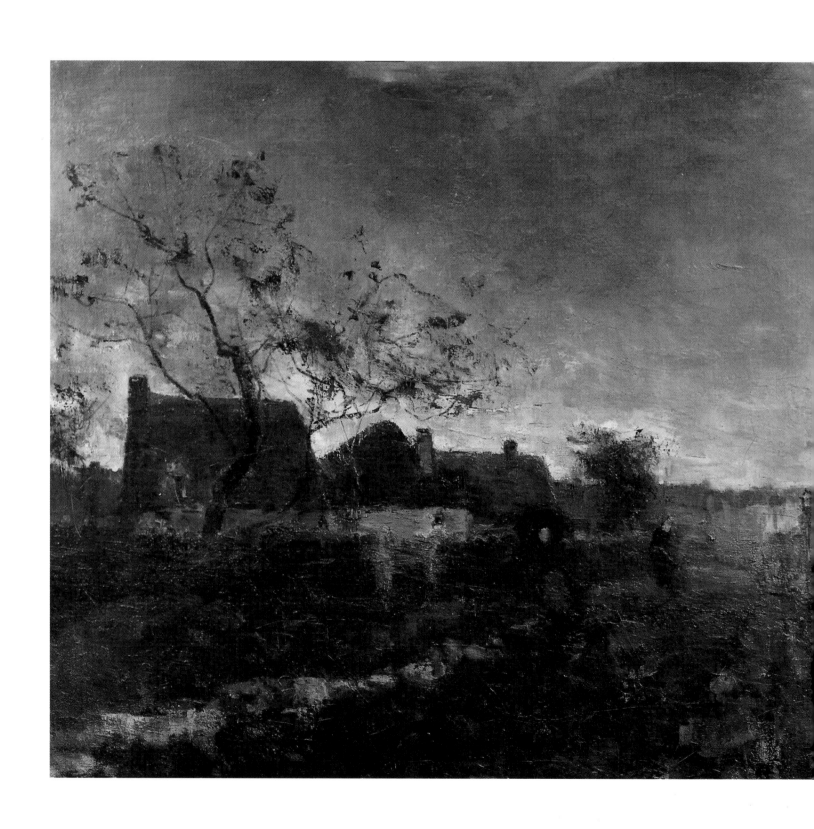

Guillaume Vogels: *Storm,* n. d. Oil on canvas, 104 x 152.5 cm.
Brussels, Musées Royaux des Beaux-Arts de Belgique.

James Ensor: *White Cloud*, 1884. Oil on canvas, 80 x 99 cm.
Antwerp, Koninklijk Museum voor Schone Kunsten.

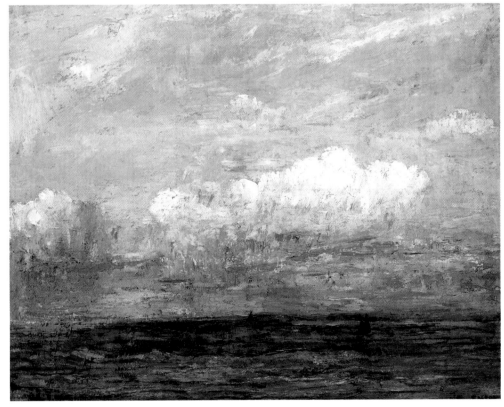

firmly rooted in the expressive realism that Vogels and Ensor had imbued with expressionist power. In 1887 – when Les Vingt were discovering Seurat's scientific interpretation of light – Ensor confronted the dismayed Brussels public with his *The Haloes of Christ or the Sensibilities of Light*. These hallucinatory drawings permanently broke with the gentle harmony of his bourgeois interiors to create a confused and jumbled world of anguish, irony, nightmare and fantasy. Light was endowed with a spiritual quality and, no longer made to illuminate some little corner of nature, now expressed an introspective reality. Ensor had been profoundly influenced by the work of Rembrandt and Turner. His forms were wrenched out of the emptiness with a violence that was anticipated, preceded, and revealed by light. In Ensor's eyes, light made it possible to transcend the human condition. Indifferent to social contingencies, it equated the creative act with the Passion of Christ. The image of the Redeemer provided Ensor, like Gauguin, with the perfect embodiment of the modern artist: forward-looking, critical of the established order, and sensitive to the fate of the poor.

In Ensor's work, menacing and anguished reality was merged with the unconscious, creating an "extraordinary apotheosis in which the most grotesque products of the imagination were combined with the purest sublimity of light".[28] Ensor combined the illusion of reality – already wreathed in mystery – with the reality of an illusory consciousness that could convey only anguish and irony. In 1883, the theme of the mask enhanced the ambiguity which subsequently set its stamp on his representation of the real, placing it permanently beyond the scope of reason.

On the basis of a Luminist study of nature, Ensor transcended strictly mimetic representation to develop an "aesthetics of the bizarre", whose intensity prefigured both symbolism and expressionism. Tortured by the idea of death, obsessed by the devil, attracted by the bizarre, possessed by a theatre of masks, influenced by the themes of the Temptation and the Fall, fascinated by biblical extremes, Ensor dreamed of an apocalypse that would topple the bourgeois order. As a libertarian, he waged war on the pillars of society: Policemen, magistrates, soldiers, critics, teachers, and the king were caricatured and plunged into a grotesque universe that metamorphosed into a procession of skeletons, deformed faces, biting parodies, idiosyn-

cratic masks – they surround the artist/god on his monumental entry into Brussels. This inner world teeming with Boschian visions was never isolated from the social reality of the time. Ensor's ironic gaze skewered the failings of a self-satisfied bourgeoisie. The established order was replaced by a fluid, unstable and luminous universe, in which dream and reality went hand-in-hand. True to his self-appointed mission, the painter became increasingly marginalised, both by society, which ignored him, and by the avant-garde, who found him impossible to understand. Maus, angered by Ensor's views, broke with him. In 1888, in contravention of its own principles, Les Vingt refused to hang Ensor's *Temptation of Saint Anthony*, now in the Museum of Modern Art in New York. The following year *Christ's Entry into Brussels* was similarly rejected. It is possible that Ensor's work embarrassed Les Vingt, at a time when the neo-impressionist school was at the height of its fame in Brussels and Maus was finally seeing this radiant style receive the recognition he felt it deserved. Ensor's libertarian views threatened to subvert the consensus on aesthetics that Maus had laboured to impose. Moreover, the prime movers of the artistic world were at loggerheads with Ensor. This is the subject of *Dangerous Cooks*, which features Picard and Maus preparing to serve up the head of Vogels and that of an "Art Ensor" – a pun on the dish Hareng Saur (kipper) – to the critics, who include Lemonnier and Verhaeren. Maus kept a firm hold on the reins of the group, backed by supportive weekly articles in *L'Art moderne*, while Ensor became increasingly isolated. Surrounded by his visions, he created a self-contained universe, turning a critical gaze on the modern world with his trenchant line and caustic palette.

The idea of a system: Neo-Impressionism and the Belgian school

The impressionist group had been founded in 1874, and the style's Brussels début coincided with the final group exhibition in Paris, at Rue Laffite. Seurat's work caused a scandal, and his *chromo-luminarist* manifesto,

James Ensor: *The Scandalised Masks*, 1883. Oil on canvas, 135 x 112 cm. Brussels, Musées Royaux des Beaux-Arts de Belgique.

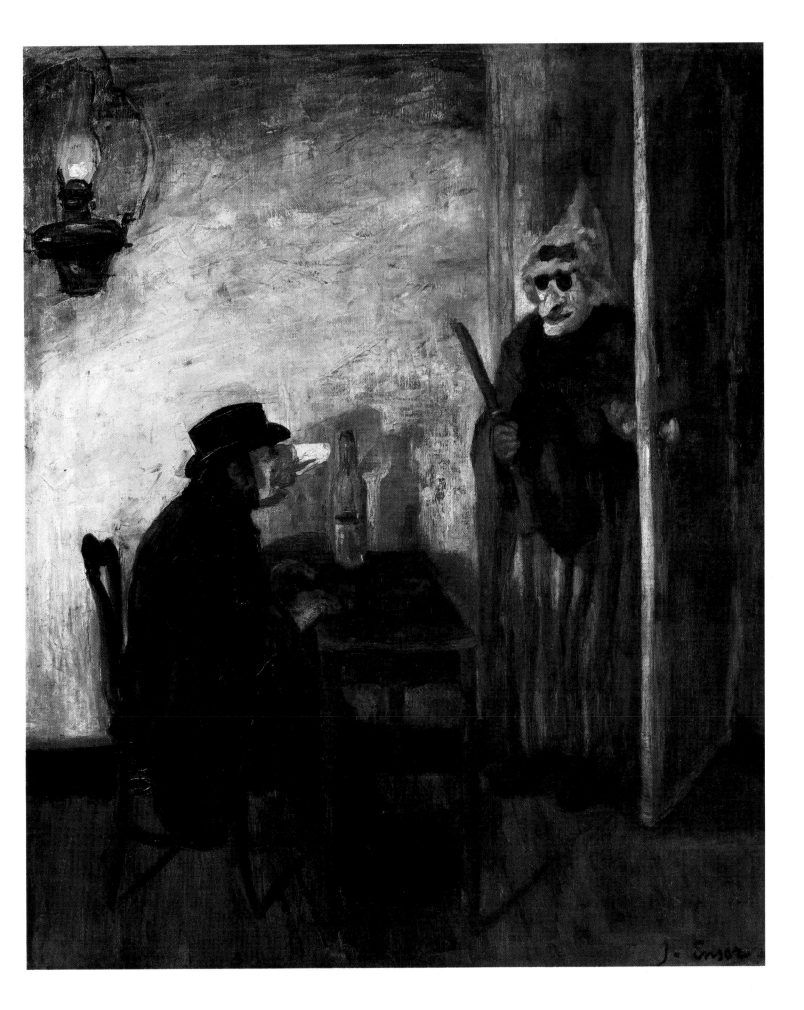

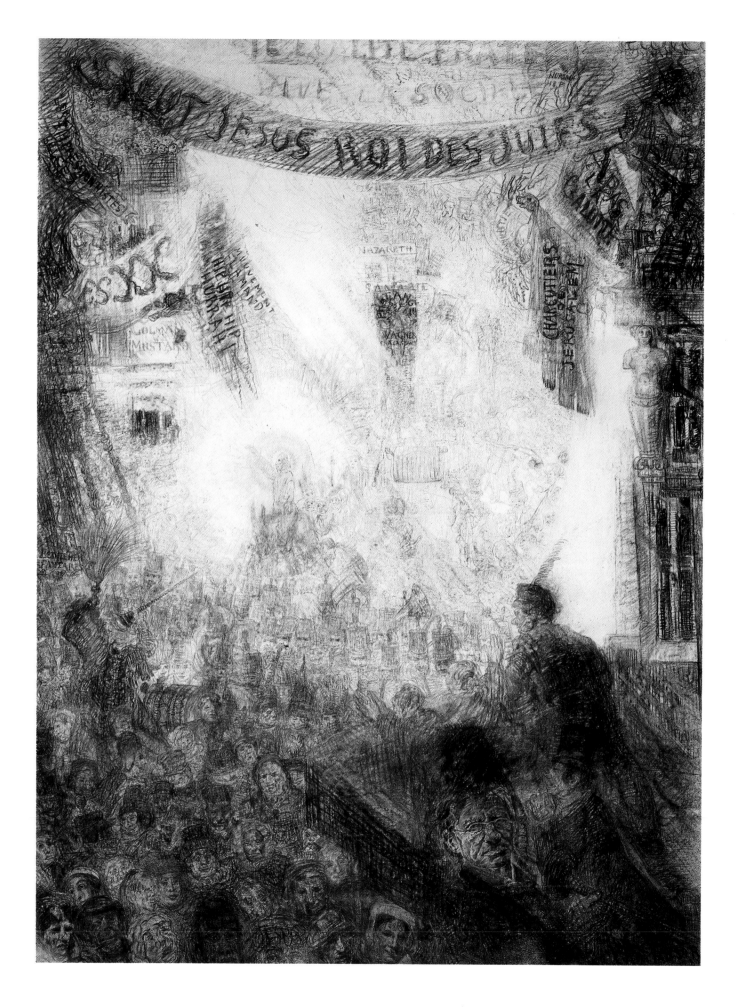

James Ensor: *The Fall of the Rebellious Angels*, 1889. Oil on canvas,
108 x 132 cm. Antwerp, Koninklijk Museum voor Schone Kunsten.

Left page: James Ensor: *The Entry of Christ into Jerusalem*, 1885.
Black and brown crayon and paper collage mounted on paper and
Japanese paper, 206 x 150.3 cm. Ghent, Museum voor Schone Kunsten.

Sunday Afternoon on the island of La Grande Jatte, was universally mocked. Verhaeren informed van Rysselberghe and Maus. Eager to stage a provocation, they could not but be attracted to an artist whom the secretary of Les Vingt later described as the "Messiah of a new art". A review of the exhibition in *L'Art moderne*, significantly entitled 'Les Vingtistes parisens', suggested that Les Vingt might enjoy a *succès de scandale* by exhibiting the Seurat painting in Brussels.[29] Les Vingt invited Seurat, Pissarro and Signac in 1887. It is difficult to know whether they actually appreciated the significance of *La Grande Jatte*. The public certainly did not. Scandal guaranteed a popular success, but Maus felt that, given Seurat's very cerebral style,

this was not enough. *L'Art moderne* was therefore tasked with providing the background necessary for understanding this enigmatic painting. Between the eighth impressionist exhibition (1886) and the posthumous tributes to Seurat in 1892, a series of articles was published explaining the significance of Neo-Impressionism and its historical importance. One of the most important contributors to this project was Félix Fénéon, the Paris correspondent of *L'Art moderne*. He used this platform to write the first theoretical paper on Neo-Impressionism, whose very name derives from an article published in *L'Art moderne* in

ABOVE: James Ensor: *The Entry of Christ into Brussels in 1889*, 1888, Oil on canvas, 260 x 430.5 cm. Malibu, The J. Paul Getty Museum.

LEFT: James Ensor: *Dangerous Cooks*, 1896. Coloured chalks and ink on paper, 22 x 31 cm. Antwerp, Plantin-Moretus Museum.

September 1886.[30] Fénéon's articles were a relevation: They demonstrated to the public, and to the Belgian artists faced with these works, the modernity of this new style, which, rather than reviving Impressionism, transcended or even negated it. Fénéon perceived an evolution: Impressionism, which made nature "grimace" in order to "imprint one of its fugitive appearances on the canvas", was succeeded by a style of painting which based its technique on scientific principles: the way that light is refracted by a prism. The painter grasped not an immediate impression but a fundamental truth. The "accidental and the transitory" were discarded in favour of "a synthesis of the landscape's definitive appearance".[31]

Seurat's research thus rested as much on positivist principles as idealist aims. Fénéon particularly stressed the scientific character of Seurat's approach in comparison with the Impressionism of Monet, Sisley or Renoir. A Belgian painter, Henry van de Velde, wrote several articles offering a symbolist reading of Seurat's work; these were the more remarkable in that a symbolist reading was not part of the accepted discourse. Henry van de Velde rallied to Neo-Impressionism, continuing its original thrust in his own paintings. In

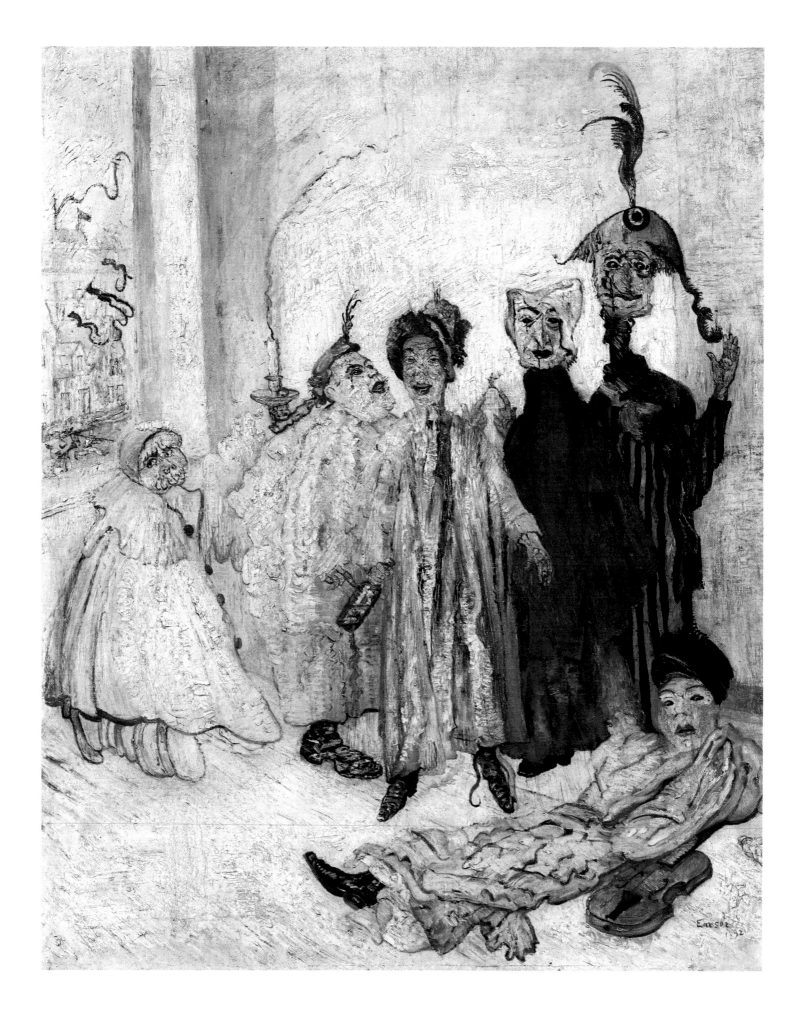

his 'Art Notes', published in February 1890 in the symbolist review *La Wallonie*, he described Neo-Impressionism as aiming to depict "the other side of reality":

> To set down the Dream of realities, with the Unformulated hovering above them, to dissect them mercilessly so as to see into their Soul, to pursue the Intangible with all one's might and to meditate – in silence – so as to record its Mysterious Significance. [32]

Variously interpreted, Neo-Impressionism compelled recognition in Belgium as the logical extension of Impressionism. In the work of van de Velde, it also gained a symbolist aspect, the "Rational Architecture of the Idea".

At the Les Vingt Salon of 1888, a "pointillist school" made its appearance. It was at first described in terms of old and new Impressionism.[33] The emergence of a

scientific system of aesthetics was seen as a consummate expression of modernity. Seurat's introverted nature did not encourage personal contact, but Signac's enthusiasm and eloquence enabled him to forge new friendships within Les Vingt, and he became a member of the circle in 1890. Signac saw in Maus' activities an echo of the combative spirit of the Parisian independents. In 1887, Les Vingt discovered Seurat and Signac. The latter was to maintain a high-profile presence in 1888.

Beginning in the winter of 1887–1888, Willy Finch was the first to start using the divisionist technique in accordance with Signac's principles. His works were presented at Les Vingt in February 1888 and a pointillist drawing was printed in the catalogue. They came under severe attack by the critics, who condemned this act of subservience to a French model. Finch's landscapes had a spareness and severity reminiscent of

LEFT PAGE: James Ensor: *Strange Masks*, 1892. Oil on canvas, 100 x 80 cm. Brussels, Musées Royaux des Beaux-Arts de Belgique.

BELOW: William Finch: *Haystacks*, 1889. Oil on canvas, 32 x 50 cm. Brussels, Musée Communal d'Ixelles (O. Maus collection).

Seurat's compositions. The golden light favoured by
Seurat was replaced by a diffuse radiance, inspired by
the atmosphere of the North Sea. The harmony of the
composition was derived from the coherence of the
palette: The contrasts between the different colours
was softened by the predominant use of white, which
imbued the light with a sensual physicality. Finch's
work combined the influence of Seurat with that of
Whistler, who was at that time highly esteemed among
Les Vingt: a well-balanced composition – enhanced
by the use of a painted frame that cut the composition
off from the outside world – a coherent palette and a
harmonious use of light.

The following year, Anna Boch, Théo van Ryssel-
berghe and Henry van de Velde began applying Seu-
rat's theories, although not without adding their own
distinctive touches. In tandem with Lemmen, van
Rysselberghe made a name for himself as the principal
neo-impressionist portraitist. By 1888, he had resolved
the problem posed by the representation of face and
body by softening the pattern of dots in the flesh tints.
Taking liberties with the *chromo-luminarist* system, he
condensed the texture of his brushwork when painting
figures, so that they appeared to be caressed by light.
Seurat himself, in fact, never came up with a satisfact-
ory solution to the question of human representation,
as is evident from the remarkable studies for *Women
Posing*, exhibited at Les Vingt in 1889. The studies
reveal the ambiguous effect of reducing the human
body to a flickering pattern of "coloured fleas".

Lemmen too made outstanding neo-impressionist
portraits. Their representation of textures is highly
accomplished. In *The Serruys Sisters*, he used a variety
of subtle effects to convey the rug's thickness, the sil-
very radiance of the honesty, the freshness of young
skin, and the delicate fabrics.

The Belgians' keen interest in Neo-Impressionism
revealed not only a very real fascination for Parisian
modernity, but also a desire to give wholehearted
support to positivist ideology, which saw in scientific
progress an instrument of social emancipation and
truth. Signac's commitment to anarchism was insepar-

Henry van de Velde: *Beach at Blankenberghe with Beach Huts*, 1888.
Oil on canvas, 77.5 x 100 cm. Zurich, Kunsthaus.

able from his aesthetic concepts. Following in his wake, Henry van de Velde gave modern shape to his political beliefs. His conversion to Neo-Impressionism took place in 1888 during a period of self doubt and socialist militancy. In Blankenberghe, a Belgian seaside resort frequented by Brussels high society, van de Velde first applied the concepts that he later expounded in *La Wallonie*. A severe spatial architecture underpinned the works. The composition achieved a sense of balance through the harmonic progression of the expanses of flat colour. The perfectly complementary shades were modulated in minute contrasts of tones. The en-

tire composition acquires a sense of movement from its sparkling light and a sense of serenity from its structural stasis. Giving the composition emphasis and a sense of rhythm, the lines still function as boundaries; they were soon to become autonomous. The forms are abstract and the palette unreal, revolving around contrasting violets and greens. These beach-scenes inaugurate a period of formal experiment in which line serves to structure the broad areas of colour. These works are almost "abstract" in their architectural approach. Van de Velde continued his work on rural life with six canvases grouped together under the generic title *Village*

Théo van Rysselberghe: *Portrait of
Alice Sèthe*, 1888. Oil on canvas,
194 x 96.5 cm. Saint-Germain-en-Laye,
Musée Départemental du Prieuré.

Jan Toorop: *Collecting Shellfish*, 1891. Oil on canvas, 61.6 x 66 cm. Otterlo, Rijksmuseum Kröller-Müller.

Happenings. The composition was still musical: a rigorous structure was paired with soft light, underscoring the harmony of a peaceful world.

Also in 1888, Toorop, a Dutch artist who had settled in Brussels, started to apply neo-impressionist principles while retaining features of his earlier works, painted in the spirit of Whistler. Horrified by the miners' living conditions, he painted a series of divisionist canvases in homage to the strikes which in 1886 had spread throughout the coal-mining regions. His variant of *pointillisme* had a melodic character matched by the

mellow quality of the light. A tragic vision of the workers' lot, *After the Strike* revealed his desire to combine the idea of progress with visual modernity. When he returned to the Netherlands in 1890, Toorop, like van de Velde, developed a symbolist Neo-Impressionism which used colour as a symphonic element and line as melody; the infinite variety of shades were deployed on the canvas like notes on a score. Symbolist in spirit, his *Collecting Shellfish* transformed the principle of colour divisionism into a decorative formula akin to that of Art Nouveau. Toorop described his "linear idealism" as

Georges Lemmen: *Sunset over Knokke-Heist Beach*, 1891. Oil on wood, 37.5 x 46 cm. Paris, Musée d'Orsay.

a desire to combine aesthetic investigation with a mystical quest and a concern for social reform.

Les Vingt could not ignore the vogue for *pointillisme*. Its supporters saw to it that the poster for the 1889 Salon was done by van Rysselberghe in a divisionist style. Other members, like Ensor and Khnopff, followed the reactionary critics in regarding Neo-Impressionism as a mere rash of coloured pimples. In France, Sisley and Renoir turned away from Brussels. Among the many neo-impressionists gathered around Seurat figured Paul Gaugin and James Ensor. There

was a variety of different avenues for modern art to explore. The following year, Cézanne and Van Gogh were in Brussels, and their works infuriated symbolists like Henry de Groux.

Seurat's death in 1891 caused a spate of new articles and a retrospective at the 1892 Salon des Vingt. Nevertheless, enthusiasm was waning and defections were in the air. The time was ripe for Symbolism and the revival of the decorative arts. The enthusiasm of the Brussels avant-garde for Neo-Impressionism not only ensured its status but enabled it to acquire a theoretical

foundation. It also transformed the attitudes of many Belgian artists. The constant bias towards realism, perceived as stemming from the generous, wilful Flemish character, was replaced. Painting was seen as a project whose aesthetic foundations were linked to the social concerns of the literary and political avant-garde. Van de Velde's artistic development shows this clearly. Tired of the strict, small-scale brushwork and mechanical procedures of divisionism, he turned his back on it. His return to the use of line brought him closer to Van Gogh, while his need for evenly-coloured forms emphasised by a bold outline identified him as a follower of Gauguin. The arabesque reintroduced the object and challenged the validity of Neo-Impressionism. It even found its way into neo-impressionist compositions like the *Knokke-Heist Beach*, painted by Lemmen in 1891, resulting in a somewhat unreal quality due to the decorative treatment of the dense clouds that transformed the sky into a canopy of luminous brushstrokes.

Some defended their abandonment of Neo-Impressionism as a return to real life. Opposed to the underlying intellectualism of a style of painting that had become mechanical, these artists wanted to restore spontaneity, intuitive freedom, the sensuality of a light that enveloped the object rather than creating – theoretically – an image of reality. This feeling pushed certain painters in the direction of Luminism; they laboured to achieve an effect without investigating its cause, without even grasping the principle. Many landscapes tended to be conformist in their opportunist exploitation of innovations, their polished and rhetorical use of colour, their excessive artificiality and their superficially spontaneous technique. Other artists, influenced by the Intimism of the Nabis, transformed a more flexible form of divisionism into a vehicle for a sensitive painting style recording the well-heated interiors of Patrician residences. Lemmen excelled at this. In his portraits of Verhaeren and Toorop and his interiors, painted as if glimpsed by an inquisitive intruder, one senses the tranquil atmosphere of a domestic cocoon where everyone lives a secret life and colour savours of familiar, much-loved objects.

The question of the practicality of easel painting came to the fore, while creative output vacillated between metaphysical enquiry and technical mastery. Symbolism and the decorative arts succeeded Neo-Impressionism, which had at least enabled young Belgian artists to widen their perception of painting and reality. For Emile Claus and Franz Gailliard, who retained an affection for pictorial techniques, the legacy of Neo-Impressionism was a particular emphasis on the quality of light: They abandoned theoretical exploration to rediscover that subjective intensity of colour so dear to Boulenger, Artan and Vogels.

The emergence of symbolism

Generally speaking, symbolism asserted itself in the same way as the breakaway movement that the Germans were to call the Vienna Secession. This was also the first point that Verhaeren had made: It moved away from the French philosophy of Comte and Littré, in other words, from the prevailing positivist philosophy. This is why the French translation of Schopenhauer's *The World as Will and Idea*, published in 1886–1890, exerted such a profound influence on future symbolists, from van Lerberghe, who saw it as a confirmation of his idealism, to Max Elskamp, who suffered a terrible "anxiety attack"[34] on reading it. This was a watershed; not only a vision of the world, but also the very identity of those who wanted to follow an artistic career was at stake. It was to have a dramatic impact on all artists. Van de Velde described in his *Mémoires* the profound depression that he could not shake off during his stay in Campine. It is impossible not to see similarities between his narrative and the biographical accounts of Stéphane Mallarmé's 'Tournon sickness', the anguished nights spent by Maeterlinck a prey to "typhoid visions", the mental distress experienced by Max Elskamp between 1887 and 1892, or van Lerberghe's permanent state of uncertainty. There may also be similarities between the fascination felt by the young Verhaeren for monks, the title of his second collection (*Les Moines*) published in 1886, and the drawings brought back by Constantin Meunier from his stay in La Trappe. These physical symptoms of anxiety are indissociable from the symbolist crisis; they show just how deep it went.

However, rather than blocking the creative urge, this mood of enquiry sustained it, to judge from the famous *Confession de poète* published by Emile Verhaeren in *L'Art moderne* in March 1890: "Torturing

oneself skilfully" was the poet's watchword and the image of himself that he wanted to convey.

The themes explored by symbolism are not peculiar to it. They are the aesthetic reflection of a break with the past. Marginal figures (the madman, the Pierrot, the clown and the poor), images lacking financial substance or social status (hermaphrodites and women), death, water, vegetation, the unconscious mind, and the inexpressible were all used by the symbolist discourse in its battle against the prevailing positivism. This revealed two diametrically opposed worlds. The artist was in conflict with his class of origin and its predominant values. It is hardly surprising that the poets, keen to draw their inspiration from actual experience, should have taken this area of tension as one of their main themes. The image of the hothouse had already intimated this scission. It then evolved into the use of aquatic imagery in which the poet sought an atmosphere in which he felt at home. Then came a state of immobility, described as happiness, and this, in its turn, becomes a vantage point for observing the world with a critical eye. This can be seen in Rodenbach's *Les Vies enclose:*

Ah! my soul under glass, and protected so well
Belongs to itself in hermetic redoubt;
Its alluvial dregs have all fallen away
And the crystal walls darken no more.
Transparent the soul in its ally of glass
No desire attains it, no ruffle disturbs!
My soul is closed in on itself and confined
Holding no truck with the turmoil of life,
But, purging itself, it grows evermore clear.
My soul is a fluid that ceases to feel,
A compound of water and moon
All coolness and bright luminescence I live,
As if my soul were the rays of the moon,
Passing through water that stands in a bowl. [35]

In *Ame de nuit,* Maeterlinck set up the same conflict and then proceeded to invert the values. The soul waits for the intercession of the poor, the sick, ice and coolness. Sunshine and the external world provide nothing but a tepid death:

My soul is sad at last
Sad at last of its fatigue
Sad at last of emptiness

Sad and weary at the last.
I await your hand on my face.

I await your fingers on my face
They come like angels of ice
I wait for them to bring the ring
I await their cool touch on my face
Like a treasure beneath the wave.

I await the remedy they bring
Lest I should die in the sun.
Ah, death without hope in the sun!
I wait for them to bathe my tepid eyes
Where the many poor drowse in the sun.

Where so many swans float on the sea
So many swans adrift on the sea
Stretch their gloomy necks in vain

George Minne: frontispiece for Maurice Maeterlinck's *La Princesse Maleine*, in *La Jeune Belgique*, 1890, vol. IX. Brussels, Musée de la Littérature, Bibliothèque Royale Albert Ier.

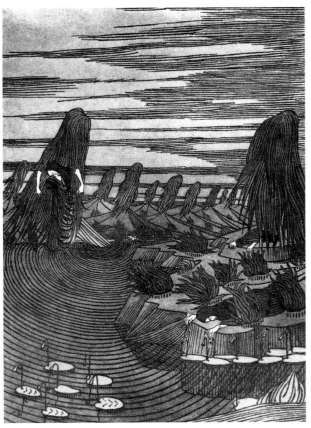

Where patients wander in the gardens
And gather the roses on the banks.

I await your fingers on my face
They come like angels of ice
I wait for them to moisten my gaze,
The dead grass of my gaze
Where the many weary lambs do graze![36]

Last but not least, in Verhaeren's work the same aquarium again served as a shelter, but the external world was observed in all its absurdity, bourgeois stupidity, and conformism, in terms reminiscent of Ensor:

And still my thoughts, slow in this crystal of drifting flows, dream, happy and beautiful: how unimportant they are, in front of the tiles of their palace, these faces round with stupidity, gaping with foolish questionings! Alone! in this eddy of plump, curious faces, noses flattened against the glass; alone! in this mob with staring eyes that see without understanding, and seemingly indignant, their scales strangely golden, their fins delicate as wings, their unchanging journeys around the same watery emerald, their long siestas immobile between two mossy stones and their entire life passive and voluptuously cold.[37]

This imaginary template also influenced Maeterlinck's conception of death. Most of his early plays take as their subject the unendurable tension existing within an enclosed environment. Tormented by their infirmities (as in *Les Aveugles*), their weakness or melancholy, his characters are doomed to exist in a fatal state of flux. In each case, death brings them together, not only when their fate has been played out, but from the start, like a projection of their difficult lives against the white walls of the house. Death is not external to them; it plays a part in fissures that will bring the walls down, materialising in the form of agents whose intervention seems inseparable from that of death. Maidservants, nuns, the poor or the old bring this intolerably oppressive atmosphere to an end: anonymous agents who exist outside the bourgeois family unit and link it to the world.

In *Intérieur* (1890), death finds the family timidly huddled in their home. A stranger brings the news, followed by a funeral procession of villagers bearing the dead girl. Similarly, news of the death of Tintagiles, in the eponymous play, is brought by the maidservants who emerge from the tower. Mélisande's death, too, is notified in the last act by the serving women who enter the room in silence. In each case, the enclosed

Jean Delville: illustration for Maeterlinck's *The Blind*, published by L'Essor, 1891.
Lithograph, 37 x 27 cm. Private collection.

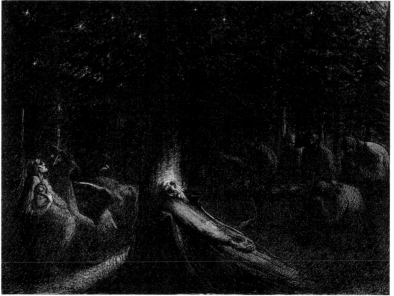

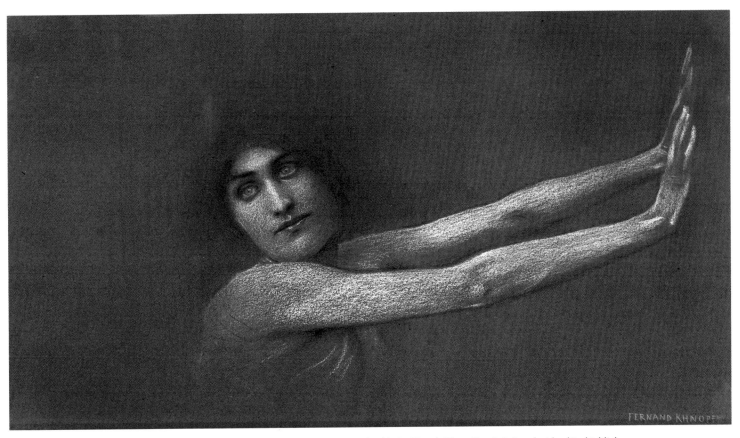

Fernand Khnopff: *Ygraine at the Door*, sketch of an illustration for Maurice Maeterlinck's *La Mort de Tintagiles*, 1898. Pastel with white highlights on paper, 23 x 29 cm. Private collection.

space of the house is violated, and deliverance, both feared and desired, hinges on that violent intrusion. Debussy appears not to have understood this; his opera omits the highly significant opening scene in which the maidservants are washing the threshold of Arkel's home.

The characteristic feature of Maeterlinck's protagonists is that they actively help to breach their closed environment. They either come from another world (Mélisande, Alladine), or strangely resemble the repressed poor, like Maleine: "She is a poor young girl who has lost all her worldly possessions" (*La Princesse Maleine*). Pelléas and Mélisande are found stretched out on the doorstep "like poor hungry people" (*Pelléas et Mélisande*), while Palomides declares, "When I think about it, we are here like two poor people in rags" (*Alladine et Palomides*). In a late satirical play, Pelléas and Mélisande are likened to circus entertainers

and serve as a link with the figure of the artist; they are compared to "tightrope walkers" whom the bourgeois "saw at the circus" several years before the Day of Judgement. Vulnerable themselves, Maeterlinck's characters sense the flaw running through the world; the most sensitive of them feel the influence of "the other world" and an anguished yearning for deliverance.

Les Vingt and symbolism

Within Les Vingt, Neo-Impressionism had entered the symbolist discourse because of its distinctive colour combinations, its quest for harmony and perfection, its unreal quality and its musicality, its desire for truth still shaped by positivism, and its desire for subjectivity arising from experience rather than intent. As the true embodiment of modernity, Neo-Impressionism opened

new horizons for others to explore. The results were sometimes antithetical to, sometimes merely different from the originating style.

Once again, *L'Art moderne* was there every step of the way, and indeed anticipated the views of the 'vingtistes'. In the early 1890s, several articles redefined the meaning of Neo-Impressionism in terms of Japonism, the decorative arts and closely-related symbolist interpretations. In this flowering of styles we perceive the desire to merge the arts in a common language, creating that Wagner-inspired fusion of the arts so dear to *fin-de-siècle* Europe. With the Théâtre de la Monnaie as a rallying point, the dream of a total art pervaded Brussels. It came true in Art Nouveau architecture, which assimilated and exceeded the symbolist vision, and in the revival of the decorative arts.

In Belgium, symbolism was not merely a reaction against realism. It was more a widening of the perception of reality. Positivist materialism was still the enemy, but Symbolism focused less on the appearance of the natural world than on the questions raised by its limits. Symbolist painting focused on the self described by the poets, playwrights and novelists in all its multifarious states. The world of the symbolist painters and sculptors was on the sidelines of the major debates that animated the Belgian literary scene from 1885 on: the figure of Mallarmé paved the way for an exploration which was more to do with suggestion than representation; Whistler's work asserted the need for harmony, imbuing light with a musical quality.

In this domain, young artists discovered several tutelary figures in the past: Wiertz with his dramatic excesses and Rops with his sensual Satanism suggested a painting of the imagination, drawing on the sixteenth-century visions of Hieronymous Bosch. Literary symbolism, dominated by Baudelaire, Villiers de L'Isle-Adam, Barbey d'Aurevilly and Péladan, fostered an eroticism perceived as divine curse or social rebellion. In women, the doubts and terrors of this modernity found their embodiment: being a "[…] wild beast with human features, a lithe and powerful creature", she appeared to have been born "for every form of melancholy lechery and every type of refined cynicism".[38] Ambiguity prevailed. In *La Saltimbanque* (1879), *Les Sataniques* (1883), *La Tentation de Saint Antoine* (1877) and *Pornokratès* (1877), Rops presented a diverse vision of womanhood, sometimes as muse, now inspiring, now undergoing evil; here embodying lust, there exiled from society.

Xavier Mellery explored another approach rooted in his desire to commune with the universe. In his drawings, he presented an internalised image of reality in which every object was imbued with an animating spirit. In the words of one critic, "external life is merely the surface beneath which the inner life sprouts and grows".[39] Although not impressionist, his work displays a sensitive vision of the world around him, generated by the dialogue between shadow and light in his concentrated use of white and black. The subject emerges from this luminous unveiling: Mellery's drawings present mysterious interiors, largely shrouded in shadow. The artist was attentive to the inner life of objects; his art was concerned with representing soul rather than form. Reality is held captive by the darkness; life does not define but interrogates the unknown. The flickering of a candle in the dark, a shaft of light glimpsed through a half-open door, a lamp left on the corner of a table, these images arouse a pervasive feeling of the uncanny at the very heart of everyday reality. A continuation of the realist tradition, Symbolism emerged as a need to interrogate anything that, beyond the natural world, allowed an insight into a fundamental truth. Artists, like initiates, had a mission to educate their fellow human beings: The truth, concealed by illusion, had to be offered up for the contemplation of all. This concept of didactic imagery was closely linked to the city's town-planning programme. Painting, like sculpture, continuing the fresco tradition brought back into favour by Puvis de Chavannes and the English Pre-Raphaelites, joined forces with urban architecture to assert timeless values; in the guise of allegories, these bore witness to the principles of social and moral order in the city. Mellery sought to make of them a "modern synthesis". Against idealised golden backdrops, realist figures engaged in a dreamlike discourse. These projects were never realised on the large-scale that he intended. Intuitively symbolist, they mingle ideal and reality in a remarkable combination of iconic and almost photographic scenes. In this dreamlike vision, reality took on another dimension; silent and transfigured, it pointed to the "soul of things" revealed on the obverse of familiar objects and places.

Mellery's predilection for exploring a reality peripheral to modern life and its frenetic activity, makes

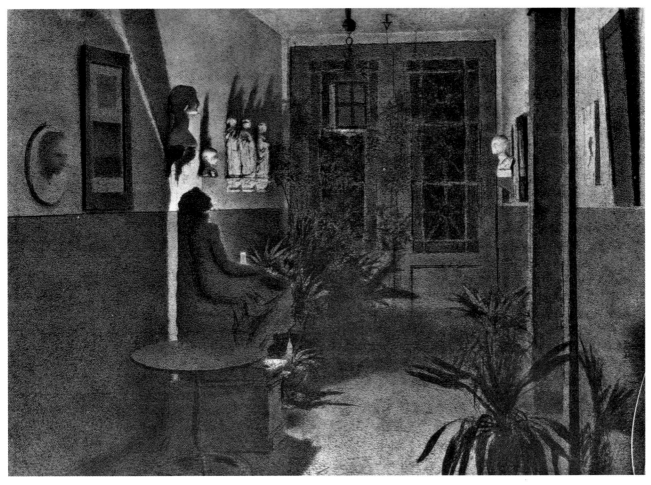

Xavier Mellery: *My Hallway, Light Effect*, circa 1889. Black chalk and ink and wash on paper, 54 x 75 cm. Private collection.

clear the links between Realism and Symbolism. This art of withdrawal aspired to silence and the suppression of colour. Harmony was created by sensuous restraint, by the quest for the inexpressible at the pulsing heart of the smallest things. This quest was to find its true expression in the work of Mellery's pupil, Khnopff.

Khnopff's work, like his life, appears static, devoid of conflict or event. Stylistically, his painting drew its inspiration from the Flemish Primitives, from Gustave Moreau, the Pre-Raphaelites and Anglo-Saxon artists like Whistler and Alma-Tadema. From Moreau he derived a visionary approach which saw a mythical reality beneath surface illusion; from Rossetti and his friend Burne-Jones he obtained his ideal woman with demonic red hair and hermetic features; from Whistler came his feeling for harmony, enriched by the influ-

ence of Memling. In the manner of photography, Khnopff's use of form heightened the ambiguity of a mimetic reality somehow become enigmatic, while the literary tenor of his symbolism was inspired by Mallarméan hermeticism.

In Khnopff's work, nothing is stated clearly. His landscapes present an enigmatic reality caught halfway between impression and dream. Each form suggests a hidden meaning. This brought Khnopff closer to the world of the Primitives, whose influence pervades his illustrations for *Bruges-la-Morte* (1892). The artist's precise rendering of detail concealed hidden meanings; he wreathes his forms in a misty haze, emphasising the primacy of Mallarmé's beloved art of suggestion over representation. Khnopff perceived reality as an enigma, and this is as powerfully conveyed by his

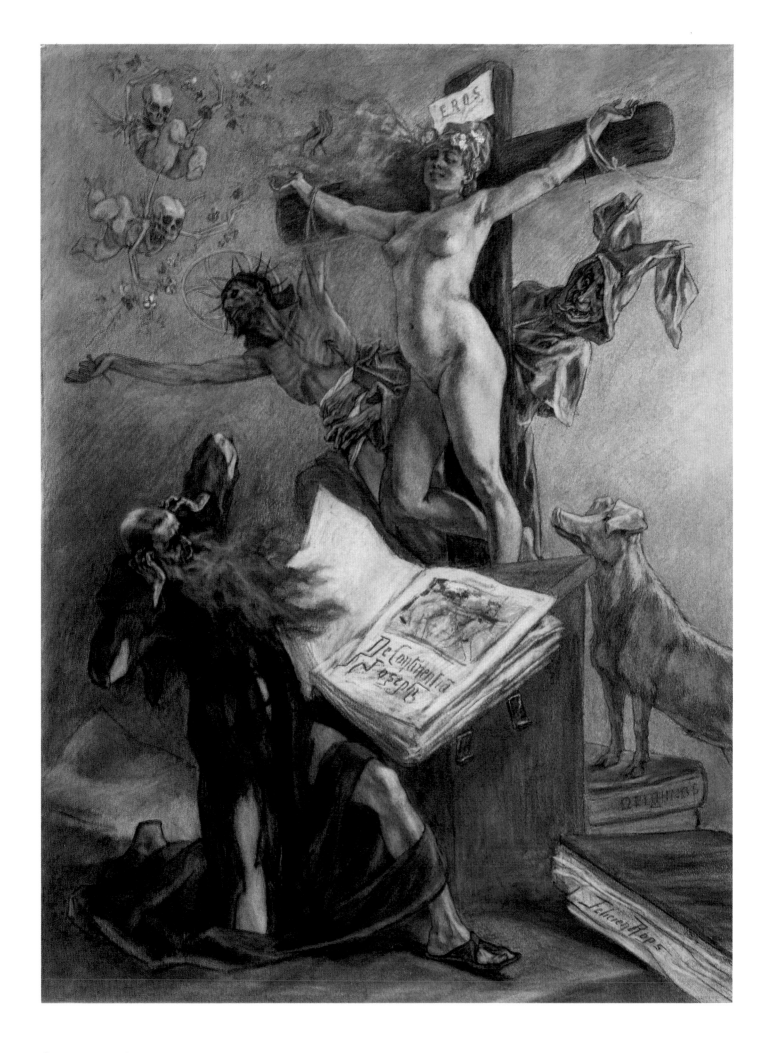

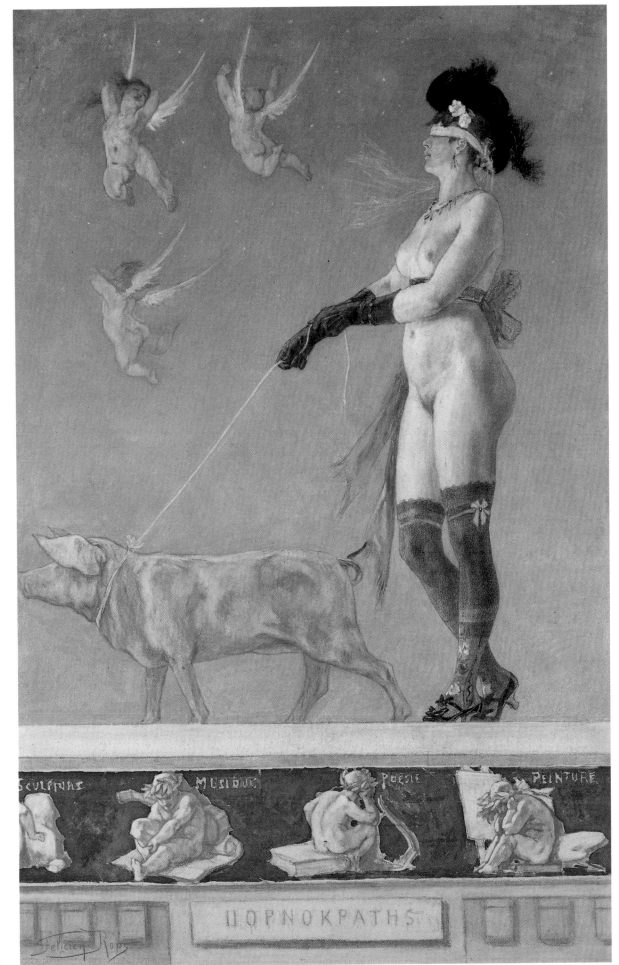

landscapes and portraits as by his great idealist compositions. His imagery becomes an interrogation, an embodiment of uncertainty: Each canvas, each drawing is a coded message, transforming and internalising reality such that it becomes a mysterious memory that cannot be mistaken for the transient spectacle of reality.

In the 1880s, Khnopff imbued his realist visions with an aura of mystery and a literary quality that were reminiscent of Ensor. The quarrel which flared up between them – Ensor accused Khnopff of plagiarising his *Russian Music* in Khnopff's *Listening to Schumann* – was no coincidence. It showed that they were both pursuing the same goal: to go beyond immanent reality to find a deeper meaning, both idealist and personal. They were, however, employing different methods. Ensor presented music as a "consumer product" in the cosy enclosed atmosphere of a bourgeois interior. This placed the emphasis firmly on the relationship which, through their shared enjoyment of the Russian music, united the two figures depicted: Anna Boch and Willy Finch. Khnopff, on the other hand, was attempting to depict the act of listening to music as a form of introspective contemplation. The musical instrument has all but disappeared from the picture; only an anonymous hand remains, which clarifies the title without explicating its deeper meaning. For Khnopff, music defined a new way of relating to the world: Knowledge was no longer gained by maintaining a visual relationship with objects but by being able to enter them from within by identifying with them.

The painter expressed this need for deep concentration both in portraits and landscapes. Faces take on the quality of icons, while nature is stripped of its illusory promises. In what Verhaeren described as a "too vividly perceived reality" Khnopff sought the signs of some transcendent intuition, and he did not balk at using esoteric devices. Between 1892 and 1897, Khnopff participated in four of the six Salons organised in Paris by Sâr Péladan. The latter welcomed Khnopff as model and ideal. Esoteric compositions like *Who Shall Deliver Me?* (1891), *I Lock My Door upon Myself* (1882), *Art or The Caresses* (1896), *Incense* (1898) and *Of Long Ago* (1905) revealed a deeply-considered hermeticism and desire for dissimulation. The mimetic illusion that he creates partakes of a symbolic density in which the self-evident collapses in on itself, taking with it all certainties. Memories of myths and archetypes are interpreted

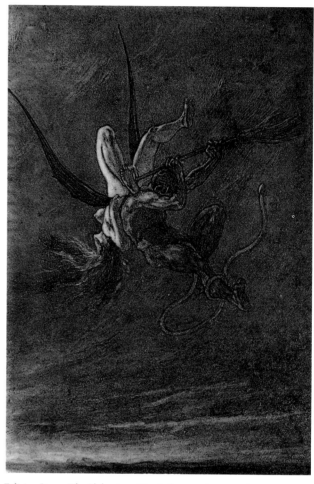

Félicien Rops: *The Abduction*, 1882. Soft ground, 24.1 x 16.5 cm. Namur, Musée Provincial Félicien Rops.

in a personal fashion to create indecipherable enigmas. His imagery makes play with photography, frames, detail, and colour to create an uncanny impression. His works embrace silence and contemplation, calculation and elegance, mystery and idealism.

The literary tenor of his "hothouse" work was evident. Khnopff moved in literary circles and provided drawings for works by van Lerberghe, Maeterlinck, Verhaeren and Rodenbach. He did not 'illustrate' these works so much as recreate their atmosphere, echoing the feelings conjured by the words. This can be seen in works whose title suggests that the memory of a poet's lines lives on, enhancing the picture's meaning while obscuring its sense: *An Angel; With Verhaeren; With Grégoire Le Roy. My Heart Weeps for Days Long Past.*

HUTE DES DERNIERES FEUILLES D'AUTOMNE

Xavier Mellery: *Fall of the Last Leaves of Autumn* or *Autumn*, n. d. Watercolour, Indian ink, charcoal and black chalk on paper mounted on gold card, 92 x 59 cm. Brussels, Musées Royaux des Beaux-Arts de Belgique.

Fernand Khnopff: *Memories* or *Lawn Tennis*, 1889. Pastel on paper mounted on canvas, 127 x 200 cm.
Brussels, Musées Royaux des Beaux-Arts de Belgique.

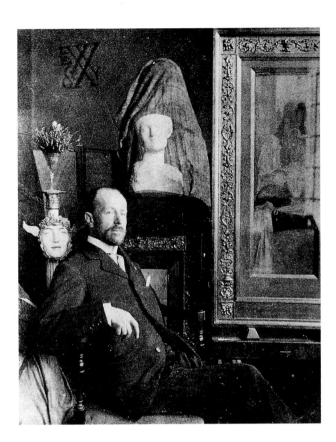

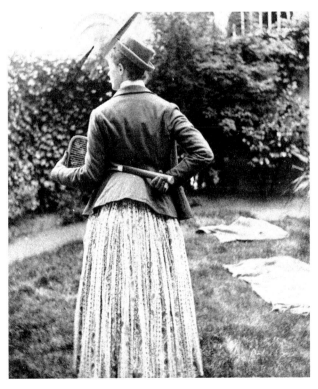

RIGHT, TOP: photograph of Khnopff in his studio. Beside him, *Mask* (1897), a marble bust lacking its laurel wreath and, on the easel, *A Blue Wing* (1894). Private collection.

OPPOSITE: photograph of Marguerite Khnopff, circa 1888–1889, taken by Fernand Khnopff, Brussels, Musées Royaux des Beaux-Arts de Belgique, Archives de l'Art Contemporain. These photographs served as studies for the two central figures in *Memories*, 1889.

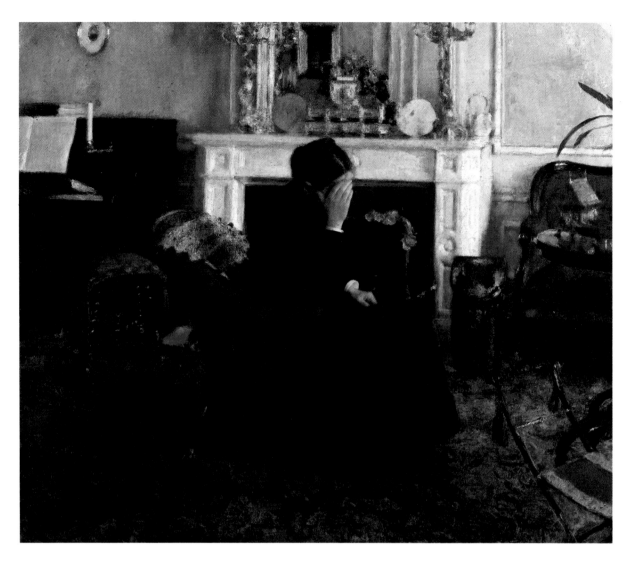

ABOVE: Fernand Khnopff: *Listening to Schumann*, 1883. Oil on canvas, 101.5 x 116.5 cm. Brussels, Musées Royaux des Beaux-Arts de Belgique.

OPPOSITE: James Ensor: *Russian Music*, 1881. Oil on canvas, 133 x 110 cm. Brussels, Musées Royaux des Beaux-Arts de Belgique.

RIGHT PAGE: Fernand Khnopff: *Abandoned City*, 1904. Pastel and pencil on paper mounted on canvas, 75 x 69 cm. Brussels, Musées Royaux des Beaux-Arts de Belgique.

Fernand Khnopff: *I Lock my Door upon Myself*, 1891. Oil on canvas, 72 x 140 cm. Munich, Bayerische Staatsgemäldesammlungen. This painting was

inspired by the poem *Who Shall Deliver Me?* by Christina Rossetti, the sister of the Pre-Raphaelite painter.

Hostile to boisterous modernity, taking refuge in his studio-cum-temple, Khnopff was not wholly indifferent to the affairs of the world. His efforts to promote the Pre-Raphaelites in Belgium were rivalled only by his enthusiastic advocacy of Belgian painting in England. In Brussels itself, he was involved in the formation of the Section d'Art at the Maison du Peuple, which aimed to elevate the people through art. His reputation was international: in 1900, Emperor Franz Joseph of Austria commissioned a portrait of his wife Elisabeth, who had been assassinated two years before. Invited to exhibit at the Glaspalast in Munich, the Vienna Secession, and the Society of Portrait Painters in London, he achieved recognition not only as a fashionable society artist but as one of the masters of European Symbolism.

Exhibiting at Les Vingt for the first time in 1890, George Minne belongs to the same tradition. He, too, returned obsessively to the same themes. In 1886, he associated motherhood and death in a synthetic vision that he never abandoned. The artist's sensibility found expression in an austere style that focused on the essential, thereby enhancing its emotional impact. In Minne's work, the past is a dead weight: Humanity is blighted by a destiny that it cannot avert. Minne returned again and again to these themes throughout his life. The figure of the kneeling youth, which first appeared in 1889, images the soul doomed to a life of meditation through fear of living. He used the motif of *Boy Holding a Reliquary* on countless occasions: as part of a monumental group, *Fountain with Youths* (1898), and in a series cast on a smaller scale. A version of the latter can be seen, next to Rodin's *Kiss*, on Verhaeren's mantelpiece in Van Rysselberghe's 1904 painting *The Reading*. It came to symbolise the modern spirit, the "self that, losing sight of itself, becomes nothing more than the site of a presence".[40] An idol emptied of its certainty and the icon of a new sensibility, the kneeling youth bore witness to the vulnerability of the individual. Francine-Claire Legrand has shown that Minne's work developed the combined themes of the self encompassed by itself or by its double, the mother. The suffocating nature of this dialectic is embodied in neurotic visions, a sickly Mannerism, and feverish morbidity: hair, hands and bodies are twisted and elicit just such emotions as Huysmans felt on seeing the Grünewald altarpiece at Isenheim. The same prim-

itive ideal was at stake. Minne was fascinated by the Middle Ages. He saw Gothic sculpture as the physical representation of a living faith. The commonplaces of Neoplatonism, which profoundly influenced *fin-de-siècle* thought throughout Europe, were transfigured by the mystical passion inspired in Minne by his study of the Primitives.

Austerity and mystical concentration do not exclude autonomy of form. Like the hair of the *Christ Baptised,* an engraving of 1889, which deserts Christ's body and becomes a cloud, so forms unfurl in space, asserting the unity of the universe. Humanity is excluded from this state of harmony; it is grief-stricken and tormented by the uncertainty of fate. Minne, too, moved in literary circles. His illustrations for Maeterlinck (*Les Serres chaudes* in 1889; *Alladine et Palomides, Les Aveugles* and *La Mort de Tintagiles* in 1894) or for Verhaeren (*Les Villages illusoires* in 1895) shared a mood of spiritual passivity relative to the forces of the cosmos, and of melancholy humility in the face of destiny. Minne's symbolism conveys the anguish that informs Maeterlinck's plays. This *Weltanschauung* also inspired the work of the leading Belgian symbolist illustrator, Charles Doudelet.

Minne left his mark on symbolist culture and sculptural practice in Belgium. He broke away from realist conventions without losing contact with a reality that he viewed, like Rodin, as an interplay of forces enlivening the surface, endowing stone with inner life that inhabits the figure. He jettisoned romantic clichés without renouncing the lessons of tradition.

Around 1890, Toorop, influenced by Minne's work, also moved towards Symbolism, though his technique continued to show the influence of Neo-Impressionism. His colours gradually lost their realist radiance, becoming increasingly cerebral. The style that appealed to Toorop at that time was not dissimilar to the decorative landscapes by van de Velde, with their dots that had lengthened into lines and their expanses of plain colour gradually creeping over the surface of the canvas. Toorop was more interested in ideas than in form. Idealist iconography with its myths, legends, and knights, was a major source of inspiration for him.

Fernand Khnopff: *Portrait of Marguerite Khnopff*, 1887. Oil on canvas mounted on wood, 96 x 74.5 cm. Brussels, Fondation Roi Baudouin, lent to the Musées Royaux des Beaux-Arts de Belgique.

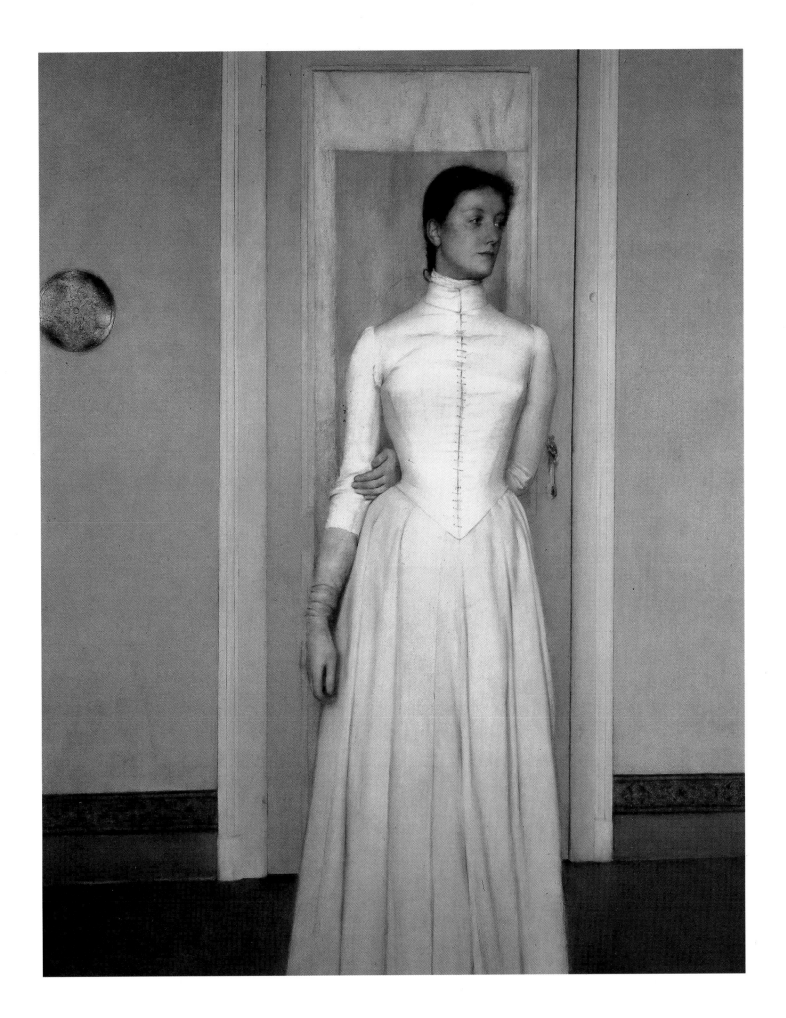

George Minne: *Mother Mourning her Dead Child*, 1886. Bronze, 45.5 x 16.5 x 27 cm. Brussels, Musées Royaux des Beaux-Arts de Belgique.

He drew on it to create a nightmarish and macabre universe. In these works, the environment proliferates organically and writhing plants threaten to obliterate the cadaverous human figures, who cannot restore order. His works become increasingly monochromatic; light becomes dull, and the lines, like Narcissus, become self-referential, concerned only with the sickly emotions of a hothouse soul. In works like *O Grave, Where is thy Victory?* Toorop prefigured both the idealism of the disciples of Delville and the assimilation of ornamental principles in Art Nouveau.

In 1892, the year of the Seurat retrospective, Verhaeren drew attention to the development of a "literary style of painting"; in his view it confirmed the revival of a type of idealism "called symbolism, intellectualism or esotericism".[41] The revival of the decorative arts and the increasing prominence of Symbolism are parallel phenomena. Les Vingt invited the European representatives of Symbolism to Brussels: Burne-Jones, Ford Madox Brown, Redon, Gauguin, Denis, Klinger, and Thorn-Prikker. Some, like Moreau or Puvis de Chavannes, refused to make the trip. Symbolism allowed Les Vingt to discover the unity of thought that *L'Art moderne* had sought in Neo-Impressionism. The movement had an impact on the arts in general. It endorsed the ideal of a synthesis of the arts, which had fired the enthusiasm of an entire generation, and called on artists to acknowledge the treasures of the inner world that Freud dubbed "the unconscious". This did not, however, obscure an awareness of the social problems of the time.

The realist vein had not been exhausted. While Meunier was acquiring an international reputation, social concerns provided young artists like Léon Frédéric with a source of inspiration for an original body of work. Moved by the life of the poor during a prolonged stay in the Ardennes, he turned to Naturalism. His canvases, influenced by Charles de Groux and Bastien Lepage, powerfully depicted the daily life of the most underprivileged classes: chalk sellers, workers, and peasants. Tramps and beggars became metaphors of a freedom of spirit untrammelled by material possessions. An ardent utopian strain, gradually uniting ideal and reality, could be glimpsed beneath the committed social criticism. This resulted in an emphasis on the heroism of the worker, which combined abstract aims with illusionist detail.

George Minne: *Fountain with Kneeling Youths*, 1898. Bronze, H: 67 cm.
Period photograph at Hagen, in the entrance hall by Henry van de
Velde. Brussels, Bibliothèque Royale Albert Ier, Fonds Van de Velde.

George Minne: *Boy Holding a Reliquary*, 1897. Bronze, H: 66 cm.
Rotterdam, Museum Boymans Van Beuningen.

George Minne: tailpieces for Maurice Maeterlinck's *Alladine et Palomides. Intérieur. La Mort de Tintagiles*, three short plays for marionettes, 1894. Brussels, Musée de la Littérature, Bibliothèque Royale Albert Ier.

George Minne: illustrations for Emile Verhaeren's, *Les Villages illusoires*, 1895. Brussels, Musée de la Littérature, Bibliothèque Royale Albert Ier.

Charles Doudelet: illustration for Maurice Maeterlinck's *Douze Chansons*, 1896. Brussels, Musée de la Littérature, Bibliothèque Royale Albert Ier.

Frédéric used allegorical imagery to unite political commitment and social utopia. Accordingly, the two series of paintings *Ages of the Worker* and *Ages of the Peasant* demonstrate a commitment to social issues combined with respect for tradition – regarded as a golden age – and a sensitivity to the inexorable passage of time. Each canvas in the series is at one and the same time a group portrait of a social class and a symbolic moment in the life of humanity.

Developments in the field of sculpture

Sculpture was hard hit during these years of economic crisis. The uncertainty of the times was not conducive to the acquisition of works, public commissions went almost exclusively to academic sculptors, the slump in prices reduced the attraction of the Salon, and the policy of decorating new or restored buildings meant that the sculpture had to conform to the particular style of architecture in question, which led to a certain vulgarisation. This situation plunged certain artists into abject poverty; Guillaume Charlier, Julien Dillens, Jef Lambeaux and Victor Mignon lived in complete destitution.

Commercial procedures had to change. Artists reacted by creating works that were easier to sell. They began working with terracotta, which was less expensive and multipliable; serial production made it possible to obtain a better rate of return. In Brussels, the Compagnie des Bronzes started making small-scale copies of works by Dillens and Rodin. The marketing of these products gave artists a greater degree of freedom and enabled them to start work on monumental projects – rarely completed – without a commission. In order to get around the established system, the sculptors exhibited more and more, both in Belgium and abroad. After La Chrysalide, L'Essor – the group headed by Julien Dillens – contributed to the emergence of a new trend in sculpture. It gained recognition at Les Vingt as well as at the many other exhibitions and organisations that distributed the works of local artists throughout the country.

Finally, to meet public demand, sculptors began producing decorative – and soon practical – objects, including ornamental statuettes and busts. The small format became increasingly popular and these ornamental pieces soon made their appearance in bourgeois homes. At the turn of the century, this was to be one

of the major markets for sculpture. The decorative arts employed the services of an increasing number of artists. There were programmes to embellish the city, championed by the Société pour l'Art Appliqué à La Rue, in which Dillens was involved. But private interiors assumed increasing importance. The success of sculptural *objets d'art* was boosted by current trends; the decorative arts came into their own at the World Exhibition in Paris in 1889, and a section was devoted to them at the annual Salon on the Champ-de-Mars. In 1892, Les Vingt followed suit; one year later, La Libre Esthéthique was founded.

The growing number of exhibitions, the large number of sculptors, and the sociological changes that affected the purchase of sculpted works encouraged stylistic development. This emerged in the 1880s as a natural extension of Naturalism and Realism. Meunier established a social realism inspired by a heroic vision of industrial labour. Reality became a 'material' interpreted by the artist in such a way as to heighten the expressive impact of the work, although a certain Mannerism was inherent in the nascent idealism. Thus Lambeaux made a name for himself with a mannered, almost rocaille lyricism. In 1883, he sculpted *Brabo*

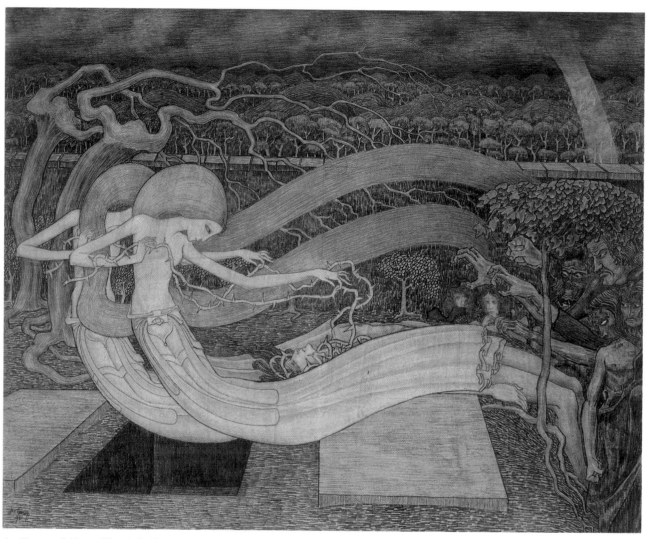

Jan Toorop: *O Grave, Where is thy Victory?*, 1892. Drawing, 62 x 76 cm. Amsterdam, Rijksmuseum, Rijksprentenkabinet.

Fountain, which became the symbol of the city of Antwerp; but in 1881, he had shocked the public by the sensuality of his *Kiss*, despite the fact that it could not compare with Rodin's bronze of the same name. Lambeaux compelled recognition for his sense of movement. His graceful representation of flesh was reminiscent of Rubens: His bodies escaped the material in sinuous, supple lines that revel in the pleasure of circumvolution. His works prefigure a certain type of idealism, which he combined with the expression of the human soul seeking perfection in the ebb-tide of passion. The huge marble relief that he began in 1887 was completed in 1899 and entitled *Human Passions*;

it testifies to this predilection, influenced by Schopenhauer, for ample forms carried away by passion and doomed to annihilation.

The work of Lambeaux, Dillens, van den Stappen, de Vigne and du Bois, displays a heightened, even exaggerated, sensitivity. Symbolism imbues these realist representations with a sense of mystery. Van der Stappen's work, despite its Italianate eclecticism, demonstrates the growing refinement of a proven technique. His *Wave* was the culmination of this process. Sentimentality increasingly prevailed, lines became more self-referential, forms became elongated, poses lost all semblance of naturalness, and movement grad-

ually lost touch with reality. Figures no longer reflected the real world, losing themselves in an introspection that made of the body a mirror of the soul. Movement emerged as a decisive factor in the new style. At times, it was seen as a principle of spatial deployment, at others as the expression of a contained introspection. This strain of Symbolism gained coherence with the second generation of artists who, after Isidore de Rudder, discovered a new approach to material and form in the symbolist ideal and the decorative trend.

Polychromatic sculpture made its appearance in Belgium in the wake of the French academism of Clésinger, Gérôme, Cordier, which combined exotic themes with luxurious materials. The Belgians, fascinated by symbolic ambiguity, used colour to enhance the appeal of their plaster figures. Hippolythe Leroy, Hélène Cornette, and Arthur Craco began experiment-ing with polychromy in 1888. Colour provided Khnopff with the means of bringing those enigmatic figures, distanced from ephemeral human existence in his paintings, back into touch with reality. In 1893, *L'Art moderne* devoted an article to polychrome sculpture, and the vogue it experienced was boosted at the turn of the century by the advent of exotic woods and ivory imported from the Belgian Congo.

Les Vingt and chamber music

The musical life of the 1880s, like the artistic scene, was dominated by the Cercle des Vingt. Octave Maus' efforts to build bridges between contemporary art and music had resulted only in some fairly unadventurous concerts, given in 1884, 1886 and 1887. Vincent d'Indy's

Jef Lambeaux: *Human Passions*, 1899. Marble, 610 x 1,090 cm. Parc du Cinquantenaire.

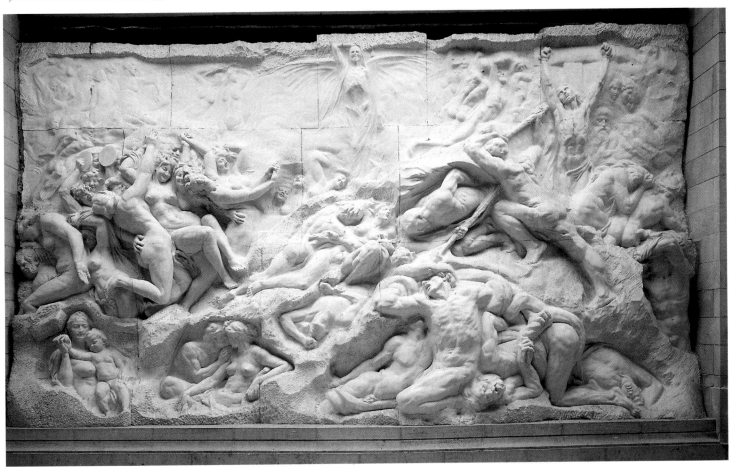

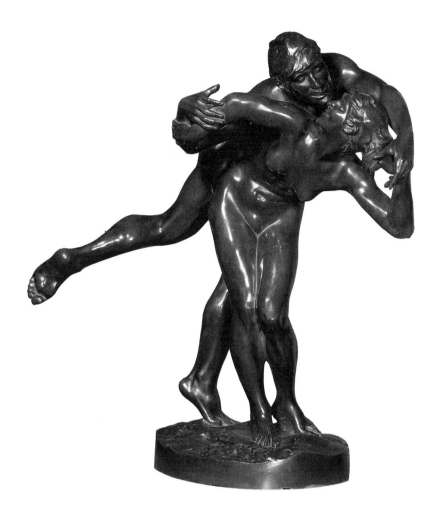

Jef Lambeaux: *The Kiss*, 1881. Bronze, 56.5 x 58 x 26.5 cm. Brussels, Musées Royaux des Beaux-Arts de Belgique.

RIGHT PAGE: Isidore de Rudder: *La Princesse Maleine*, circa 1895. Glazed sandstone, 29 x 20.5 cm. Manufacture Vermeren-Coché. Brussels, Galerie l'Ecuyer.

Charles van der Stappen: *The Four Periods of Day*, jardinière, 1898. Bronze and marble. Support by Victor Horta, circa 1902. Mahogany, 134.5 x 114 x 118 cm. Brussels, Musées Royaux d'Art et d'Histoire.

friendship remedied that state of affairs. In 1888, d'Indy, disgusted with Paris,[42] was happy to receive a warm welcome for himself and his friends abroad, all the more so because his 'refuge' was both artistic and avant-garde in spirit: d'Indy was a discriminating modern art lover. He liked Redon, Gauguin, young Belgian artists such as Lemmen and van Rysselberghe, and idolised Fernand Khnopff.

With d'Indy, the influence of César Franck arrived in Belgium. Franck, after nearly twenty years of teaching at the Paris Conservatoire, had formed a school whose apparently diverse exponents shared the same underlying aesthetic approach, imbued with Wagnerism and rooted in a thorough knowledge of the Old Masters. Franck identified cyclic form with a principle of eternal recurrence. Darting modulations and chromaticism were skilfully combined in a musical language that, although dated, had for several years represented the *nec plus ultra* of modern music. Franck's works exerted a powerful sway over Belgian composers.

The establishment of a 'Franckiste' school – of which Gabriel Fauré may be considered an 'associate member' – at Les Vingt was assisted by Eugène Ysaÿe, who began collaborating on the concerts at the same time as d'Indy. Ysaÿe, whose reputation in Belgium had not yet reached its peak, saw Maus' group as an ideal platform for the continuation of his promotional activities in favour of modern French music. He had lived in Paris between 1882 and 1886 and had forged close friendships with all Franck's disciples, not to mention Fauré and Saint-Saëns.

From 1888 onwards, the concerts at Les Vingt were among the most advanced in Europe. Fauré and Chabrier were performed alongside Duparc, Castillon (who died prematurely), Chausson, Bréville, Vidal, Bordes and later Magnard and Serres.

Les Vingt did not confine itself to French music. Belgian composers, such as Auguste Dupont, Paul Gilson, Franz Servais, Emile Mathieu, and Guillaume Lekeu, were well represented, as was Russian music:

Tchaikovsky and Borodin in 1891, and Glazunov and Rimsky-Korsakov in 1892. German music, by contrast, was completely neglected: Maus, d'Indy and Ysaÿe were unable to find any German chamber music, piano pieces or lieder that had the emotional impact of Wagner's music.[43]

With his quartet[44] and his musician friends from La Monnaie, the Conservatoire, and various other musical walks of life, Ysaÿe put together the programmes with d'Indy and commandeered the composers themselves as instrumentalists, when not depending on the services of Octave Maus himself.[45]

This small world of artists, many of whom wore their hair long enough to shock the bourgeoisie, were paid in a currency that made wages irrelevant: that of musical discovery. For six years, each concert mounted by Les Vingt was a milestone in the promotion of contemporary music in Brussels. The 1888 session devoted to Fauré was extraordinarily daring, given that the year before a similar initiative in Paris had proved a complete failure. Few people understood Fauré's historical importance on hearing a masterpiece like the *Quartet (op. 15)*. Articles in *L'Art moderne* and the *Guide musical* helped audiences to understand this music and, when Fauré returned to Brussels in 1889, the climate was more propitious. A performance of a two-piano reduction of d'Indy's *Symphonie cévenole* might be followed by a song by Fauré or Chausson without exciting undue attention. Then, in 1891, modern music received a decisive boost.

In that year, the Salon des Vingt was largely retrospective in spirit. The world of art was paying tribute to Van Gogh, while the disciples of Wagner and Franck in Brussels were mourning César Franck. To highlight his importance, it was decided to show the profound influence he had exerted on an entire generation of composers. The first two concerts, in 1891, were thus intensely symbolic in character. At the first, devoted to the memory of César Franck, the Ysaÿe Quartet performed his *Quartet*, as yet unpublished, and *Piano Quintet*. The second was designed to showcase the talents of Franck's friends and disciples. Ysaÿe gave the first performance of the masterpiece that was to make D'Indy the leading composer of his generation: his first string quartet, an intensely expressive work in cyclic form. With Maus, D'Indy performed Saint-Saëns' two-piano transcription of Duparc's *Lénore*.

Fernand Khnopff: *Vivien. Idylls of the King*, 1896. Polychromatic plaster, H: 98 cm. Vienna, Kunsthistorisches Museum.

RIGHT PAGE: Charles van der Stappen: *The Sea* or *The Wave*, for the mantelpiece of the billiards room in Victor Horta's Hôtel Solvay, before 1902. Marble, 40 x 73 x 31 cm. Hôtel Solvay, 224, Av. Louise (see pp. 176–178).

The Brussels audience was then regaled with Chausson's incidental music to Shakespeare's *The Tempest*; the programme also included songs by Benoit, Fauré, Bordes, Bréville, Tiersot, and Vidal. D'Indy and Maus brought the concert to a rousing close with Chabrier's *Valses romantiques* for two pianos.

The première of d'Indy's *Quartet* had considerable impact in Paris. It was, moreover, merely the first of many important premières. In 1892, at Les Vingt, a very young disciple of Franck and d'Indy from Verviers, Guillaume Lekeu, attended a performance of his cantata *Andromède*; the work captivated Ysaÿe. At the same time, Chausson and Fauré were also receiving important premières at the Brussels Salon. Chausson's famous *Concert for Violin, Piano, and String Quartet* was given its first performance on 4 March by Ysaÿe and his friends, the same day as four of Fauré's five *Mélodies venitiennes* after Verlaine. The prestige of these events was occasionally marred by the uneven quality of the performances; young, inexperienced singers found it difficult to navigate their way through the intricate chromatic vocal writing of these ultra-modern composers.

In 1893, Chausson's *Poème de l'Amour et de la Mer* was given its first performance at Les Vingt. A few days later, Ysaÿe gave the première of the *Violin Sonata* that he had commissioned from his young protégé, Guillaume Lekeu. This piece was greeted with great acclaim; despite its unevenness, it clearly announced a composer of genius. At the time of its première, Lekeu, encouraged by his friends – Ysaÿe, d'Indy, Théodore de Wyzewa, Maurice Pujo, Carlos Schwabe and Gabriel Séailles – was working relentlessly on a new work: a sensationally ambitious piano quartet. He put everything he had into this work, in a characteristically Franckinan quest for musical paroxysm.

> The subject of my first piece is grief, at first intense, uncontrollable, then easing sometimes, turning into impassioned melancholy. But, as the second section will suggest that love is the source of this grief, I must, when working on the first section, think continually about the second and combine all my themes and sketches so that they may merge fully with those that are to follow.[46]

Les Vingt's final concert had launched Lekeu's career, alas, to no avail; he died unexpectedly on 21 January 1894. La Libre Esthétique, which replaced Les Vingt, was thus bereft of the most promising composer in Belgian history.

La Monnaie, the Concerts Populaires and Wagnerian music

In 1886, Joseph Dupont and the tenor Lapissida, long established as stage-manager and director respectively, took over the reins at La Monnaie. Wagnerism made a forceful comeback, not without a certain degree of hostility on the part of Brussels' tutelary authorities, who were nostalgic for the Stoumon-Calabresi regime. The première in French of Wagner's *Die Walküre* was the first coup pulled off by Dupont and Lapissida, in March 1887. The sparkling cast and attendance by the Parisian smart set made this a sensational event. La Monnaie's prestigious reputation was founded as much on its programming policy as on the calibre of the ensembles and the performers it engaged: Nellie Melba, Rose Caron, Emile Engel, Felia Litvinne and Henri Seguin.

In 1888–1889, La Monnaie premiered several important Belgian works. The ballet *Milenka* by Jan Blockx was a resounding success, its vitality and Flemish flamboyance revealing a composer in the mould of Peter Benoit. Emile Mathieu's lyric tragedy *Richilde* confirmed the success of its composer, who was already popular with the public for his symphonic vocal *Hoyoux* and *Freyhir*. Most importantly, *Richilde* demonstrated that a Belgian composer had the ability to create a work of considerable magnitude – the libretto was by Mathieu himself – while avoiding the bombastic, at times vacuous Wagnerism of certain of Benoit's followers.

However, the policy adopted by the Monnaie was not to the liking of the Brussels city council, which reduced its subsidy. Despite tireless campaigning by the progressive press, Dupont and Lapissida handed in their resignation and mounted a tribute to Wagner: Amalia Materna, the Brünnhilde from Bayreuth, came to sing three performances of *Die Walküre*, and the season closed symbolically with a production of *Lohengrin*.

For ten years, the world of Belgian opera was divided between supporters of Dupont and partisans

Arthur Levoz: Guillaume Lekeu, circa 1892. Period photograph. Liège, Library of the Conservatoire Royale de Musique.

exorcised: public demand was too powerful. Stoumon and Calabresi relied on Reyer and Massenet to win over audiences. Accordingly, they gave the Brussels première of Reyer's last work, *Salammbô*. A few years before, Reyer's *Sigurd* had been eagerly anticipated. But *Salammbô* proved to be an overblown work, alternating moments of splendour with completely vapid passages. The première took place on 10 February 1890 before an international audience; the prestigious cast included Rose Caron in the lead role. Massenet allowed Stoumon and Calabresi to stage his Byzantine and ultra-Wagnerian *Esclarmonde* six months after its Parisian première.[48] Once again, the cast was outstanding, clinching the prestige of La Monnaie's company.

Stoumon and Calabresi were forced by events to mount a new Wagnerian première: *Siegfried*. The first performance, on 12 January 1891, boasted a good cast in an appalling production, which was panned by those opposed to the directorial team. Jules Destrée, later a leading figure in socialist politics and culture, was furious at the cuts inflicted on the score. He took Stoumon and Calabresi to court, demanding a refund; his case was dismissed.

Always on the lookout for new musical trends to distract the Brussels public from Wagnerism, the directors of La Monnaie welcomed French realism and Italian verismo with open arms. Novelty appeal soon wore off and only *Le Rêve* by Bruneau and *Cavalleria Rusticana* by Mascagni entered the repertoire. The year in which Les Vingt was dissolved, La Monnaie gave one major première: *Werther* by Massenet, premiered in German in Vienna and given its first French performances almost concurrently in Paris and Brussels. The first essays by Franck's disciples in the field of opera were yet to come. Albéric Magnard's operatic debut (*Yolande*) was a complete flop.

Dupont and the Concerts Populaires definitely had the upper hand over the Opera House in Brussels' cultural life. Inviting guest conductors – as yet an unusual practice – Dupont introduced Brussels audiences to several leading figures in modern music: Edvard Grieg, Edgar Tinel, Rimsky-Korsakov and Hans Richter. Despite the conspiracy between La Monnaie and the Hôtel de Ville, Dupont eventually won the day, thanks to support from Gevaert, Maus, Kufferath and Ysaÿe and a loyal public. The Concerts

of Stoumon and Calabresi. The latter dominated the world of opera, while Dupont presided over the destiny of the Concerts Populaires which, since their foundation, had been allowed to use La Monnaie's orchestra and auditorium. The city authorities had made several attempts to terminate this contract, but had failed owing to opposition from the progressive press. In view of the fact that the Concerts Populaires had become a bulwark of Wagnerism, Stoumon and Calabresi secured the assistance of two new conductors: Franz Servais, a bizarre character,[47] son of the great cellist, a friend of Liszt and the luckless rival of Joseph Dupont, and the mediocre Edouard Baerwolf. Naturally, Wagner's ghost could not be completely

Théo van Rysselberghe: *Portrait of Vincent d'Indy*, 1908. Oil on canvas, 60 x 90 cm. Private collection.

Populaires promoted the sophisticated new works welcomed at the Salon des Vingt: a French festival brought together the names of d'Indy, Lalo, Chausson, Chabrier, Bourgault-Ducoudray and Berlioz. In the following concert, Dupont combined works by Brahms and Wagner in a sensational programme.

The following season was dominated by the first performance of *La Mer* by Paul Gilson, a vast symphonic vocal work. Predating the work of the same name by Debussy, this piece was a huge international success at the Concerts Colonne in Paris, the Philharmonic Society in New York, in London and Berlin. Somewhat Wagnerian, it had flashes of Latin brilliance, Flemish flamboyance and Straussian orchestration. It was Gilson's masterpiece.

Wagner remained the god of the Concerts Populaires. There the great Bayreuth maestros – Mottl, Levy, Richter, Muck and Siegfried Wagner – succeeded one another on the podium. In Brussels, Wagner's music was emblematic of a modernity with which the progressive bourgeoisie could identify. Keen to bring about social change through the promotion of radical subjectivity, the Brussels avant-garde elected music as an aesthetic model for the progress of the arts. Ensor, Khnopff, Verhaeren, Maeterlinck, Picard and Maus raised music to the status of an ideal. For them, harmony embodied a form of perfection attainable through the unconscious, a sensibility that could be reached only through release from the straitjacket of reason.

RIGHT PAGE: Fernand Khnopff: *Isolde*, 1905. Charcoal on paper, 49 x 34.5 cm. Private collection.

OPPOSITE: Amédée Lynen and Devis: set design for Ernest Reyer's *Salammbô*, produced at the Théâtre Royal de la Monnaie in 1889–1890. Watercolour. Brussels, Archives du Théâtre Royal de la Monnaie.

BELOW: Stage set for Richard Wagner's *Siegfried* (Act I), produced at the Théâtre Royal de la Monnaie in 1890–1891. Period photograph. Brussels, Fievez collection.

Jean Delville: *Tristan and Isolde*, 1887. Pencil,
black chalk and charcoal on paper, 44.3 x 75.4 cm.
Brussels, Musées Royaux des Beaux-Arts de
Belqique.

1893–1914
The avant-garde:
modernity
and conformism

The economic crisis that had hit Belgium so hard in the 1880s – culminating in the bloody strikes of 1886 – had resolved itself by the end of the century. A period of economic recovery had begun and the two decades preceding World War One were boom years for Belgian industry. Wages rose and unemployment fell, but it was the upper echelons of the bourgeoisie who reaped most of the benefits of this growth. Industry became increasingly concentrated.[1]

On the political front, 1893 marked a watershed in the nation's history: Constitutional reform had introduced universal suffrage for men, although certain electors still qualified for more than one vote. This initial victory for the Belgian Labour Party represented a decisive step towards universal suffrage. It meant that all men over twenty-five were to have at least one vote but, in order to give a greater say to the conservative factions, certain electors received one or several additional votes, depending on various criteria relating to economic or domestic status and property qualification. In addition, the vote was made compulsory to prevent a situation in which only extremists bothered to vote. Despite these precautions, electoral reform enabled the Labour Party to win a major success: Twenty-eight socialists were elected to parliament, thereby upsetting the bipartite structure of political life (Catholic and Liberal). This electoral triumph was achieved at the expense of the Liberal Party, while the Catholics, capitalising on the support of the Flemish provinces where they commanded a majority, succeeded in remaining in power.

The appearance of the socialists in parliament made it easier to adopt several measures in aid of the workers, but social legislation always fell short of what was needed. This was one of the factors that encouraged the party to continue its battle for universal suffrage. In 1902, a general strike punctuated by violent incidents failed to sway the government. In 1913 another strike, which had been brewing for years, elicited a certain number of declarations that set out the conditions for a programme of constitutional

reform; this was unfortunately cut short by the war. The issue of suffrage was resolved in 1919 for men and thirty years later for women.

Symbolism in literature

There is no doubt that the Belgians played a crucial role in the development of the symbolist movement, but commentators are divided over the reason for this success. The question is why symbolism, of all the major literary trends in Belgium, alone acquired a European audience. Some writers have attributed the sudden impact made by Belgians in Francophone literature during the last years of the century to a Germanic influence, which spread with the growth of Wagnerism. Moreover, the context was an artistic milieu at odds with a society scarred by the war of 1870. It has often been observed that many Belgian symbolists were polyglots and thus able to benefit from sources outside the Latin tradition. They were inspired by the writings of the Flemish mystics, German philosophy and the esoteric tradition: Maeterlinck translated Ruysbroeck the Admirable, Novalis, John Ford and Shakespeare; Georges Khnopff translated Rossetti and Oscar Wilde, Olivier-Georges Destrée – the brother of the socialist politician – translated the Pre-Raphaelites and André Fontainas de Quincey. This openness to outside cultural influences, which were often introduced to France by Belgian writers, should not be overlooked. The critical success of Belgian literary symbolism – putting aside for a moment its linguistic brilliance – can also be traced back to its history of relations with French contemporary writers.

Two other key factors distinguished the symbolist school from other literary movements of the time. Symbolism, formed around two former members of the Parnassian movement, Mallarmé and Verlaine, brought together authors who were keen to repudiate the literary genres in vogue. Lacking a precise doctrine – the *Manifeste du symbolisme*, published in 1886 by Jean Moréas, was written by a young writer on the periphery of the group – the French symbolists formed an "emotional community" of writers some twenty years younger than their masters. The latters' influence over their followers was by no means akin to the power-

ful sway exerted by Zola or Leconte de Lisle. They were poor, they had no journals or publishing houses to disseminate their theories; Mallarmé held forth at his soirées on the Rue de Rome, and Verlaine possessed a certain bohemian charisma. Several small reviews, *La Vague*, *Le Symboliste*, and *La Décadence*, were founded in 1886, but it was not until the early 1890s that the more important journals (*La Plume*, *Les Entretiens politiques et littéraires* and particularly *Le Mercure de France*) began to advocate the new aesthetics. This state of affairs contrasts with the early welcome provided by the Belgian literary world. Mallarmé, Verlaine, and after them René Ghil, found a platform in Belgium, an audience – small, certainly, but enthusiastic – and a warm reception in fashionable and artistic circles that had been lacking in France. Their lectures were generously remunerated. The younger generation, including Elskamp, Rodenbach, van de Velde, and Verhaeren, showered them with admiration and the older artists were not to be outdone in compliments. Verlaine's dedication of a poem to Edmond Picard and Mallarmé's '*Remémoration d'amis belges*' bear witness to the warmth of this hospitality.

In addition, the French symbolists, Mallarmé in particular, obtained special terms and conditions for publication from their Belgian friends. Besides his contributions to small magazines, Mallarmé published many volumes in Brussels, including his *Album de vers et de prose* (Librairie nouvelle, 1887 and 1888), *Les Poèmes d'Edgar Poë* (Deman, 1888), *Pages* (Deman, 1891), and *Les Miens* (Lacomblez, 1892). The posthumous collection *Les Poésies de Stéphane Mallarmé* (Deman, 1899) was, for fourteen years, the only edition of major works by the leader of symbolism available to the French-speaking reader, and it was largely responsible for securing his reputation. These publishers were concurrently publishing texts by their customers and friends, van Lerberghe and Verhaeren. Many contacts were made on these occasions. Laud-

ABOVE: Maurice Maeterlinck: *La Princesse Maleine*, Ghent, L. van Melle, 1889. Cover of the original edition, drawing by George Minne. Brussels, Musée de la Littérature, Bibliothèque Royal Albert Ier.

OPPOSITE: Théo van Rysselberghe, cover for Emile Verhaeren's *Les Aubes*, 1898. Brussels, Musée de la Littérature, Bibliothèque Royal Albert Ier.

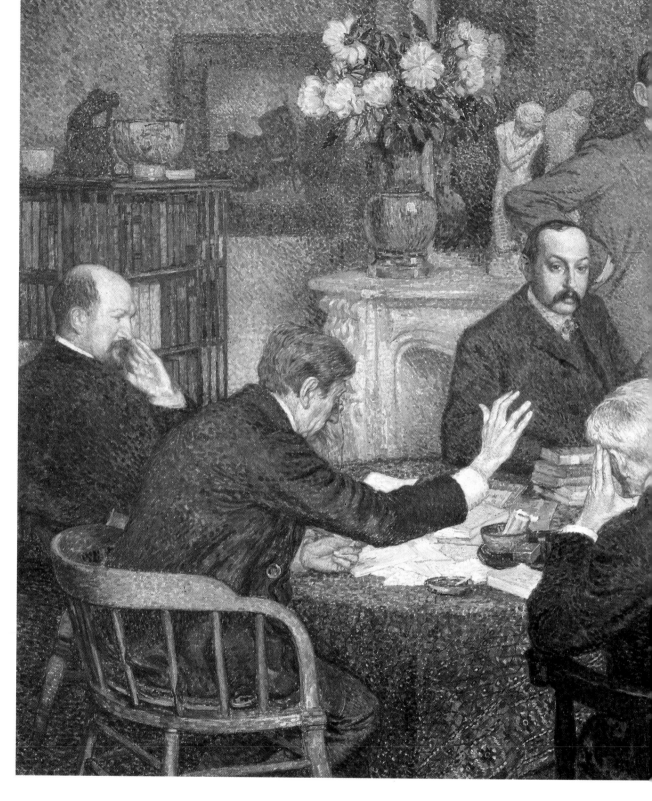

Théo van Rysselberghe:
The Reading, 1903. Oil on
canvas, 181 x 241 cm.
Ghent, Museum voor
Schone Kunsten. From
left to right, Félix Le
Dantec, Emile Verhaeren,
Francis Viélé-Griffin;
standing at the back, Félix
Fénéon, Henri-Edmond
Cross (in the foreground,
with his back to the
spectator), André Gide
with, behind him,
Henri Géon and, on
the far right, Maurice
Maeterlinck.

atory articles that appeared in *La Wallonie*, a review founded by Albert Mockel in 1886 in the first flush of enthusiasm after he had discovered the symbolist *Manifesto*. *L'Art moderne* by Emile Verhaeren and Georges Khnopff published favourable reviews. Consequently, when the Belgian symbolist writers 'went up' to Paris, they were fêted rather as prophets than belated disciples.

Furthermore, rather than competing with Parisian symbolism on its home ground, the Belgians carved out a distinctive niche for themselves by turning their hand to genres that had not yet been fully explored. While the vast majority of the French followers of Mallarmé were poets and confined themselves to that genre, the Belgians were primarily interested in drama, the novel and unfamiliar poetic forms such as those that Verhaeren invented for *Les Villes tentaculaires*.

In February 1893 at the Théâtre d'Art in Paris, Paul Fort staged three short scenes that were nothing short of manifestos for modern dramaturgy: an act from *Faust* by Georges Marlowe, *Les Flaireurs* by van Lerberghe and a reading of the *Bateau ivre* by Rimbaud. The conjunction of these three authors sums up the significance of Belgian symbolism's Parisian manifestations.

When, in a famous article in *Le Figaro*, Octave Mirbeau compared Maeterlinck to a "new Shakespeare", he did not just establish the reputation of a promising young writer. He focused as much on the renaissance of the dramatic genre as on the mysterious origins of the author of *La Princesse Maleine*: The writer must come from somewhere closer to the Northern mists, the Germanic countries and the London fogs than a Parisian writer. He placed particular emphasis on the continual quest that had been pursued throughout the nineteenth century in France, a quest that had always accompanied poetic innovation: for a type of French drama that did not conform to the standards laid down by classicism. Victor Hugo had thought long and hard about this problem, and he had written the *Préface de Cromwell* and *Ruy Blas*; for Mirbeau, the "new Shakespeare" was following in this tradition! In fact, the masterful five acts of *La Princesse Maleine*, telling the story of the engagement, then death of the young princess, heralded a new type of theatre. This dramatic form lacked unity, created a doom-laden

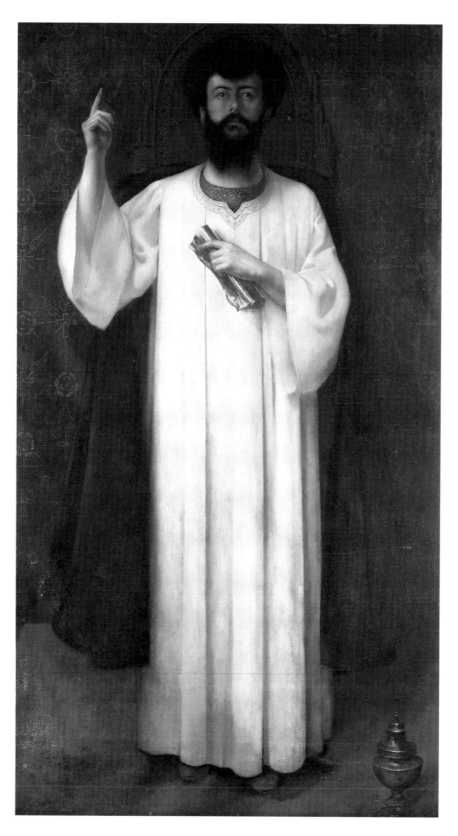

atmosphere, and took the focus of attention away from the actors to place it firmly on the *mise-en-scène,* which played a more important role than speech. This was precisely what was needed in a country whose bourgeoisie favoured Alexandre Dumas *fils* and Victorien Sardou. Naturally, by this time, Maeterlinck was no longer a beginner. Like other young authors, he had first published a "transposition d'art", then had moved on to write the remarkable *Serres Chaudes.* But the latter were barely known in France. Plays, music and later, essays – another genre little exploited at the time, Quiévrain being the sole exception – established Maeterlinck's reputation.

Most of Maeterlinck's Belgian contemporaries or successors in the "great generation" wrote works for the stage. With his *Les Flaireurs,* van Lerberghe rivalled Maeterlinck as the father of the genre. But Georges Rodenbach, never at a loss for innovation, hurriedly adapted the subject of *Bruges-la-Morte* for the Comédie-Française: *Le Voile* (1893). The play was a resounding success not least because of the exotic winged coifs of the Beguines. In the same period, Verhaeren began *Les Aubes* (1898), in which the movements of the groups, the alternation of dialogue and poetic recitative, and the use of symbolic characters to communicate ideas were all of the new aesthetics. He wrote three other plays, including *Hélène de Sparte* (1912), which earned him publication in the prestigious *Nouvelle Revue française.* A lawyer by training, Ywan Gilkin was the member of the editorial board of *La Jeune Belgique* the most receptive to Picard's ideas. He ultimately abandoned poetry to write *Etudiants russes* (1906) and *Le Sphinx* (1907).

Justice has rarely been done to Picard's crucial role in this movement. A master of agit-prop and provocation, whose motto was "I disturb", Picard was a great theatre-lover. He invited Lugné-Poë to collaborate in the performances put on by his Maison d'Art. He wrote a series of theoretical articles on the *Renouveau au théâtre* (1897), in which he defined a transcendental,

OPPOSITE: Jean Delville: *Portrait of the Grand Master of the Rosicrucians wearing a Surplice,* 1894. Oil on canvas, 112 x 242 cm. Nîmes, Musée des Beaux-Arts.

RIGHT PAGE: Jean Delville: *Portrait of Madame Stuart Merrill, Mysteriosa,* 1892. Chalk on paper, 35.5 x 28 cm. Private collection.

The signature reads "Jean Delville 1892"

Fernand Khnopff: *Art* or *The Caresses*, 1896. Oil on canvas, 50.5 x 150 cm. Brussels, Musées Royaux des Beaux-Arts de Belgique.

hieratic and silent drama, and proposed a new and more economical mode of performance: monodrama, which prefigured today's 'one-person shows'. In *Jéricho* (1902), *Psychè* (1903) and *La Joyeuse Entrée de Charles le Téméraire* (1905), Picard endeavoured without great success to put his theories into practice.

Allegory and symbol

Among the literary forms explored by writers who did not want to be swallowed up by the vast symbolist poetical movement, the inspired irregular lines developed by Verhaeren or van Lerberghe demonstrated an approach to language which was later to be taken up by Claudel or Péguy in their own fashion. Also worthy of mention is Albert Mockel's theoretical examination of works by Mallarmé, Régnier and Viélé-Griffin. In his *Propos de littérature* (1894), one of the most profound theoretical essays of the time, he expounded his philosophy of symbols as distinct from the idea of allegory.

Mockel's argument was extremely advanced in theoretical terms; he highlighted the difference between symbol and allegory. The latter has an illustrative function: It *represents* a preconceived abstraction analytically by clothing it in imagery. Its legibility is assured by a conventional system of representation that allows no divergence from the illusion of reality. Symbols, by

contrast, have their source in reality, diverging from it after an intuitive process of enquiry. They take fragments of scattered meanings from the real world, arranging them in such a way as to guide the reader, by means of suggestion and a process of decipherment, towards the inexpressible. In the atmosphere of imprecision deliberately created by the artist, Mockel argued, the aim of the symbol is "less to draw a conclusion than to provide food for thought, so that the reader, who becomes a collaborator through what he imagines, completes the written words within himself".[2] Allegory represents, while symbols evoke.

In this sense, allegory is more frequently encountered in painting than symbolism. Certainly, allegory strongly influenced the monumental works of Mellery, Frédéric, Montald, Fabry and Ciamberlani. Among the symbolists, Fernand Khnopff is preeminent in the richness and diversity of his work.

Idealism

The revival, in 1888, of the Rosicrucian order went hand in hand with hermetic research influenced by spiritualism, alchemy, freemasonry and the Kabbala. Péladan ostentatiously divorced himself from this trend to affirm a Christian idealism, which found fertile ground in Belgium. The Catholic Rosicrucians, founded in 1890 and called the Rose+Croix du Temple

et du Graal, led by Sâr Péladan, saw the artist as an initiate eager to depict the struggle for Christian values begun by the Magus. In 1893, the brotherhood, ruled with a rod of iron by the Sâr, launched an "aesthetic" initiative which, for the next four years, brought together "exceptional beings" devoted to the cult of Beauty. Exhibitions were accompanied by a form of drama that was "idealist rather than hieratic", a programme of "sublime music", and lectures "capable of awakening the idealism of the worldly". Péladan's aesthetics were inspired by Wagnerism; he aspired to a total art in which spiritual unity was to become a magical force.

According to Péladan, magic transfigured human beings and initiated them into the fundamental truth that underpinned the harmony of the universe. The mission of art was to embody this ideal beauty in icons. Wreathed in archaism, art was important "as the median part of religion, between the physical and the metaphysical". Hostile to any manifestation of the immanent, Péladan criticised Realism and Impressionism and condemned landscapes, still lifes and portraits. In the wake of the Rosicrucians, classical canons were re-examined in the light of a Nazarene primitivism which, as in literature, reflected a deep-rooted Germanophilia: Harmonious proportions reflected a state of perfection on which gestures and faces conferred an unhealthy and unrealistic sensuality. This effect was heightened by a subdued palette and a predilection for chiaroscuro. The idealisation of reality precluded the individualisation of features. Figures were frozen into types and the mystery so highly esteemed by Péladan was reduced to a conventional hermetic repertory.

The fascination with death revealed in this esoteric syncretism conferred a certain ambiguity on idealism. The latter aspired to the triumph of mind over body, ideality over flesh, intellect over sex, without being able to say that this victory was desired. The terror of annihilation could not quell the sensual pleasure aroused by death glimpsed in the deep sleep of entangled bodies. The soul possessed its own sexuality hidden in the unconscious mind: Flesh dematerialised to float,

Fernand Khnopff: *With Joséphin Péladan. Istar.* Preparatory sketch for the frontispiece (soft ground) to J. Péladan: *Istar* (Paris, 1888), 1888. Red chalk on paper, 16.5 x 7 cm. Private collection.

undetermined, in celestial spaces characterised by muted colours, soft light, and musical harmonies. The mysteries of the real world were replaced by a realism of the hereafter, bringing in its wake an academism that found expression in weighty allegories on monumental public buildings.

Identifying progress with barbarism and democracy with decadence, Péladan's disciples perceived their attachment to tradition as a rejection of the future. Idealism was tinged with pessimism, and reading Schopenhauer strengthened the aristocratic disdain of those who could not accept the changing face of the modern world. In their elitism, the idealist artists regarded reality with a jaundiced eye. Their vision of the world was modelled on the dreamlike paintings of Gustave Moreau. They substituted a chimerical

elsewhere for the world, a place in which opposites merged and their neurotic subjectivity encountered the founding myths of humanity. Their iconographic themes were keys rather than signs of recognition: Prometheus, Ophelia, Orpheus and Oedipus symbolised the artist confronting his divinatory mission; the ideal woman or *femme fatale* was sometimes a source of inspiration and sometimes a threat; the ideal took on the features of the androgynous figure from the Orient, which Wagner had endowed with fresh power. Idealist iconography continually combined myths and esoteric doctrines to affirm the reappearance of a religious feeling both mystical and arcane.

For Péladan, who despised landscape painting and non-heroic portraiture, the true embodiment of the idealist artist (apart from Moreau, who did not know

OPPOSITE: Jean Delville: *The Love of Souls*, 1900. Distemper on canvas, 238 x 150 cm. Brussels, Musée Communal d'Ixelles.

LEFT PAGE: Jean Delville: *Orpheus Dead*, 1893. Oil on canvas, 82 x 103 cm. Private collection.

Constant Montald: *The Boat of the Ideal*, 1907. Oil on canvas, original state: 535 x 525; present state: 400 x 505 cm. Musées Royaux des Beaux-Arts de Belgique, deposit by the Province of Hainaut.

Péladan) was Fernand Khnopff. The artist maintained close ties with both Péladan and the Rosicrucians. Khnopff illustrated several texts by the Sâr: *Le Vice suprême* in 1885, followed by *Istar, Femmes honnêtes* and *Le Panthée*. Between 1892 to 1897, he participated in four of the six idealist "aesthetic exploits". His presence at these exhibitions does not, however, explain the true extent of his enthusiasm for Péladan's theories. In Belgium, although a circle of disciples formed around Jean Delville, Khnopff remained in the background.

Delville and La Mission de l'art

Brussels had become one of the most influential idealist centres in Europe. Péladan's vision of art – the use of allegory to express a type of beauty exemplifying the moral values of a society devoted to order and virtue – exerted a powerful sway. A nucleus of artists formed around Jean Delville. Painter, poet, and essayist, Delville strove to change society by revealing to it

a wisdom combining esoteric tradition, Neoplatonism, and theosophical utopianism. Kabbala, magic and hermetism formed the basis of a mysticism in which the soul is guided by astral light, "the second state of substance and the great magnetic reservoir of undefined forces".[3] In this fluid universe, each form, each colour is imbued with a mysterious power whose source is God and whose contemplation affords ecstasy to the soul. The esoteric vocabulary concealed a mystical dimension, which drove the artist towards the ideal in his rejection of the immanent.

Striving for the absolute, Delville pared down the "accidental" existence of his figures to focus on dematerialised bodies, evanescent colours, and the radiance of astral light. Space was sucked into this ascesis, decomposing in smoky spirals and shimmering nimbuses. This shifting universe, embellished by plant-like arabesques whose endless unfolding was inspired by Art Nouveau forms and the jewelled technique of the decorative arts, combined Wagnerian theatricality with a certain weakness for the decadent. Entangled limbs, mannered poses, and vacant faces speak of the morbid

surrender symbolised by *Orpheus Dead*, painted in 1893. Drifting in indistinct space, both sky and sea, the head resembles a star radiating spiritual light.

Artist and initiate, a friend of Scriabin and Villiers de L'Isle-Adam and a disciple of Péladan, Delville was also an organiser. He viewed Maus' activities as the natural ferment of the decadent *status quo*. His foundation of the Salon Pour l'Art in 1892 may simply have marked a need to throw off Sâr's authority and promote a theory that he formulated in 1895 in his *Dialogues entre nous* and *La Mission de l'art* (1900, preface by Edouard Schuré).[4] The Salon featured various disciples: Albert Ciamberlani, Emile Fabry, Charles Filiger, Victor Rousseau, Jan Verkade, and the old master, Félicien Rops. The latter, although he illustrated Péladan's *Le Vice suprême*, did not set much store by these idealist excesses.

In 1894, the esoteric study group Kumris organised a major exhibition of idealist art which brought to-

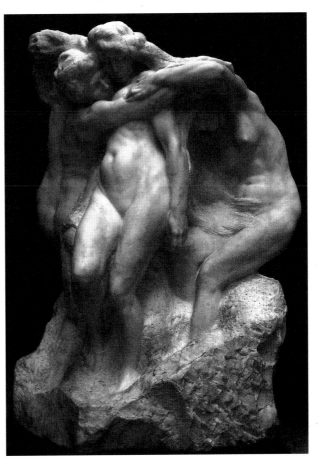

Egide Rombaux: *The Daughters of Satan*, 1900–1903. Marble, 205 x 151 x 108.5 cm. Brussels, Musées Royaux des Beaux-Arts de Belgique.

OPPOSITE: Auguste Lévêque: *The Fate*, n. d. Oil on canvas, 295 x 204 cm. Tournai, Musée des Beaux-Arts.

gether, besides the members of Pour l'Art, William Degouve de Nuncques, Auguste Donnay, George Minne and the illustrator Charles Doudelet. Pour l'Art was dissolved in 1895. It was succeeded the following year by the first Salon d'Art Idéaliste, which featured work by the Belgian artists Albert Ciamberlani, Constant Montald, Emile Motte, Victor Rousseau, Isidore de Rudder, Gustave Max Stevens and Adolphe Wansart, alongside the French artists Armand Point and Alexandre Séon. Shortly thereafter, Auguste Levêque and Léon Frédéric joined the movement. A sublimated reality transcending the empirical world was a characteristic of the works of all these artists, and one of the hallmarks of idealist art. In 1897, the journal *L'Art*

idéaliste, edited by Delville, was founded. Apart from attacks on the avant-garde artists, Delville confirmed the mission of idealist art as the fusion of a hermeneutic system (the work is a sign representing an enduring idea), a mystical system (the artist seeks to create a sense of harmony between the three great Words of life: the Natural, Human and Divine), and an aesthetic system founded on an essential light. The light generated ideas and shapes in which the artist "was to decipher the living prisms of the divine beauties in which the splendour of the universal Soul is refracted".[5] To ensure the luminous, mystic unity of these visions, Delville abandoned oil painting in favour of distemper and egg-tempera, creating a monumental effect reminiscent of the paintings of the old masters. As a general rule, the Belgian symbolists rejected oils in favour of crayon and pastels, materials whose effects call to mind Renaissance frescoes, softening the clear outlines of objects and veiling them in hazy atmospheres.

Idealism and monumental allegory

Alongside Delville, a movement took shape. Idealism's dependence on tradition limited it to contemplative elitism that could not evolve. Only by resort to large scale allegorical painting could the mission of idealism be fulfilled. Allegory's didactic nature allowed of a unified pictorial space within the confines of the mural and called for a higher level of abstraction. Montald, Ciamberlani, Levêque, and Fabry made a name for themselves as painters of ideas, who decorated the walls of public buildings with impressive allegories. The ideal world towards which symbolism yearned thus came to embody the reassuring values of a conservative society, which saw in the Elysian Fields a world frozen in time, untouched by change and progress. The many decorative programmes carried out, for example in the town halls of Laeken and Saint-Gilles, the monumental Palais de Justice and Palais de Cinquantenaire, the Théâtre de la Monnaie and the Palais

William Degouve de Nuncques: *The Peacocks*, 1896. Pastel on paper mounted on canvas, 59.5 x 99 cm. Brussels, Musées Royaux des Beaux-Arts de Belgique.

William Degouve de Nuncques: *The Pink House* or *The House of Mystery* or *The Blind House*,
1892. Oil on canvas, 63 x 42 cm. Otterlo, Rijksmuseum Kröller-Müller.

de Tervuren, offered the public ethical lessons in the guise of clichés that were still in use late in the twentieth century.

The concept of beauty to which these artists subscribed gradually evolved toward a decorative tendency that reflected contemporary tastes. Montald inserted his figures into landscapes using plant-like arabesques, unreal ornaments, and mannered effects of light. Dream became decoration. This style no longer spoke of a world beyond the everday. It simply gave perfunctory expression to a moral order resistant to change. Art Nouveau provided it with a stylised vocabulary that marked its rejection of both reality and modernity. Fabry's hieratic figures express the impossibility of communication; the theme is Maeterlinckian. Fabry went on to collaborate with Horta, Hankar and

Sneyers. In the aftermath of World War One, although the idealist movement was already a thing of the past, its doctrines spread through the country in the form of a patriotic genre of sculpture dedicated to the cult of the nation's heroes.

Idealism and reality

Picard's demand for art with a social message had found a paradoxical ally in Khnopff's aestheticising but political art. Two figures in Delville's circle combined ethereal symbolism and critical naturalism. Léon Frédéric and Auguste Levêque continually moved between a social reality that distressed them and a timeless ideal oblivious to injustice and oppression. Levêque's *The Fate* underlined this tension in a somewhat incoherent phantasmagoria. All that remained of his realist intentions was an almost caricatural precision of detail, and of his idealist aims, merely a Rubensian saraband of stylised bodies. At poles from any Mallarméan art of suggestion, the painting attempts to express the inexpressible by resort to a stereotypical and unconvincing discourse. The idealist artists viewed matter in the ambiguous light of a moralising Neoplatonism; it symbolised creation rather than the Fall.

In 1882–1883, Léon Frédéric had belonged to the naturalist contingent in Belgian Realism. He had gradually widened the discourse of critical naturalism to give allegorical expression to utopianism. *One Day the People Will See the Sun Rise*, exhibited at the Salon d'Art Idéaliste of 1896, combined progressivist demands with the allegorical recollection of a golden age. The life of the farmers or labourers preoccupied Frédéric, whose idealised notion of the future went well beyond social reportage. Dream and reality combined in his unbending desire for progress, material and spiritual.

In Frédéric's view, nature set its seal on this new alliance. Under the artist's brush, the natural world proliferated; in an alpine landscape, beneath an avalanche of flowers, it spawned a mass of pot-bellied cherubs. Frédéric rivals Wiertz for bombast when, in *The Stream* – a homage to Beethoven – he paints a pastoral symphony of entangled bodies. Flowers and plants pullulate in a terror of empty space whose lyrical afflatus derives from the paintings of Rubens. In this river of flesh with its sumptuous excess of orna-

mentation, demands for social reform merge with Christian mysticism.

Henry de Groux, an eccentric personality working in complete solitude, was also drawn to this style of idealist painting. From his early years, he was a self-styled medium. In 1890, his *Christ Outraged* caused a sensation. The heaving baroque man is drawn up the diagonal axes as if absorbed into the vertical figure of Christ. This pyramidal structure focuses the dramatic tension and imbues the scene with an emotional power characteristic of de Groux's work. Christ's solitude symbolises the position of the artist on the fringes of a society that despises and is despised by him. A single theme runs through de Groux's oeuvre: upheaval, destruction, apocalypse and war, which reduce society to ruins littered with dismembered corpses. Unlike Delville, Levêque or Frédéric, de Groux does not represent the body in order to venerate the soul; he wishes to conjure up a picture of humanity swept away by the march of history. His battle scenes verge on the chaotic: trampled, broken bodies in muddy, dirty colours. De Groux yearned for destruction in megalomaniac and desperate fashion. His anarchist sympathies find expression in heroic feats of bravery that push men beyond their natural limits. His work is haunted by the supernatural figures of imaginary or real heroes: Napoleon, Baudelaire, Wagner, Poe, Siegfried, Charles the Bold, Lohengrin and Dante.

De Groux's antisocial nature quickly set him at loggerheads with Les Vingt, which he had joined in 1886. Four years later, he was expelled for insulting Van Gogh and challenging Lautrec to a duel. A victim of his turbulent unconscious, de Groux sought excess in painting, engraving, drawing and sculpture.

Degouve de Nuncques, by contrast, was a contemplative. His marriage to Verhaeren's sister-in-law brought him into the symbolist sphere of influence. His sensibility made him a keen spectator of the natural world. Under the influence of Toorop, Degouve discovered symbolist idealism; under the influence of de Groux, he became deeply religious. His sensitivity found expression in the hazy and introspective character of pastels. He sought to render the slightest atmospheric graduations and capture the most delicate play of light. The uniform appearance of snow or night satisfied his desire for harmony. Landscapes appear shrouded in a light melancholy mist. Solitary contem-

Henry de Groux: *Christ Outraged*, 1888–1889. Oil on canvas, 293 x 353 cm. Avignon, Palais du Roure, Fondation Flandreysy-Espérandieu.

plation, an unrealistic palette, and an awkward technique contribute to his expressiveness, which makes each work an ode to nature. However, the artist did not just paint any corner of nature; his work tends towards a synthesis of vision, impression and intention. Harmony is created at one remove from reality, as if the sight of nature had to be steeped in thought before being set down on paper. Degouve's ascetic rigour derives from his distance from reality, while a surreal quality is generated by colours radiant with inner light. Nothing can exist outside the nexus of the drawing, which resolves within it the diversity of the universe, the macrocosm. From 1892–1899, Degouve produced a

variety of symbolist works, whose poetical quality arose from his emphasis on the "soul of things" and an interiority that enabled the artist to perceive in nature what others could not. He cultivated a hot-house spirituality by which the colours of mimetic illusion are tinged with a feeling of unreality.

Synthetism and symbolism

In its mystical vein, Symbolism repudiated the idea of painting from 'life' (i. e., illusion). The Pantheist fervour that animated most of the idealist masters,

Gustave van de Woestyne: *Desk Seated*, n. d. Oil on canvas, 120 x 107 cm. Private collection.

from Delville to Montald, tended towards considered compositions in which emotion was intellectualised. Humanity was led towards a better world, a world hostile to the very notion by which society was shaped: progress. The theme of the golden age, so dear to the Elysian art of Péladan's disciples, was not merely archaic; it confirmed the superiority of mind over matter, of myth over history, and of the divine over the immanent. Some artists, like Frédéric, found visual expression in the blooming flowers and entwined bodies of Art Nouveau; others regarded their mission as a quest for purity and sought soberness, severity, and concentration. The essentialist forms used by Minne, Doudelet, van de Woestyne, and Degouve de Nuncques avoid illusionism and reject the use of perspective, trompe-l'oeil and realist detail.

Although drawing its inspiration from the formalism that resulted when purposeless virtuosity left the plant-like lines of Art Nouveau limp and facile, synthetic symbolism also reacted against it. It also opposed the aristocratic elitism of the idealists, who rejected modernity as decadent. Its visual ideology was inspired by architecture, and saw art as a means of achieving social progress. The symbolists found confirmation of Picard's polemic against 'art for art's sake' in the works of William Morris and John Ruskin, and the activities of the Section d'Art. Firmly rooted in the present, this brand of Symbolism claimed to be less moralistic and more human. Although its commitment to social issues placed it in the wake of the Naturalism which, in Belgium, had laid the foundations of the modernist movement, its underlying aims situated it clearly within the vast movement of primitivist idealism.

In 1902, the exhibition of Flemish Primitives organised in Bruges reinforced the interest in early art that had begun in the 1890s.[6] The illuminations, stone sculptures, wood cuts and particularly the paintings of the fifteenth century encouraged a reaction against the bombastic mannerism of Art Nouveau. The profound interiority and mystical austerity of the primitive ideal

Jakob Smits: *The Symbol of the Kempen*, 1901, Oil on canvas, 115 x 140 cm. Brussels, Musées Royaux des Beaux-Arts de Belgique.

led the artists towards the ideal that Maeterlinck had discovered in the flamboyant texts of the Flemish mystic Ruysbroeck. Patriotism played a part in this return to primitivism, as it had in the romantic era. Encouraged by campaigns to gain recognition for Flemish culture, artists went back to the golden age of Flemish tradition. They sought a new identity involving the rejection of the French language and Latin culture, which they regarded as symbols of bourgeois oppression. In this primitivist quest, archaism was set against industrialisation: The artists inspired by the Flemish ideal countered class conflict and progressivist slogans with the picture of a variegated nation, united in the Catholic faith.

The Flemish movement had till then centred on the recognition of Flemish cultural identity. But between 1870 and 1880, its political successes led to the first demands for linguistic recognition. The Koninklijke Vlaamse Academie voor Taalen Letterkunde (Flemish Royal Academy of Language and Literature) was

founded in July 1886. It bore witness to the need to establish a Flemish identity in all areas of society, not just the cultural domain. In the 1890s, industrialisation was coming to Flanders, aided by the social unrest in Wallonia. The French-speaking heavy industries were matched by a growing number of small and medium-sized Flemish companies with an autonomous structure and animated by the Catholic ideal of class reconciliation.[7] From 1895, the Flemish nationalist movement drastically revised its political and ideological aims. The standard of living of the worker or farmer was linked to economic growth, and the only reason for Flanders' economic backwardness was excessive domination by the French-speaking culture. A cultural programme should be instituted to boost Flanders' development and ensure its recognition. Accordingly, the militant nationalist Flemish focused on culture. Supporting the general battle to introduce Flemish language instruction into secondary schools, technical colleges and universities, the literary reviews

Auguste Levêque: *Edmond Picard*, 1900. Oil on canvas, 111 x 61 cm. Antwerp, Koninklijk Museum voor Schone Kunsten.

RIGHT PAGE: Eugène Laermans: *Evening of the Strike/The Red Flag*, 1893. Oil on canvas, 106 x 115 cm. Brussels, Musées Royaux des Beaux-Arts de Belgique.

played a vital role. In 1892, August Vermeylen, university professor and the brains behind the movement, founded the review *Van Nu en Straks* (*Today and Tomorrow*). Van de Velde's artistic vocation had revealed itself through contact with the Flemish composer Peter Benoit, whom Liszt had called "the Rubens of music". In his *Mémoires*, he emphasised the social and nationalist aims of this venture which came into existence in April 1893.

> Vermeylen made no secret of the fact that he was personally convinced that no truly modern literature could confine itself to the art for art's sake and ignore the awakening of a social conscience and the idea of international solidarity. "For us, young Flemish writers", he commented, "our literature is inextricably linked to the *Vlaamsche Beweging* which is inextricably linked to Flanders' political emancipation and social awakening."[8]

This pro-Flemish cultural agitation, nurtured by social aspirations and a desire for progress that embraced anarchist theories,[9] clashed with a reactionary Catholic system of beliefs, rural and traditionalist in inspiration, which regarded the modern city as corrupting ancestral values. This may well have been the driving force behind the move to return to the countryside that characterised Flemish art from Symbolism to Expressionism. At the turn of the century, George Minne felt the need to leave the poisonous atmosphere of the city. Once settled near Ghent, in the village of Laethem-Saint-Martin, he renewed his contact with rural reality, experiencing once more the satisfaction of manual labour and energetic physical exertion. His sculpture became more powerful: The figures were at home with their bodies, the universe no longer oppressed an anguished humanity with thoughts of an incommensurable destiny. His work became less cerebral, more unified. The 1902 exhibition made this clear. Minne gradually turned his back on Symbolism, investing his humanism with true expressive power; he exerted a profound influence on the Flemish movement that developed in his wake.

At Laethem-Saint-Martin, this return to national roots entailed a rejection of modern civilisation in favour of rediscovered Flemish folk traditions. The village, besieged by artists, became an artistic centre in its own right, independent of the cities of Antwerp,

Ghent, and Brussels. Influenced by Minne and by the allegorical Intimism of Jakob Smits, Karel van de Woestyne, the poet, and his brother Gustave, Albert Servaes, Albijn van den Abeele and Valerius de Saedeleer formed the first Laethem-Saint-Martin school, combining the biblical message with a rural existence on the fringes of modern society. Anachronism was regarded as exotic. In works like *Desk Seated*, painted in 1908, van de Woestyne likened country life to a manifestation of the divine. Timeless nature revealed the presence of God in the smallest details;

painting became a Pantheist celebration and an act of faith.

Under the guise of landscape painting, primitivist feelings also emerged within the symbolist movement. While the Flemish artists were moving towards Expressionism, young Walloon painters were gathering on the perimeters of the industrial area in the Meuse River valley to paint scenes of timeless country life. In the protected area of the Hautes Fagnes, several artists, among them Georges Le Brun, attempted to portray peasant life as lived close to nature in a region where

time had stood still. In Wallonia as in Flanders, the return to the countryside expressed a complete rejection of industrialisation which, in the south of the country, was ravaging the landscape and destroying a time-honoured social equilibrium. Sprawling cities were seen as a human hell for workers doomed to spend their days in exile from the natural world. This "ecological" vision also signalled a revival of mystical Catholicism which, in the early 1910s, affected most of the idealists, including Khnopff, Frédéric, Delville and Montald.

Social commitment

Of all the ideological conflicts that divided the avant-garde during the 1880s, the clash between art for art's sake and art with a social message was probably one of the most bitter. It has been extensively studied and little understood. *La Jeune Belgique* championed the theory of a pure art, exempt from social preoccupations. Its vision of literary activity in Belgium was one in which artists could not be ruled by any extra-artistic constraints. The world of art should, it said, be autonomous and develop its own rules and methods of assessment. By contrast, *L'Art Moderne* championed a point of view more in keeping with the tastes and interests of its editorial board. Eugène Robert, Victor Arnould and Edmond Picard were all lawyers involved in public life and described themselves as aesthetes, not creators. Their political commitment – all three were involved in restructuring the progressive wing of liberalism – prompted them to seek works that satisfied both their requirements as art lovers and their convictions about the inexorable march of social progress. Picard registered the emergence of the "young literary movement" with satisfaction, but opposed the basic premises of its self-obsessed approach to the arts. The social art he advocated had nothing to do with being a party member; its terms were far wider. Lukács himself would not have scorned them:

> The art [of the great artists of the past] was social in
> the sense, and this is the true sense, that they exerted an
> authoritative influence over their period, taking hold of
> the prevailing ideas of their time, plucking them out of the
> air, standing tall in a society that moved restlessly around

Georges Lemmen: design for *L'Art moderne*, Brussels, 1893. Ink, 26.5 x 22.6 cm. Brussels, Musée Communal d'Ixelles.

them, stripping them of all their contingencies, reshaping them, imbuing them with unexpected power and resonance, then throwing them back into that seething, tragic mass, in order to stamp it with new impressions, and, by virtue of a magical amalgam, relaunch it, at a faster pace, into the current of progress and history.[10]

These words seemed too conceptual and too abstract for the young people who were confronting widespread indifference. *La Jeune Belgique*, therefore, continued to be controversial, disrespectful in its polemics.

These differences of opinion were less surprising than their outcome. From 1890 onwards, the champions of art for art's sake were exclusively traditionalists, while the symbolists, who supported a highly sophisticated art, violently rejected the thesis. Indeed, the symbolists joined forces with Picard and the naturalist writers and participated in the activities of the Section d'Art at the Maison du Peuple in Brussels. From 1891 to 1914, the Maison welcomed lecturers who had come to "speak to the people". It also organised concerts and guided tours

Henry van de Velde: cover for Max Elskamp's *Salutations, dont. d'angéliques*, 1893. Brussels, Bibliothèque Royal Albert Ier.

of the leading exhibitions of modern painting – particularly at Les Vingt and La Libre Esthétique. The Section d'Art was initially headed by Lalla Vandervelde, the first wife of the socialist leader, and subsequently by Paul Deutscher. Everything points to the fact that Emile Vandervelde himself was passionately devoted to this cause and kept a watchful eye on its activities. Octave Maus, the secretary of Les Vingt, organised the musical events. Georges Eekhoud was responsible for commissioning texts and illustrations from his colleagues for *L'Annuaire de la Section d'art et d'enseignement* produced by the Maison du Peuple in 1893. In the spirit of its founders, the Section d'Art was not intended to promote art with a social message, but to socialise avant-garde art, which was just then rediscovering the virtues of "simplicity" and "popular appeal":

> To see certain writers, for example Eekhoud, certain
> painters, for example de Groux, certain sculptors, for

example Meunier, moving closer to the people and seeking inspiration there, one wonders whether, just as people need art, the artist needs people. This may be what is required for renewal. When one listens to modern aesthetic quarrels, their sophistic fragmentation, their disputes about whether one should, according to certain rules, cut an apple into four or eight, one realises that it is high time for a return to the source of feeling, to the freshness of sensation and instinct that are found in the people. Apart from soldiers, there are only two sorts of hero nowadays: the poet who dreams and the revolutionary who topples governments. Only two types of people are innocent and pure of heart: the poet and the revolutionary. Only they still feel enthusiasm and the emotions of hate and love, along with anger and childlike goodness.

Having such vast territories of the soul in common, they are bound to like and understand each other eventually. For the artist, it is not a question of a social art, nor of struggling in vain to produce works that might be other than plain and simple.[11]

The aims of this early 'Maison de la Culture' are clearly displayed in its first season's programme. Maurice Kufferath talked about Wagner, Picard about art and the social movement. There was a visit to an exhibition of paintings by Constantin Meunier. Georges Eekhoud, Jules Destrée, Edmond Picard, Emile Vandervelde and Emile Verhaeren described the Belgian literary movement. Two lecturers spoke about the Congo and sparked off a debate about whether Belgian laws should be enforced in Leopold II's private colony. And finally Verhaeren, Picard, Eekhoud and Vandervelde paid tribute to Victor Hugo, and the lecture became an improvised campaign-meeting in favour of universal suffrage!

Alongside leading naturalist figures like Lemonnier, the main exponents of Symbolism took part in the political struggle. Maeterlinck, a member of the Cercle des Etudiants Socialistes – and therefore a *de facto* member of the Belgian Labour Party – financially supported the general strikes of 1902 and 1913; van Lerberghe chaired the committee of Belgian writers in support of Dreyfus; Khnopff lectured to the Section d'Art on English art (1892) or the Flemish Primitives (1893), van de Velde developed his theories about the "renaissance of art through activity, industry and the people" (1894) and spoke on William Morris (1897),

Henry van de Velde: *The Vigil of the Angels*, 1893. Wall hanging.
Zurich, Museum Bellerive.

while Maus talked about Wagner's *Die Meistersinger* (1898) and the decorative arts (1901). Verhaeren, finally, remained the most loyal supporter of the Section d'Art in the literary field. Even Mockel regarded socialism with some degree of sympathy.

In practice, the activity of the Section d'Art was made possible by the extraordinary rapprochement between the Belgian Labour Party, headed at that time by young members of the bourgeoisie with a liberal background, and the key architects of artistic innovation. The positions either occupied in their respective fields facilitated this activity, as did their consciousness of its limits. Well aware of what was at stake in art and politics and active on both fronts, the generation of young bourgeois rebels created an alliance unique in Europe. Its site, Victor Horta's Maison du Peuple, merely symbolises the powerful sway that Art Nouveau exerted over socialist culture in *fin-de-siècle* Belgium.

The social ideal sought its modes of expression not only in the established modernity of the symbolists or the exponents of Art Nouveau, but also in a compassionate social realism that gradually emerged as the sole and dogmatic interpretation of Marxist aesthetics. The appearance, in 1906, of the *Essais socialistes* by Emile Vandervelde, head of the Socialist Party in parliament, marked the first attempt to formulate a cultural strategy for the Labour Party. Stressing the fact that art was a social product, he wished to break with

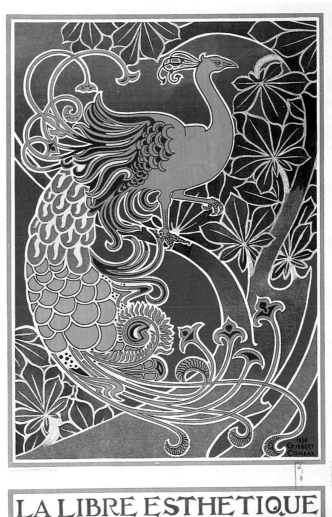

Gisbert Combaz: *La Libre Esthétique. Salon annuel* (Annual exhibition of La Libre Esthétique), 1897. Coloured lithograph, 70 x 47 cm. Antwerp, Museum Vleeshuis.

"the wishy-washy humanitarianism of intellectuals in revolt"[12] and make the artist an instrument for the continued education of the masses.

Although social realism developed into socialist realism, it lost none of its artistic vigour. Meunier emerged as a tutelary figure and Laermans as a visionary painter. Laermans was discovered by the public in the early 1890s when he abandoned the heroic motifs which had, until then, marked his representation of the world of work. Laermans' everyday scenes teemed with allusions to Bruegel. The social tensions of the period were clearly represented. His tragic vision found a powerful mode of expression; the monumentality of his figures and his unreal use of colour constitute a form of expressionism *avant-la-date* which, eschewing the trivial, went straight to the heart of the matter. Laermans'

social realism was laden with a sense of mystery generated by analogies and correspondences. Transcending any suggestion of the political slogan, Laermans' sincerity found expression in monumental and fragmented forms. This lack of realism perhaps indicates a utopian dimension in his work. If so, it would have been perfectly in keeping with his politically-committed idealism.

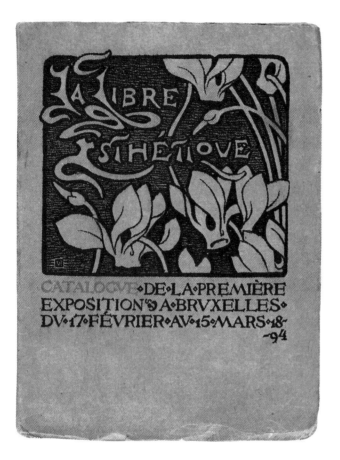

Les Vingt and La Libre Esthétique

The shift in attitudes was profound, and the artistic commitment announced in the first issue of *L'Art moderne* in 1881 now seemed premonitory.[13] Aesthetic exploration was now directed towards the social art that was transforming the very concept of modern art. For Les Vingt, this was both a confirmation and an irrelevance. Since 1890, the group's annual exhibitions had provided a forum for some significant discoveries from abroad, particularly England, and for some of the vingtistes themselves. England's influence, combining Symbolism and Pre-Raphaelitism was decisive. The appearance of Liberty pottery, cretonnes and lacquered furniture in the windows of the Compagnie Japonaise on Rue Royale in Brussels initiated the widespread distribution of English products: Benson ironwork and lamps and wallpaper made by Jeffrey and C° caught the eye of the Brussels avant-garde. English art established itself as a model in Brussels. In the *Annuaire de la Section d'art* (1893), Fernand Khnopff defined the specificity of English art as compared to state-controlled French or Belgian cultural life: "In England, [...] all kinds of works of art have an immediate function. English art is part of everyday English life, and that is its strength."[14]

In his *Mémoires,* Henry van de Velde credited Gustave Serrurier-Bovy with being the first "to recognise the revolutionary importance of the English artists, craftsmen and manufacturers, and the first on the continent to create furniture in line with the new aesthetic".[15]

A moral concept of art developed, which was to arise from the marriage of industry and craftsmanship. By emphasising the importance of beauty in everyday objects, artists would redeem industrial products from the vulgarity of economic pragmatism; at the same time, they would industrialise the craft industry by exploiting technical resources and capitalising on the potential for mass distribution, to the greater benefit of art. Influenced by the socialist utopias of William

ABOVE: Cover of the catalogue for the first exhibition of *La Libre Esthétique*, 1894. Private collection.

OPPOSITE: Henry van de Velde: *Fleurs* wallpaper, n. d. Floral motif produced by the Schulfaud firm, Brussels. Private collection.

Morris, certain vingtistes, like the Pre-Raphaelites, combined their love of nature with an extremely subjective approach; they regarded ornamentation as an abstract vehicle for expression and an aesthetic principle of collective utility. Social life became the forum for continuous efforts in which every object contributed to the spiritual quest for universal progress. The individualism advocated in the past was now refined to allow a commitment to the community. Finch, Lemmen, and van de Velde were the architects of this change, which heralded the appearance of La Libre Esthétique. Full of personal ambitions, aesthetic notions, and often antagonistic political visions, vingtisme now appeared marginal to the principal debate of 1891 and 1893.

In 1891, Les Vingt devoted a great deal of space to the decorative arts. Lemmen, one of the first to take an interest in the applied arts, proposed a Japanese-inspired design verging on abstraction for the cover of the catalogue: a sun rising above stormy seas. The group invited the poster artist, Jules Chéret. Finch exhibited decorative ceramic panels. England was the source of inspiration: Morris, Ruskin, Crane, the Pre-Raphaelites and the Arts and Crafts movement. In *L'Art moderne,* Lemmen devoted two articles to Walter Crane, whom he described as a "true worker of art", a "decorator, an artist concerned exclusively with forms, arabesques, and lines [...] whose expressive power he explores".[16] In these articles, he confirmed that England was "currently the only country where one might find a modern object that bears the stamp of art". Jointly invited by Lemmen and Maus, Crane displayed two watercolours alongside Lemmen's albums. The following year, Les Vingt planned an extended decorative section to accompany the Seurat retrospective. Gallé refused an invitation to exhibit alongside Lautrec, Delaherche, Horne, Selwyn Image, Finch and van de Velde. In 1893, two rooms were earmarked for an increasingly varied range of objects.

In an article devoted to the aesthetics of wallpaper, van de Velde affirmed the need to combine creative output with industrial production, stressing the "uselessness" of easel painting. This thesis became a *leitmotiv* of the twentieth-century constructivist avant-garde. Van de Velde gave up painting after a period of intense soul-searching. The discovery of Van Gogh's work at Les Vingt in 1890 had occasioned a return to

the use of lines "to escape the mechanical technique of the dot".[17] At the time, van de Velde was suffering from severe depression. He studied engraving and Japanese script. He immersed himself in reading: the Bible, Marx, Kropotkin, Nietzsche, and Dostoevsky. In 1892, Finch introduced van de Velde to the philosophy of Morris and Ruskin. Convinced of the artist's social mission, in 1893 he brought out his "Première prédication d'art", stating that "[...] the development of ideas and social conditions is such that paintings and statues alone no longer suffice. The world is governed by the need to earn its daily bread."[18]

Les Vingt's drift towards La Libre Esthétique was reflected in the metamorphoses of *L'Art moderne*. In January 1891, the review appeared with a new Japanese-inspired vignette designed by Lemmen. Two years later, at Les Vingt, Lemmen exhibited a cover design for the review inspired by Japanese stencils, and not unlike the one for *Contes hétéroclites* by Carton de Wiart (1892). The inclusion of letters in the composition and the ornamental style tending towards abstraction influenced van de Velde's first forays into the field of books – the covers for *Dominical* (1892) and *Salutations dont d'angéliques* (1893) by Max Elskamp. Lemmen then transferred his attentions to the applied arts. In this field again, as in the development of a new type of ornament, he preceded van de Velde. Between 1893 and 1894, the two men collaborated on the review *Van Nu en Straks*, for which van de Velde was art editor and designer.[19] Lemmen's works showed the influence of textile designs and English models; his keen interest in Gauguin's wood blocks is clearly shown in his designs for *Le Réveil*.

At the last Les Vingt exhibition, van de Velde exhibited *The Vigil of the Angels*, a wall hanging "as sumptuous and rich as an Oriental rug",[20] in which he faithfully continued to use the complementary colours of his *pointilliste* phase, though now in carefully outlined areas of coloured silk. The decorative style of Maurice Denis' paintings, exhibited at Les Vingt in 1892, was here made to serve utilitarian ends. The need for art to be utilitarian still seemed to extend the range of pictorial art: Tapestry, illustration, and bookbinding maintained a conventional relationship with imagery.[21] Gradually, van de Velde exploited the visual experience he had acquired from his past as a painter to develop a new aesthetic vocabulary. This

LEFT: Henry van de Velde: bookbinding for W. Y. Fletcher's *English Bookbindings in the British Museum*, 1895. Green leather with orange and blue inserts, and gold lines made with bookbinder's punch, 30 x 31 cm. Hamburg, Museum für Kunst und Gewerbe.

RIGHT: Victor Horta: design for a rug for Anna Boch, circa 1897. Watercolour. Private collection.

RIGHT PAGE: Gustave Serrurier-Bovy: rug, circa 1905. Bunched wool, 394 x 300 cm. Private collection.

eventually influenced the way decorative objects, and subsequently architectural space, were regarded, marking a transition from the one-dimensional plane to the three-dimensional nature of everyday life.

Les Vingt disappeared from the scene at a time when the functional objects were beginning to challenge the traditional primacy of painting. Anna Boch and Emile Bernard made folding screens, Albert Besnard designs for stained-glass, Alexandre Charpentier pewter and ceramic ocjects, Henri Cros worked in *pâte de verre*, Finch in enamel and ceramics, Lemmen drew illustrations and Lautrec designed posters.

The influence of the Arts and Crafts movement heralded a new type of artist, described in an article by Picard, entitled 'Art et socialisme' and published in *L'Art moderne* in 1891:

One will see [the artist], as in the past, again involving himself in the details of life, decorating the worker's tools,

the furniture of simple homes, the national costume. Plates, pots, signs, doors, and locks will again become objects worthy of attention in the artist's eyes […].[22]

The emphasis placed on the decorative arts and the scope of the exhibitions mounted under the aegis of Les Vingt had increased the burden of its administration. Change was inevitable; not least because, over the previous ten years, many of the group's initial objectives had been attained. In April 1893, a long article in *L'Art moderne* took stock of Les Vingt's achievements. A new era was about to begin.

Wearied by tensions that were pulling the group apart, Octave Maus devised a more manageable and versatile system. A committee composed of industrialists, collectors, literary figures and critics was to take over responsibility for selection and organisation. La Libre Esthétique was born. It seemed at first merely

an extension of Les Vingt, maintaining its quest for independence and its support for "progressive and evolutionary art" in its various activities. In its issue of 29 October 1893, *L'Art moderne* published the programme of the successor to Les Vingt, which had dissolved in July. Desirous of "giving national and foreign artists who practise [an independent art] the opportunity to exhibit publicly in Belgium in the best conditions",[23] La Libre Esthétique abandoned the adventurous spirit of Les Vingt and became a pluralist initiative. Keen to avoid rivalries and dogmatic cliques, Maus excluded artists from the organisation of the group, preferring a board of patrons drawn from the upper echelons of society, to whom the catalogue of 1896 paid tribute.[24]

In 1894, the first exhibition mounted by La Libre Esthétique comprised some 85 artists and 500 works, and supplanted the Brussels Salon once and for all. Single-handedly run by Maus, its status was fully

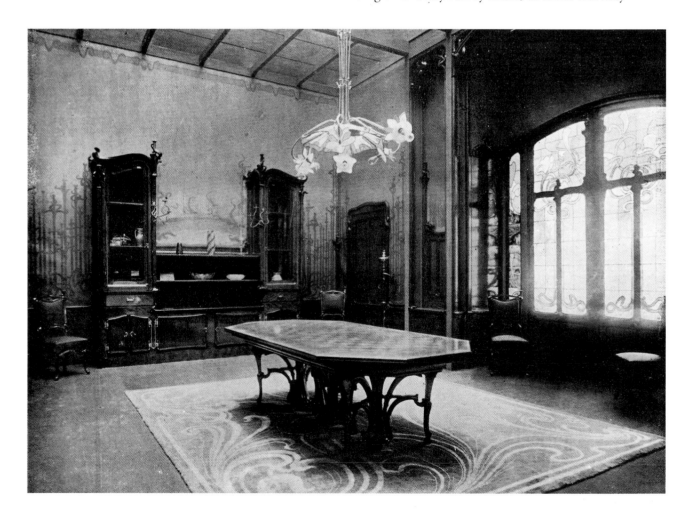

ABOVE: Gustave Serrurier-Bovy: large version of 'Artisan's chair', 1898. Oak. Liège, Musées d'Archéologie et d'Arts Décoratifs.

LEFT PAGE: Victor Horta: dining room shown at La Libre Esthétique exhibition in 1897. The stained-glass windows, the large sideboard, the doors and the wall hangings were designed for the Hôtel van Eetvelde; the dining-room table and chairs were designed for the Hôtel Solvay. Period photograph. Reproduced in *Art et Décoration*, 1897, p. 47. Brussels, Musée Horta.

confirmed by the success of the first exhibition. Attitudes had changed: Startling discoveries were replaced by the need to pay homage to established figures and, for the first time, to look back over the development of modern art.

La Libre Esthétique focused its energies mainly on the promotion of the decorative arts, to such an extent, in fact, that the Parisian press became concerned about the threat of a "Belgian invasion" following hard on the heels of the English invasion. In 1894, under a header designed by Georges Lemmen, the presence of societies and guilds like the Estampe Originale, the Fitzroy Picture Society or Ashbee's Guild and School of Handicraft, confirmed the new tendency. Furniture, tapestries, illustrations, bookbindings, silver and gold work, decorative panels, embroidery, engravings, and wallpaper by Belgian, French and English artists dominated the exhibition where, as Madeleine-Octave Maus recalled, the public "collected curios" and museums, individuals, and companies made extensive purchases.[25] Lemmen exhibited his first rug, *Fishes*, woven by the Manufacture Royale de Bruxelles. Serrurier-Bovy presented a collection of furniture, which he followed, in 1895, with his *Artisan's Room*. The Daum brothers exhibited some fifteen of their finest pieces; Beardsley showed his illustrations for Oscar Wilde's *Salome*. In 1897, Horta exhibited a dining room entirely of his own design made of redwood from the Congo. With the revival of the decorative arts, engraving and bookbinding became a focus of attention. The graphic arts also assumed greater importance, as can be seen in the posters produced for La Libre Esthétique by Lemmen, van Rysselberghe and Gisbert Combaz. The visual innovations of Japonism wore a symbolist air, as fashion required. These new aesthetic concepts became common currency with Art Nouveau, which emerged in the 1890s. They marked a watershed in the changing status of the artist.

The decorative arts and Art Nouveau

A revolutionary architectural style, Art Nouveau also transformed the surroundings of daily life. It reflected changes in the family unit and the new image that an enlightened bourgeoisie wished to project. Capitalising on the widening gap between ornamental convention

ABOVE: Philippe Wolfers: *Orchids*, 1897. Müller stoneware cachepot, enamelled, H: 62 cm. Ghent, Museum voor Sierkunst.

FOLLOWING PAGE, LEFT: Jean Désiré and Eugène Müller: fleur-de-lis vase, circa 1907–1908. Made by Val-Saint-Lambert. Three layer, clear, blown cameo glass, with etched decoration and enamelling, H: 29 cm. Brussels, Galerie l'Ecuyer.

FOLLOWING PAGE, RIGHT: Val-Saint-Lambert lily-of-the-valley vase, n. d. Made of several layers of cameo glass with etched decoration and enamelling, attributed to the Müller brothers, 14 x 7 cm. Charleroi, Musée du Verre.

and structural logic, modern architecture opened up many horizons. New techniques made possible an expressive use of space with lighter structures and improved ventilation, and a new ornamental repertory evolved drawing on Japonism, *Nabisme*, Symbolism and Neo-Impressionism. The concept of the house as a global environment, like Wagner's *Gesamtkunstwerk* (or total work of art), remained a key aspect of Art Nouveau. Its underlying social aims attracted painters who, abanding the 'elitist' art of easel painting, turned to the decorative arts. On the other hand, recent developments in the visual arts had given the architects a formal vocabulary that breathed new life into craft practices. Thus Horta adopted the abstract curve as the basis of his system of ornamentation, both to convey the malleability of metal and to develop the modern forms exhibited at Les Vingt; his use of perspective was inspired by Japonism, in which a feeling of depth was imparted through the play of slender curved lines.

The development of architecture now mirrored that of the decorative arts. It was their endpoint, and situated earlier pictorial revolutions in a wider perspective: the organisation of life and the city. A new attitude emerged in the wake of social art, resulting in a synthesis of styles that La Libre Esthétique both promoted and documented. Around 1895, Lemmen, now a painter and interior decorator, founded his own company, Arts d' Industrie et d' Ornementation. He designed a wide range of products: book plates, vignettes, letter-headings, lock designs, and alphabets. His supple, flowery style of ornament, with its attractive brush-drawn curves, formed a marked contrast with the dramatic tension that van de Velde's lines imparted to forms and materials. In Gustave Kahn's poetry volume *Les Limbes de lumière*, published by Deman in 1897, animal and plant forms, stylised to the point of comedy, appeared side by side with strictly abstract motifs.

Despite the support of Meier-Graefe and the laudatory articles published in *Dekorative Kunst* (1897) and *L'Art décoratif* (1898), Lemmen failed to make a career for himself in the decorative arts. The fabric designs he offered Deneken in 1898 for the Krefeld factory were rejected. Lemmen seemed unable to realise his new ideas in three dimensions. His most important work consisted in his treatment of flat surfaces, stylised forms and areas of plain colour. By contrast, van de Velde's ideas culminated in the vision of architecture as environment.

The artistic vitality of Liège was confirmed by the work of Gustave Serrurier-Bovy, praised by Khnopff in *The Studio* for his "true and original conception of decorative art".[26] His sphere of influence extended well beyond Liège, dazzling first Brussels then Europe at large.

In 1894, Serrurier-Bovy showed a *Study* at La Libre Esthétique, followed the next year by an *Artisan's*

Room. The study was obviously "inspired by English interiors, without being a slavish copy of them".[27] The unpainted wood, simplicity of execution, rustic air, and attractive wide frieze of poppies were reminiscent of English furniture in the Neo-Gothic tradition. Serrurier made this a selling-point in the brochure for the first catalogue of his decoration firm, which he founded in 1884; he offered interiors "in English and American styles". Serrurier-Bovy's promotion of English art proved decisive. The Salon de l'Oeuvre Artistique exhibited a collection of works from the Glasgow School of Art, marking a first for the continent. But the English influence had already begun to weaken; the Belgian movement was moving ahead under its own steam.

In view of his success, Serrurier soon decided to offer his customers a range of furniture of his own design. His reputation earned him a commission to decorate the Hôtel Chatham in Paris.[28] The severity of the padauk-wood furniture was mitigated by the wealth of ornamental motifs: The chairs did not have straw bottoms but were covered in a fabric decorated with sinuous scrolls, which also appeared on the fabric of the armchairs, benches and wall hangings. This fluidity of line was reminiscent of the work of Horta, who was not discovered as a decorator until the La Libre Esthétique exhibition in 1897. In the drawing room of the Hôtel Chatham, a wide frieze ran around the upper part of the walls; motifs of different types of orchids decorated the painted ceiling, the tiles on the mantelpiece, and an intersecting pattern on the stained-glass windows. Part of the drawing room was divided off by an enormous glass screen decorated with slender trees, whose falling leaves seemed to lie strewn over the woollen carpet.

In 1899, Gustave Serrurier-Bovy joined forces with the French architect, René Dulong, to open a shop in Paris called L'Art dans l'habitation. The formal influence of English furniture began to disappear. While still continuing to produce simple, sturdy furniture, Serrurier experimented further with frames, which became a sophisticated interplay of arcs, sometimes

Val-Saint-Lambert Jonghen vase with iris motif, 1902. Clear blown crystal with carved floral decoration, H: 30 cm. Liège, Musées d'Archéologie et d'Arts Décoratifs.

Val-Saint-Lambert glasses engraved with a pantograph, n. d. Crystal. Liège, Musées d'Archéologie et d'Arts Décoratifs.

curving away from solid panels, sometimes inscribing a shape within a void. Solidity and space are sharply contrasted in these pieces, while the textures and colours of wood harmonise.

Serrurier's studios on Rue Hemricourt, Liège, expanded and, between 1899 and 1907, supplied various branches in Brussels, Paris and Nice. The Pavillon Bleu, built in collaboration with Dulong, was a rare example of Art Nouveau architecture at the World Exhibition held in Paris in 1900: Serrurier adopted serpentine lines for the interior decoration, perhaps under the influence of his partner. Commissions from the wealthy followed. Serrurier also offered his customers less expensive products: plain wallpapers with hand-stencilled decorations.

Although aware of the new forms appearing at La Libre Esthétique or coming onto the market as imports, industries such as the Val-Saint-Lambert crystal factories or the Boch Frères ceramics firm failed to adopt any effective policy for distributing these aesthetic innovations. Only a handful of artists, backed by top-quality craftsmen, took their artistic experiments into the factories. Most industries remained attached to the forms and motifs of the past.

In the field of pottery, Finch, having abandoned painting for the applied arts, exploited his contacts with the Boch family and worked for the Boch Frères ceramics firm in La Louvière. There he came up against the customs and traditions of the craftsmen in situ. Having failed to win support for his theories about colour and form, which derived from his experience as a neo-impressionist painter, he turned to the studios of Forges-les-Chimay and Virginal in Brabant to produce simple pieces of pottery whose only ornamentation was a flambé glaze. The sinuous lines are reminiscent of Art Nouveau, but do not attempt to fill every inch of space. Finch's rigorous austerity is more akin to Art Deco.

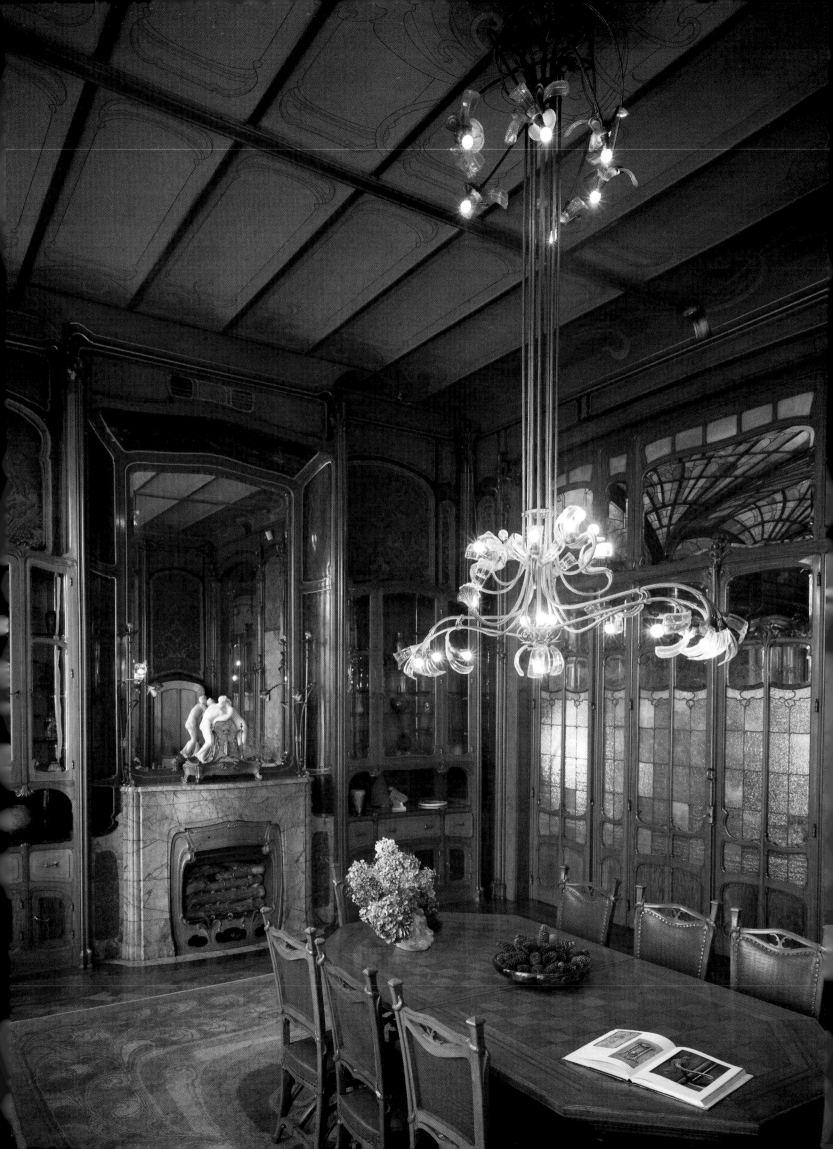

Besides Finch's idiosyncratic foray into ceramics, the main investigation into this field was carried out by sculptors. Isidore de Rudder worked temporarily for the Brussels firm Vermeiren-Coche, designing decorative ceramic panels for their shop, and Wolfers collaborated on several pieces with the Müller ceramics firm.

The Val-Saint-Lambert crystal factory in Seraing, near Liège, dominated glass production in Belgium. It was the only company to incorporate the new forms into its traditional practices while also exploring new technical developments, such as blue glass decorated with gilt bronze applied by an electroplating process. With regard to form, glassware perpetuated the mannerist tendencies of a Neo-Rococo style that exploited the sensuality of materials and the play of light. At 'le Val', the adaption of Art Nouveau forms was instigated by Français Léon Ledru, head of the design department. His activity, supported by the outstanding technical abilities of the craftsmen at Val-Saint-Lambert, gave artists like Horta, van de Velde, Wolfers and Serrurier-Bovy the means to produce original designs. In 1905, Ledru employed the Müller brothers, Desiré and Eugène, former collaborators of Gallé. They worked at Le Val until 1909, exploring a stylistic vein similar to the 'Ecole de Nancy'.

From a technical point of view, Le Val had, till 1900, been noted for its unusually large, geometrically-shaped pieces made of transparent or cameo glass. In the 1900s, distinctive colours came into use: The artists strove to create striking contrasts, combining grey, orange, pistachio green, plum, and straw yellow.

Art and design at Val-Saint-Lambert were not confined to the creation of prototypes for mass production. The factory also collaborated closely with Horta, on crystal for the Hôtel Solvay in 1894, and on designs for dinner services and sets of glasses. In 1897, Horta

LEFT PAGE: Val-Saint-Lambert at the Hôtel Solvay: chandelier in the dining room, after a design by Victor Horta, 1897–1900. Bronze and crystal. Hôtel Solvay, 1894–1898, 224, Av. Louise.

TOP: Philippe Wolfers: *Dusk* vase, 1901. Multi-layered cameo glass from Val-Saint-Lambert, H: 30.5 cm. Liège, Musées d'Archéologie et d'Arts Décoratifs.

OPPOSITE: Philippe Wolfers: *Combattants* vase, 1899. Produced by Val-Saint-Lambert. Made of multi-layered crystal with wheel-cut decoration in relief, H: 25 cm, ø 12 cm. Brussels, Argus collection.

designed Val-Saint-Lambert's World Exhibition pavilion. Van de Velde saluted Le Val's invention of a revolutionary technique, three-layer etched glass, which provided exciting new aesthetic possibilities. The Brussels artist, Philippe Wolfers, collaborated even more extensively with Val-Saint-Lambert. He achieved his first success at the World Exhibition of Brussels and their partnership was to last until 1903, spanning some twenty projects.

Wolfers emerged as one of the outstanding figures in the field of the decorative arts. An inveterate traveller, in 1883 he had seen the 3,000 or more pieces of Japanese art exhibited by Louis Gonse at the Galerie Petit in Paris. A year later, he designed his Japanese-inspired Bamboos coffee set. Wolfers' most important work is in the 'Louis XV Wolfers style', which made the firm's reputation. At the Antwerp exhibition of 1894, he exhibited his own designs for the first time: vases, and a box carved from ivory given to him by Leopold II in order to promote his Congolese holdings. Throughout his career, Wolfers drew hundreds of documentary plates. He had a marked predilection for orchids and other motifs rarely used in decoration – irises and lizards. He combined natural forms with precious materials to transform rare objects into symbolic expressions of the spiritual. The use of exotic materials, prompted by a mannerist approach typical of Neo-Rococo, led him to take a keen interest in glass.

In 1896, he began a profitable collaboration with the Val-Saint-Lambert crystal factories. His plaster (later bronze) models were sent to Liège, where several copies were produced under Ledru's supervision. The 'sketches', made of various superimposed layers of different-coloured crystal, then returned to Wolfers' studios to be carved into cameos using a dentist's drill. The metal mounts were delicately chased and echoed the decorative theme of the vase, as in *Fire* and *Dusk*. In these works, Wolfers exploited a strictly ornamental repertory of plant-like motifs. In 1898–1899, he turned to animal motifs interpreted in symbolic terms. In 1897, he was also employed by the French ceramics firm, Müller: He produced a number of cachepots and vases with orchid motifs. In 1903, after presenting his pieces at St Petersburg (1899), Brussels (1900) and in Turin (1902), Wolfers stopped working with glass.

In 1897, he exhibited at the Congo Free State exhibition. This was part of the colonial exhibition organised at Tervuren for the Brussels World Exhibition; the family business had a stand there. The French designer René Lalique sent a collection of pieces that won him a Grand Prix. From this time onwards, Wolfers' career changed course. He was fascinated by Lalique's symbolic jewellery, by the unconventional combinations of materials – horn, enamel and glass used in conjunction with diamond or sapphire – and by the use of baroque pearls or stones like opal, tourmaline, and moonstone. The Belgian jeweller went on to design belt buckles, fasteners, and pendants, enabling him to give free rein to his talent as a sculptor and his taste for the bizarre. The *Flirt* belt buckle, for example, illustrates the love affair between a prawn and a crab with ruby eyes, whose shell is inlaid with a baroque pearl. In 1898, Wolfers created a series of large combs; combs had come back into fashion because artists were fascinated with the hairstyles worn by courtesans in Japanese prints. The terrifying *Méduse* pendant, an ivory mask of a woman with opal eyes and a crown of serpents, dates from the same year. Snakes appeared frequently in Wolfers' work (*Two Serpents*, *Nenuphar and serpent* and *Swan and Two Serpents*), as they do in that of Léopold van Strydonck. Their sinuous lines reflect the Art Nouveau aesthetic and an unspoken fascination with dark forces: symbolic poppies, owls and bats belonged, with the woman/vampire, in the artistic imagination of the time. The critics compared the delicate opulence of Wolfers' jewellery with the highly-wrought paintings of Gustave Moreau.

Abandoning these miniatures, Wolfers then turned to sculpting ivory; his buxom *Juno* is accompanied by a peacock and holds a bronze bell made up of peacock feathers with enamel ocelli that glowed, illuminated from within by an electric light bulb. This subject, treated with Byzantine lavishness, tended to excess, and Wolfers *Fairy with Peacock* did nothing to correct the tendency. Peacocks and peacock feathers had appeared in many guises since 1898, but Wolfers was

Philippe Wolfers: *Medusa* pendant, 1898. Carved ivory mask with opal eyes and chased gold snakes. Side casing of the mask: clear enamel shaded off over chased gold, pear-shaped opal drop, 10 x 5.2 cm. Private collection.

LEFT PAGE

TOP, LEFT: Philippe Wolfers: *Winged Orchid* brooch-pendant, 1901–1902. Gold, enamel, diamond, ruby, cornelian, pearl, 6.7 x 5.7 cm. Brussels, Centre Public d'Aide Sociale.

TOP, RIGHT: Philippe Wolfers: *Large Dragonfly*, 1903–1904, Gold, opal, enamel, ruby, brilliant, 11.5 x 13 cm. One-off design no. 146. Private collection.

BOTTOM, LEFT: Philippe Wolfers: *Nike* brooch-pendant, 1902. Chased gold, partly enamelled, *plique-à-jour*, ruby, emeralds, brilliants, mask made of tourmaline and baroque pearl, 5 x 7 cm. Private collection.

BOTTOM, RIGHT: Philippe Wolfers: *Swan and Two Serpents* pendant, n. d. Gold, enamel, opal, brilliant, rubies and pearls, 5 x 5 cm, chain: 40 cm. Private collection.

ABOVE: Léopold van Strydonck: *The Struggle of Good and Evil*, 1897. Ivory and bronze, 76 x 70 x 35 cm. Paris, Musée d'Orsay.

OPPOSITE: Philippe Wolfers: *Fairy with Peacock*, 1904. White marble, bronze, *pâte de verre*, 170 x 110 x 101 cm. Green marble plinth, 101 x 45 x 45 cm. Private collection.

Philippe Wolfers: *Maléficia*, 1905. Red porphyry, ivory and amethyst,
H: 61.5 cm. Plinth: red marble, 122 x 40 x 36 cm. "Philippe et Marcel
Wolfers" Association Collection.

visibly attempting to add a new dimension to his art.
In 1903, a year after his successful retrospective in Turin,
he created his first sculpture, *Open Flower*. Shortly
after this, he designed his last pieces of jewellery, tak-
ing large insects as his theme: *Stag Beetle* and *Scarab*.
Thereafter, he devoted himself to sculpture and to the
management of the family business. In 1909, Horta
constructed new shops on Rue d'Arenberg in Brussels
for Wolfers' company. It thrived: Silver, jewellery and
gold were much prized by fashionable Brussels society.
Two important later works still show the influence of
Art Nouveau: the monumental mantelpiece *The Dance
of the Hours*, exhibited in Liège in 1905, and *Maléficia*,
an enigmatic woman's torso made of porphyry, her
head crowned with ivory serpents twisting around the
mask of an amethyst fury. Wolfers now abandoned the
principle of mannerist stylisation that had dominated
his works. Feeling the need for more concentrated
forms, he adapted a more geometrical style. In 1915,
his designs formed the subject of a publication whose
title *New Method of Ornamental Composition. Applying
Abstract Geometrical Elements to Flat Decoration* bore
witness to an internal reform of Art Nouveau. Like
Lalique, Wolfer's company enjoyed a revival of interest
in the wake of Art Deco which, in the 1920s, returned
to the *fin-de-siècle* ideal[29].

Whether glass or ceramics, the collaboration
between the art world and industry was handicapped
by mutual misunderstandings, and was not ultimately
a fruitful one. The industrialists took no part in the
furtherance of social art, and the work of the artists
was confined to the art end of the craft markets,
impervious to the requirements of mass production.
Unable to find support for this type of collaboration,
which first established itself twenty years later in re-
volutionary Russia and subsequently at the Dessau
Bauhaus, artists found in the decorative arts a new
mode of expression, which satisfied the requirements
of an enlightened bourgeoisie that appreciated beauti-
ful objects. However, it should be emphasised that
some of the ideas that constituted the driving force
behind the avant-garde movements of the twentieth
century originated in Belgium in the writings of van
de Velde; he took the theories of the Arts and Crafts
movement and shaped them into a coherent aesthetic
programme.

The invention of Art Nouveau

The growth of the decorative arts was the product of political considerations combining with a modern aestetic. It reached its pinnacle in architecture. A new perspective on space was emerging, and alongside it, a new approach to decoration. This was the birth of Art Nouveau. It found its first key exponents in Horta, Hankar and van de Velde, who also laid its theoretical foundations.

After a stay in Paris, Victor Horta settled in Brussels in 1880, and entered the Academie des Beaux-Arts the following year. There he made friends with Paul Hankar and various sculptors. From sculpture, he acquired a feeling for sculptural volume and an awareness of space that influenced his architecture; he continued to design plinths for statues throughout his life. Balat had instilled in him a feel for classicism, which he resisted, although not without assimilating its basic principles. Horta did not obtain a decisive commission until 1889,[30] when the State commissioned him to build a pavilion to house Jef Lambeaux's *Human Passions*, which created a scandal at the World Exhibition in 1897. The 'temple' was not completed until 1906, after many changes. Looking back on this building, Horta perceived in it the seeds of his future development: the desire to replace the straight line with the curve, and the exploration of outlines not derived from the past but invented by the artist, in this case his capitals and pediments.

The year 1893 marked a watershed. Horta received commissions from two men whom he had met at Masonic gatherings and who were willing to give him a free rein: Emile Tassel, professor of geometry at the University of Brussels, and Eugène Autrique, a renowned lawyer. The year before, these two friends had invited him to apply for the post of lecturer at the Ecole Polytechnique of Brussels University. There, Horta expounded the teachings of Viollet-le-Duc, who believed that architecture should be "true to function, and true to the construction method".[31] The two patrons were members of Brussels' cultivated bourgeoisie, which soon came to regard Horta as its 'own' architect.

In the Maison Autrique, Horta felt he had produced an "honest work, not having borrowed anything from anyone". The building showed his distinctive tal-

Victor Horta, circa 1905, in his office on the first floor of the studio on Rue Américaine. Behind the architect hangs a large photo of the Hôtel Max Hallet. Period photograph. Brussels, Archives du Musée Horta.

ent for adaptation; he was able to gain an extra floor on the traditional plan by converting the skylight into a window.[32] A spirit of innovation was in the air. It materialised the same year with the Hôtel Tassel, at 6, Rue Paul-Emile Janson, which marked the true birth of Art Nouveau in architecture.

The façade displays an idiosyncratic version of the bow-window: Rounded, it swells organically from the façade thanks to the use of curved stones. The metal structure was clearly visible. The size of the windows matches the dimensions of the rooms they illuminate. The overall lack of symmetry does not detract from the balance of the façade. The largest window in the middle illuminated Emile Tassel's first-floor office; directly above it, on the second floor, was a study. On the mezzanine level, stained-glass windows created a cosy atmosphere for the smoking room. The windows of the basement-kitchen make no appearance in the façade; they open onto the back,

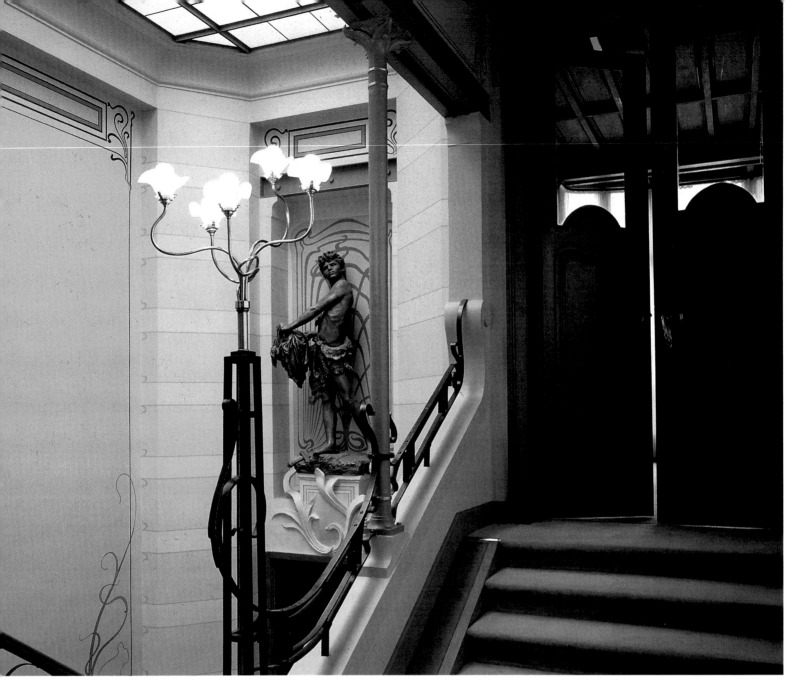

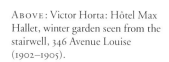

freeing space on the same level for reception facilities – a cloakroom with toilets and a parlour. This means that the dining room overlooking the garden is raised. Inside, the privacy of the owners is guaranteed by a small central hall closed by a double door decorated with stained glass, which opens onto a second, octagonal hall. A few white marble steps lead the visitor to the main landing, on a level with the drawing and dining rooms. There are no partitions between the landing and the drawing room; completely glazed doors allowed natural light to flood in from the windows and the glass roofs crowning the winter garden and the stairwell, whose mural paintings and ornamental corner irons are reflected in the large mirror in the winter garden. Because there are no partition walls, light and air circulate freely throughout this storey. The smoking room opens over the main landing like a theatre box. Horta broke decisively with the traditional *piano nobile* of the bourgeois house, in which the ground floor is raised to accommodate the basement kitchen, and comprises a suite of three rooms in a row with a corridor running alongside. The main

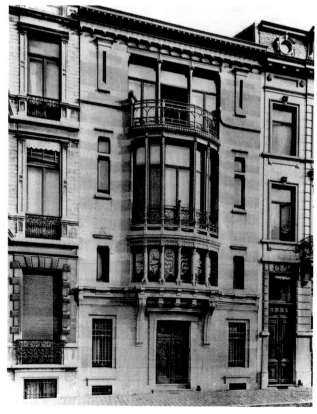

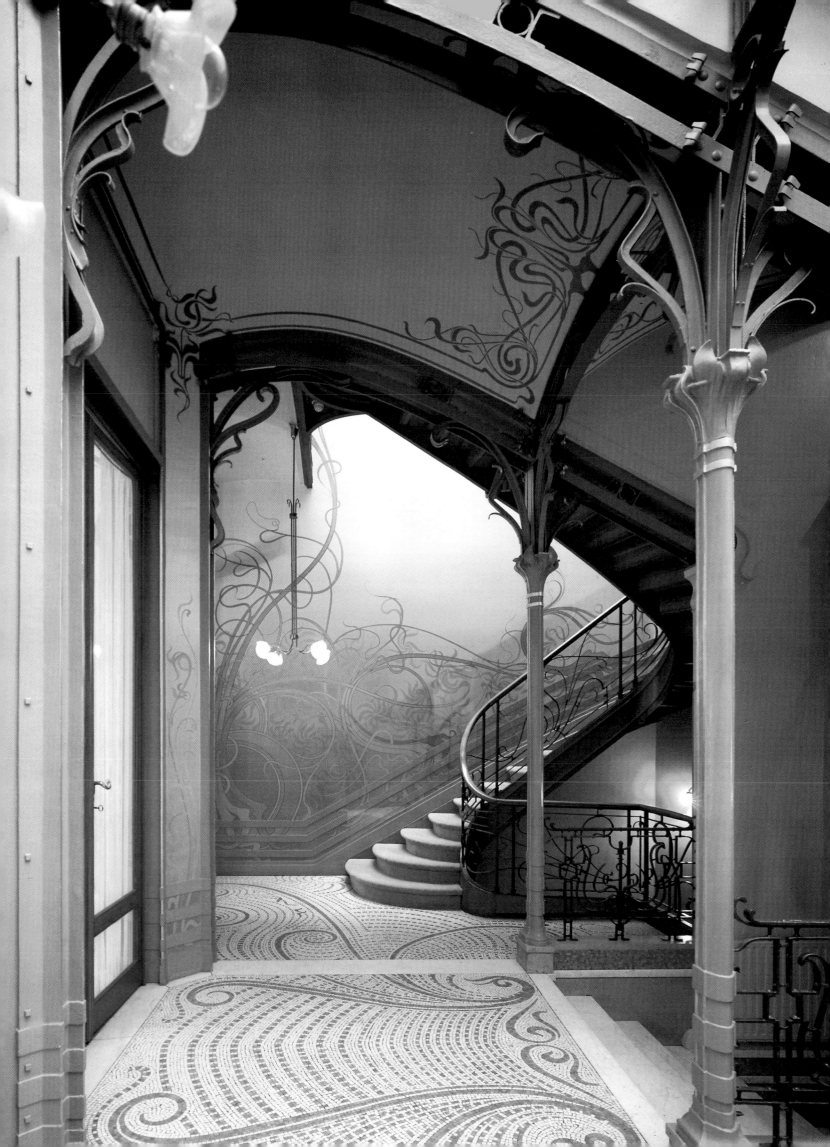

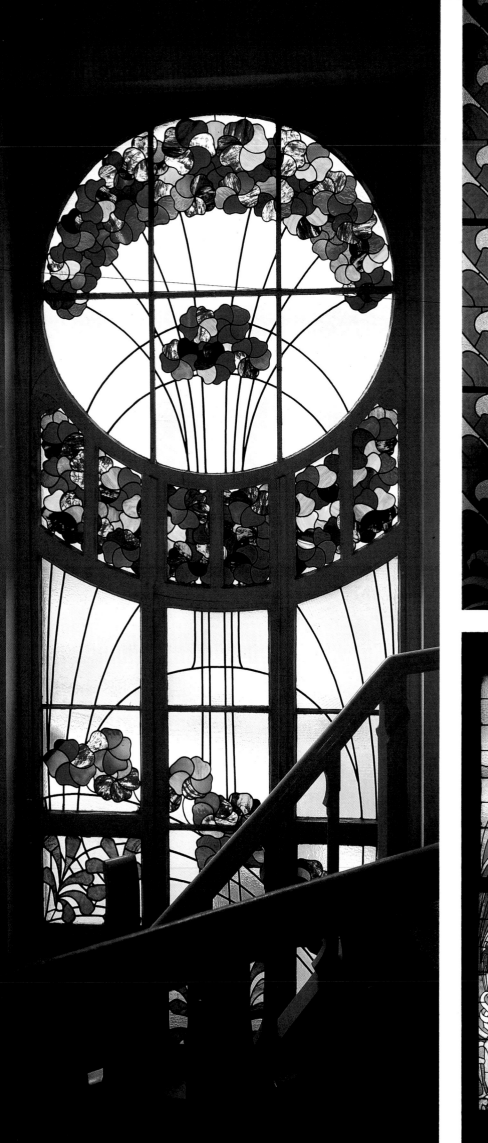
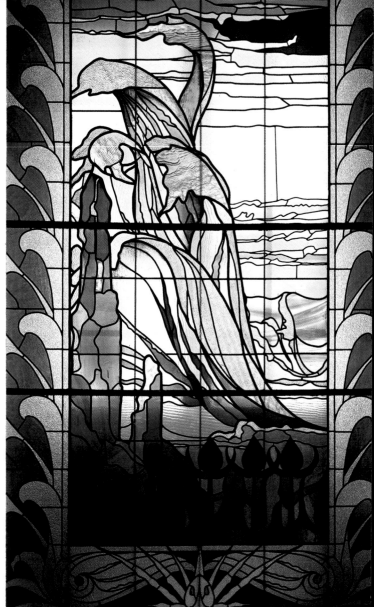
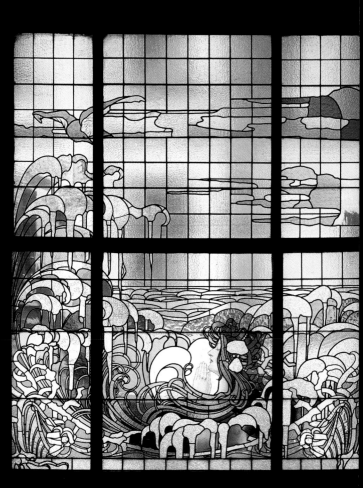

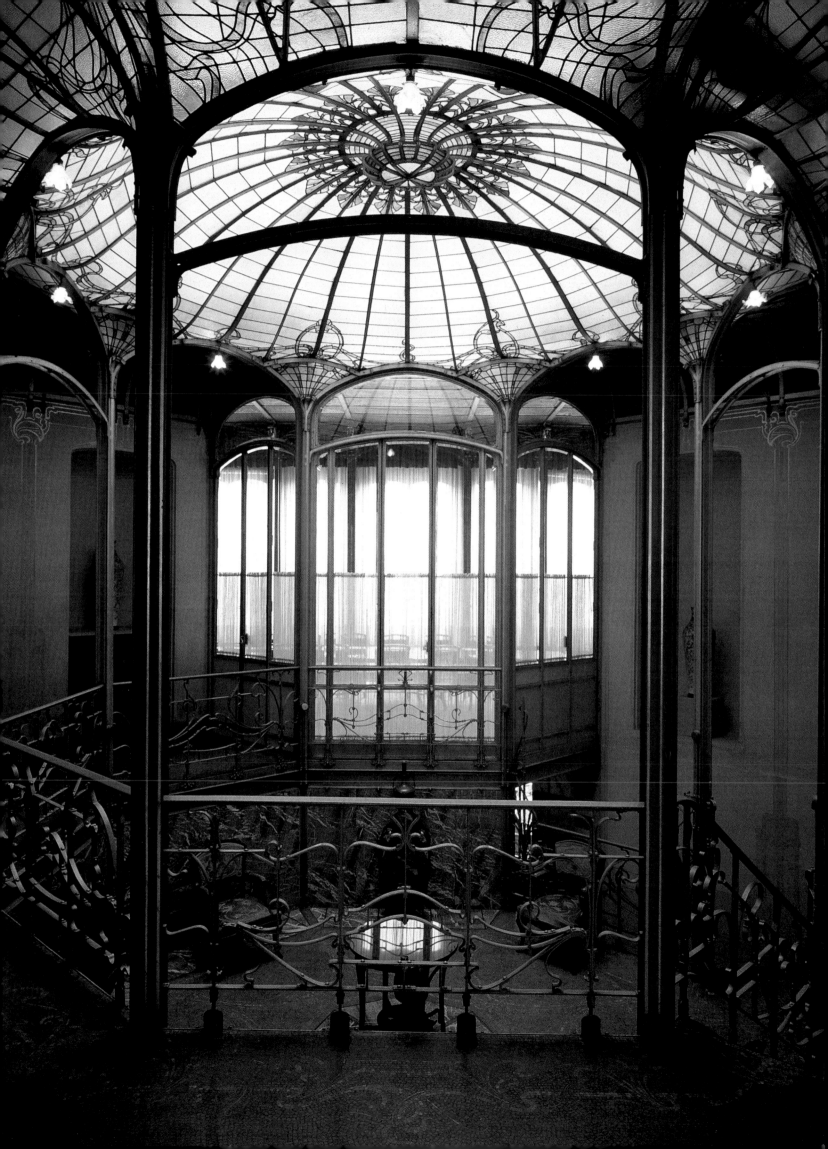

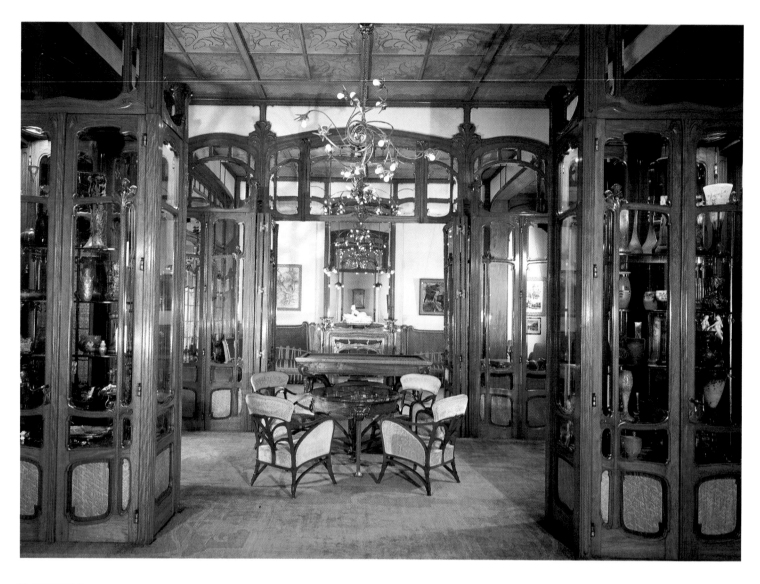

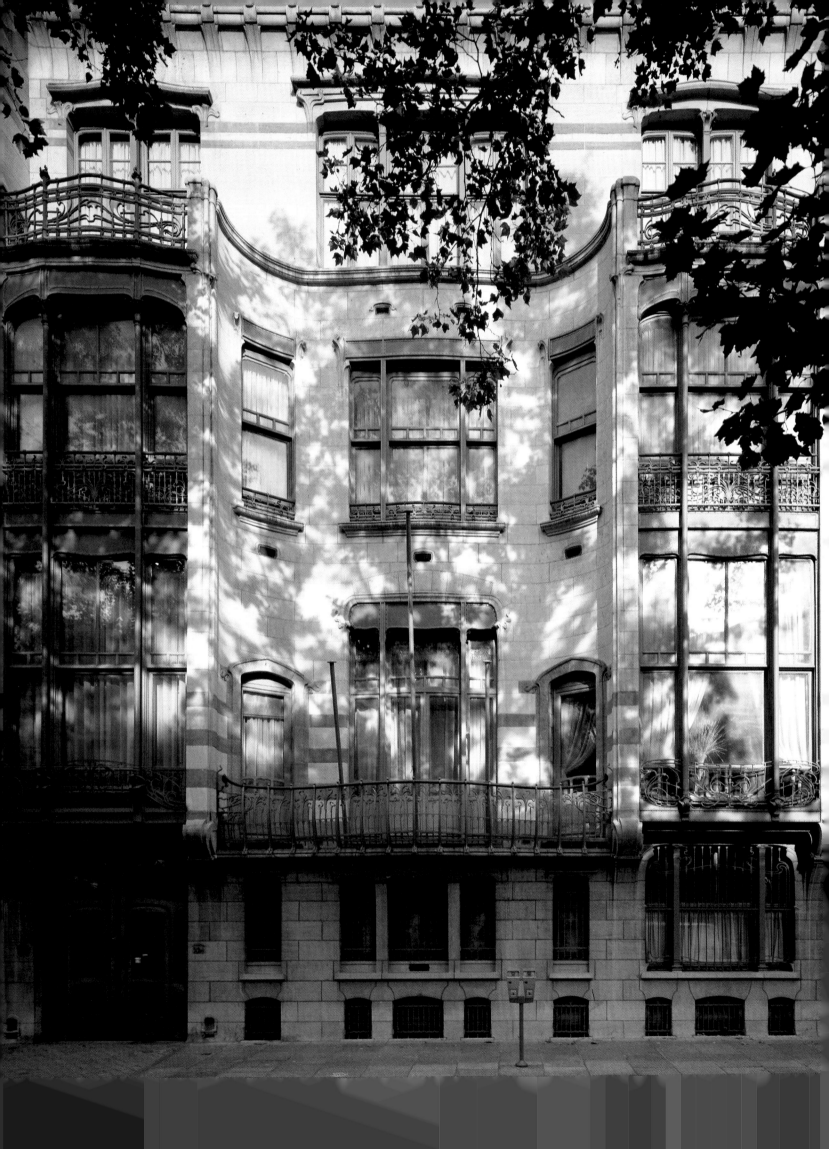

PREVIOUS PAGES

LEFT, TOP: Victor Horta: Hôtel Solvay, 224 Avenue Louise, suite of drawing rooms (1894–1898).

BOTTOM: Victor Horta: Hôtel Solvay, details of the façade (1894–1898).

RIGHT: Victor Horta: Hôtel Solvay, façade (1894–1898).

OPPOSITE: Victor Horta: Hôtel Solvay, billiard cue holder (1896–1900). Wood, 182 x 66 x 62 cm. Behind, an armchair whose motifs were also designed by Horta.

RIGHT PAGE: Victor Horta: Hôtel Solvay, winter garden on the second floor (1894–1898).

BELOW: Victor Horta: Hôtel Solvay, first floor landing with view of *Reading in the Garden* (oil on canvas, 1902) by Théo van Rysselberghe.

disadvantage of this plan is, obviously, the lack of light in the central room.

The decoration is completely coherent and inspired by nature. The relation of humanity to plant-life is given expression by Horta's sinuous line; it unfurls with a power, a "will" that has been compared to the logic of evolutionary law. In adopting the abstract curve as a leitmotiv, Horta echoed the contemporary explorations of painters like Toorop or Lemmen, who had abandoned the direct representation of reality for a lyrical evocation of it, using a stylised repertory that avoided any precise or rational organisation of space. This theatrical desire to awaken successive emotions in the spectator made architecture itself into a kind of spectacle. The building was no longer merely a receptacle, it became a setting: the stage of a social drama in which the role played by the scenery was as important as that of the actors. The Hôtels Frison and Winssinger of 1894 show Horta's awakaning interest in the internal structuring of the spaces that he built. Horta was aware of the social purpose of architecture and of its role as a vector of progress. Influenced by his reading of Viollet-le-Duc, he advocated a global approach to the design of furniture and architecture. This gave rise to new industrial practices: In his studio, teams of

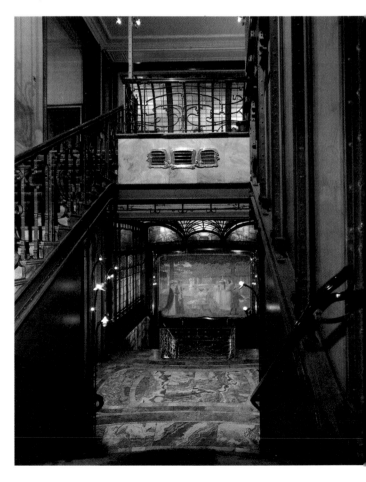

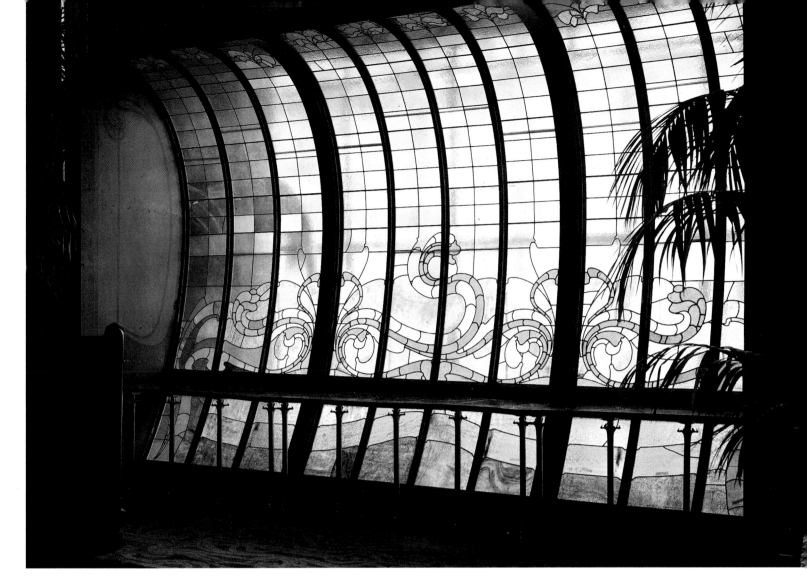

sculptors produced plaster models of his designs. Three years later, at La Libre Esthétique, Horta exhibited a brilliant example of his expertise: a dining room completely designed and made by himself. He lavished attention on every component of the residence; the smallest elements were carefully integrated with the whole. The metalwork echoes the forms used in the decorative woodwork or wrought-ironwork like musical leitmotivs. The fabrics on the walls structure the space, with a lighter shade for each new storey. The different species of wood used in the panelling and the various types of illumination create an infinite interplay of light and colour. The wrought-ironwork components are designed to fit easily together. The whole house is designed to ensure a constant supply of fresh air and the heating system was devised for maximum fuel-efficiency. Horta took an interest in all aspects of the house. His talent for invention was aided by craftsmen whose consummate technical skills made it possible to achieve architectural breakthroughs and formal innovations. Thus the stained-glass windows capitalise on the technical innovations of Louis Confort Tiffany. Horta used "American" glass, a cast coloured glass whose marbled and opalescent texture excluded painted decoration and whose hues varied

depending on the intensity of the light and its source. Altered by the play of light, this stained glass with its wavy lines of colour also boasted excellent reflective qualities. Horta exploited this in his glass roofs and internal partitions. This technique required the services of specialist studios who cut the glass and created the designs using lead tracery. By emphasising the line, this technique also favoured a Japanese-style interpretation of the art of stained glass: The lead took on a calligraphic function that continued the movement of the aerial line, reinforcing its curvilinear effect in the image and disrupting the classical legibility of space with expanses of shimmering colour.

Raphaël Evaldre was to be the principal exponent of this art. Collaborating with Horta on the Hôtel Tassel, he enabled the latter to abandon the traditional practice of using glass with painted decoration in favour of the American glass produced in Brussels by Overlopp & Cie, taken over by Evaldre in 1895. Evaldre was highly successful. While working regularly with Horta, he collaborated with Hankar, Saintenoy, Delune and Brunfaut, and still found time to complete projects of his own. Like many master glass-makers, Evaldre transferred the designs realised by painters or illustrators to stained glass. In the Hôtel

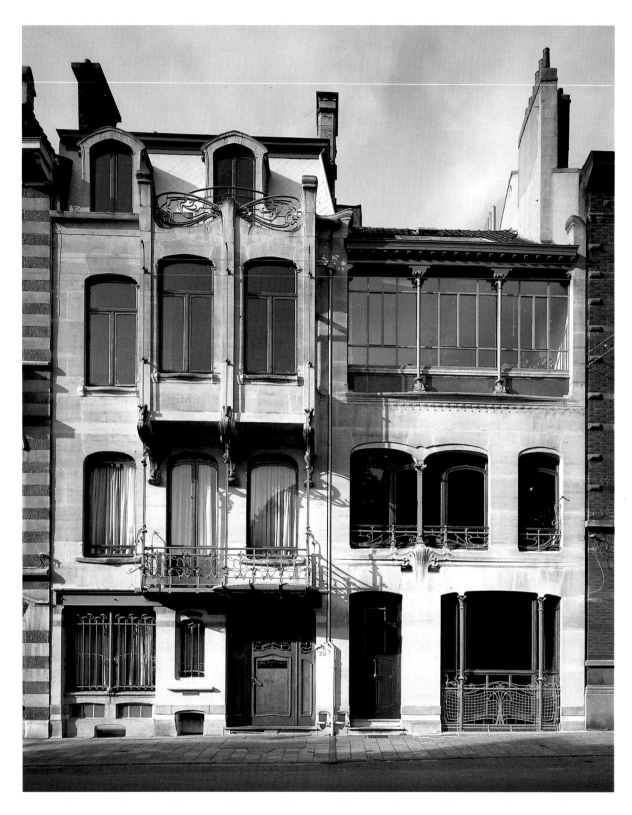

ABOVE: Victor Horta: façade of house and studio, 23–25 Rue Américaine (1898–1901). Now the Musée Horta.

RIGHT: Victor Horta: house and studios, dining room (1898–1901).

van Eetvelde, the stained-glass motifs chosen by Horta echoed the curves of the colonnettes. His interior decoration emphasised and extended the structure of the building by extending the sinuous line through a variety of different levels, its curve energising the space before ending in a graceful whiplash. The role of stained glass became decisive; it metamorphosed and idealised natural light. Casting a coloured radi-

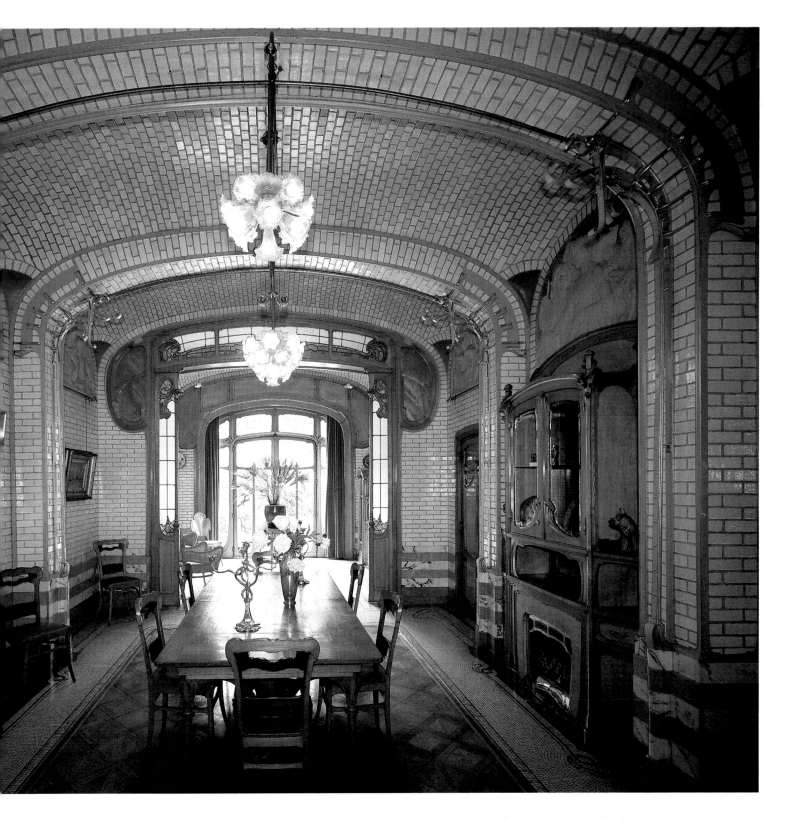

ance, the glass enhanced the harmonious effect to which all the various components aspired: It suffused the light with a spiritual quality and imparted an atmosphere of serenity.

Horta's collaboration with specialist craftsmen contributed to the spectacular virtuosity of his houses. His reputation grew and prestigious commissions flooded in. The Hôtel van Eetvelde on Avenue Palmerston was begun in the same year (1895) as the Hôtel Solvay on the stately Avenue Louise.

Tassel's confidence in Horta prompted Armand Solvay, an industrialist at the head of a chemicals empire, to commission Horta to build a huge house. Its façade, some fifteen metres long, boasts a serene majesty that gives no hint of the dazzling virtuosity of the internal decoration, which is still virtually intact.

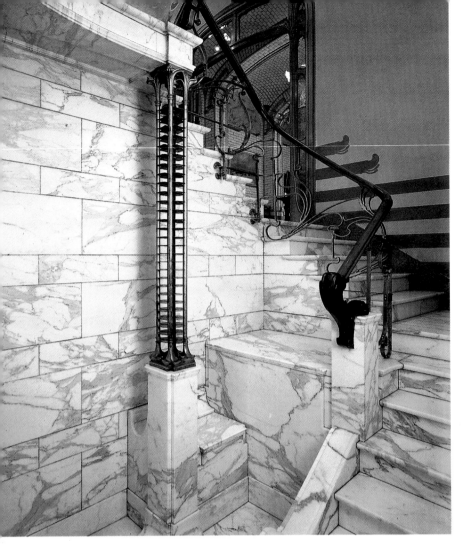

A suite of rooms, including a music room and a billiards room, runs the entire length of the first floor, overlooking the street. The curvaceous wooden partition screen can be admired from the balcony on the façade. The dining room, service stairs and pantry are on the garden side. The main staircase divides into two at the main landing, leading on either side to other living rooms and a dining room. Here too, the partitions can be folded so that all the rooms open onto each other. Leaning on the handrails of the staircase as if on those of a balcony, guests can admire *Reading in the Garden*, a neo-impressionist composition by Théo van Rysselberghe painted in 1902 and situated under the double fan-shaped glass roof. The unity of the Hôtel Solvay, with its warm colours in perfect harmony with the mural decorations, marble work and panelling, is in marked contrast to the "jumbled collection of curios"[33] held in affection by Horta's contemporaries. A desire for complete harmony emerged: The artist organized all the component parts with a view to creating a unity of light, form and colour that cemented the tectonic stability of the whole. The eye runs around the curved walls, becomes absorbed in the undulating light fittings, and revels in the way the graphic decoration of the ceiling is again picked out in the floor. Light plays a vital role in this sense of movement; it colours space and enhances the chromatic harmonies, becoming gradually clearer with each successive floor. The attention lavished on aesthetic details extended to functional requirements, the ventilation system constantly renews the air in the building, while the bathroom radiator also serves to warm the towels. The dramatic visual impact of the architecture was matched by modern standards of comfort.

For Edmond van Eetvelde, General Administrator of Foreign Affairs for the Congo Free State, who became Congolese Secretary of State in 1891, Horta built a mansion which is a masterpiece of simplicity

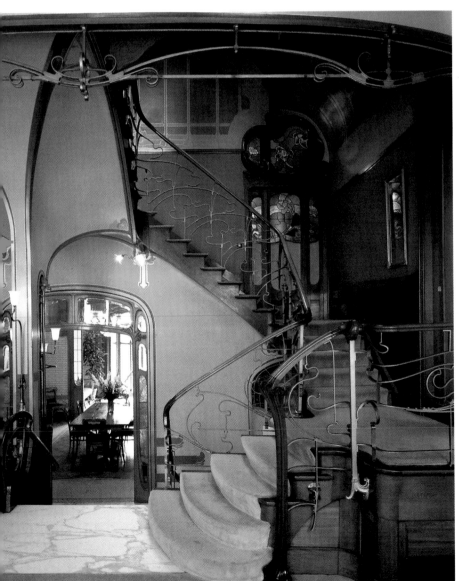

ABOVE: Victor Horta: house and studio, bottom of the staircase with column-style radiator (1898–1901).

OPPOSITE: Victor Horta: house and studio, first-floor landing (1898–1901).

RIGHT PAGE: Victor Horta: house and studio, skylight at the top of the stairwell (1898–1901).

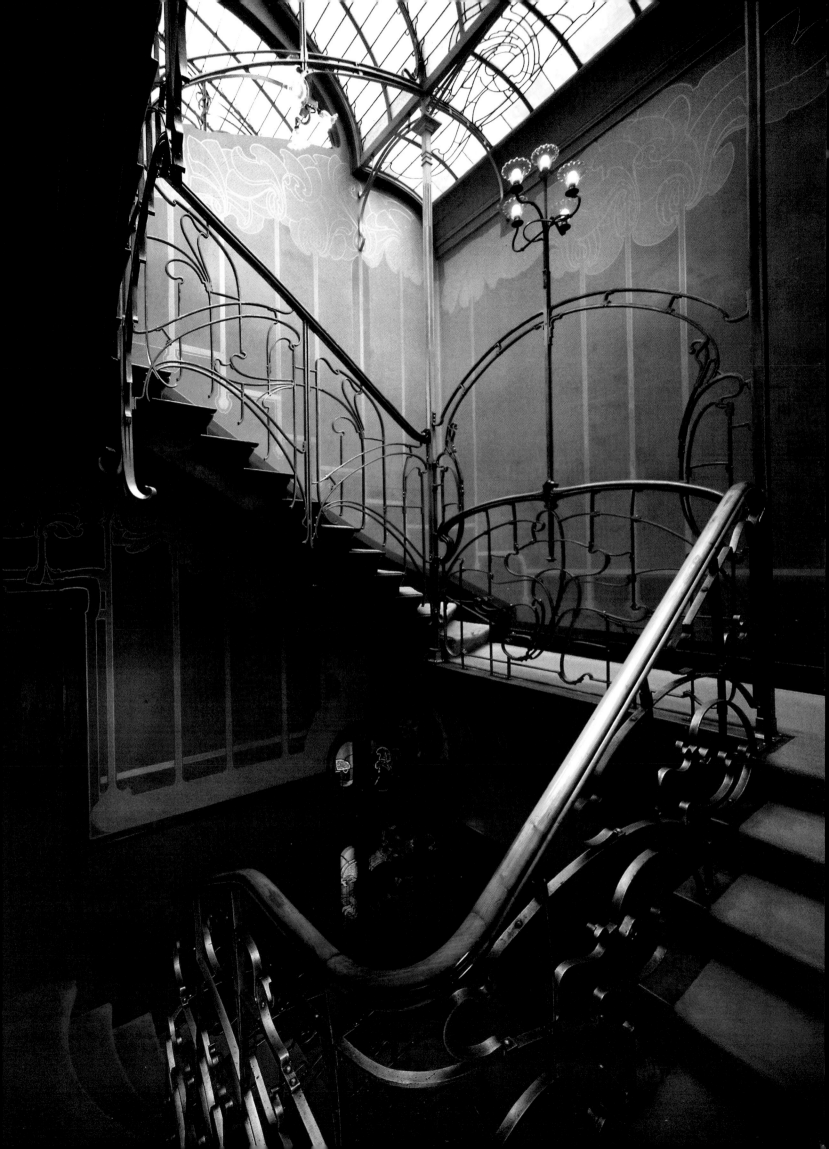

Jules van Biesbroeck: poster for the inauguration of the Maison du
Peuple, 1899. Coloured lithograph, 124.5 x 90 cm. Antwerp, Museum
Vleeshuis.

mirrors reflecting the light of the electric bulbs create a
sumptuous imaginary landscape. In the dining room,
Horta contrasts the chilly brilliance of white glazed
bricks (designed to catch the light from the garden)
with the warm tones of the American ash panelling.
In the hall, the flayed industrial radiator, transformed
into an elegant column supporting the first landing of
the staircase, combines industrial modernity with the
ideal of a total work of art.

Horta noted with amusement in his *Mémoires* that
Mme van Eetvelde found modernism "vulgar": The
visible use of iron in her home was a continual reminder
to her of the Maison du Peuple, which was then being
built. On a problematic site, below the Place du Grand
Sablon, Horta built the community centre and meet-
ing place commissioned by the leaders of the Belgian
Labour Party. It cost a little over a million Belgian
francs in the currency of the time. He envisaged "a
palace that would not be a palace, but a 'house' offering
the luxury of air and light so long absent from the work-
ers' hovels".[34] The building, now demolished, housed
a vast complex: shops and a large café on the ground
floor, offices, a clinic, a library, meeting rooms and an
auditorium with a seating capacity of around 1,500.
Its slender metal framework crowned the building,
making use of the unobstructed "roof" space. The
façade, almost completely glazed, was structured so
that the different levels were not disguised but made
an integral part of a subtly-balanced whole. Emile Van-
dervelde said that the finished building resembled "a
steamship speeding towards the shores of a New
World".[35]

Horta's success earned him commissions from the
owners of department stores who wanted to present a
fashionable image to their customers. The first Brus-
sels department stores had appeared in the 1850s and
were mainly run by French and German businessmen.
The Thiéry brothers had opened some of the most
prestigious Brussels stores: Bon Marché, Les Grands
Magasins de la Bourse, La Vierge Noire, Les Magasins
Waucquez. At the turn of the century, they were flour-
ishing. Newcomers, such as Innovation or the Grand
Bazar on Boulevard Anspach, were extremely success-
ful. During this time, Bon Marché gradually acquired
the houses clustered around it, before spanning the
street with an elegant bridge that became a Brussels
landmark.

and clarity. The *bel-étage* is structured around an
octagonal conservatory entered through an oblique
passage reminiscent of the whorls on a snail shell. The
visitor is thus conducted on an "architectural tour",
taking in the many points of view created by Horta.
The interior space is truly stunning.

In his own house-cum-studio, built in 1898 on Rue
Américaine, Horta designed a staircase that occupied
half the width of the house and formed an integral part
of the living space. It's pale ochre walls form a back-
ground for the golden outline of large abstract flowers,
while the glass-roof with bright yellow panes and the

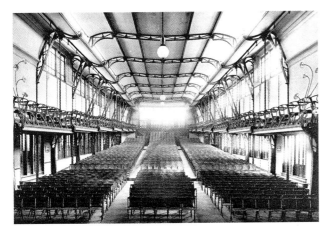

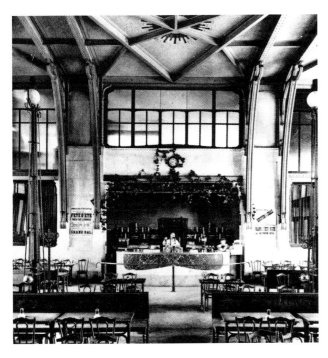

These new businesses sported an elegant exterior; a permanent advertisement for their products. They rejected the traditional horizontal structure of shops in favour of a vertical structure that enabled them to enlarge the sales area, and they wanted to be seen as grand commercial monuments at the heart of the urban landscape. They therefore called on the services of the most distinguished architects of the period. In 1902, the directors of Innovation commissioned Victor Horta, who had just completed the Maison du Peuple, to rebuild their shop as a department store, maximising display space. Horta devised a building modelled on Parisian stores, in which he gave free rein to his Art Nouveau vocabulary. The galleries opened out onto a central space surmounted by a glazed skylight. The shop quickly compelled recognition as a gem of commercial architecture. Alas, it has not survived. Horta later redesigned the façade of the Grand Bazar on Boulevard Anspach.

On Avenue Louise, Horta constructed a number of large buildings such as Hôtel Aubecq (1900), now demolished, or Hôtel Max Hallet (1902). These magnificent houses alternated with more modest buildings designed for friends: the house for the sculptor Braecke on Rue de l'Abdication (1901), and that of the art critic Sander Pierron, Rue de l'Aqueduc (1903). Horta's career took a different turn with his public commissions. The first was the Musée des Beaux-Arts in Tournai (1903, opened 1928). This was followed in Brussels by the Brugmann Hospital (1906, opened 1923), the Palais des Beaux-Arts (1919, opened 1928) and the Central Station (1912), left unfinished when he died in 1947. From then on, private commissions dwindled; Art Nouveau, once a sign of modernity, had become increasingly popular and early patrons grew weary of it. Horta meanwhile began to devote time and energy to the reform of architectural teaching in Brussels.

ABOVE: Victor Horta: Maison du Peuple, façade, Place Emile Vandervelde (1896–1899). Subsequently demolished. Period photograph. Brussels, Musée Horta.

CENTRE: Victor Horta: Maison du Peuple, main auditorium.

OPPOSITE: Victor Horta: Maison du Peuple, large café on the ground floor.

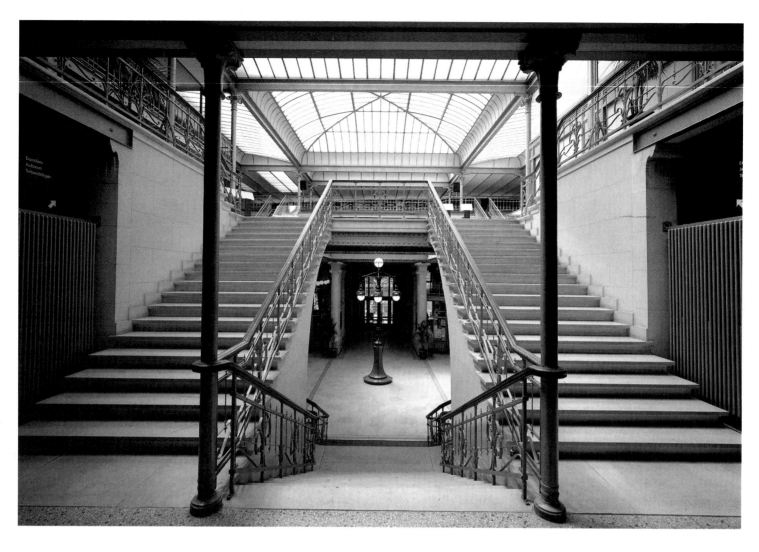

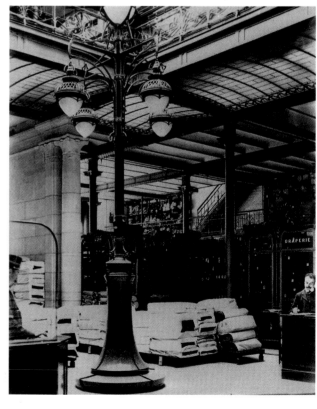

The year in which Horta built Emile Tassel's town house, Paul Hankar constructed his own house on Rue Defacqz. At first sight, these two buildings have nothing in common. Horta's classical modernity with its delicate ironwork contrasted strongly with Hankar's asymmetrical composition, his taste for polychromy and his varied treatment of materials. Hankar delighted in irrelevant detail, and was a master of wrought-ironwork. Horta was inspired by Balat's work; Hankar showed the influence of Beyaert. Both had read Viollet-le-Duc. Unlike Horta, completely absorbed by his passion for architecture and design, Hankar combined architecture with the arts and a commitment to social architecture.[36]

Hankar taught architecture at the Ecole de Dessin et d'Industrie in Schaerbeek. Adolphe Crespin, one of his colleagues there, soon became his collaborator. Crespin was a student of nature: His ornamentation drew on the exuberant lines and bright colours of herbariums. His decorative floral compositions decisively influenced the stylisation characteristic of the work of Art Nouveau architects. Crespin also drew inspiration from Japanese models and became one of the most skilled exponents of this style in Belgium. Hankar, too, displayed a fascination for plant-like decorative motifs in his works. His distinctive design for the railings of Hôtel Zegers-Regnard, Chaussée de Charleroi (1888), was noteworthy in a building unremarkable in other respects. For the façade of his own house, Hankar earmarked panels for Crespin's Japanese-style sgraffiti. He was very fond of the sgraffito technique, which was much admired by painters like Privat Livemont and Ciamberlani. Crespin described it as "engraving a design in a fresh layer of stucco with a lime base and thinly applied over a layer of black cement. While fresh, various colours can be applied to this layer of stucco […] employing the techniques used in frescoes".[37] The polychrome façade of Hankar's own house included sgraffiti but was achieved by the use of many different materials: pink pudding stone, blue Hainaut stone, Gobertange stone, and brick. The effect has a certain lyrical charm. The architect decided on an asymmetrical composition: staircase to the right in a clearly delineated bay, and living quarters to the left illuminated by a bow window two-stories high, whose delicate iron structure was enclosed by massive stone uprights resting on

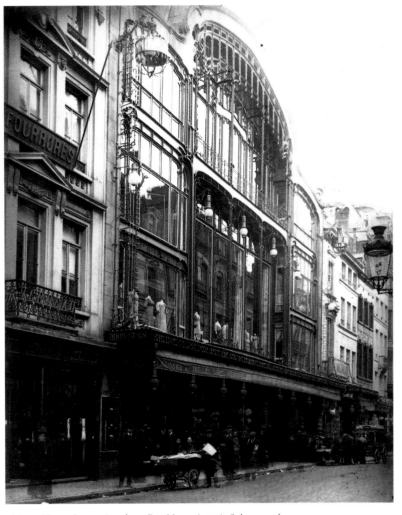

Victor Horta: Innovation shop, Rue Neuve (1900). Subsequently demolished. Period photograph. Brussels, Musée Horta.

LEFT PAGE

TOP: Victor Horta: Magasins Waucquez (now the Centre Belge de la Barde Dessinée), main foyer, 20 Rue des Sables (1903–1906).

BOTTOM, LEFT: Victor Horta: Magasins Waucquez. Period photograph. Brussels, Musée Horta.

BOTTOM, RIGHT: Victor Horta: Magasins Waucquez, main entrance hall. Period photograph. Brussels, Musée Horta.

Paul Hankar's studio. Period photograph. Brussels, Archives d'Architecture Moderne.

Tailoring new artistic modes of expression to utilitarian purposes, Crespin and Hankar virtuosically combined architectural design and decorative brilliance in a way that seemed simplicity itself. Hankar developed an inspired typology of openings that created a vogue for round windows. Ever the artist, he ingeniously exploited the potential of his form; varying the shape of the balconies from one floor to another, he created an overall feeling of harmony within diversity. This talent for renewal met the requirements of shop owners keen to promote their brand image. Only one of these shop fronts, with its delicate tracery of wood reminiscent of bird skeletons, can still be seen today: the former Chemiserie Niguet on Rue Royale in Brussels (1896).

A commission for a new pharmacy or jeweller's was not confined to the design of a shop front. Hankar and his team were responsible for every detail of the furniture and decoration: the counter and cash desk, an umbrella stand or a typewriter troller were all designed to fit into the overall vision. This vision is also found in the projects he carried out for his artist-friends: house-cum-studios, country houses, plinths and display cases[39] all inspired new combinations of colour and form.

Hankar's virtuosity is in marked contrast with the theoretical approach taken by van de Velde, who had already excelled as a painter and interior designer. As a painter, in his first forays into architecture, and in the many decorative projects he carried out after 1893, van de Velde applied the same visual principles: His dynamic line transformed decorative expanses of solid colour into objects that energised. One such is his six-branched candelabra; van de Velde's line is much more focused than that of Fernand Dubois. It makes a firm and deliberate statement. For van de Velde, the line drew its energy from the will of the artist; it embodied life. This theory, reiterated by the artist in an article in

extremely tall consoles framing the window on the *bel-étage*. The projecting cornice efficiently protected the façade and, supported by two elegant wrought-iron pillars, also provided shelter for the balcony. Inside, the use of squares and rectangles for the panelling and the ceilings displayed Hankar's taste for geometric designs. The layout, less innovative than that of the Hôtel Tassel, continued the tradition of a suite of three rooms on the *bel-étage*, the last extending onto a glazed veranda with central skylight. The two narrow architectural studios were on the axis of the front door, behind the two stairwells and the pantry. Hankar also paid close attention to the garden, which combined utilitarian considerations with aesthetic appeal: espalier fruit trees along the walls, standard trees, and rose bushes and climbing plants for their perfume.

Hankar and Crespin were noted no less for their pioneering work in town-planning than for their architecture and decoration. In tandem with Edouard Duyck, Crespin introduced the art poster in Belgium.[38]

Right page:

Left: Paul Hankar: Zegers-Regnard house, 365 Avenue Louise (1895). Subsequently demolished. Period photograph. Brussels, Archives d'Architecture Moderne.

Right: Paul Hankar: Bartholomé house and studio, Avenue de Tervuren (1898). Subsequently demolished. Period photograph. Brussels, Archives d'Architecture Moderne.

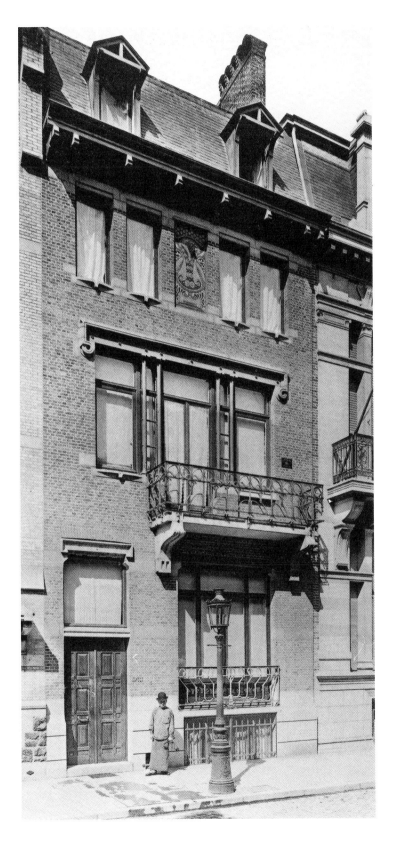

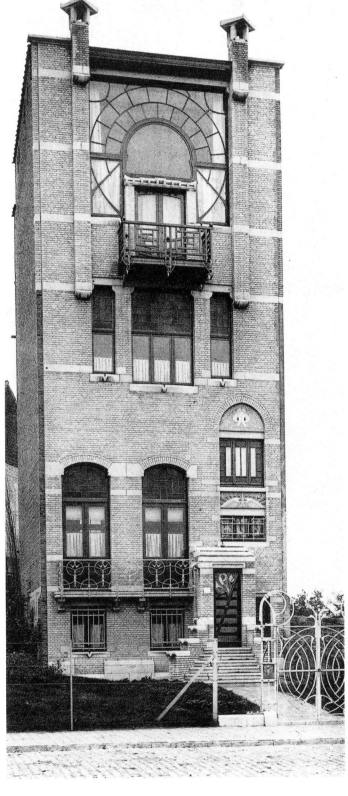

the German review *Zukunft*, confirmed the "force-line" principle[40] that van de Velde had developed after discovering the work of Van Gogh. Product and vector of an emotion, the force-line's concentrated power and tense relationship to its surroundings generate form and determine the organic value of the ornament, which complements the form itself.

> The line must conjure up those complementary elements which the form still lacks, but which we sense are indispensable. These relationships are structural relationships and the function of the line, which establishes them, is to suggest that there is an energy at work where the line of the form diverges for no apparent reason; where the effect of the tension on the elasticity of the line of the form reveals the workings of a powerful force that has its source within the form. Ornament devised in this manner completes and extends the form; we recognise the sense and justification of the ornament by its function. This function consists in 'structuring' the form and not in 'ornamenting' it, as is commonly believed. Without the support of this structure, to which the form adapts in the same way as a flexible fabric cover fits a frame or as flesh covers bones, the form might alter in appearance or completely collapse. The relationship between this 'structural and dynamographic' ornamentation and the form or surfaces must be so close that the ornamentation seems to have 'determined' the form![41]

This concept of the line as an inner force structuring objects and space naturally tended towards abstraction and architecture. The artist organizes the linear forces at work until their movement ends in a point of fixed equilibrium "whose result is form". In its austerity, simplicity and organic unity, this instant of arrested motion, this moment of eternity, verged on perfection. Imbued with an inner force, the line breathed new life into forms that conferred on it their perfect balance and saturated harmony. Whence the stained-glass win-

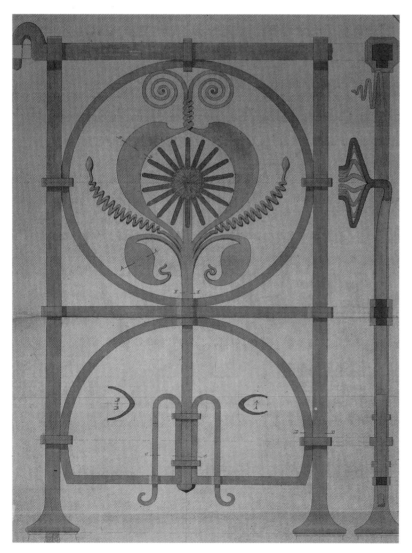

ABOVE: Paul Hankar: architect's own house, detail of the façade, 71 Rue Defacqz (1893–1894).

OPPOSITE: Paul Hankar: architect's own house, detail of the balcony railing (1893–1894). Watercolour. Brussels, Archives d'Architecture Moderne.

RIGHT PAGE: Hector Guimard: drawing of the façade of Hankar's house, 1893. Paris, Musée des Arts Décoratifs.

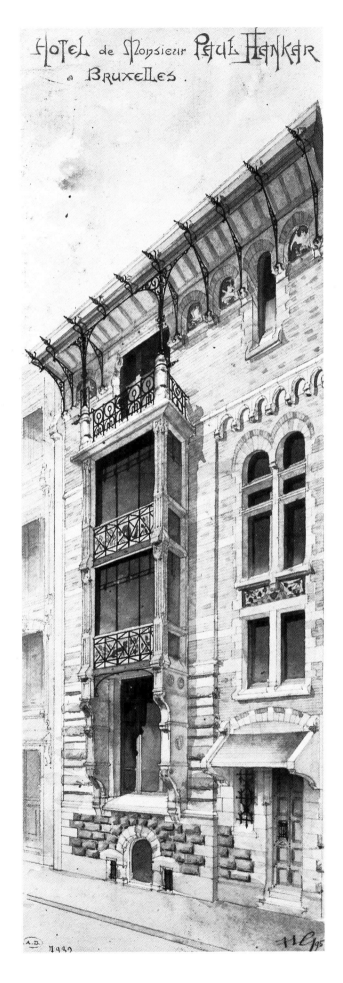

dows of the Hôtel Otlet designed by van de Velde in 1889. The elements of the interior decoration are fixed by the layout: The furniture is secured to the wall and the stained-glass windows unfurl in a linear movement reminiscent of graphic compositions – illustrations, bookbindings or jewellery. The dynamism of the whole is stabilized by the symmetry of the composition, which is integral to the central window, and dependent on the overall composition in the side windows. It is further enhanced by the harmonious tones employed.

In 1895, van de Velde turned to architecture as an autodidact. In Uccle, a verdant suburb south-west of Brussels, he built his own house, the Bloemenwerf, which he designed as a non-urban manifesto, a place where a couple could "create a life of freedom for themselves, leaving vulgarity and social injustice behind them, sheltered from offensive ugliness".[42] This was close in spirit to the egalitarian theories of the English Arts and Crafts movement. The house is completely free of ostentation, and resembles the English cottages reproduced in *The Studio* magazine. The irregular plan, the windows with their small leaded panes, the three gables faced with wooden slats in alternating colours, the porch sheltering a small raised terrace, created a picturesque effect wholly lacking in affectation. The house stood in a vast garden, landscaped by Maria Sèthe, van de Velde's wife. They took up residence in spring 1896, when the artist was for the first time exhibiting a collection of furniture (he called 'salle de five o'clock') at La Libre Esthétique. The layout of the interior was also influenced by English architecture, notably by Baillie Scott. The rooms were arranged around a central hall which rose the full height of the house and was crowned with a skylight; this space was dominated by Maria Sèthe's piano, in front of which van Rysselberghe had painted her in 1891. Upstairs, the gallery leading to the bedrooms was broadened along the façade to become a work area with table, library and printing press. The railing was replaced by display cases containing books, samples of arts and crafts, and pottery by Finch, which van de Velde was distributing in Brussels. On the ground floor, there was another huge studio at the end of the hall, in line with the entrance. The entire house was decorated with Japanese prints and stencils and carefully chosen paintings and drawings: Théo van Rysseberghe's *Portrait of Maria*, Seurat's *Sunday in Port-en-Bessin*, and two

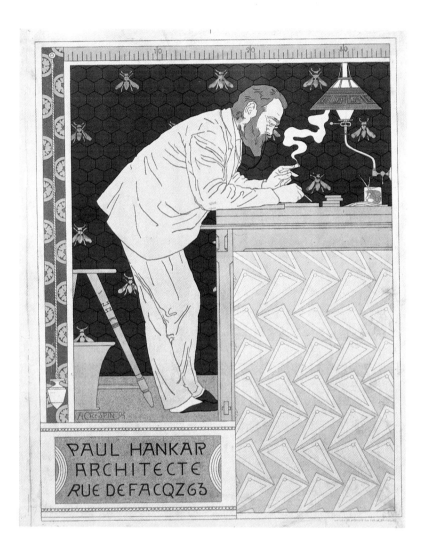

drawings by Van Gogh and Thorn-Prikker bore witness to the artist's past and present taste. The few pieces of furniture were built-in or fixed to the walls. For the dining room, van de Velde came up with a highly personal design for the chairs; sturdy and rustic in appearance, with straw seats, they were inspired by Serrurier-Bovy and the Arts and Crafts movement. Van de Velde knew liitle about cabinet-making and made many mistakes. At first he tended to highlight his furniture rather than blending it with its surroundings. His painterly background was holding him back. The sensuality of the carved material was less important than the line inherited from the mobilization of the *pointilliste* dot, the lesson of Van Gogh superimposed on the legacy of Seurat. Van de Velde's best designs combined architectural aims with pictorial effects, as can be seen by the 'office' he presented at the Munich Sezession exhibition in 1899.

Life at Bloemenwerf is known to us from a series of photographs. They show the aspiration to an all-encompassing art, which affected all aspects of everyday life, creating an 'artistic environment' conducive to the realisation of personal creative potential. Most of the shots feature Maria Sèthe wearing dresses designed by her husband: sometimes made from English fabrics, sometimes embroidered by the young woman from patterns by her husband. This interest in women's clothing led to the self-taught architect's first lecture in Germany, in April 1900.[43] His designs, based on clearly expressed concepts, ranked van de Velde among the pioneers of the reform of women's clothing. In 1898, Friedrich Deneken, director of the Kaiser Wilhelm Museum in Krefeld, invited him to provide fabric designs for the silk industry in his city.

Following the example of his parents-in-law, the Sèthes, van de Velde made his house a rallying point

ABOVE: Adolphe Crespin: poster: *Paul Hanker, Architecte*, 1894. Lithograph, 58 x 42.5 cm. Brussels, Musée Communal d'Ixelles (J. Botte Collection).

OPPOSITE: Privat Livemont: sgraffiti in the Athénée Emile André built by Henri Jacobs, 58 Rue des Capucins (1907–1910).

RIGHT PAGE: Paul Hankar: town house of the painter Ciamberlani, 48 Rue Defacqz (1897–1898). Period photograph. Brussels, Archives d'Architecture Moderne.

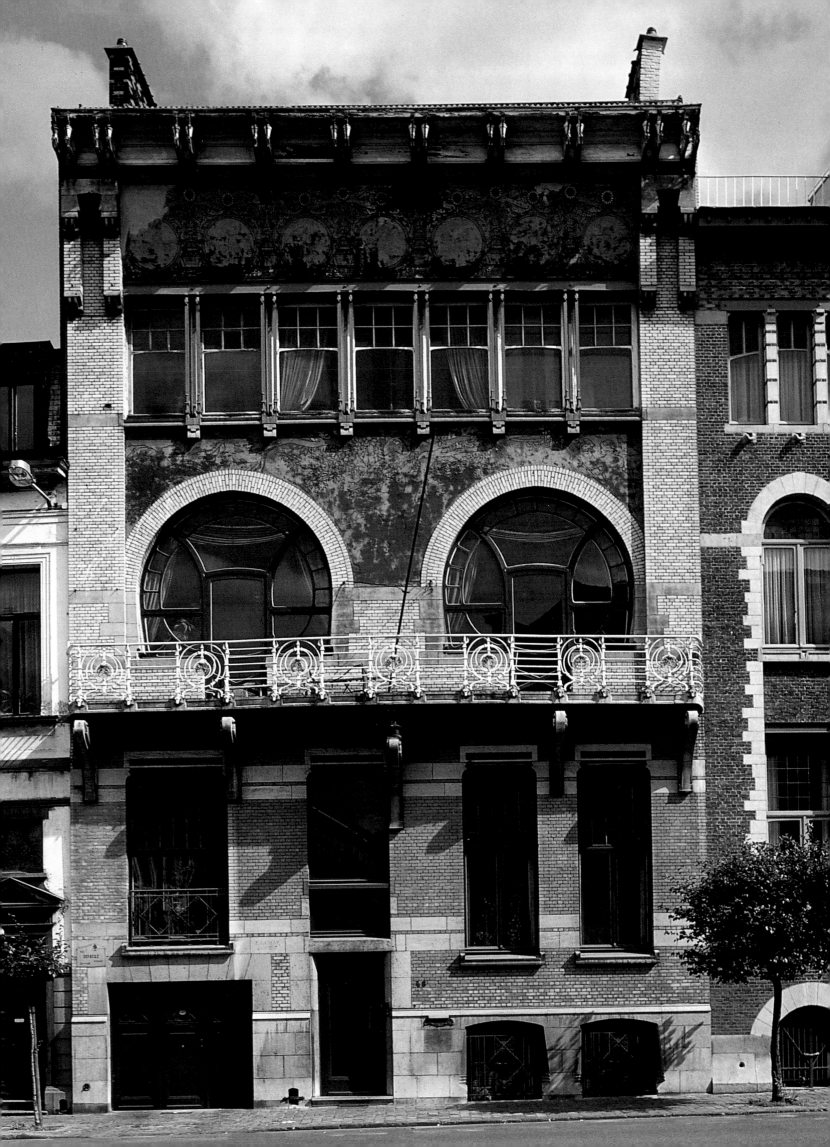

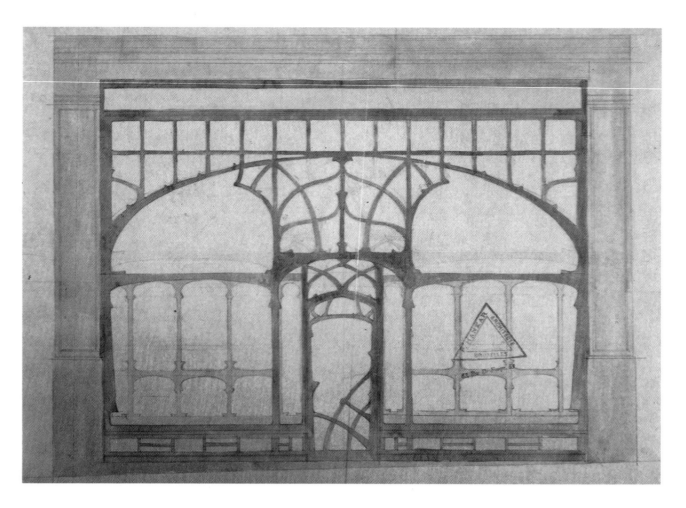

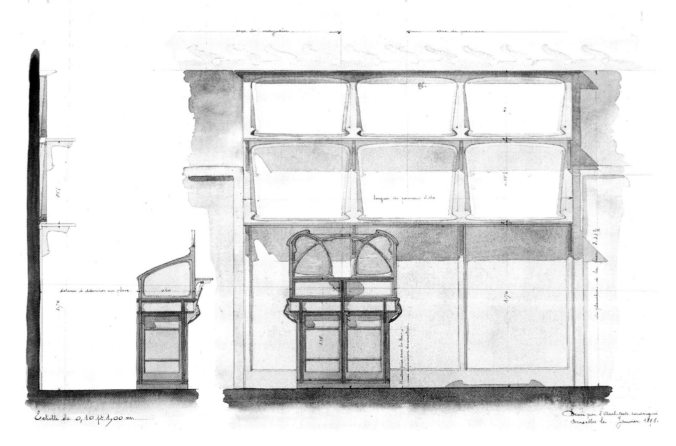

for members of the avant-garde passing through Brussels. Besides regulars like George Minne and Constantin Meunier, their visitors included artists in town for La Libre Esthétique exhibitions: Lautrec, Signac, Pissarro or Luce, contributors to *Van Nu en Straks* and the director of the review *La Société nouvelle*, Fernand Brouez, and his wife Neel Doff, the anarchist geographer Elisée Reclus and the many other figures so vividly described in van de Velde's *Récits de ma vie*.

Van de Velde produced little architecture before 1900. He collaborated with Octave van Rysselberghe on two houses, Hôtel Otlet and Hôtel de Brouckère, for which he realised only the interior decoration, and built a house for the sculptor Paul du Bois, who became his brother-in-law. In 1897, van de Velde received a commission from the German industrialist, Eberhard von Bodenhausen, to create a promotional image for a tonic called Tropon. The following year, he designed posters, packaging, and newspaper advertisements that helped to promote his style of ornamentation throughout Germany. Tropon was not a commercial success, although it paved the way for modern marketing. An enterprising man, von Bodenhausen decided to invest in a company selling van de Velde's designs. The business was based in Berlin, though some of the capital was put up by Mme Louise Sèthe, Maria's mother. Late in 1898, van de Velde began looking for studios and, in 1899, he published the first catalogue of his 'Industries d'Art et d'Ornementation'. Because the commissions flooding in were almost exclusively from Germany, it was soon imperative to open studios there. Furthermore, van de Velde had to make frequent trips to Berlin to supervise the building projects that his growing German reputation had brought him. The decor of the Keller und Reiner

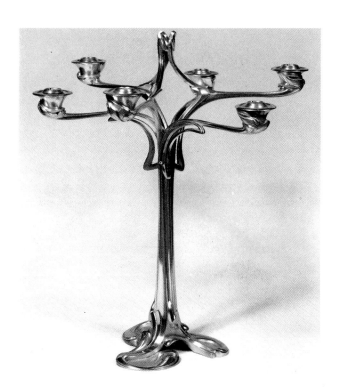

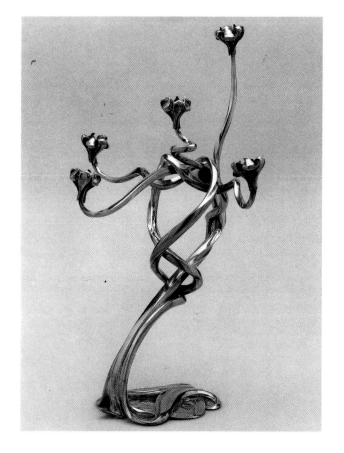

Left page, top: Paul Hankar: Magasin Niguet, shop front design, 13 Rue Royale (1896). Watercolour. Brussels, Archives d'Architecture Moderne.

Left page, bottom: Paul Hankar: Magasin Henrion, Namur, section and elevation of the shelves and cash desk (1897). Subsequently demolished. Watercolour. Brussels, Archives d'Architecture Moderne.

Above: Henry van de Velde: six-brand candelabra, 1900. Bronze, H: 59 cm. Brussels, Musées Royaux d'Art et d'Histoire.

Opposite: Fernand Dubois: five-branch candelabra, circa 1899 (?). Silver-plated bronze, 52.5 x 45 x 45 cm. Brussels, Musée Horta.

gallery (1897), the art exhibition organised by Bruno and Paul Cassirer (1898), many international exhibitions, the home of Count Harry Kessler (1898), the Havana Company cigar shop (1899) and the Haby hairdressing salon (1901) were such a success that he was commissioned to design the interior of a museum founded by an industrialist from Hagen, Karl Ernst Osthaus. This job was too large to be handled exclusively by the Brussels studios; they were moved to the Hohenzollernkunstgewerbehaus in Berlin, which was to distribute their products. In October 1900, the family left Villa Bloemenwerf to settle in Berlin. Unlike Théo and Octave van Rysselberghe, Verhaeren or Maeterlinck, van de Velde preferred the atmosphere of Berlin to Paris, which had given him an icy reception in 1895 when he designed Bing's Art Nouveau gallery.[44]

Another Parisian commission – which did not do much for his career in France – was the design of the Paris office of the art critic Julius Meier-Graefe, editor of the review *Dekorative Kunst* (1897). The French language counterpart of this review, *L'Art décoratif*, founded in October 1898, devoted its entire first issue to van de Velde. Meier-Grafe founded a Paris art gallery, the Maison Moderne, in Rue des Petits-Champs, which was in direct competition with Bing's gallery. While Meier-Grafe was employing the services of van de Velde and Lemmen, Bing, disappointed by the lack of success achieved by Belgian Art Nouveau, was turning to Feure, Gaillard or Colonna, whose designs were more in keeping with French taste. The two galleries did not, however, make much impression on the Parisian market, and their closure ended the spread of Belgian Art

ABOVE: Henry van de Velde and Octave van Rysselberghe: Paul Otlet house, detail of the floor, 48 Rue de Livourne and 13 Rue de Florence (1894).

CENTRE: Henry van de Velde: wallpaper, n.d. Private collection.

OPPOSITE: Henry van de Velde: belt buckle, 1898–1900. Silver with an amethyst set in the clasp, 19.7 cm. Hagen, Henry van de Velde-Gesellschaft.

RIGHT PAGE

TOP: Henry van de Velde and Octave van Rysselberghe: Paul Otlet house, stained-glass window (1894).

BOTTOM: Henry van de Velde and Octave van Rysselberghe: Paul Otlet house, stained-glass window (1894).

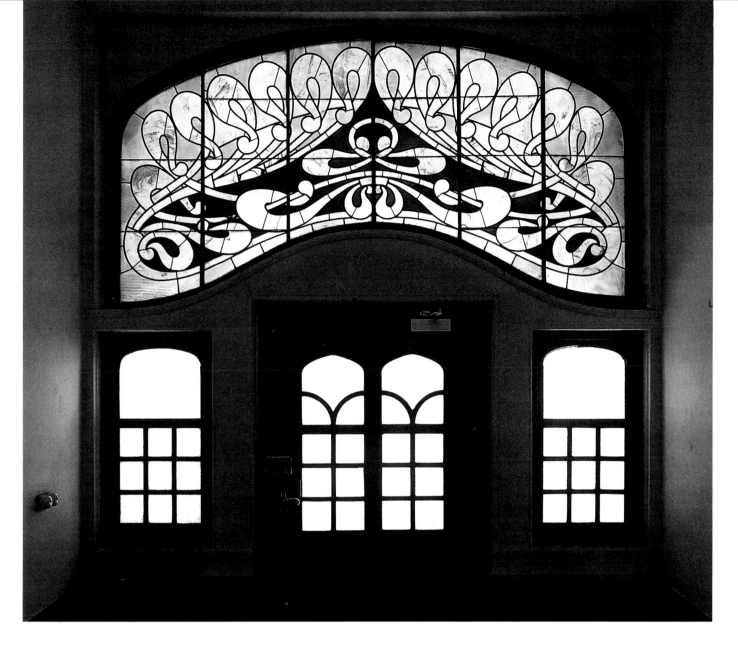

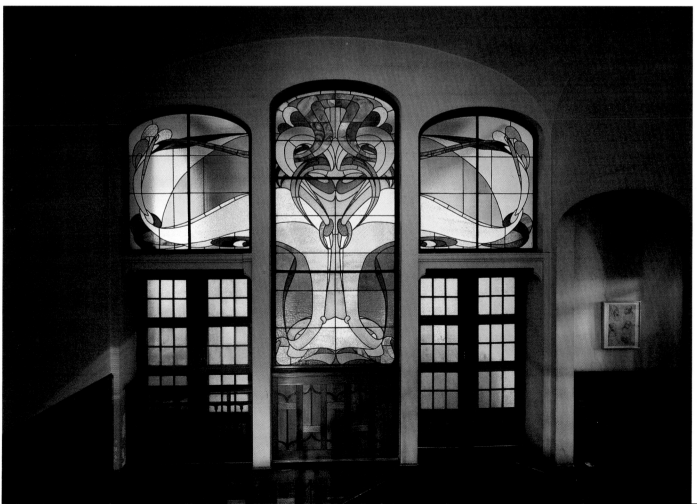

Nouveau in Paris. Van de Velde's influence, however, was far-reaching. He made his career in Germany, where his vision of artistic modernity gained a huge following, while his teaching activities led to the foundation, in Brussels, of the Ecole de La Cambre, the Belgian version of the famous Bauhaus.

La Libre Esthétique and painting

Alongside the decorative arts, the 'vingtistes' still maintained a presence within La Libre Esthétique. It's first salon, in 1894, provided a forum for Ensor's hallucinatory visions, obsessed with the emblematic figure of the mask and grotesque fantasies teeming with devils and scenes of torture; for the portraits and landscapes of Khnopff and van Rysselberghe; for the views of Brussels suburban life and boldly-painted seascapes by Vogels, who died in 1896; and for Toorop's idealist compositions. Sculpture and painting had a firm foothold in La Libre Esthétique. On this occasion, the public discovered Mellery's eighteen allegorized drawings on gold backdrops, as well as Laermans' social realism and the Flemish landscapes by Emile Claus, who soon became one of the darlings of La Libre Esthétique.

Symbolism had been gaining in strength independently of La Libre Esthétique, and was well represented at it's second Salon. Degouve de Nuncques exhibited various pastels including *Angels in the Night* and *House with Owl*; Henry de Groux showed canvases and lithographs from the wine harvest series including *The Upheaval*. It was not until 1900, however, that Delville presented his *The Love of Souls*. Idealism made its appearance at the same time as this enigmatic realism which, like Khnopff landscapes or the drawings from Mellery's series *The Soul of Things*, transformed surface appearance by suggesting the existence of the absolute. The same exhibition marked the advent of the young sculptor Victor Rousseau, who exhibited decorative pieces and designs of idealist inspiration. Meunier's work was outstanding. Besides his pastels and drawings, he exhibited some twenty plasters and bronzes. Praised in Paris by Octave Mirbeau, his contribution proved a resounding success.

In 1896, Maus indulged his desire to relive the past. This need to confront the present with time-honoured

Maria van de Velde wearing the *Tea Gown* in front of her Blüthner piano, 1900. Period photograph. Private collection.

LEFT PAGE

TOP: Maria and Henry van de Velde at Bloemenwerf in the work room on the first floor. In the background, a *Kneeling Youth* by George Minne. Period photograph. Brussels, Bibliothèque Royale Albert Ier, Fonds Van de Velde.

BELOW: Henry van de Velde: Villa Bloemenwerf dining room (1894–1895). Period photograph. Brussels, Bibliothèque Royale Albert Ier, Fonds Van de Velde.

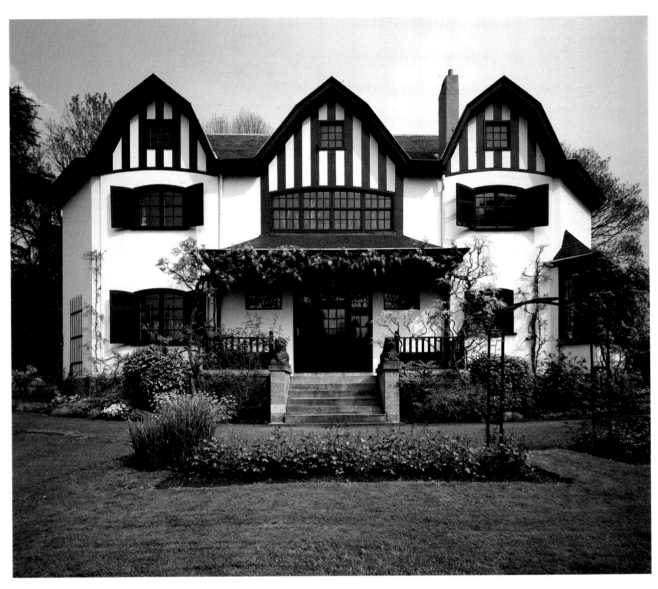

Henry van de Velde: Villa Bloemenwerf, 102 Avenue Vanderacy (1894–1895).

values emerged in the year when a homage was being paid to Carrière and Signac was presenting his designs for the decoration of a Maison du Peuple, *In the Days of Harmony*, now in Montreuil Town Hall. This need to reinstate the stability created by the tastes of an enlightened yet established bourgeoisie went hand in hand with Maus' desire to put some distance between La Libre Esthétique and the painters who had exerted considerable influence in Les Vingt. Novelty was losing its edge, giving way to an increasingly pronounced yearning for the past, while the group's aesthetic com-

mitments, now exclusively reflecting Maus' tastes, were more and more conformist, eventually reducing themselves to a bland form of Impressionism.

Retrospectives were now the order of the day. In 1898, La Libre Esthétique paid homage to Rops, who had died shortly before. His realist landscapes, satirical drawings, frontispieces, lithographs and etchings all featured, alongside a number of watercolours. These were taken from *One Hundred Light and Unpretentious Sketches to Delight Decent People*, from *Burial in Walloon Country* – a homage paid to Courbet at the start

of Rops' long career – and *The Lyre*, an illustration
for Mallarmé. Maus also exhibited *The Quarrel* and
Pornokratès which, several years before, had created
a scandal at Les Vingt. Two years later, Maus paid
homage to Evenepoel by exhibiting several of his finest
canvases: *The Spaniard in Paris, Fête at Les Invalides*,
and *Sunday Walk in the Bois de Boulogne*. In 1902, it
was the turn of Lautrec. Maus seemed keen to provide
a comprehensive round-up of his past enthusiasms. At
the same time as these retrospectives, La Libre Esthé-
tique welcomed the nation's artistic circles in all their
diversity. In 1899, Berchmans, Donnay and Rassen-
fosse followed in Serrurier-Bovy's footsteps and testi-
fied to the vitality of artistic life in Liége. In 1900,
Maurice Pirenne and Georges Le Brun revealed the
existence of a Walloon intimism entirely divorced from
industrial progress.

Now an established institution, La Libre Esthétique
had lost the spark that had made Les Vingt so adven-
turous. A prosperous initiative, entirely the fruit of
Maus' tireless work, it confirmed the importance of
Brussels as a crossroads of European art. It contributed
to the reputation of a *fin-de-siècle* cultural scene that
included names like Cézanne, Monet, Puvis de Cha-
vannes, Redon, Denis, Rodin, Gauguin, Vuillard,
Bonnard, Khnopff, Ensor, Minne, Meunier, Horta,
Beardsley, Liebermann, Klinger and their disciples.
Painters and sculptors, writers, musicians, and com-
posers all made the trip to Brussels. La Libre Esthé-
tique had become part of the establishment.

La Libre Esthétique and music

When Les Vingt was dissolved, the echoes of Lekeu's
sonata had barely faded away and Ysaÿe's reputation
was steadily growing. Ysaÿe performed four concerts
with his quartet at the first Salon of La Libre Esthé-
tique. In keeping with the circle's new trends, earlier
works were now accepted in small doses to make it
easier to compare differences in language. Beethoven's
Opus 131 was therefore played alongside Franck's *Quar-
tet*, and Schubert's posthumous *Piano Quintet* with
d'Indy's *1st Quartet*.

Within this context, a remarkable event took place
on 1 March 1894: a concert of Debussy. Ysaÿe, one of
Debussy's last links with the Franck school, had given

Henry van de Velde: *Tropon*, 1897. Coloured lithograph, 111.5 x 76 cm.
Krefeld, Kaiser Wilhelm Museum.

the first performance of Debussy's *Quartet* several
weeks earlier in Paris. His quartet performed it in
Brussels, after which Debussy accompanyied his young
fiancée of the time – Thérèse Roger – in two of his
Proses lyriques. The programme ended with *La Damoi-
selle élue* and the audience in a state of bemusement.
Delighted with these performances, Debussy promised
Ysaÿe that he would write *Trois Nocturnes* for lead vio-
lin and orchestra. The two friends quarrelled, the solo
violin part was abandoned, and the *Nocturnes* were

completed in 1899 in another form entirely.

Despite the absence of Eugène Ysaÿe, who was on tour in the United States in 1895, the second series of Libre Esthtétique concerts maintained their prestigious image. Georgette Leblanc, Maeterlinck's muse, sang *La Légende de Sainte-Cécile* by Chausson. Théophile Ysaÿe gave the Brussels première of Franck's *Variations symphoniques* and presided over the first performance of the *Quintet for Wind and Piano* dedicated by Albéric Magnard to Octave Maus. In 1896, there were fewer new works and when Ysaÿe played the final chord of the *Sonata* by his disciple Crickboom, on 15 April 1896, it marked the end of an era. Ysaÿe abandoned La Libre Esthétique to its fate. Somewhat put out, d'Indy and Maus took immediate action. In 1897 D'Indy was appointed director of the recently-opened Schola Cantorum, which was openly hostile to the Paris Conservatoire, the "Servatoire", as he described it to Maus; he organised some concerts of older music. In no danger of taking anyone by surprise, therefore, La Libre Esthétique returned to the seventeenth and eighteenth centuries. The desire to return to the past, the keynote of the association's exhibitions, had now found its musical embodiment in a tasteful eclecticism.

La Libre Esthétique could not continue in such a manner. After two years of silence, music made a hesitant comeback in 1900 in the form of a lecture given by Tristan Klingsor on *Poets Set To Music*. D'Indy and Maus joined forces again with renewed enthusiasm. But something had died: The Franckian school had become middle-of-the-road and codified within the Schola Cantorum, while Chausson's subtle, tender melancholy had died with him in 1899. Les Vingt had been able to distance itself from the Société Nationale; La Libre Esthétique found it difficult to escape the label 'Schola Cantorum of Brussels'. This had some positive repercussions. Excellent performers came from Paris. And the Belgian disciples of the Schola – Victor Vreuls, Albert Dupuis, Joseph Jongen and Léon Delcroix – rubbed shoulders with the French old guard – Fauré, d'Indy, Bréville, Ropartz, Bordes, and Magnard – and the up-and-coming composers presented in Brussels – Déodat de Séverac, Paul Dukas, Gustave Samazeuilh, Georges Witkowski and even Albert Roussel, whose first *Trio* was performed in 1905.

Henry van de Velde: dining room of Count H. Kessler, Berlin (1898).
On the wall, study for *Seated Woman* by Georges Seurat, 1887–1888.
Period photograph. Brussels, Bibliothèque Royale Albert I^{er}, Fonds
Van de Velde.

Henry van de Velde: offices of *L'Art décoratif*, Rue Pergolèse
Paris (1898). In the background, *Chahut* by Georges Seurat,
1889–1890. Period photograph. Brussels, Bibliothèque
Royale Albert I^{er}, Fonds Van de Velde.

The question was whether Maus' nose for talent
was still sensitive after his "thirty-year struggle for art".
The fact remains that a very young Darius Milhaud
was to perform his *1st Violin Sonata* at the third con-
cert of 1914 … With war fast approaching, the promise
of things to come was never fulfilled.

Poster art and photography: new media and their modes of expression

In the early 1890s, artists were influenced by the revival
of the decorative arts which arose out of the political
dimension of modern art. Visual artists were now
interested in exploring the harmonious expression of
an object's structure; ornament combined with form
to create an organic and synthetic whole. The form was
required to reveal the inner life of the object. Van de
Velde's work provided a synthesis of this principle, pre-
figuring an abstract concept of ornamentation, but in
most Art Nouveau works it amounted to little more
than a commonplace, the same iconographic clichés
endlessly reproduced in the same stereotypical forms. A
formalist movement, Art Nouveau drew its inspiration
from the symbolist ideal: Musical harmony, mystical
severity, rigorous stylisation, and an idealised palette
were expected to imbue the lyrical forms with mean-
ing. Around 1900, the unrealistic symbolist style seemed
doomed to reincarnation in a decorative form that
gradually lost its metaphysical function and began to
exert a stylistic influence on all areas of social life. Thus
poster art flourished under the influence of Chéret,

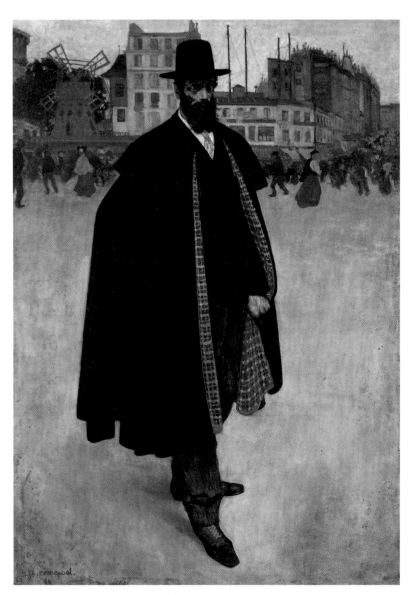

Henri Evenepoel: *Spaniard in Paris*, 1899. Oil on canvas, 215 x 150 cm. Ghent, Museum voor Schone Künsten.

RIGHT PAGE: Henri Evenepoel: design for a poster advertising an imaginary newspaper, *La Dépêche*, circa 1895. Pencil, charcoal and watercolour, 88.5 x 70 cm. Brussels, Wittamer-De Camps Collection.

Lautrec and Mucha. Dedicated to the promotion of the industrial society, the poster heralded the consumer age. The flowering of poster art was made possible by technical advances that allowed lithography to be used on an industrial scale.

At first, posters featured images not originally intended for a commercial context, and only the text identified what the poster was promoting. They quickly acquired a distinctive style, however, and began to be widely used after 1894. Artists' work was quickly superseded by studios specialising in the production of posters. Gisbert Combaz, Henri Evenepoel, Henri Cassiers, Duyck and Crespin, Victor Mignot and particularly Privat Livemont, the 'Belgian Mucha', made names for themselves alongside a school – Rassenfosse, Donnay, Berchmans – that had grown up around the Bernard printing house in Liège. The poster as a medium for marketing imposed its own requirements, which were often contrary to symbolist theory. Its very function precluded obscurity, suggestion, imprecision. The poster, both picture and text, had to be perfectly explicit. Japanese art offered a corrective influence; the message was emphasised by spare figures, economy of line and bright colours. This visual medium found its most influential exponent in Henry Meunier. For Dietrich, the poster became a synthetic, concise and powerful tool.

A fundamental part of the burgeoning consumer society, posters had to be eye-catching to fulfil their commercial function. Visual impact was combined with a conventional iconography that satisfied the customers' expectations. Women were omnipresent. These femmes fatales no longer urged men to give in to temptation, but invited them to savour the delights of Robette absinthe, or believe the promises of Bec Auer. A mane of demonic red hair grabbed the customers' attention; no longer confined to Baudelairean garrets, it now accompanied a brand name or an establishment, attracting attention and vaunting the qualities of a fashionable article. The emblematic hero now advertised a role performed by Sarah Bernhardt or a novel serialised in *La Réforme*. Fashion alone dictated the commercial utility of a Japanese-influenced idealism which used its didactic and moral prestige to sell loans, shares or patents. Posters, packaging, paper, everyday objects and dresses were affected by this trend, which swept the city, favouring industrialisation

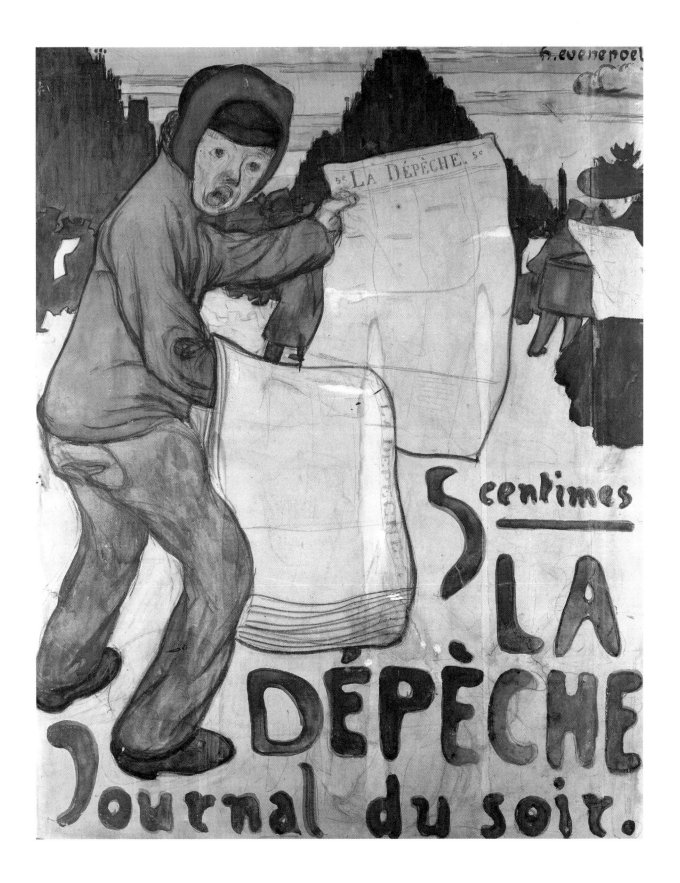

and, soon, the successful consumer society. Bayreuth was superseded in the life of the imagination by Bon Marché or Innovation – well-supplied department stores in which art mirrored the evanescent image of a contented bourgeoisie, united in its dreams of prosperity.

Technical progress also affected the development of a new art form still in search of an identity: photography. At the turn of the century, photography was considered as inferior to painting and the graphic arts; the prestige accorded to the created image was such that artists concealed the mechanical methods used to produce a photographic image, opting for a pictorialism criticised by many painters, including Khnopff. Their rejection concerned not photography as such but its subordination to the canons of painting. This state of affairs, influenced by the theories of English practitioners then in vogue – Alfred Maskell, Henry Peach Robinson and Horsley Hinton – made Brussels one of the leading centres of pictorialism. At the end of the century, photography became more popular. A market was created as a result of the exhibitions mounted by an increasing number of professional or amateur organisations. The field of photography diversified, ranging from hobby to documentary reportage and high art. It also acquired its first true masters, who exploited major technical advances – fixatives, mediums, papers, and lenses – to give it a more modern format. Léonard Misonne developed a sensitive brand of pictorialism, using technical effects to create a mood halfway between Impressionism and Symbolism. Edouard Hannon, who worked for the Solvay family, leading patrons of Art Nouveau in Brussels, had a completely personal approach to the photographic image, eschewing pictorialist formulae. The composition, minute detail and immediacy of his works gave them a power which, with their sensitive treatment of light, called to mind Mellery's intimist drawings. As art photography freed itself from the shackles of pictorialism, photographic output in the broadest sense intensified. Documentary photography became more widespread, trivialising the image of a momentary reality whose surreal qualities were soon to be discovered.

Top: Privat Livemont: *Absinthe Robette*, 1896. Coloured lithograph,
110 x 82.4 cm. Brussels, Wittamer-De Camps collection.

Bottom: Privat Livemont: *Bec Auer*, 1896. Coloured lithograph,
111.5 x 80 cm. Brussels, Wittamer-De Camps collection.

Opposite: Gisbert Combaz: *Maison d'Art à la Toison d'Or*, circa 1895.
Lithograph printed by A. Bernard (Liège), 198 x 104 cm. Brussels,
Wittamer-De Camps collection.

Below: Henry Meunier: design for Dietrich art postcards, 1898. Oil
on canvas, 60.5 x 90 cm. Brussels, Wittamer-De Camps collection.

Art Nouveau and colonial expansion

Under the pretext of setting up humanitarian organisations like the Comité d'Etude du Haut-Congo and the later Association Internationale du Congo, Leopold II had for many years endeavoured to establish a Belgian settlement in the heart of the African continent. With this in mind, he had personally financed the exploration of the Congo river. In 1885, this policy had resulted in its first major diplomatic success: The European powers attending the Berlin conference recognised his sphere of influence, allowing the birth of the Congo Free State, the ruler's personal domain. Guided by Edmond van Eetvelde, Congolese Secretary of State, Leopold II increased the number of initiatives taken to enhance the status of a colonial administration that was highly unpopular in certain Belgian circles. In 1894, at the Antwerp Salon, the ruler gave several renowned sculptors elephant tusks imported from the Congo that were to be carved into decorative objects or statuettes. Noting the recent revival of eburnean carvings in France, Leopold II hoped to revive the popularity of this art, which had been greatly valued in the Netherlands during the seventeenth and eighteenth centuries. Chryselephantine sculpture continued to be influenced by its status as a luxury curio; the precious material itself often took precedence over artistic expression. At the Antwerp exhibition, the ivory works of Philippe Wolfers, Isidore de Rudder and Fernand Dubois were markedly mannierist. Many of the other carvings showed a twisting form intended to make the most of the tusk's shape.

The sculptor-decorator Fernand Dubois was asked to monitor the trade in ivory, while the limited company l'Art signed a contract with the Congo Free State to promote an 'art-industry' of ivory carving. The initiative was not, at first, very successful. It was not until the World Exhibition of 1897 that ivory carving became fashionable.

In parallel with the Exhibition, which took place in the Parc du Cinquantenaire, Leopold II mounted a successful exhibition (later transformed into a colonial

Edouard Hannon: *Coppélia*, 1895. Photograph. Antwerp, Provinciaal Museum voor Fotografie.

museum) in Tervuren, on the outskirts of the city, illustrating the ample market opportunities presented by the Congo. The Congo exhibition opened on 23 April 1897. It was divided into four main halls, each designed by one artist: the Ethnographic Room was by Paul Hankar, the Import Room by Gustave Serrurier-Bovy, the Export Room by Henry van de Velde and the Plantation Room by Georges Hobé. Paul Hankar was responsible both for co-ordinating the design team and designing the Salon d'Honneur, in which chryselephantine sculpture was displayed. Each artist had been given complete aesthetic freedom on condition they used Congolese wood, whose quality the exhibition was intended to showcase. Thanks to van Eetvelde's influence, Art Nouveau held pride of place.[45]

The painted friezes in Paul Hankar's ethnographic hall were executed by his friends Duyck and Crespin. Eight groups of remarkable ethnological sculptures by Isidore de Rudder, Julien Dillens and Charles Samuel

illustrated the life of African tribes with didactic intention and unsparing realism.

In the Salon d'Honneur, visitors found an exceptional collection of some eighty ivory carvings produced by some thirty sculptors, including Khnopff, van der Stappen, Rombaux, Samuel, Dillens and de Vigne. There was a variety of styles and influences, but ivory's symbolic dimension seemed to predominate. Alongside traditional Sulpician pieces, which associated ivory with the purity of revelation, there were more 'modern' pieces inspired by the French style. Ivory carving had experienced a revival in France at the end of the 1880s within the context of an academism which focused on ivory's distinctive eroticism. In fact, in the work of Gérôme, Clésinger or Cordier, ivory was identified with the mysterious, milky pallor of the skin. Khnopff used this medium for further enigmatic portraits of women. The mask he presented at Tervuren was as much Medusa as Sphinx. Beneath

Gustave Marissiaux: *Gust of Wind*, 1901. Photogravure taken from the album *Visions d'artiste*, 1908. Charleroi, Musée de la Photographie.

Top: Congo exhibition at Tervuren, 1897. Ethnographic Room designed by Paul Hankar. Period photograph. Brussels, Archives d'Architecture Moderne.

Bottom: Congo exhibition at Tervuren, 1897. Import Room, designed by Gustave Serrurier-Bovy. Period photograph. Tervuren, Musée Royal de l'Afrique Centrale.

the pale skin pulsed the unknown; the ivory disguised more than it revealed. Charles van der Stappen exploited this symbolic depth in his *Mystery* or *The Secret*: Inspired by Athena, the helmeted, armoured woman gives nothing away. Her face remains enigmatic. Her gesture imposes silence, and the material heightens her presence with a sense of mystery.

However, ivory continued to be used exclusively for small-scale projects; the need to join the constituent parts inhibited the realisation of large-scale works or

the evocation of movement. Certain styles and subjects prevailed. The rendering of draped materials or realist themes often resulted in mawkishness. However hard it was to master, ivory became very popular with the public after 1897, as can be seen from the vast output of the time. These sculptures were not primarily works of art but luxury objects to be placed on view, hence the care taken to produce plinths that accentuated the beauty and value of the material. And ivory remained the ideal material for the decorative object. By the 1900s, chryselephantine sculpture was almost entirely confined to the production of ornamental objects. A candelabra designed by Egide Rombeaux showed a naked woman surrounded by thistles, her ivory body harmonising perfectly with the silver.

The taste for different materials was a byproduct of the development of polychrome sculpture. The interplay of colours could be obtained by combinations of precious materials smacking of decadentism or, more simply, by the use of paint. Khnopff used polychromatic plaster or tinted wax to create the idolatrous illusion that his inaccessible icons were made of flesh and blood. The jeweller, Philippe Wolfers, a genius when it came to the marriage of precious materials, was a master of his art.

The Tervuren exhibition boasted some remarkable examples of the applied arts. The exhibits by Fernand Dubois and Philippe Wolfers were among the most striking. Dubois presented a box, *The Ages of Life*, whose silver-plated bronze frame was enveloped in fluid interwoven lines and small objects – fans, seals, and brooches. Wolfers exhibited sections of tusk delicately carved with floral motifs and set in bronze bases: *Poppies* or *Iris and Lizards*. These small vases were accompanied by a monumental flower-holder, *The Swan's Caress*: a whole tusk held under the wing of a powerfully modelled bronze swan. This was a resounding success and led to many commissions.[46] The walls of the Salon d'Honneur carried eight wall hangings produced by Hélène de Rudder from sketches by her husband; these used a technique combining fabric and embroidery with themes contrasting 'Civilisation' and 'Barbarism'.

A widespread style

The extremely popular exhibition at Tervuren provided Art Nouveau with one of its most popular guises: 'Congo style'. This became highly fashionable. Its forms were derivative, although the Art Nouveau spirit was not always respected, and a sort of rocaille eloquence resulted. Thus Gustave Strauven, who had worked for Horta as a draughtsman, enlivened the graphic style of his ironwork with a whimsical lightness of touch. The woodwork and railings of the house that Strauven built for the painter Saint-Cyr, in Square Ambiorix (1900), displayed a matchless exuberance. His lyrical use of line found expression in a visual bel canto that covered the façade in a filmy lacework of iron unravelling against the sky. Strauven also used arches detached from the façade to create an interplay of light and shadow. In the business premises at the corner of Avenue Louis Bertrand and Rue Josaphat, he created a variety of decorative effects by using different-coloured bricks and a number of different-shaped bays.

This rocaille Art Nouveau style, in Strauven's distinctive interpretation, formed a striking contrast to the many mediocre buildings then being erected and thus contributed to the triumph of Art Nouveau in Brussels. The townhouses on Rue Franz Merjay and Avenue Molière by Paul Vizzavona were closely modelled on Horta's style, but their ornamentation never rose above an anecdotal lyricism that lacked any true relationship to the architectural structure. Eclecticism also acquired a 'fashionable' vocabulary under the influence of Art Nouveau. In 1902, the architect Jules Brunfaut undertook a commission from the engineer Edouard Hannon, drawing his inspiration from Horta's work while remaining loyal to his customary Italian Renaissance style.[47]

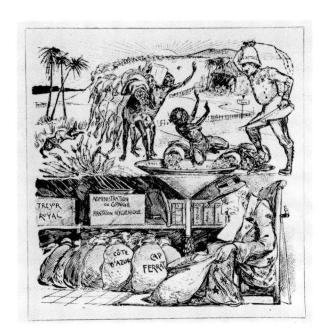

Above: The productivity of free labour, in *La Trique*, 25 February 1906. Private collection.

Opposite: Fernand Khnopff: *Vis. Superba. Formae*. Drawing for the frontispiece of the exhibition catalogue for *Congo Free State. Chryselephantine Sculpture*, Brussels-Tervuren, 1897. Drawing on a photographic background with coloured highlights on paper, 20.2 x 13.5 cm. Brussels, Bibliothèque Royale Albert Ier, Cabinet des Estampes.

Congo Exhibition at Tervuren, 1897. Salon
d'Honneur designed by Paul Hankar. Period
photograph. Tervuren, Musée Royal de
l'Afrique Centrale.

Congo Exhibition at Tervuren, 1897. Salon
d'Honneur designed by Paul Hankar.
Period photograph. Brussels, Archives
d'Architecture Moderne.

The middle classes jumped on to the Art Nouveau bandwagon with the help of architects and property developers who, like Blérot, brought mass-production techniques to the style in vogue. Ernest Blérot built entire streets – the Saint-Boniface district in Ixelles and Rue Vanderschrick in Saint-Gilles. The façades were all different and misleading, since the interior plan was always the same. These houses formed an elegant urban landscape that, as a bonus, allowed the owners to express their individuality; the type of windows, the design for the woodwork on the front doors, the sgraffiti, the appearance of the gables, the iron-work, the shape of the bow-windows varied from one house to the next, while creating an undeniable impression of unity.

One of Horta's imitators was Paul Saintenoy. An eclectic architect, he was also the creator of that incredible patchwork of architectural styles, the Palais de la Ville de Bruxelles at the World Exhibition held in Brussels in 1897. On Rue Montagne de la Cour, he built a Neo-Gothic pharmacy (1895), a few yards down a department store, Old England (1899). The latter was a simple glass and iron structure that took the Parisian model of the shop to new heights of trans-

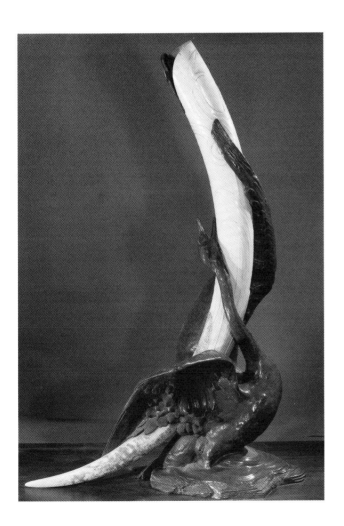

Philippe Wolfers: *The Swan's Caress*, 1897. Bronze and ivory, H: 173 cm. Brussels, Musées Royaux d'Art et d'Histoire.

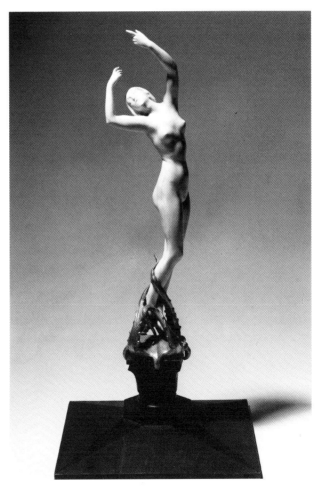

Pierre Braecke: *Towards Infinity*, 1897. Ivory, gilt bronze, 40.8 x 12 x 7 cm. Wooden plinth designed by Victor Horta, 14 x 28 x 28 cm. Brussels, Musées Royaux d'Art et d'Histoire.

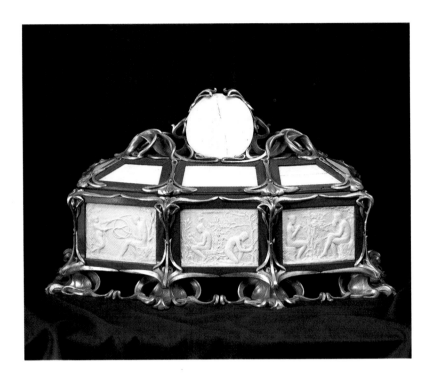

Opposite: Fernand Dubois: wedding chest, before 1897. Ivory, plaster, silver-plated brass, tropical wood. 30 x 70 x 46 cm. Brussels, Musées Royaux d'Art et d'Histoire.

Right page: Charles van der Stappen: *Mysterious Sphinx,* 1897. Ivory, alloy of copper and silver, onyx plinth, 56.5 x 46 x 31.3 cm. Brussels, Musées Royaux d'Art et d'Histoire.

Below: Fernand Khnopff: *Mask*, 1897. Polychromatic plaster, 18.5 x 28 x 6.5 cm. Brussels, Bibliothèque Royale Albert Iᵉʳ, Cabinet des Estampes.

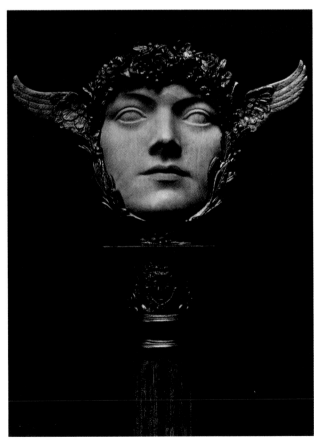

parency. Only the wrought ironwork maintained the Art Nouveau exuberance. Horta's influence is clear, but the effect unsatisfactory.

The growing popularity of Art Nouveau was not limited to architecture. It also generated soaring public demand that caused industries like the Val-Saint-Lambert crystal factories, the Boch ceramics firm or the Brussels glassworks to produce vases, pottery, or stained-glass windows in the fashionable style. A far cry from the aesthetic requirements of the pioneers and the prices paid by their patrons, a variety of less virtuosic but more affordable stereotypical items began to be mass produced. In stained-glass windows, it was not the abstract motifs prized by Horta and van de Velde that prevailed but plant and animal motifs whose symbolic meanings were derived from the popular imagination of the time. Boch began to mass produce lines of pottery that reproduced but attenuated Art Nouveau principles: crockery, decorative pieces, and faïence tiles. This was a thriving trade which affected interiors and façades, private homes and public places; products were exported as far afield as Buenos Aires.

At the end of the century, the Brussels *communes* invested a great deal of money in education. Different models were followed in Brussels, Saint-Gilles, Schaer-

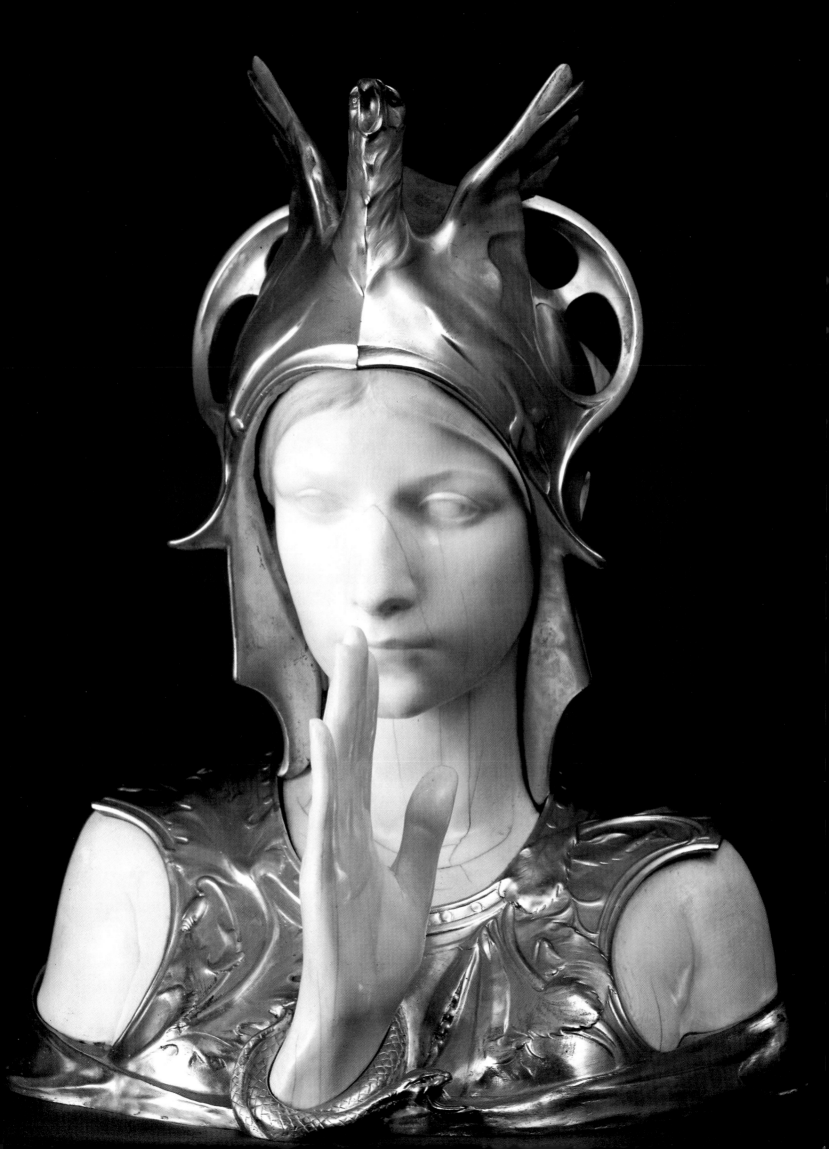

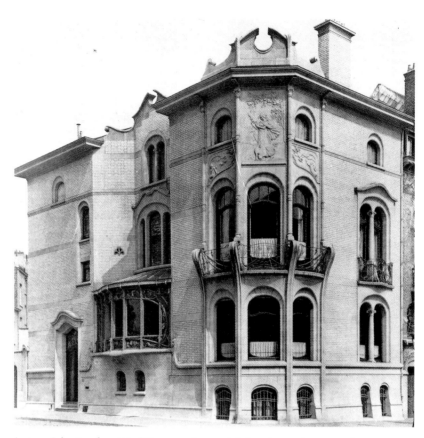

ABOVE: Jules Brunfaut: Hôtel Hannon, 1 Avenue de la Jonction, at the corner of Av. Brugmann (1903). Period photograph. Brussels, 1905.

RIGHT PAGE: Gustave Strauven: house for the painter Saint-Cyr, façade, 11 Square Ambiorix (1898).

beek, and Ixelles. In terms of stylistic choice, the Neo-Renaissance model, seen as the embodiment of modern knowledge, was adopted for municipal schools, while the Neo-Gothic style, the incarnation of devout faith, remained the prerogative of Catholic schools. The commune of Schaerbeek was conspicuous for its choice of architect, Henri Jacobs, who applied the Art Nouveau style to schools. The high architectural quality of these schools was intended to be didactic in itself; it was supposed to inculcate the people with a taste for Goodness and Beauty. No detail was spared. Frescoes, mosaics, lamps, school furniture, and sgraffiti combined to make the whole building a total work of art committed to its pedagogical mission. Henri Jacobs used the services of many collaborators, painters, decorators (including Privat Livemont), and artisans who shared his moral vision. In the same spirit, Jacobs

drew up plans for the low-cost housing estates built by le Foyer Schaerbeekois: Olivier in 1903–1905 and Helmet in 1908–1910. They were financed largely by the public authorities who had recognised the right of the workers to decent housing. Another socially-concerned architekt was Emile Hellemans, who built the low-cost housing on Rue Blaes and Rue Haute in the heart of Brussels. It was modelled on the traditional apartment block, and its spatial disposition and ornamentation showed it to be the product of a pragmatic rationalism that made economy an expression of moral integrity. These buildings provided all their inhabitants with comfort, sanitation and privacy, but precluded personal expression; each block was similar, and the façades were standardised and repetitious. The collectivist initiative was under way. This need for social uniformity was not a product of the Marxist doctrines that ani-

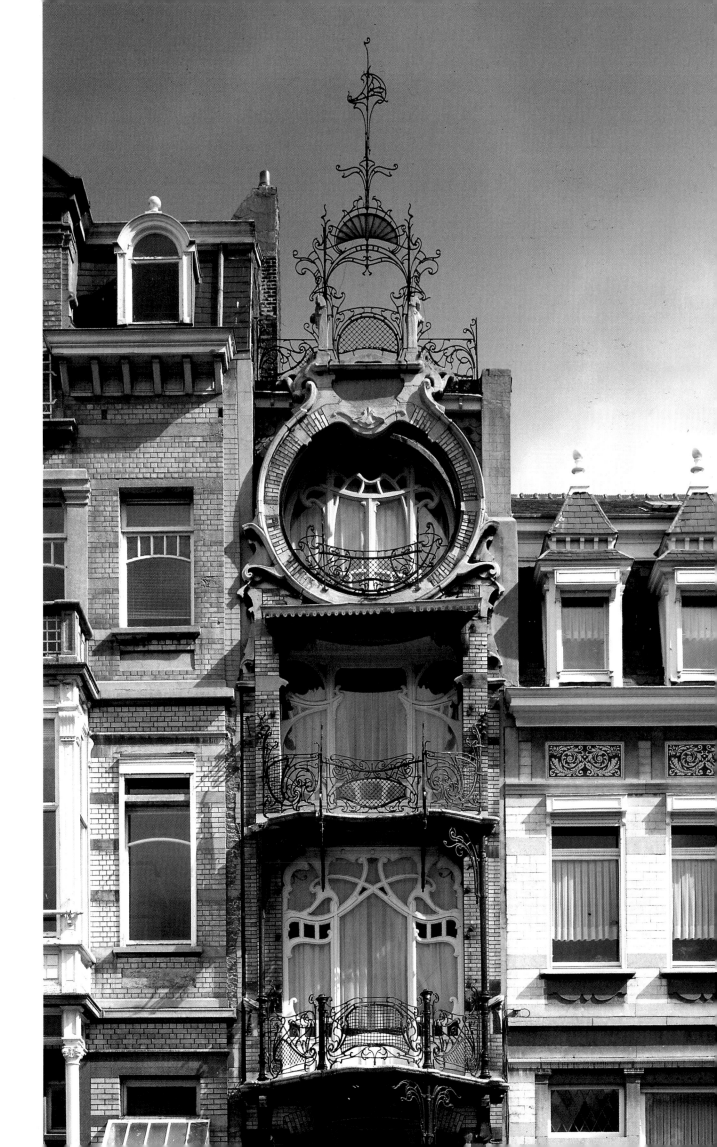

mated the avant-garde in the 1920s; the architects believed in an interventionist approach, intending to educate a working class that had to be organised and guided to avoid unruly behaviour or unrest. Social architecture was strongly influenced by the military model. Similar to the barracks, the apartment block regimented individuals whose only importance was as part of a collective. These buildings not only organised the workers' life, but also shaped their spirit by hammering out slogans. Thus the façades of the Cité de l'Olivier bore the maxim "Be active, be clean, be thrifty."

Under the guise of moral edification, social architecture prevented any possibility of individualisation. Rationalism and rigour merged in a shared desire for order and stability that ultimately attacked the very notion of ornamentation. The arabesque had found its way into everyday decoration, and now aroused a feeling of weariness; the architects, on the lookout for a new spatial order, turned to Vienna.[48]

In fact, Belgians and Austrians alike had drawn their inspiration from the Arts and Crafts movement. In the programme-manifesto of the Wiener Werkstätte, published in 1905, Hoffman acknowledged the debt he owed to Ruskin and Morris. Although the Belgian 'line' had exerted a certain influence in Vienna – apparent, for example, in Wagner's Majolikahaus or in the Austrian halls of the World Exhibition in Paris designed by Olbrich and Hoffmann – it had rapidly been superseded by Mackintosh's contribution to the eighth Viennese Secession in 1900.

In 1898, Fernand Khnopff, who wrote a regular column about artistic life in Brussels for *The Studio*, was invited to the first Sezession exhibitions, and an article paying homage to him appeared in the second issue of *Ver sacrum*, a magazine whose layout Khnopff himself designed. His work, like that of Minne, fascinated an entire generation of Viennese artists, and his influence on the art of Klimt was decisive. Conversely, Austrian modernism seems to have appealed to him because of

ABOVE: Henry Vandevelde: Bibliothèque Solvay, Parc Léopold (1903–1904).

OPPOSITE: Paul Saintenoy: former Old England shops and warehouse, detail of the ironwork, 2 Rue Montagne de la Cour and 10 Rue Villa-Hermosa (1899).

its taste for restraint and rigour. The house-cum-studio that Khnoppf commissioned in 1900 from the architect Edmond Pelseneer, on Rue des Course, a stone's throw from the university, signalled a break with both eclecticism and the floating graphic line of Art Nouveau. It heralded a more classical and more streamlined sensibility. The statue of Aphrodite placed on the gable showed that the master of the house worshipped at the altar of Beauty. Like the artists of the Sezession, Khnopff had a marked liking for Greek Antiquity, plain, white surfaces, pure geometric forms, and Japanese art. He countered the brightly-coloured formal exuberance of Belgian Art Nouveau with silence and restraint.

The following year, the exhibition of the art colony at Darmstadt, entitled 'Ein Dokument deutscher Kunst', confirmed the impression that the Belgians were only to play a minor role in the future of architecture. Two articles in *L'Art moderne*[49] revealed Serrurier-Bovy's thoughts on the abandonment of iron as a constructional element and the rejection of ornament as an impediment to the legibility of space. Peter Behrens' principle that "nothing in architecture or decoration should be approximately, distantly or even conventionally reminiscent of anything alive, whether it be of a human figure or a plant"[50], rang out like a condemnation of the increasingly bombastic Art Nouveau style. The exhibition at Darmstadt was to exert a considerable influence on Serrurier-Bovy, who kept it in mind when he built his own house at Cointe, near Liège.

As Art Nouveau began to lose momentum, Serrurier modified his style. His simplification of form, which was dictated by financial considerations – the artist wanted to create a popular range of furniture – opened up new horizons. Influenced by the aesthetics of the Wiener Werkstätte, Serrurier abandoned the powerful curves that had structured his furniture in favour of geometric designs. Forms became more slender and elegant, stylishly adorned by brass leaves punched with holes that allowed glimpses of wood or

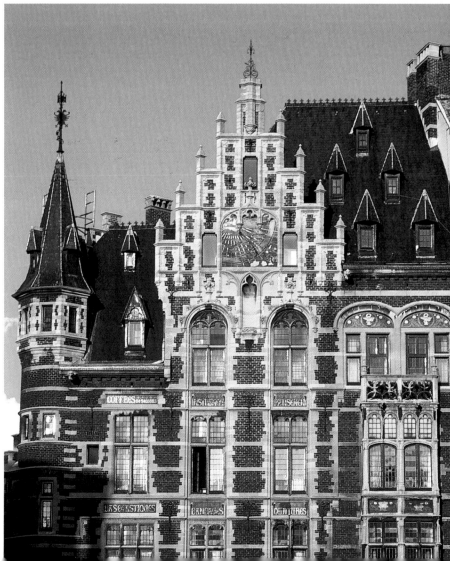

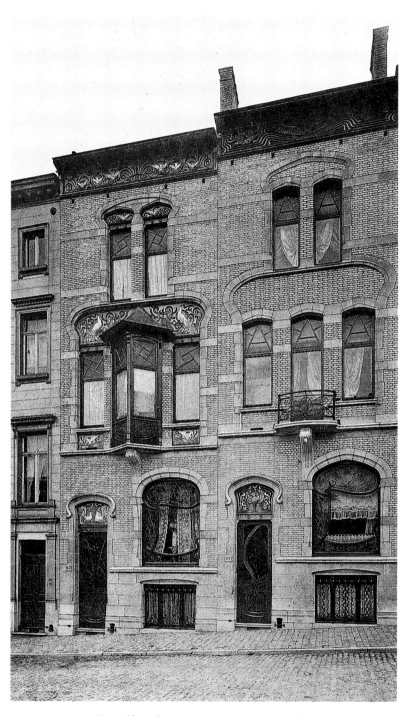

Ernest Blérot: houses, 42–44 Rue de Belle-Vue (circa 1900). Period
photograph. Brussels, Bastin & Evrard.

RIGHT PAGE: Ernest Blérot: house, detail of the loggia, 38 Avenue du
Général de Gaulle (1904).

coloured enamel. He also employed marquetry borders
made of precious woods that boasted almost abstract
patterns. The modernism of his increasingly rational
forms was countered by his continued use of precious
materials, which confined sales of these everyday
objects to the privileged classes.

In 1905, Liège organised a World Exhibition. Ser-
rurier presented his own pavilion and entered the open
competition to design "decoration and furniture for
low-cost housing" built in Cointe. His so-called "Silex"
furniture ushered in the productivist principles that
were to animate the twentieth-century avant-garde.
Serurrier presented a range of furniture made of vari-
ous inexpensive woods – elm, poplar or pine. The
alternating patterns of screw-heads and hinges served
as ornamentation. Averse to rationalist uniformity,
Serrurier had little in common with the utilitarianism
which was to influence architects in the 1920s. He
remained first and foremost a decorator, designing
linen curtains decorated with small pieces of applied
coloured cotton, and stencils that made it possible to
personalise furniture and walls. Serrurier had achieved
an "art for all" reflecting the political and aesthetic
imperatives discussed above. However, the question
remained whether this art was suitable for the workers
for whom it was designed. In a contemporary article,
Jules Destrée wrote: "Working-class taste has been so
oddly distorted by flashy and artificial things, by imi-
tations of bourgeois luxury, that I fear it will take some
time for people to appreciate all the wholesome, new
things introduced by M. Serrurier."[51] This comment
showed a growing awareness of the gulf that existed
between the dreams of the progressivist intellectuals
and social reality: a dilemma that was to continue
throughout the history of the twentieth-century avant-
garde.

Serrurier's firm, employing around one hundred
workers, soon ran into difficulties; the studios in Liège
were repossessed and one of his main commissioners
withdrew. The situation improved around the time
of the World Exhibition in Brussels in 1910. But this
recovery was short-lived. Serrurier died on 19 Novem-
ber, although his firm survived until 1918.

The new generation of architects preferred more
geometric forms. Paul Hamesse and Léon Sneyers, for-
mer collaborators of Paul Hankar, adopted Viennese
ornamental motifs: simple crowns or crowns with three

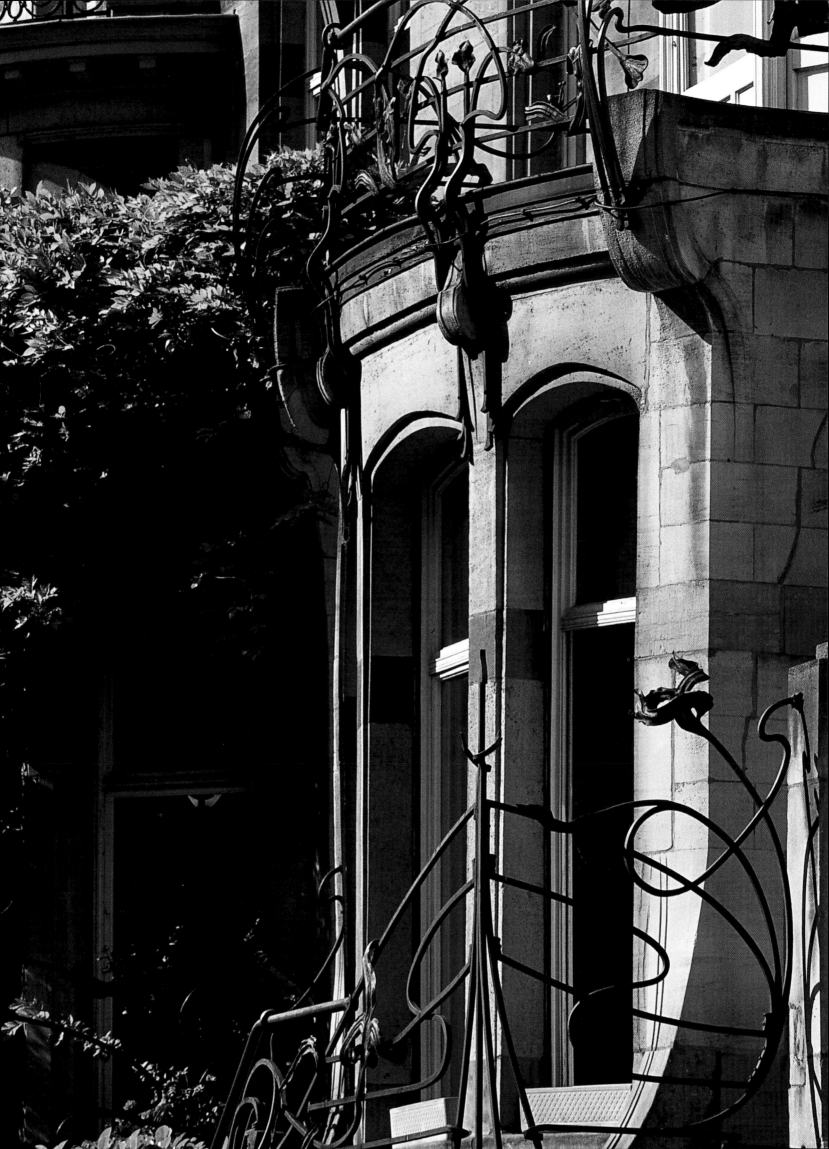

ribbons, the use of repeated horizontal lines, often in groups of three to emphasise the slender ridge-lines, a taste for truncated forms, chequered patterns, and the ornamental use of evenly-spaced spherical studs.

From Turin to Vienna: early signs of change

The two main trends followed by Belgian architects and artists were clearly identifiable at the International Exhibition of Decorative Arts held in Turin in 1902. As part of a retrospective survey[52] of decorative arts in Belgium during the last decade of the nineteenth cen-

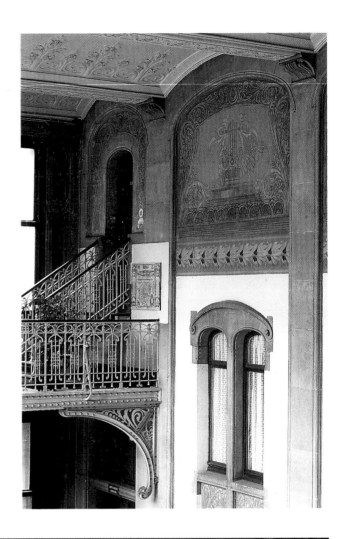

OPPOSITE: Henri Jacobs: Athénée Emile André, 58 Rue des Capucins (1907–1910).

BELOW: Henri Jacobs: state school, main hall, 229 and 243 Rue Josaphat (1907).

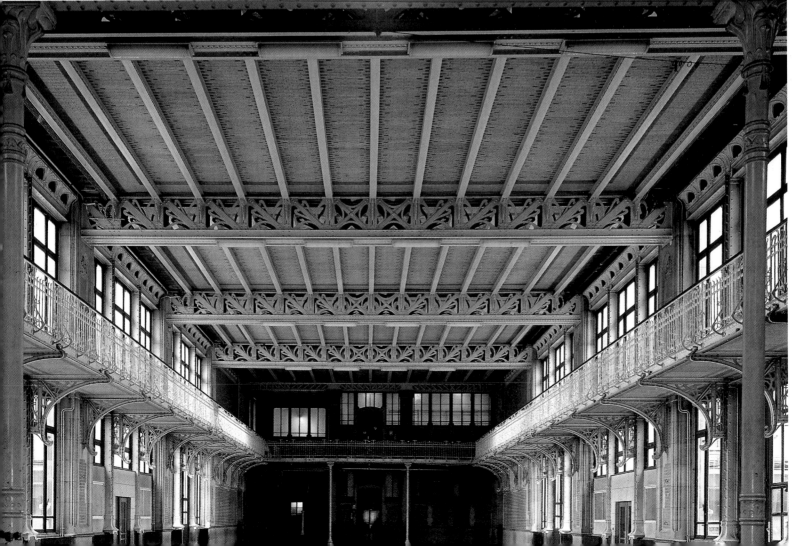

tury, Horta emerged as an established figure while the new trends were represented by Léon Sneyers and Adolphe Crespin on the one hand, and Georges Hobé and Antoine Pompe on the other.

The Belgian section began with the Book Fair, presented by Léon Govaerts. The latter selected a florid line, a synthesis of old styles and Horta's stylistic approach. The Belgian publishers Deman, Lamertin and Veuve Monnom exhibited publications spanning over fifteen years. Beside Wolfers, who received universal praise, Horta was given the largest amount of space. He sent a set of sycamore office furniture and a dining room made of finely carved American ash. The architectural aspect of his earlier pieces of furniture – with powerful contours and complex forms creating an interplay of light and shadow – was superseded by more enveloping forms. The elegance of the pieces was enhanced by their surroundings: large tapestries painted on rep by Emile Fabry, whom Horta had just commissioned to decorate the dining room of the Hôtel Aubecq. Horta was unanimously acclaimed by the press and awarded a prize by the judges. Other artists distinguished themselves, notably, Hélène de Rudder with her tapestries *Spring* and *Summer*, Fernand Dubois and his silver-plated bronze candelabras, which perfectly exemplified the Belgian line: abstract, fluid, lively and well-balanced.

Hobé and Pompe, partners from 1899 to 1903, provided a contrast to Horta's "showy opulence" with a liking for simplicity and subtlety that softened the severity and structural transparency of Arts and Crafts furniture. Sneyers and Crespin, by contrast, favoured stylised ornament that bore no relation to structure.

In the years after the Turin exhibition, the prevailing trend for geometric designs became more marked. It was apparent in buildings by Paul Hamesse, such as the Cohn-Donnay interior (1904), the conversion at 6 Rue des Champs-Elysées and the house at 120 Avenue de Tervuren, that even before the construction of the Palais Stoclet, the whiplash line was obsolete. The

ABOVE: Emile Hellemans: low-cost housing, 146–174 Rue Blaes, Rue Haute, Rue de la Rasière, Rue Pieremans (1906–1915).

OPPOSITE: Théo Serrure: school, glass roof, 21 Rue Véronèse (1903–1908).

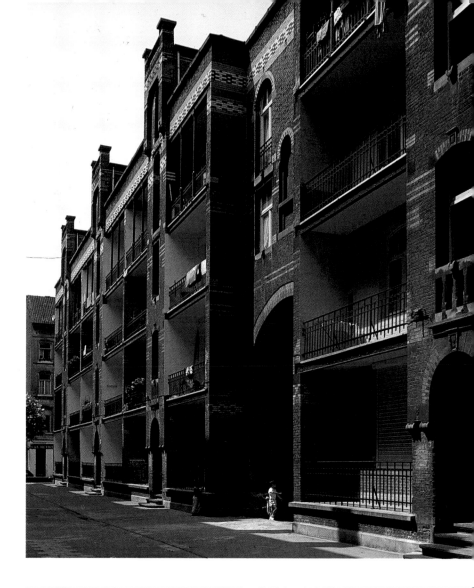

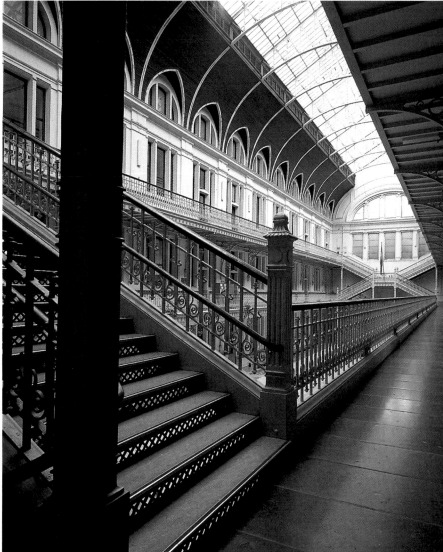

RIGHT PAGE, TOP: Gustave Serrurier-Bovy: lamp, circa 1905. Copper, H: 174.5 cm. Private collection.

BOTTOM: Gustave Serrurier-Bovy: vases, circa 1902–1904. Brass and crystal, H: 25 and 40 cm. Liège, Musées d'Archéologie et d'Arts décoratifs.

OPPOSITE: Edmond Pelseneer: villa for Fernand Khnopff, Rue des Courses (1900). Subsequently demolished. Period photograph.

BELOW: Gustave Serrurier-Bovy: music room, villa L'Aube, Cointe (1902–1904).

designs by Léon Sneyers for the Liège exhibition (1905)
or that of Milan (1906) combined distinctive Viennese
lines with Mackintosh-style motifs. Around 1910,
Sneyers opened an art gallery called L'Intérieur. The
designs sent in 1913 to the Ideal Home Exhibition in
London illustrated the transition from Art Nouveau to
Art Deco under the influence of Viennese taste: furni-
ture with pure, simple lines, contrasting stripes and
floral motifs, whose exuberance was kept strictly in
check by borders and the repeated use of baskets of
flowers.

The days of Art Nouveau in Brussels were num-
bered when construction began of a "nabob's dream,
a mysterious temple"[53] on Avenue de Tervuren: the
town house of Adolphe Stoclet, director of the Société
Générale. This enlightened patron of the arts was
responsible for the construction, between 1905 and
1911, of a masterpiece of the Wiener Werkstätte which
displays a perfect synthesis of styles, influences and
registers, ranging from the Germanised English to
modernised Arabic and *fin-de-siècle* Byzantine. The
Klimt friezes in the dining room, *Waiting* and *Ful-
filment*, call to mind the splendours of Byzantine
mosaics, though they were not composed of regular
tesserae. The textural effects are created by the use of
different techniques and materials: painting, enamels,
marble, inlaid semi-precious stones. The richness stem-
med from the variety: Hoffmann borrowed freely from
the Orient and from Mackintosh, without endangering
the balance or coherence of his own stylistic choices.
Although a dream house, this building was tailored to
meet everyday requirements: The services occupied the
lower wing, to the right of the staircase tower that
housed the staircase. The four male figures carrying
horns of plenty who crown the staircase tower are by
the sculptor Frantz Metzner, who also made the group
of women carrying offerings, enclosed in a perfect
square under the high glass roof of the staircase. The
structural framework, which had formed one of the
focal points of Art Nouveau architecture, is concealed
under a facing of white marble slabs; the sheer façade is
no longer a playground for light caught by mouldings,
hollows and projections. The windows, for example,
are flush with the general layout of the façade. The
weightless quality of the white marble façades is coun-
terbalanced by the thick bronze moulding strips. In
the railings, the central oval is surrounded by foliated

Gustave Serrurier-Bovy: design for a dining room. Watercolour.
Colour plate published in a supplement to *L'Art décoratif*,
November 1904.

OPPOSITE: Gustave Serrurier-Bovy: magazine rack, n. d. Oak
and brass. Private collection.

RIGHT PAGE

LEFT, TOP: Gustave Serrurier-Bovy: 'Silex' chair, 1905. Varnished
poplar, 90 x 40 x 44 cm. Private collection.

BOTTOM: Serrurier-Bovy: 'Silex' armchair, Château de la Cheyrelle,
1903–1905. Birch. Private collection.

RIGHT: Gustave Serrurier-Bovy: large wardrobe, circa 1905. Wood
with stencilled motifs; hinges and uprights made of green painted
metal, 225 x 94.5 x 47 cm. Brussels, Denys-Eischen collection.

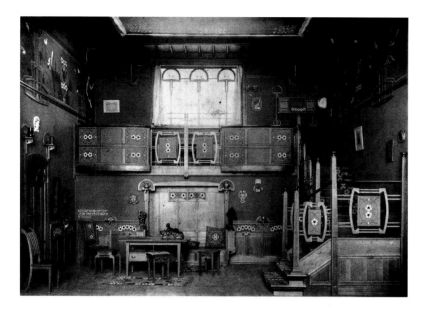

OPPOSITE: Léon Sneyers and Adolphe Crespin: artisan's studio shown at the International Exhibition of Decorative Arts at Turin in 1902. Watercolour. Brussels, Archives d'Architecture Moderne.

RIGHT PAGE: Léon Delune: house, 6 Rue du Lac (1904).

BELOW: Georges Hobé: design for living room/library produced for International Exhibition of Decorative Arts at Turin in 1902, drawing by Antoine Pompe. Brussels, Archives d'Architecture Moderne.

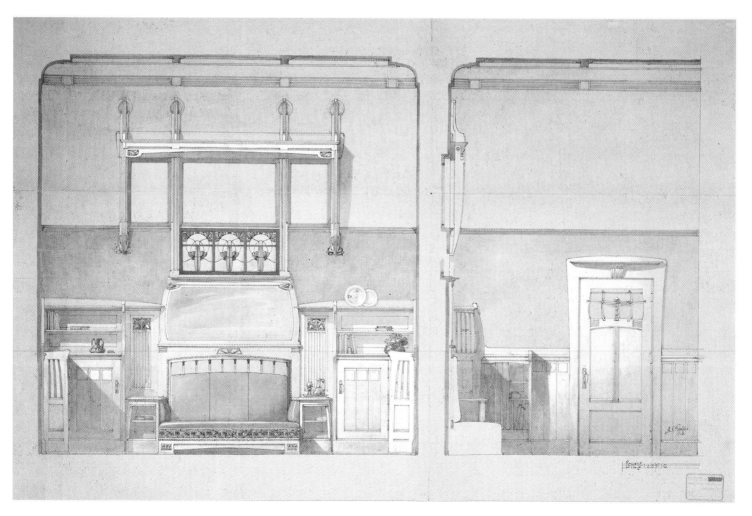

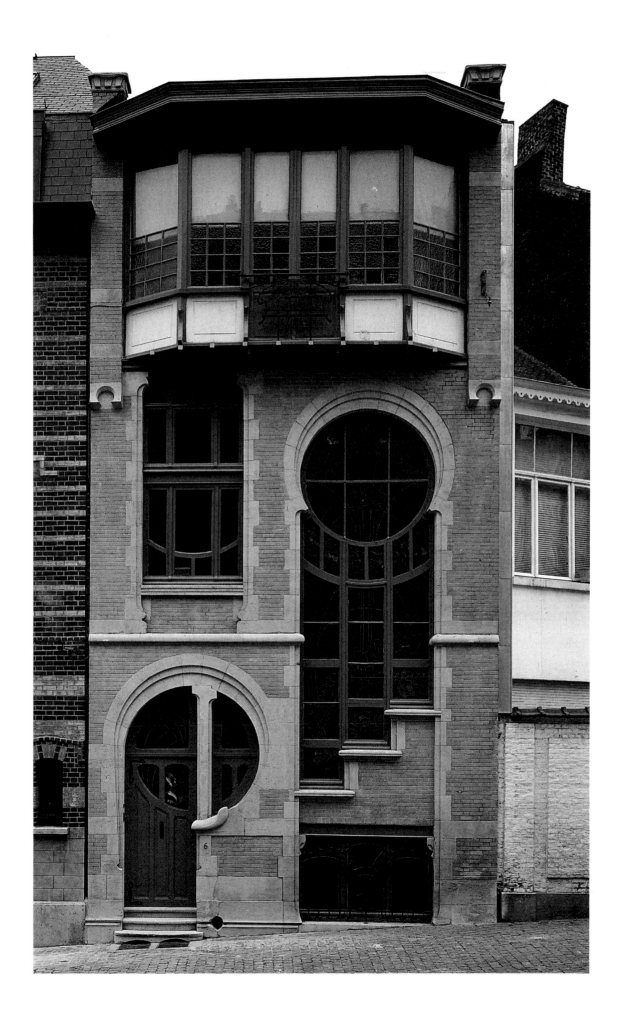

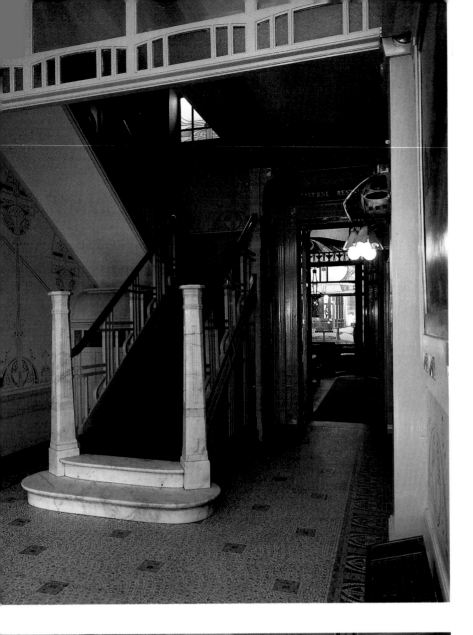

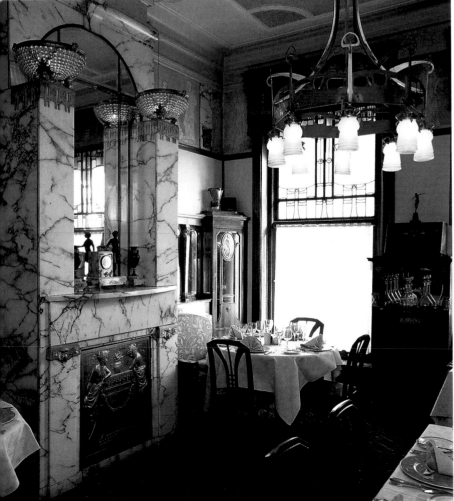

scrolls that echo the tree of life in Klimt's frieze, while the windows of the façade are geometrically divided; the contrast typifies the Viennese sensibility. In line with the apse, the central hall, two stories high, is flanked by the dining room and a study whose windows open onto the garden. The far end of the left wing houses a music room, decorated by a Khnopff painting. The semicircular stage at the end of this room extended the side façade, making it possible to create a large terrace outside the master bedroom on the first floor. Besides the master bedroom with ensuite boudoir and bathroom, the floor holds three children's rooms and a bedroom for their governess, as well as a playroom and a small bathroom. The guest rooms and servants quarters are on the top floor under the roof. The Palais Stoclet represents the crowning achievement of the 'artistic house' as envisaged by English designers, who thought the role of the artist should not be restricted to the practice of fine arts;[54] the beauty of the house reflects the artist's input at the planning stage and the owner's artistic temperament.

'Artistic house' also describes the house of the painter-interior decorator Paul Cauchie, designed the same year as the Palais Stoclet, next to the Parc du Cinquantenaire. The façade is dominated by a huge sgraffito panel – this was Cauchie's speciality. The sombre colours and elongated lines of female figures symbolising the arts are reminiscent of idealism. The stylised motifs, particularly the rose, show the influence of the Glasgow school. Extremely simple methods were used with great sophistication: contrasting textures such as the rock-faced rustication of the foundation courses, roughcasting, sgraffiti, and cement string

ABOVE: Paul Hamesse: Maison Cohn-Donnay, 316 Rue Royale, (1904).

OPPOSITE: Paul Hamesse: Maison Cohn-Donnay (1904).

RIGHT PAGE

TOP: Josef Hoffmann: Palais Stoclet, façade overlooking the street, 275 Avenue de Tervuren, (1904).

BOTTOM, LEFT: Josef Hoffmann: Palais Stoclet, façade overlooking the street, detail.

BOTTOM, RIGHT: Josef Hoffmann: Palais Stoclet, façade overlooking the street, detail.

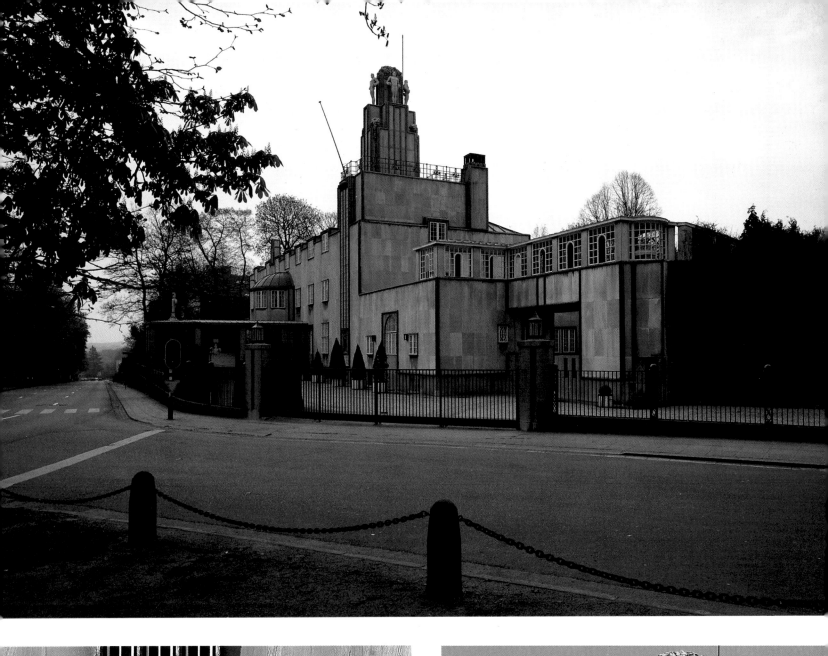

courses are combined with delicate colours, elegant window shapes and a Japanese-style screen of wooden pillars. Inside, the decorative woodwork and furniture draw their inspiration from Mackintosh's designs. In the posters he designed around 1900, those he made for the firm Engros-Lager in Hamburg, for example, Cauchie was deeply indebted to Mucha. By 1902, perhaps influenced by the widespread distribution of pictures of the Scottish exhibit at Turin, he succeeded in achieving a highly personal sense of balance, in compositions that combined dignified figures with abstract or geometric decorative motifs.

Mackintosh's influence is also obvious in the work that, in the eyes of many, marked the birth of modernism in Brussels: Doctor van Neck's clinic built by Antoine Pompe in Rue Wafelaerts, Saint-Gilles, in 1910. Some of the details are reminiscent of the Glasgow School of Art (1897–1899 and 1907–1909): the repetition of the three-sided loggias whose ascent is curbed by the horizontal cornice, the interplay of different types of brick, the delicacy of the wrought-iron work which, rational in spirit, provides access for cleaning the glass bricks of the first floor, the balcony of cut sheet-metal, and the complete asymmetry of the front door. This building marked Pompe's architectural debut; he had previously made a name for himself as a designer of carpets, jewellery and silverware, and wrought iron. The clinic heralded a change. As early as the 1900s, the modern tendency had challenged the validity of the mannered Art Nouveau style so firmly entrenched in Brussels. In the aftermath of the First World War, it emerged with renewed strengh.

Alongside the ubiquitous Art Nouveau, eclecticism went from strength to strength, achieving one of its most successful modes of expression in glass structures. In 1868, the King had decided to build a winter garden in Laeken, for which Balat had submitted the first plans in 1874. This building was not opened until May 1880. Faced with a typical nineteenth-century structure, the architect made full use of his classical training while relying on the rational principles governing metal architecture. He set the iron and glass corolla, topped by a skylight and in turn surmounted by the royal crown, on a Doric colonnade. As Viollet-le-Duc had recommended, the ornamentation of the metal parts is Gothic in inspiration, as are the flying buttresses; they radiate out from the dome as exposed

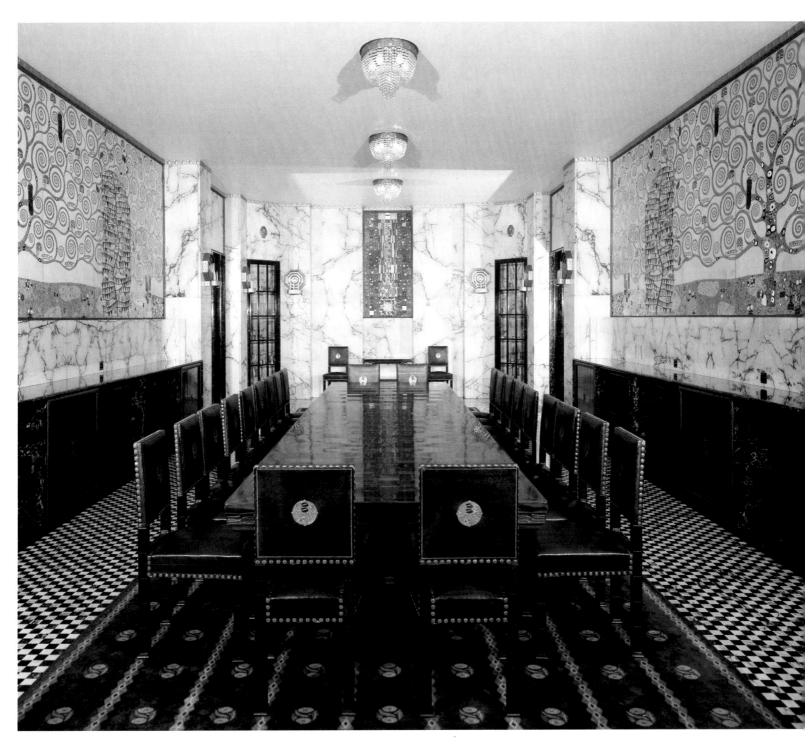

Josef Hoffmann: Palais Stoclet, dining room.

Left page: Josef Hoffmann: Palais Stoclet, façade overlooking the garden, detail.

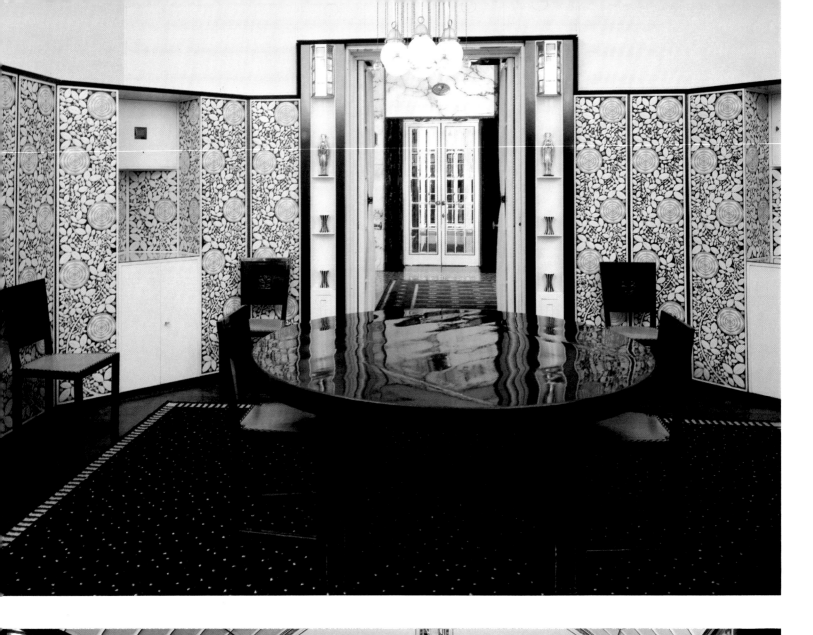

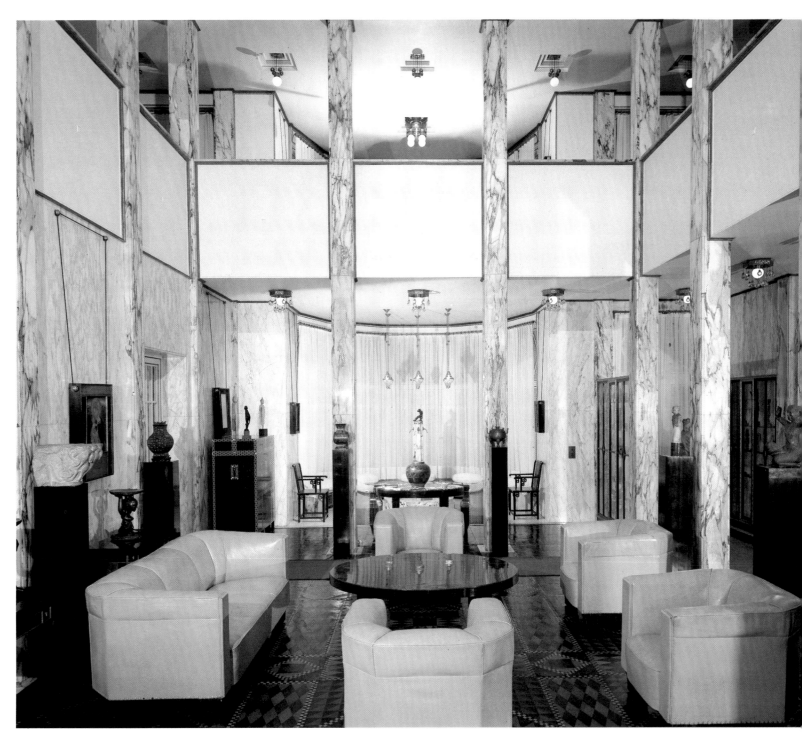

Josef Hoffmann: Palais Stoclet, drawing room.

Left page, top: Josef Hoffmann: Palais Stoclet, small dining room.

Bottom: Josef Hoffmann: Palais Stoclet, small hall.

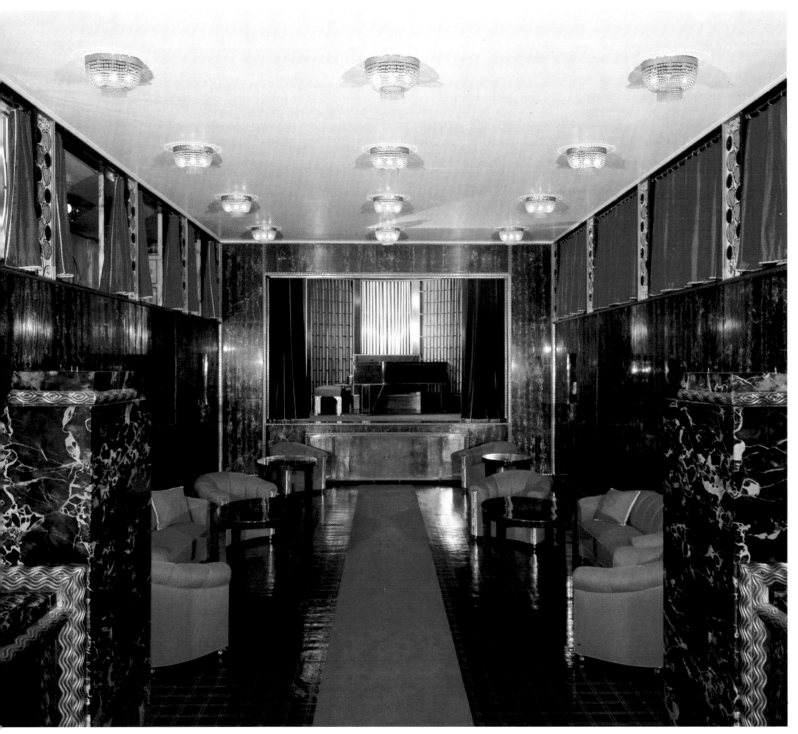

ABOVE: Josef Hoffmann: Palais Stoclet, music room.

RIGHT PAGE: Paul Cauchie: the architect's façade, 5 Rue des Francs (1905).

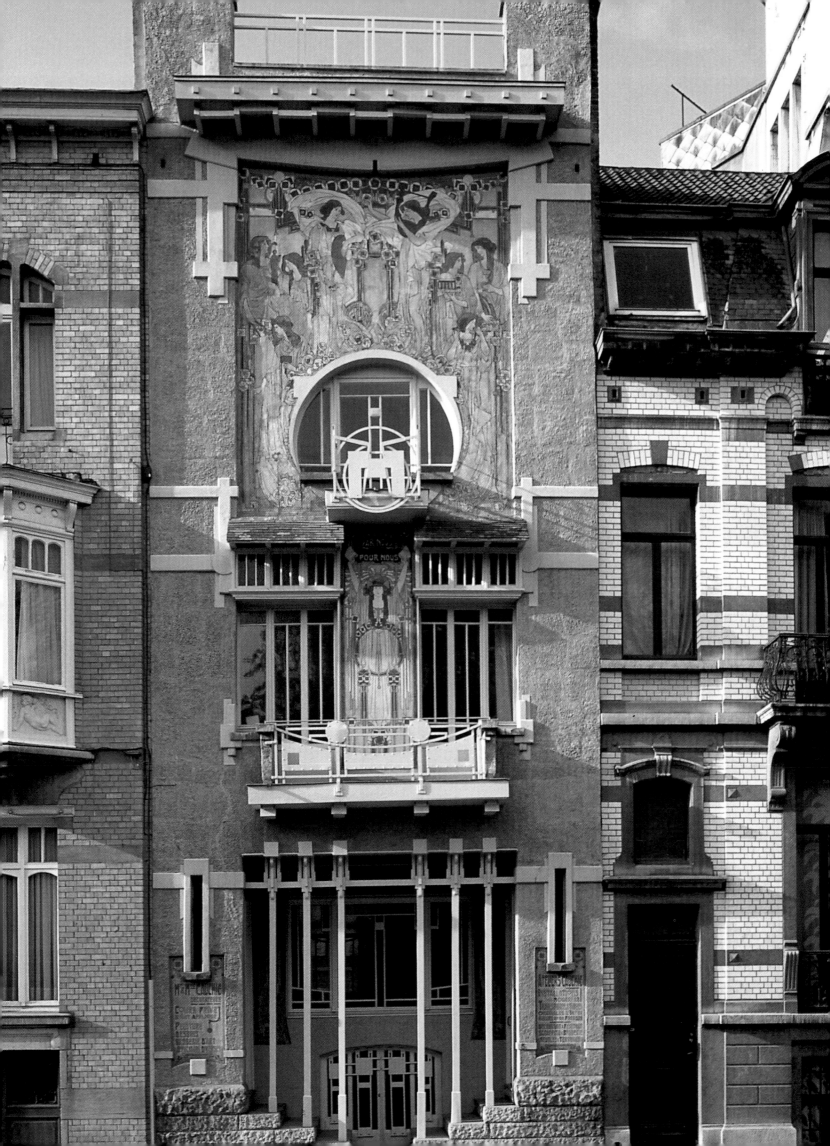

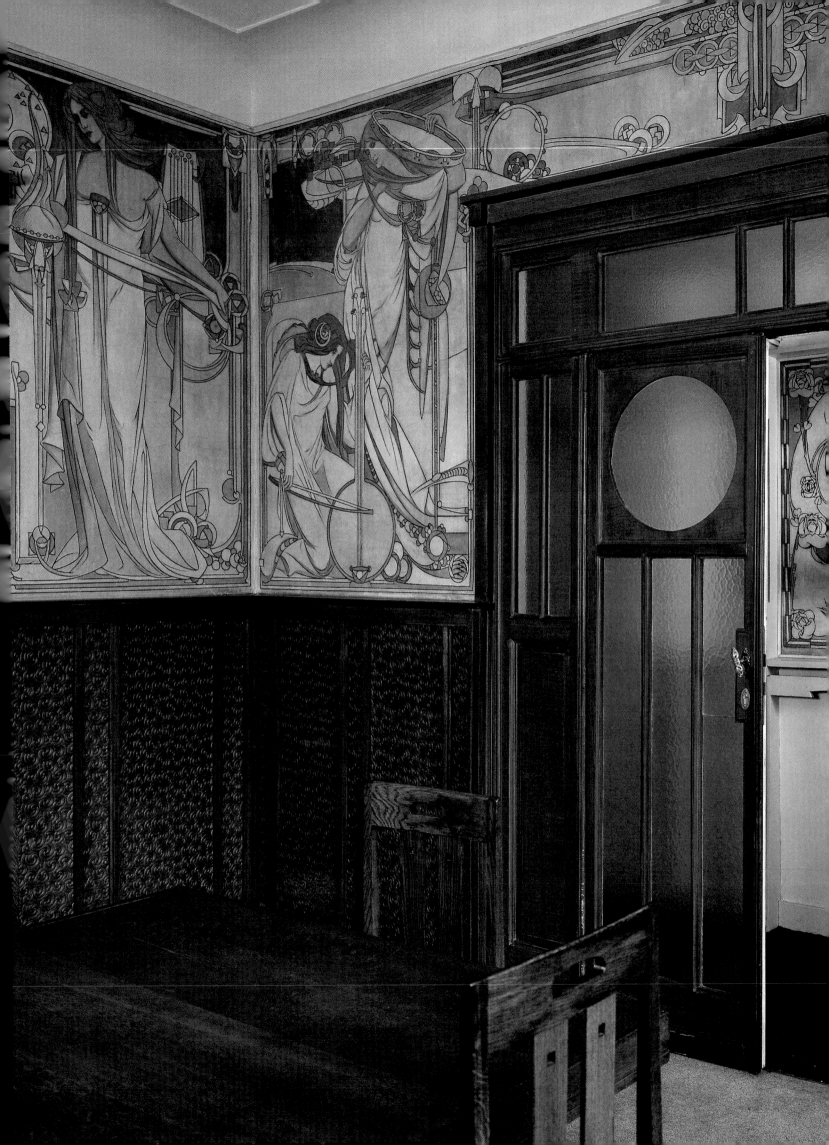

supports to form the thirty-six arches supporting the structure. Over the years, this complex was enlarged to make the Royal Greenhouses at Laeken one of the most famous glass structures in Europe. In 1886, Balat built the Congo Conservatory. Reminiscent of a Byzantine church, it was intended to house specimens from the private realm of Leopold II, who had inherited it the year before. In 1902, Maquet, whose project for the Mont des Arts enjoyed the King's support, added another greenhouse to the complex. The complex became a remarkable glass city, which Giraud further embellished with his new Palm Conservatory.

Musical life 1900

A comfortable bourgeois stronghold, Brussels extended its influence far beyond its city-limits as a result of the summer exodus. Spa, an internationally acclaimed resort on the edge of the Hautes Fagnes, acted as a magnet for European high society. Ostend, the royal seaside resort, embellished by major town-planning programmes at Leopold II's behest, and Blankenberghe, another prestigious beach resort, were popular holiday destinations for the bourgeoisie, who came to the coast for the sea air and expected to find all the facilities of the city.

Within this context, *fin-de-siècle* symphonic music experienced a watershed; Eugène Ysaÿe once again played a prominent role in Belgian musical life as did the custom of summer concerts. In fact, as soon as the opera and concert season ended, Belgian instrumentalists sought work in the fashionable summer resorts. They also headed for Brussels park, a legendary venue since the revolution of 1830. There, in the Waux-Hall, musicians from the La Monnaie orchestra played a daily morning concert. Concerts in Ostend's Casino featured touring stars, such as Caruso, and classical programmes. In Blankenberghe, the conductor Jules Goetinck put on entire festivals of Grieg, Beethoven, Berlioz, d'Indy and Gilson that were outstanding for their standard of performance. Last but not least, Spa, a popular haunt of the royal family, staged fairly traditional concert programmes.

Paul Cauchie: the architect's house (1905).

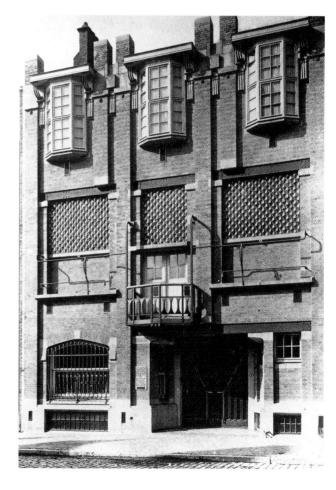

Eugène Ysaÿe, who developed a passion for conducting, contrived to conduct four Franco-Belgian festivals at the Waux-Hall in Brussels in May-June 1893. He was courageous enough to present a concert of Belgian music featuring Tinel, Gilson, Blockx, Albert Dupuis and Théophile Ysaÿe, followed by two concerts of French music, subtly split into the contemporary French school (Saint-Saëns, Massenet, Guiraud, Joncières) and the young French school (d'Indy, Chausson, Fauré, Dukas). This initiative was a memorable success and was well-supported by the press. After a season of European tours and another devoted to his first major tour in the United States, Ysaÿe felt sufficiently well prepared to found a new symphonic society in Brussels, at the same time as, in Paris, he founded his legendary duo with Raoul Pugno.

Ysaÿe was an ambitious man. From the start of its first season on 5 January 1896, the Société Sym-

TOP: Antoine Pompe: design for cutlery, plate and cup, circa 1900. Watercolour. Brussels, Archives d'Architecture Moderne.

Antoine Pompe: Doctor Van Neck's clinic, 53 Rue Henri Wafelaerts (1910). Period photograph. Brussels, Archives d'Architecture Moderne.

RIGHT PAGE: Alphonse Balat: Royal Greenhouses at Laeken (1874–1895).

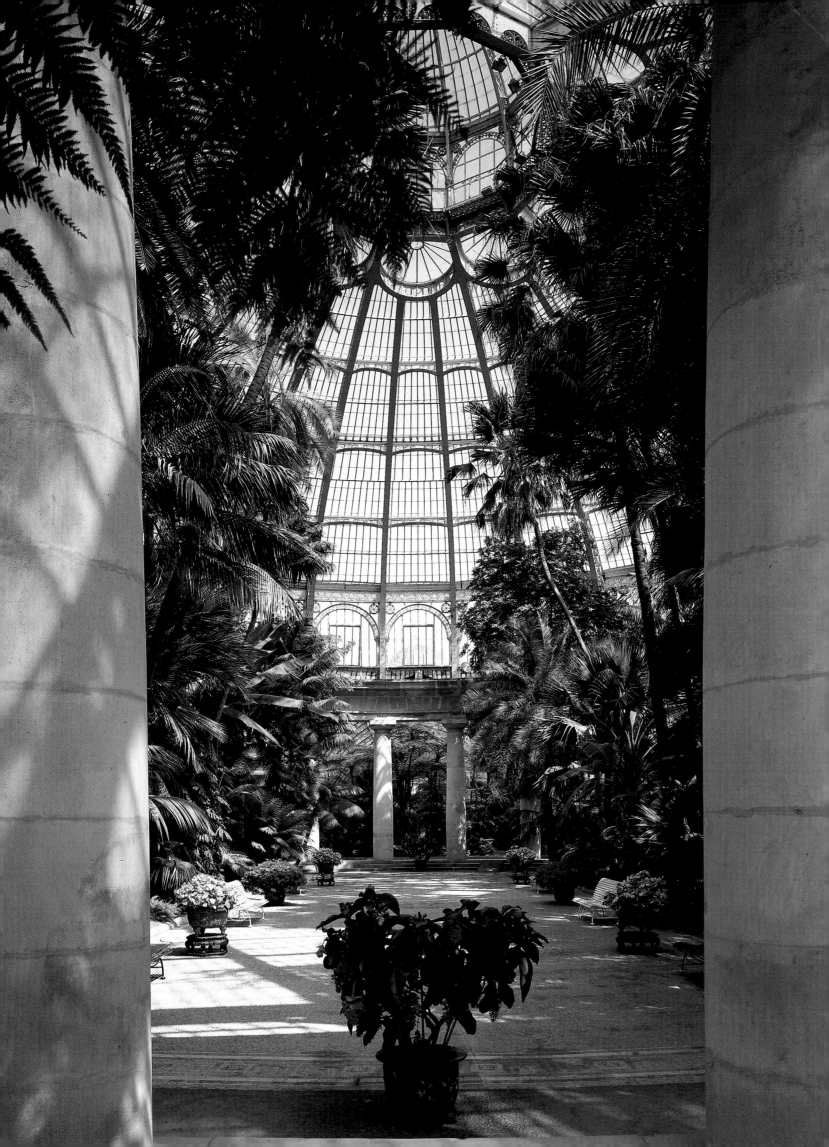

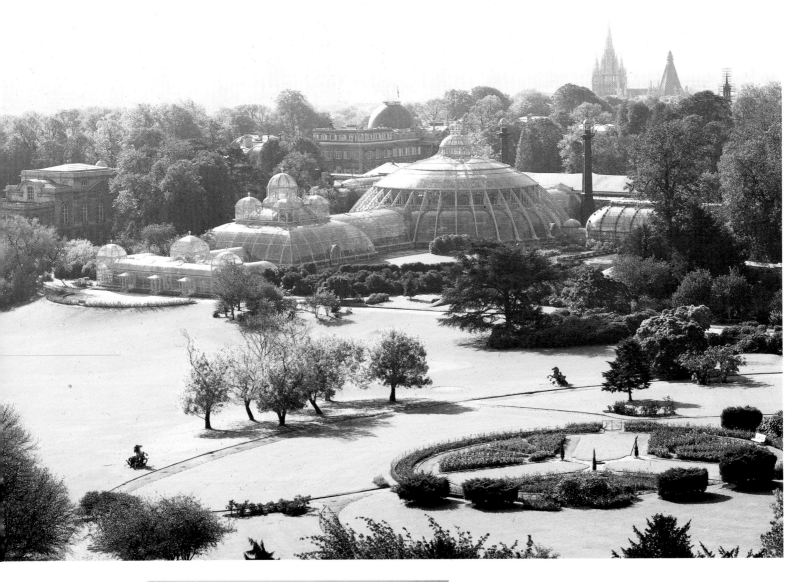

phonique des Concerts Ysaÿe aimed very high: a new orchestra with some one hundred musicians, four orchestral concerts on Sundays at the Cirque Royal with international soloists, four chamber music recitals at the Grande-Harmonie by the Ysaÿe Quartet. He had come to an understanding with the management of the Concerts Populaires and the Conservatory concerts, to judge by the co-ordination of their concert diary.

The future of the Concerts Ysaÿe soon looked bright.[55] Kufferath gave him a helping hand and wrote the reviews. The strong Franco-Belgian flavour of the Concerts Ysaÿe, mitigated by numerous forays into the German, Russian and Scandinavian repertories, perfectly complemented Dupont's Germanic tendencies and the Brussels Conservatory's historical concerts. D'Indy dedicated his *Istar* variations (1896) to the new society, probably influenced less by the book of the same name by Sâr Péladan than by its illustrations, produced by his friend Fernand Khnopff.

The chamber series soon petered out, but the orchestral concerts continued with panache. Ysaÿe was frequently absent, but his replacements included friends such as Mottl, Villiers Stanford, Svendsen, Martucci and Jehin. The orchestra's quartet soon

Left page: Alphonse Balat: Royal Greenhouses at Laeken (1874–1895).

Charles Girault and L. Schiffot: design for a new Palm Conservatory, 1907. Watercolour. Brussels, Archives du Palais Royal.

Below: Alexandre Marcel: design for an Art Nouveau palace, 1902. Watercolour. Brussels, Archives du Palais Royal.

Opposite: view of the Chalet Royal in Ostend, overlooking the sea front, with the casino in the background. Photograph by Neurdain, circa 1895. Brussels, Archives du Palais Royal.

Henry Meunier: poster, *Quattuor Ysaÿe*, 1895. Coloured lithograph, 122.2 x 87.2 cm.

RIGHT PAGE, TOP: Georgette Leblanc in the role of Leonora in *Fidelio*, n. d. Period photograph. Brussels, Archives du Théâtre Royal de la Monnaie.

BOTTOM: Carlos Schwabe: illustration for Vincent d'Indy, voice and piano score of Fervaal (Paris, Durand 1895). Etching in-4°, Brussels, Private collection.

became one of the most influential and versatile in Europe, if not the most accurate, and many other conductors and composers later congratulated themselves for having worked with the up-and-coming group. Ysaÿe's ecumenism worked wonders; his programmes brought together Saint-Saëns and d'Indy, or Bruckner and Brahms. Just as remarkable was his devotion to Belgian music. Without his efforts, the Brussels public would not have heard the works of an elite group of Belgian composers, generally influenced by Franck: Benoit, Blockx, Huberti, Kefer, Raway, Jongen, Biarent, Delcroix, Rasse or Théo Ysaÿe.

Joseph Dupont continued to invite leading foreign conductors to the Concerts Populaires and offered a wide spectrum of new but inoffensive works. Borodin, Glinka, Rimsky-Korsakov, Cui, Mussorgsky, Bruckner, Svendsen, Reznicek, d'Indy, Humperdinck, Saint-Saëns, Brahms, Tinel and Strauss were among the composers played. The performances were generally exemplary and made Dupont's reputation; death alone interrupted his success. Despite the arrival of Sylvain Dupuis, who had made a name for himself in Liège at the head of the La Légia choir and of the Nouveaux-Concerts which he had founded in 1888, with Dupont's death, an era had come to an end.

Passing easily from German to contemporary French and Russian music, Dupuis altered the Concerts Populaires. He no longer invited leading international conductors (Ysaÿe did this in his stead). He engaged top-calibre soloists and took up the challenge of large-scale works: the grandest oratorios, symphonies with chorus and soloists and nineteenth-century masses were explored. Furthermore, Dupuis brought to Brussels certain young composers whom he had introduced to Liège: Debussy, Charpentier, Delius, and Sibelius. Nor did he neglect Belgian music. When he returned to Liège in 1911 to take over as director of the Conservatory, the Concerts Populaires were unable to find a Belgian conductor capable of introducing audiences to the modern repertory. The society gradually declined into a more conventional repertory, and became increasingly out of step with its time.

At La Monnaie, Stoumon and Calabresi, exhausted by ten years of conflict, left the theatre for good. Their final years had boasted some sensational events; relying on the efforts of Philippe Flon, an uninspired but extremely reliable conductor, they had courageously held

their course against the breaking wave of Wagnerism. Few new works had featured: apart from their loyalty to Massenet – they played all his new works, *Cendrillon* in particular being a resounding success in 1899 – they mounted Jan Blockx's greatest success, *Princesse d'auberge*, which was an international hit. Their casts were always first-class. The Brussels public gave Georgette Leblanc a triumphant welcome in a production of *Fidelio* and in the Belgian première of *Thaïs*. When they turned their attention to Wagner, Stoumon and Calabresi not only won public acclaim – *Tristan* in 1894, *Rheingold* in 1898 – but also the wrath of devout Wagnerians, led by Maurice Kufferath and *Le Guide musical*.

One of the few points of common consent between the progressivists and conservatives during the last years of their dominion was the first performance of *Fervaal* by Vincent d'Indy: Wagnerian yet very French, this work, premièred in March 1898, was a sensation. The Paris smart set took it to their hearts, the Wagnerian press gave it their seal of approval and, despite the score's difficulties, the public was won over; d'Indy's star rose ever higher.

In 1900, Kufferath arrived at La Monnaie. Supported by Guidé, he engaged the services of conductors Sylvain Dupuis and Franz Ruhlmann. The company included Félia Litvinne, Claire Friche, Henri Albers, and soon Claire Croiza and Fanny Heldy. There was barely time to give the Belgian premières of *La Bohème* by Puccini and *Louise* by Charpentier (two resounding successes), before the Wagnerian machinery got under way. *Tristan*, in May 1901, with van Dyck and Marie Bréma, was an unprecedented box-office success. It was followed by *Götterdämmerung*, the *Ring Cycle* – the complete French-language première in 1903 – *Tannhäuser*, *Lohengrin*, and *Die Walküre*. Not until 2 January 1914 was the première of *Parsifal* staged. It was a huge success, but as its echoes died away, the sound of German army boots was heard in Belgium.

Kufferath did not confine himself to the Wagnerian repertory. Belgians were also featured (Blockx, Albert Dupuis, Gilson, Lauweryns, Buffin). Puccini attended the premières of all his works in a city that was to be his final resting place; verismo was admired but never popular. Richard Strauss, whom Kufferath liked, received carefully prepared performances; *Elektra* was mounted in 1910, and a Strauss week was organised in

1914. French music was represented in all its diversity. Massenet, Saint-Saëns, and Widor featured alongside Debussy – *Pelléas* was performed in January 1907 – and Messager. There was a complete performance of Berlioz's *Les Troyens* and important first performances, including d'Indy's *L'Etranger* (1903), *Le Roi Arthus* by Chausson (1903), and *Eros vainqueur* by Pierre de Bréville (1910). The reign of Kufferath and Guidé was a memorable one: a wide-ranging repertory, productions of unprecedented quality, a well-rehearsed orchestra and top-calibre soloists. Here again, the war put a stop to an era that might well have continued.

Even so, a more natural decline was beginning. Not until after the war, and the advent of the Pro Arte Quartet, did chamber music arouse the kind of excitement generated by the concerts of Les Vingt. The departure of Dupuis in 1911 hit the Concerts Populaires hard. The death of Gevaert, in 1908, undermined the prestige of the Conservatory concerts. It was the end of an era.

La Libre Esthétique
between Impressionism and Luminism

Although Symbolism came into its own with the new century, the naturalist vein had not been exhausted. As was the case with literature, painting was affected by a move back to reality, which found its anti-modernist expression in rural Flanders. In Brussels, there continued to be healthy support for the representation of nature. Moreover, Maus was an advocate of the radiant beauty of light. Among the artists he supported, the tragic figure of Evenepoel stands out. A fellow-student

TOP: stage set for *Parsifal* by Richard Wagner (Act 1, scene II), performed at the Théâtre Royal de la Monnaie in 1914. Period photograph. Brussels, Fievez collection.

CENTRE: stage design for *Parsifal* by Richard Wagner, for the Théâtre Royal de la Monnaie in 1914. Watercolour. Brussels, Fievez collection.

OPPOSITE: Jean Delescluze: set for *Elektra* by Richard Strauss, performed at the Théâtre Royal de la Monnaie in 1910. Period photograph. Brussels, Archives du Théâtre Royal de la Monnaie.

RIGHT PAGE: James Thiriar: poster for the French-language première of *Parsifal* on 2 January 1914. Lithograph. Brussels, Archives du Théâtre Royal de la Monnaie.

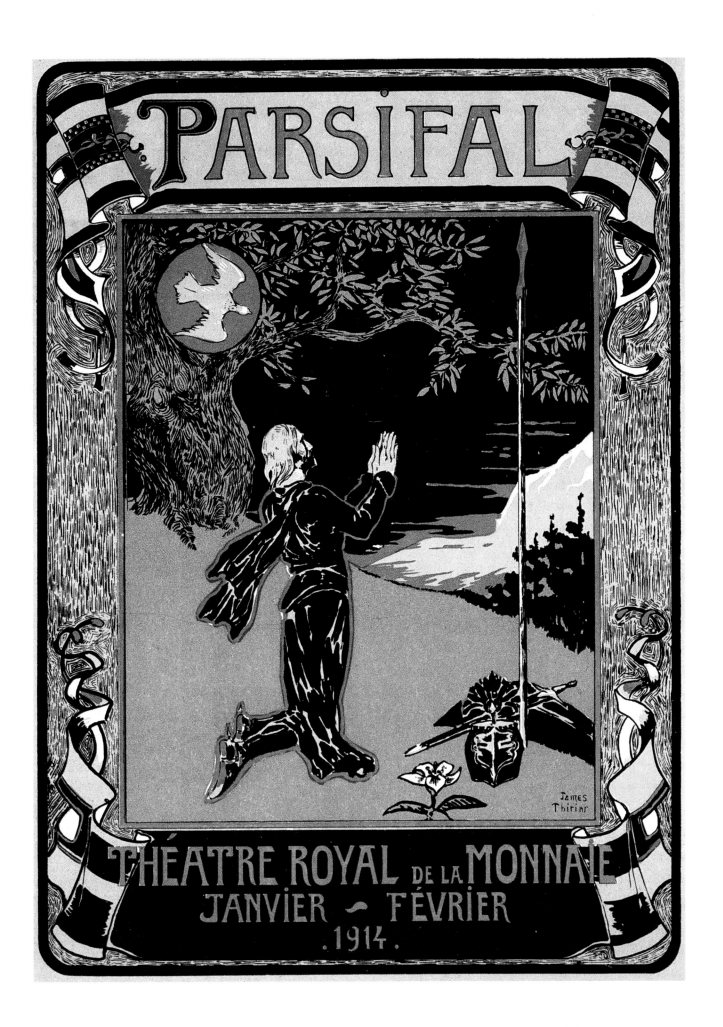

Henri Evenepoel: *Negro Festival at Blidah*, 1898. Oil on canvas, 81 x 125 cm. Brussels, Musées Royaux des Beaux-Arts de Belgique.

of Rouault and Matisse in Moreau's class, Evenepoel's creativity was stimulated by the fascinating lively city of Paris; the spectacle of urban life found highly original expression in his work. His impressionist approach was allied to a rapid technique that recreated the immediacy of life in all the brilliance of its colours and the intimacy of its urges. The visual power of Evenepoel's work transcended Realism and Impressionism. Unlike those of Lautrec or Forain, his paintings never intended to be caustic or acerbic. He gave freer rein to his talent for harmony, his exploration of different colour combinations, in his interiors and portraits. His determination to penetrate to the psychological heart of his environment went hand in hand with a desire to enrich colour by breathing new life into matter. In 1897, Evenepoel made a trip to Algeria, where he discovered a piercing quality of light that almost obliterated the object while accentuating volumes. The artist intensified this effect, stylising form in areas of flat colour in a Japanese-inspired style of art. His tragically early death, in 1899, brought his career to a premature end, leaving behind an impres-

sive body of work to which La Libre Esthétique paid tribute the following year.

From 1904 onwards, Maus decided to alter the format of La Libre Esthétique's annual exhibitions, centring them around specific themes (such as portraiture and landscape), national schools, and established styles. Alongside the retrospectives, these 'methodical shows', to use Madeleine Maus' expression, confirmed the need to go back over past history. The Salon of 1904 was completely devoted to the Impressionists. Maus brought together works by Manet, Sisley, Cézanne, Pissarro, Monet, Renoir, Guillaumin, Degas, Morisot, Cassatt, Seurat, Signac, Cross, Luce, Van Gogh, Gauguin, Lautrec, Vuillard, Roussel, Bonnard, and Denis. The only Belgian represented was Théo van Rysselberghe, a friend and associate of Maus, who had lived for long enough in Paris to be included in the French school. In fact, Maus intended to devote the Salon of 1904 exclusively to French artists, earmarking the next exhibition for tendencies outside the movement.

In his preface to the catalogue, he dwelt on the development and richness of French Impressionism.

Emile Claus: *The Chestnut Tree*, 1906 (?). Oil on canvas, 134 x 144 cm. Liège, Musée d'Art Moderne et d'Art Contemporain.

This spirit of homage, which in fact ranged from the first Impressionists to the Nabis, including Neo-Impressionism, also informed the lectures of La Libre Esthétique, as well as the series of concerts charting the development of French chamber music in the last twenty-five years of the nineteenth century. Once again, *L'Art moderne*, drawing on a *Survey of Impressionism*, saluted the supremacy of the French model and its profound influence on Belgian art. The exhibition of 1905 was intended to illustrate this thesis.

1905 brought together German, English, Canadian, Spanish, American, Dutch, Russian and Belgian disciples of what had become an international impressionist movement. The homage paid to Verdoyen, Vogels, Pantazis and Evenepoel defined an impressive Belgian heritage, which was further consolidated by the exhibition of works from the Vie et Lumière group, founded in 1904 and led by Emile Claus. This movement brought together names as diverse as Boch, Degouve de Nuncques, Ensor, Heymans, Morren and Lemmen. Alongside them,

some ten minor landscape artists illustrated what, under the name of "Luminism", was to be a style of painting which combined the influence of French Impressionism with the Belgian realist tradition to create a lyrical representation of light using vivid, shimmering colours. In 1907, Vie et Lumière was once again honoured by La Libre Esthétique. Heymans and Claus were singled out as the leading exponents of a landscape tradition that had been raised to the status of a national attribute.

As far as Maus was concerned, development – the theme chosen for the Salon of 1906 – was the continuation of the Impressionist process. The future history of La Libre Esthétique was built on this desire to continue the process begun by Les Vingt in the 1880s. It was an approach intended to combine conformism and modernity. As a result, at the exhibitions of 1906 and 1907, alongside a large number of conventional imitators of Luminism, the Brussels public were shown works by the artists who, in Paris, had been dubbed the "Fauves" at the Salon d'Autonne of 1905: Camoin, Matisse, Manguin, Derain, Vlaminck, Friesz.

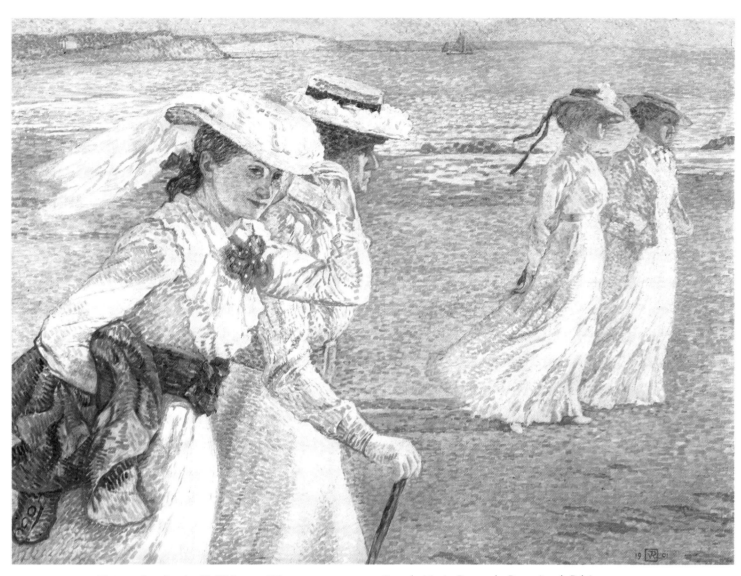

Théo van Rysselberghe: *The Walk*, 1901. Oil on canvas, 97 x 130 cm. Brussels, Musées Royaux des Beaux-Arts de Belgique.

Although Maus remained perceptive,[56] the works he exhibited were conformist, while certain extremes were no longer welcomed in Brussels. The Nabis, whose Intimism was highly esteemed by many artists, were shown in 1907, but Picasso's Blue Period was rejected from van Rysselberghe's proposed selection list.

In 1909, Maus turned his back on the representation of nature to devote his Salon to the theme of figurative representation and portraiture before returning, in 1910, to "the development of landscape". Alongside a chronological survey that ignored German Expressionism and French Cubism and went as far back as Corot and Fourmois, Maus devoted a section to Japanese landscape art between 1770 and 1850. Once again, La Libre Esthétique was honouring the past rather than breaking new ground. Neo-impressionists and Nabis were fulsomely praised along with their Belgian friends Finch, Lemmen, and Claus. La Libre Esthétique had lost touch with modernity and was reliving the mem-

ory of past battles. The final exhibitions merely prolonged the agonies of a moribund aesthetic. Based on an interpretation of realism, it resulted in a decorative style of painting full of warm light and sunny images like the "interpretations of the south" that were to thrive at the Salon of 1913. The following year, which featured a homage to Dario de Regoyos, was the last.

From Symbolism to Expressionism

At the beginning of the twentieth century, symbolist painting began to change and Flanders became its centre of activity. The artists who had withdrawn to Laethem-Saint-Martin – George Minne, Gustave van de Woestyne or Albert Servaes – refused the headlong progress dictated by modernist ideology. They were not so much rejecting society as its industrial future,

which they countered with a rustic ideal tinged with archaism and melancholy. Their contemplative and mystical works yearned to revive a past in which the Christian ideal offered the only possible route to progress. This burgeoning form of Expressionism, whose tutelary figures were Constant Permeke, Gust de Smet and Frits van den Berghe, was founded on a blend of collectivism, conservatism and mysticism. At the opposite end of the spectrum to this ideal, Léon Spilliaert imbued Symbolism with a psychological depth that hinged on the 'dramatic self' being simultaneously explored by Munch. But Spilliaert was isolated in Ostend, and his impact on the course of history was to remain minimal.

The stylisation of Spilliaert's works, with their linear arabesques, decorative, Japanese-inspired areas of colour and vivid contrasts, was derived from Art Nouveau. But Spilliaert rejected artificial ornament. He focused on what was most important; he was not interested in trivial detail, local colour, or conventional forms. Ornamentation revealed the essence of things, a way of structuring feeling that avoided the transience of Impressionism and the artificiality of Symbolism. Spilliaert employed a geometrical approach which was tantamount to creating a mathematical system of sensibility: infinite vistas where nothing moves, interminable causeways where nothing happens, vast spaces governed by loneliness are given spiritual depth in this powerfully abstract style of painting. This spiritual quality suffused with anguish and darkness was the hallmark of all his work: night took on new meaning. A far cry from Whistler's *Nocturnes*, Spilliaert's inky nights obliterate humanity and surrender to the unknown. In this deserted universe, insignificant humanity is confronted by the immensity of space and discovers its infinite anguish. A painter by night, and an insomniac, Spilliaert wandered deserted streets, abandoned embankments, the desolate breakwater. The city, so popular with fashionable Brussels society, became a repository for his hallucinatory loneliness, mingling dream and reality in a mood of the uncanny. Spilliaert may be considered symbolist by virtue of this atmosphere of constant anguish and self-questioning. Employed in 1902 by the publisher Edmond Deman, he was introduced to the symbolist literary circles that at the time held pride of place in Brussels and in Paris, where he settled for a time. A friend of Verhaeren,

Hellens, and Zweig, he was initially interested in literature and the traditional symbolist iconography: diabolic sphinxes, a pernicious atmosphere shrouded in mystery, emaciated figures with staring eyes … On his return to Ostend, Spilliaert began to produce sparer work, stripped bare of the idealist repertory. In the lonely city, the artist painted objects in their nocturnal guise, deserted spaces were transformed by the imprecise forms and strange light. Lifting the mask of reality, Spilliaert directs the spectator not to that ideal world beloved of the symbolists, but to the surreal, frozen by illusion, which allows the unconscious mind to emerge.

Between 1908 and 1910, his work became more audacious; his synthetic forms became almost abstract, resembling the plant-like ornaments designed by van de Velde at the turn of the century. Spilliaert brought to Symbolism a modernity utterly different from the ponderous rocaille of later Art Nouveau. The simplicity of construction and spareness of form established a link between what he was doing and the tendency in architecture and the decorative arts to seek a clarity and rigour inspired by the Viennese model. Spilliaert's development can be seen in his expressive treatment of space; emptiness is the anguished reflec-

Georges Lemmen: *Sewing*, 1900–1901. Oil on paper, 23 x 30 cm. Brussels, Musées Royaux des Beaux-Arts de Belgique.

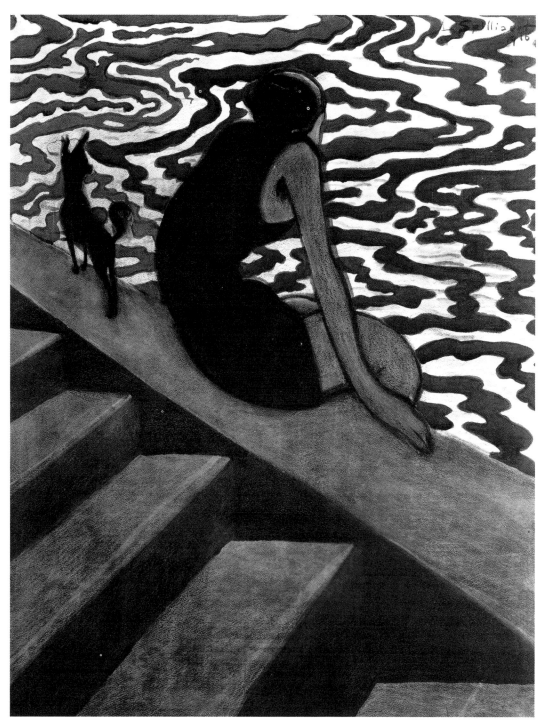

Léon Spilliaert: *Woman Bather*, 1910. Watercolour, ink and pencil on paper, 63.5 x 48 cm. Brussels, Musées Royaux des Beaux-Arts de Belgique.

tion of humanity's loneliness. This constant tension transforms nocturnal interiors and exteriors into a drama burdened with implications, an unhappy past, a shattered future (bringing Spilliaert close to the Nordic theatre of Ibsen or Strindberg), and has its roots in memory. The workings of memory carry the debris of feeling towards a place of introspection, mystery, and doubt. The seaside resort, with its bourgeois trappings imported from Brussels, deeply marked Spilliaert's

work. When he settled in the capital in 1917, his symbolist vein dried up and he turned to different subjects.

Paradoxically, Ostend emerges as a centre of solitude and marginality. Ensor, Spilliaert and soon van den Berghe guided Belgian art towards Expressionism by focusing on the only truth to have survived, however badly shaken: the self.

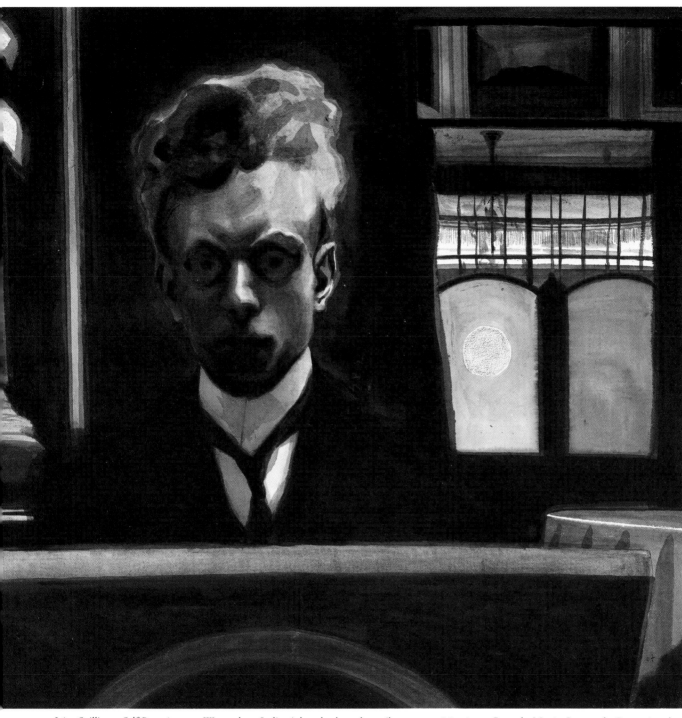

Léon Spilliaert: *Self-Portrait*, 1907. Watercolour, Indian ink and coloured pencil on paper, 48.8 x 63 cm. Brussels, Musées Royaux des Beaux-Arts de Belgique.

Brussels and future promise

In the 1910s, on the periphery of La Libre Esthétique, a younger generation gained a foothold in the art world, laying claim to the same heritage of realist modes of expression and freeing themselves from mimetic constraints to revel in Luminism. This generation favoured a joyful style of painting combining sophisticated perception with childlike enthusiasm. The new move-

ment, later called Brabant Fauvism – a label that gave it a programmatic quality of which it was unaware – enjoyed painting, drawing and sculpting. A group was formed, L'Effort, soon backed by a perceptive French merchant, Georges Giroux, who made name for himself as Maus' moral successor. Painting, literature and music appealed to this "agitateur d'art", a fashionable couturier who grouped around him several first-class artists: Rik Wouters, Fernand Schirren, Jean Brussel-

mans, and Willem Paerels. Their palette was lighter; colour became the vehicle for a quality of light that favoured instantaneous effect and sensuousness. Brushwork, tone, and composition tended toward the formless in order to render the spiritual energy which Bergson had raised to the status of philosophy. Movement within the home became the central subject of Rik Wouters' canvases, in which light took on a new consistency. Represented in shifting space, forms appeared in a new light. Schirren portrayed the features of Mme Blavatsky, the renowned theosophist, in a style reminiscent of Cubism, though not in fact inspired by it. Wouters imbued his *Mad Virgin* with an energy that opened up the body to space and gave the bronze a sleek radiance.

The Parisian avant-garde was still a significant presence in Brussels. Giroux's gallery had not yet opened when, in 1911, the Cubists were exhibited at the Brussels Salon, with a catalogue article by Guillaume Appolinaire. Belgian artists were not, however,

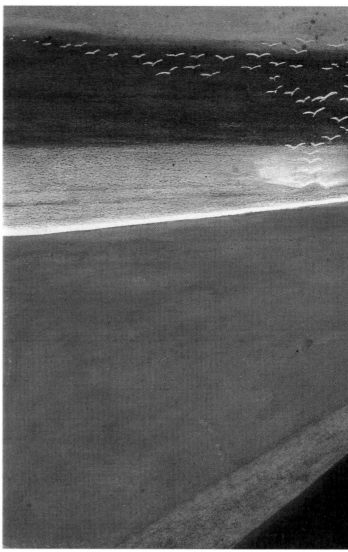

Léon Spilliaert: *The Galeries Royales in Ostend*, 1908. Watercolour, ink wash and coloured pencil on paper. 31 x 50 cm. Brussels, Musées Royaux des Beaux-Arts de Belgique.

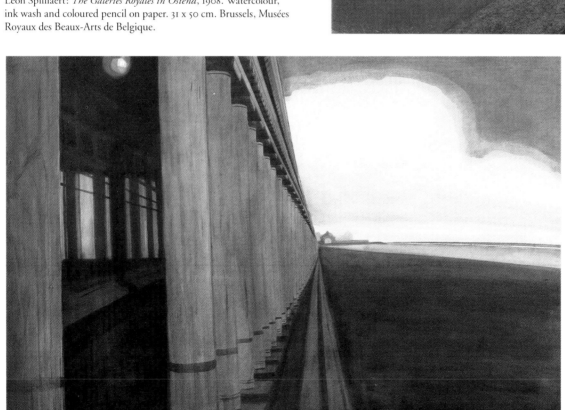

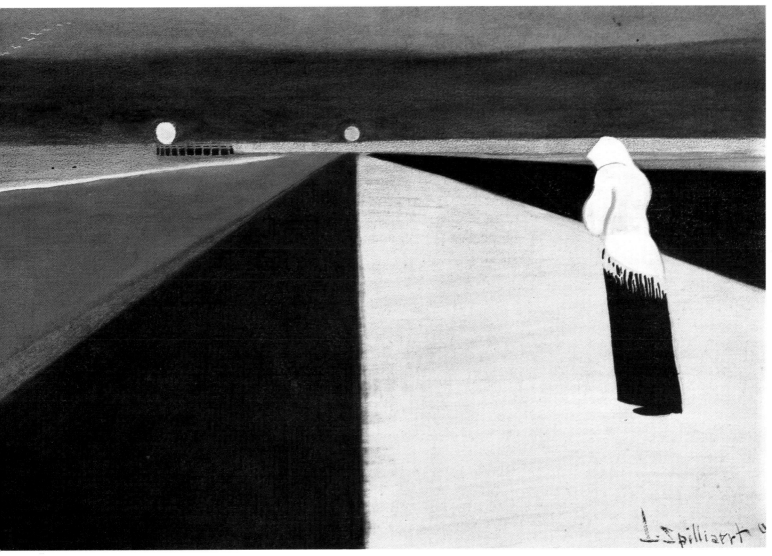

Léon Spilliaert: *Woman on the Dyke*, 1908. Watercolour and coloured pencil on paper, 33.5 x 73.2 cm. Brussels, Musées Royaux des Beaux-Arts de Belgique.

influenced by the works of Braque and Picasso; reality remained the decisive factor. Expressionism and Surrealism began to emerge, the one in the strength of a technique keen to express temperament, the other in the need to highlight the ambiguous nature of a multifaceted reality.

In March 1912, the Galerie Giroux opened. This was an event of considerable importance. The young artists, like their Parisian friends, preferred the activity of a daring and understanding dealer to the great Secessionist celebrations, which were becoming rather ossified in their approach. The Galerie Giroux became a platform for avant-garde artists like Matisse, van Dongen, Derain, Kandinsky, the German avant-garde gathered in Berlin around Herwarth Walden, and the Italian Futurists. *L'Art moderne* occasionally turned its attention to this modernity which now eluded it. When Franz Hellens spoke of the exhibition devoted

to Kandinsky, he paid tribute to Kandinsky's sense of colour, but criticised the abstract nature of his work as a type of creation unconnected with an "earthly foundation, [with] a form that draws its inspiration from forms familiar to everyone".[57] He felt the works of the Russian painter were exhausting and pointless kaleidoscopes which were, in the last analysis, purely decorative.

The *fin de siècle* became inward-looking. New movements, new figures gradually came to the fore. The avant-garde era became interested in the concept of art for everyone, in the quest for a pure visual art that would bring about the rational organisation of society already apparent in Viennese architecture. Symbolism, by exploring the unknown territory of the unconscious, paved the way for Surrealism. Belgian Expressionism remained ambiguous between tradition and innovation, as it rejected modernity in its quest

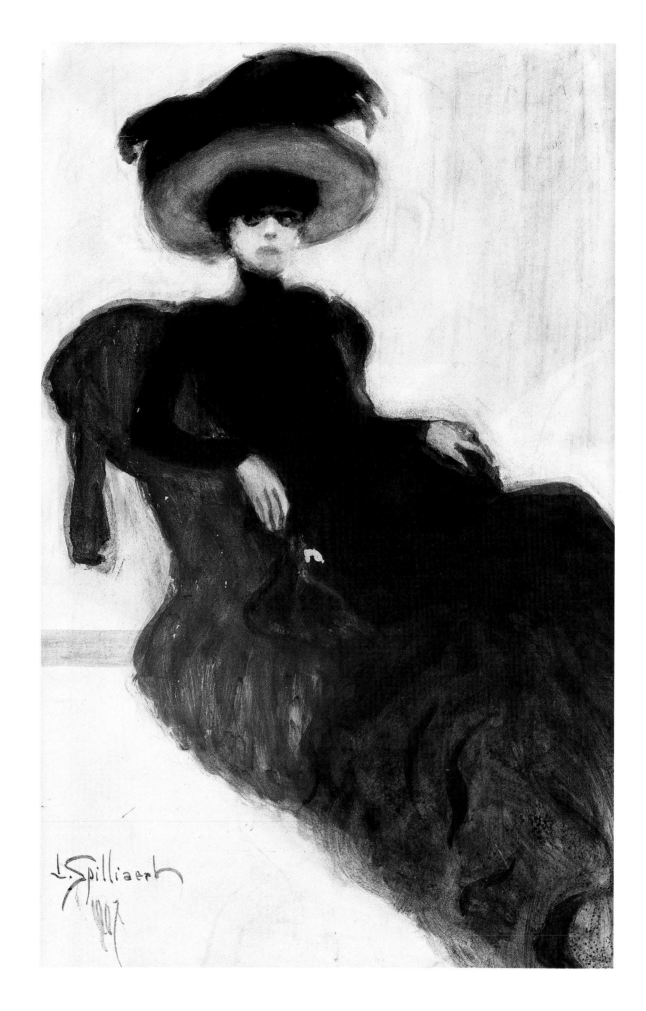

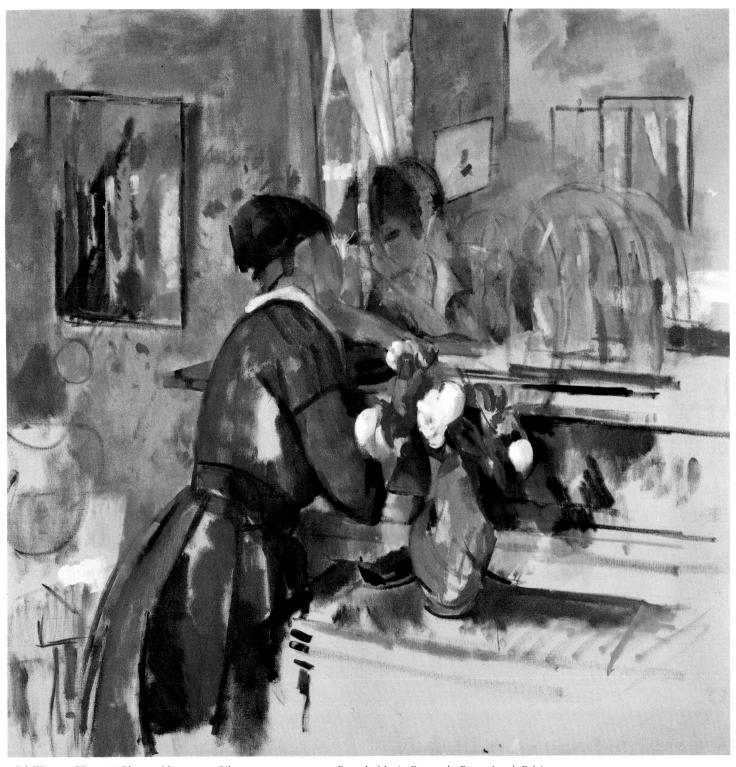

Rik Wouters: *Woman in Blue at a Mirror*, 1914. Oil on canvas, 123 x 125 cm. Brussels, Musées Royaux des Beaux-Arts de Belgique.

Left page: Léon Spilliaert: *Woman in a Hat*, 1907. Watercolour, gouache, and coloured pencil on paper, 48.5 x 30.3 cm. Brussels, Musées Royaux des Beaux-Arts de Belgique (Goldschmidt Legacy).

to express a temperament unaffected by time. The emerging vision of the world focused on life as the sole source of reality; joyous and luminous for the Fauves, anguished and unsettled for the Expressionists, utopian and voluntarist for the supporters of the avant-garde, dreamlike and critical for the Surrealists.

An end to symbolist values

Fuelled by European expansion and the technical advances symbolised by the World Exhibition in Paris in 1900, the prevailing mood of optimism at the turn of the century also left its mark on the literary world. The last representatives of symbolism abandoned the thematic heritage bequeathed by Baudelaire in favour of a cheerfulness that reconciled technique, nature and politics. "Life" became the common reference-point for everyone who adopted the ideology of the Belle Epoque. This can be seen from the titles of various collections: René Ghil's *La Vœu de vivre* or Francis Jammes' *Le Triomphe de la vie*. In Belgium, Elskamp with *La Louange de la vie* (1898) and Verhaeren with *Les Visages de la vie* (1899) manifested the same impulse. The Symbolists were succeed by "naturalist" and "unanimist" groups. For both, Verhaeren's development provided a model that was to be widely followed.

The Belgian writers moved seamlessly and without apparent difficulty from "Mallarmism" to the optimism of the international and colonial exhibitions. At the end of the century, their influence, initially transmitted through Paris, was to extend throughout Europe. On the eve of World War One, these living artists were the most highly esteemed of their contemporaries; the Nobel prize had been awarded to Maeterlinck, Verhaeren had been one of the nominees, and countless translations, articles, books and lectures had been published. It is also possible that it was their identification with pre-1914 values that caused them to take a back seat during the major debates of the 1920s.

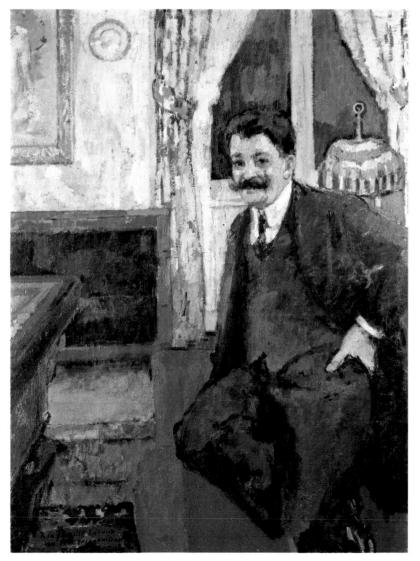

Top: Fernand Schirren: *Bust of Madame Blavatsky*, 1898. Plaster, 54 x 54 cm. Private collection.

Opposite: Willem Paerels: *Portrait of Georges Giroux*, 1913–1914. Oil on canvas, 100 x 75 cm. Brussels, Crédit Communal.

The fact that the narrator of *The Man without Qual-ities* holds a dialogue with Maeterlinck's essays in a bid to picture the end of the world, is a convincing indication both of their importance and of their obso-lescence.

It seems that at least two factors account for this remarkable fate. Their intimate involvement in local political life, which helped to tie their revolt in with that of social forces necessarily optimistic in outlook, suggests that the Belgian Symbolists were not so far along the road to deconstruction as their French coun-terparts; their rejection of society never deteriorated into nihilistic or anarchistic revolt. As regards painting, the same phenomenon almost totally isolated the principal spokesman of libertarian dissidence: James Ensor, in voluntary exile in Ostend, enjoyed fame and fortune only after Expressionism had been adopted as the national mode of expression. In addition, because they were exploring relatively new terrain, such as drama and the poetic novel, Belgian symbolist writers could perceive their role as to build rather than des-troy; yet another positive attitude. This gave rise to an ability to adapt and to take up new forms: the essay for Maeterlinck in his *La Vie des abeilles* (1901), a lyrical pantheism for Verhaeren in his *Les Forces tumultueuses* (1902). This contrasts with the silence maintained by Claudel, Gide or Valéry during this period.

But the century did not come to such an abrupt halt in people's minds. Elskamp and van Lerberghe continued after 1900 to explore the danger of perish-ing away through language, while Albert Mockel reli-giously cultivated the memories of his early years, and Grégoire Le Roy, a disciple of Maeterlinck and van Lerberghe in Ghent, revisited his first poetic loves with *Chanson d'un pauvre* (1907). A fusion of several trends, the texts of Georges Marlowe (1872–1947) achieved local fame. This was also the case with Fernand Séverin (1867–1931), the confidant of Charles van Lerberghe, and Thomas Braun (1876–1961). But authors who were to play a part in the literary movements of the interwar period were already emerging from the shad-ows. Neel Doff (1858–1942), in *Jours de famine et détresse* (1911), described her unhappy teenage years and her rise in society as a result of her marriage to Fernand Brouez (1861–1900), the editor of *La Société nouvelle,* who died young. André Baillon (1875–1932)

gave the genre of autobiography a new lease of life. Franz Hellens (1881–1972), tireless founder of Franco-Belgian reviews, and Jean de Boschère (1878–1953), an admirer of Elskamp and a poet and novelist, com-plete the list. For all of them, Symbolism was a forma-tive period, but neither cultural climate nor social background were propitious to the survival of the *fin-de-siècle* spirit.

Conclusion

Rik Wouters: *Mad Virgin* or *Mad Dancer*, 1912. Bronze, 195 x 120 x 135 cm. Brussels, Musée Communal d'Ixelles.

The term *fin de siècle* savours of decadence or adverts to the new, depending on the language in which it is employed. The years between 1880 and 1914 showed the many different faces of Brussels, a city both captive to a long tradition and hostile to the heavy burden of its past. The capital of a new state, it cherished the memory of a rich heritage whose glittering achievements had left their mark throughout Europe. Deeply attached to this past, which, throughout the nineteenth century, provided Belgium with a sense of legitimacy, Brussels also turned to face the future. There was no whiff of decadence about this young nation which avoided military and moral defeat through its lack of warlike ambition. 1870 scarred France and strengthened Belgium. The nation's self-confidence did not stem from feelings of patriotism such as prevented Paris from welcoming Wagner; it arose from an open-mindedness which, eschewing all cliques and coteries – Les Vingt were constantly to battle against the temptation to label themselves a school – acknowledged the present and thus prepared the future. Diversity was enriching; it was this attitude that made Brussels a fertile ground for innovations from all over Europe.

The *fin-de-siècle* years were characterised both by a search for identity and a desire to break with academic conventions, a trend that soon reflected the city's international aspirations. Brussels' growth and its metamorphosis into a European capital made the city a sounding board for modernity: Neo-Impressionism found a platform there, and Wagner a stage before Bayreuth became his sanctuary; Symbolism transcended poetry, spilling over into all areas of art. *Fin-de-siècle* Brussels mirrored a new world that had broken with the old order. Minne, Khnopff, Maeterlinck, Verhaeren, Meunier, van de Velde, and Ysaÿe received an enthusiastic welcome in Paris, Vienna, London, Berlin, Moscow, St Petersburg, and even New York. Their influence, although it did not invariably survive the turmoil of August 1914, was no less profound for that.

The movement that emerged at the turn of the 1880s was made possible by the nation's thriving economy. Despite the recession that had hit all the European capitals, Belgium remained powerful; its industries were running smoothly, its bourgeoisie was flourishing, fortunes were being made, market openings were being created and the colonial initiative, the unaided achievement of Leopold II, soon bore fruit. The idyllic picture of a modern state mindful of its power contrasted strongly with the negative image of a nation whose population was, in the majority, utterly destitute. Commitment to social reform soon became an ethical imperative indissociable from the modernity to which the avant-garde circles aspired. For the radical bourgeois who proved the mainspring of society, the *fin-de-siècle* period resembled a civil war waged against them, against the values that they embodied, in favour of a new progressive and modern cause, whose urgency was underlined by the major economic crisis of 1870–1880. The bourgeoisie, racked by internal tensions, wanted to reform the world on which it had built its power in order to satisfy its own hunger for progress.

The emergence of self unbounded by reason was recognised by everyone – libertarians, activists, reactionaries and progressivists alike – as an aspect of modernity. The bourgeois revolution valued a notion of individuality inseparable from the notion of freedom. Verhaeren and Ensor, in words and paint, gave voice to the independence of the human spirit confronted by the modern world. Life became the driving force behind a quest that confronted the individual with society, and society with its destiny; the fragile nature of the human being and of the world imbued their examination of the human condition with an intensity that transcended the pessimism generated by contemporary reality and fashionable theories. Through their emphasis on subjectivity, Khnopff, Minne and Maeterlinck bore witness to their period

and its moral aims and social climate, just as Lemonnier and Meunier created a collective vision of society through their portrayal of individuals. From Realism to Symbolism, the individual played a central role in challenging the established order.

Focusing on existence, the *fin-de-siècle* spirit aspired to the immaterial, to pure feeling, to "music above all else". Brussels was not a centre of new composition, but established itself as a forum for the performance of new works. La Monnaie became the rallying point for the disciples of Wagner and Franck. But the disembodied ideality of music did not conceal the need to change the present, to alter its aspect and correct its failings. Society was the ultimate work of 'total art'. With the advent of Art Nouveau, a style was born whose representative forms embodied that vital energy which, in the dynamic curves of Horta's arabesques, symbolised the individual, the evolution of the species, and the development of society. Movement was life; it linked human beings to their environment, reflected an image of their ideal, and offered a glimpse of a future society in harmony with progress.

Fraught with ambiguity, that ideal remained a dream. True, theories were developed at the turn of the century to which the avant-garde later returned. The clearest example of this is van de Velde. The theories developed by the Belgian architect were at the origin of the Weimar Bauhaus as well as of the constructivist and productivist doctrines developed in the Netherlands, the former Soviet Union, and Germany in the 1920s.

Far from brooding on its own destruction with an apocalyptic, and perhaps pleasurable, shiver, *fin-de-siècle* Brussels opened a window on the future. In a period of doubt and uncertainty, both at home and abroad, the act of creation seemed the very embodiment of freedom. And this, perhaps, defines the essential contributon of Brussels to the achievement of *fin-de-siècle* Europe.

Notes

Brussels, *fin-de-siècle* crossroads

1. R. Genaille, *L'Art flamand*, Paris, 1965, p. 19.
2. Ph. Roberts-Jones, "Eclat et densité de la peinture en Belgique", *Image donnée, image reçue*, 1989, p. 42.
3. Caricature by Germinal, in *La Jeune Garde*, Paris, 24 April 1887.
4. Champfleury, "Du réalisme", *L'Artiste*, 2 September 1855.
5. A. H. Barr, *Maîtres de l'art moderne*, Brussels, 1955, p. 34.
6. J. Pradelle, "Félicien Rops", *La Plume*, Paris, 15 June 1896, p. 409.
7. Ph. Roberts-Jones, "Le symbolisme et les formes du silence", *op. cit.*, pp. 140 and 146.
8. C. Pichois, "Maeterlinck aujourd'hui", *Bulletin de l'Académie royale de langue et de littérature françaises,* Brussels, 1992, p. 153.
9. S. Mallarmé, *Toast à Emile Verhaeren*, in *Œuvres complètes*, Paris, 1979, p. 864.
10. P. Fierens, *L'Art en Belgique*, Brussels, 1947, p. 498.
11. E. Verlant, "Le Salon de Gand", *La Jeune Belgique*, Brussels, 1892, p. 344.
12. A. France, *L'Ile des pingouins*, Paris, 1908, p. 330.

1830–1870 The city and the arts: from independence to realism

1. A network of roads radiating out from the capital links Brussels with the major Belgian and European cities, while the old canal of Willebroek, which is still used to convey river traffic between Brussels and Antwerp, was extended in 1832 when the Charleroi canal was opened. By providing the capital with direct access to the industrial docks at Hainaut, this new canal made it easier to obtain supplies of coal. It also meant that the city became the point of convergence for, on the one hand, charcoal, paving slabs, stones, lime and metallurgical products from the south of the country and, on the other, wood, manufactured products and agricultural produce from northern Europe, England and America. Until the closure of the collieries in Hainaut, the two canals were to constitute the country's main industrial axis, and the major industries took up residence in this part of the city because of this. Shortly after the first steam train on the continent left the Allée Verte station on 5 May 1835, Brussels also became the nucleus for the new rail network. Several stations were to be opened: the South Station, the North Station, the station in the Léopold district, the West Station for goods, that of Schaerbeek with its switch and freight yards, and later the maritime station of Thurn et Taxis.
2. Between 1830 and 1850, the length of roads was increased by 90%; in Wallonia alone over 1,800 km of new road were added to the public road network. Many small towns were linked in this way to the main communication routes.
3. B. S. Chlepner, *Cent ans d'histoire sociale en Belgique*, Brussels, 1956, reprint, 1972, p. 48.
4. Throughout the nineteenth century, Belgium was one of the states with the lowest wages and the longest working hours (a full working day lasted eleven or twelve hours). It was also one of the slowest to implement social legislation. In Belgium, as in the rest of Europe, there was no form of protection against accidents at work; many injured or sick workers were often abandoned to their fate. It was very difficult for labourers to protest against working conditions as they were in an inferior legal position; workers' associations were prohibited until 1866 and each employee had to carry a work record that he would hand to his employer. Work records were mandatory until 1883. The huge success of Belgian industry therefore resulted in the extreme poverty of the workers, who did not reap the fruits of this growth.
5. In the field of the arts, the French occupation had contributed to the institutionalisation of artistic life. Academies and societies promoting the fine arts organised Salons dominated by neoclassical aesthetics. In 1812, Antwerp, Ghent and Brussels had agreed to hold a triennial Salon. From the late 1820s onwards, the academies – fine arts or music – had been restructured. Their prestige was to extend much further than the frontiers of Brussels. Accordingly, the music school founded in Brussels in 1813 was raised to the status of the Royal Conservatory in 1832 and, under director François-Joseph Fétis, was to become one of the most prestigious music colleges in Europe.
6. Between 1830 and 1846, several of them saw their population quadruple while that of inner Brussels only increased by 25%. By the end of the century, however, the ratio between the city and its suburbs had been reversed. Although at the beginning of the nineteenth century, three-quarters of the people living in Brussels lived in the inner city, by 1900 this figure had fallen to 30%.
7. E. Fromentin, *Les Maîtres d'autrefois*, in *Œuvres complètes*, texts compiled, presented and annotated by G. Sagnes, Paris, 1984, p. 571.
8. L. Ranieri, *Léopold II urbaniste*, Brussels, 1973, p. 123.
9. The river that flowed slowly through the city carrying muddy water polluted by waste was a continual health hazard. When in spate, it regularly overflowed its banks to flood the neighbouring districts. In 1865, Brussels' inner city council adopted a programme proposed by the burgomaster, Jules Anspach, to improve health and sanitation in the city. This drastically altered the layout of Brussels and gave it an image more in keeping with its representative role. The programme revolved around the need to cover over the Senne and build two main sewers. This entailed demolishing over a thousand houses, including many industrial buildings – tanneries, breweries, dye works, etc. – which had stood for a long time on the banks of the river. Most of these companies and some of the inhabitants of these flattened quarters migrated to the suburbs, speeding up their urbanisation.
10. Albert Carrier-Belleuse, a French sculptor highly esteemed in Brussels, settled in the capital and invited Auguste Rodin to join him. He was to make outstanding contributions to several Brussels building projects. On his return to Paris, he entrusted his Brussels studio to van Rasbourgh, who entered into partnership with Rodin; both were to work on the sculpted decoration of the Neo-Renaissance façade of the Conservatory on Rue de la Régence, built between 1872 and 1876 by Cluysenaar (on this subject, see Th. Demey, *Bruxelles, chronique d'une capital en chantier*, Brussels, 1990, p. 66).
11. For example, *Panorama du Caire* painted by Wauters, *Panorama de la bataille de Waterloo* by Mathieu, then, after 1918, that of the Yser river by Bastien.
12. *La Renaissance*, 1849–1850 quoted by J. van Lennep, *La Sculpture sous le règne de Léopold 1^{er}*, in *La Sculpture belge au XIX^e siècle*, Brussels, Générale de Banque, 5 October–15 December 1990, I, p. 30.
13. Culturally, the growth of Brussels led to a change in its population. The capital gradually assumed the external appearance of a French-speaking city; from 1851, street names and shop signs were exclusively written in French, and cultural life became primarily French-speaking. Within the city, however, there was a large Flemish-speaking population: Until 1880, the censors counted between 20 and 25% French-speakers compared to 36 to 39% Flemish-speakers and 30 to 38% bilingual speakers, being mainly Flemish citizens who could speak French. After 1890, the percentage of bilingual speakers rose, revealing the growing gallicisation of the population.
14. Ch. Buls, "Esthétique des villes", *L'Emulation*, 1894, col. 17–21, 33–37 and 49–61.
15. Cf. *Découvrez les hôtels de ville et les maisons communales à Bruxelles*, Brussels, 1988.
16. Julien Dillens, Jacques de Lalaing, Isidore de Rudder, Egide Rombaux, and Victor Rousseau realised the sculpture, Fernand Khnopff the ceiling of the Salle des Mariages, Hélène de Rudder the tapestries in the same room. The fountain by Jef Lambeaux that stands in the city square was not added until 1976!
17. For example, the year after his trip to England in 1846, during which he visited various prisons, the architect Joseph J. Dumont employed the Tudor style in Belgium for the Brussels prison, a style that soon became the norm for this type of building. Also worthy of attention are the barracks on the Plaine des Manoeuvres (drill ground) realised in 1875 by the architect Pauwels in Louis XIII style.
18. "Rousseau, Dupré, Courbet, Troyon, Daubigny, have revived a tradition which we had lost for a while, the tradition of a vigorous realism.

Their great merit is to have been the first to adapt the time-honoured secrets of the Flemish painters for use in landscape painting. They have given us a signal, and we have heard it" (G. van Zype, *Franz Courtens*, Brussels, 1908, p. 13).

19. In the provinces, the same urge to return to nature led Adrien-Joseph Heymans to Kalmthout, near Antwerp, and Alfred Courtens to Termonde, on the banks of the Escaut. This revealed a rejection of the modern world which was to have a marked influence on the symbolists belonging to the first school of Laethem-Saint-Martin, and on their expressionist successors.

20. H. H. *Journal des beaux-art et de la littérature*, 31 January 1869.

21. Louis Dubois was also to wage his battles in the columns of *L'Art libre*, under the pseudonym of Hout.

22. The extensive "Exposition historique de l'art belge 1830–1880" was soon to take place in the halls of the Palais des Beaux-Arts to commemorate the fiftieth anniversary of Belgian independence. There, the Realism of Stevens and Dubois was seen to have earned its rightful place alongside Neo-classicism and Romanticism.

23. "I say to artists, Be part of your century. It is up to you to be the historians of your time, to relate it as you see it, to express it as you feel it, from all aspects, in all its forms, in all its guises, through all its vicissitudes and greatness" (C. Lemonnier, *L'Art libre*, 1 August 1872).

24. V. Reding "La Chrysalide", *La Fédération artistique*, 14 May 1881, p. 245.

25. "In fact, it is by studying the beauty of nature, so rich, so varied, and so fertile, that one becomes an artist. Academic convention has nothing in common with art. Nature is all we need: that is our credo" (*L'Artiste*, 28 November 1875).

26. C. Lemonnier, *L'Ecole belge de peinture 1830–1905*, Brussels, Van Oest, 1906, reprint, Brussels, 1991, p. 133.

27. This idea of the "happy medium" was derived from the evolution of French academic painting which, from the Salon of 1882, assimilated several aspects of Impressionism. A lyrical treatment with radiant colours rendered utterly conventional works fashionable. On this subject, see A. Boime, *French Academic Painting in the Nineteenth Century*, London, 1978.

28. Societies of music lovers in Belgium (choirs, brass bands, military bands, symphonic societies), which were few and far between at independence, had soared to over 500 before 1914 in the province of Brabant (including Brussels) alone.

29. This great tragic actress, who showed exemplary restraint in her bearing and had a fine voice, captivated many artists, including Khnopff, who was to feature her, to her great anger, as the nude figure in his "Rosicrucian" painting, *Le Vice suprême*, exhibited at Les Vingt in 1885. In the face of the scandal this generated, the artist shattered the glass protecting the picture with his cane and destroyed it, much to the indignation of Edmond Picard.

1870–1893 A new generation: modernity

1. E. Pirmez, *La Crise. Examen de la situation économique de la Belgique*, Charleroi, 1884, p. 30.

2. See the preface to the French translation of A. W. Pugin, *True Principles of Pointed or Christian Architecture*, London, 1841: *Les Vrais Principes de l'architecture ogivale où chrétienne avec des remarques sur leur renaissance au temps actuel*, Brussels and Leipzig, 1850.

3. *L'Emulation*, 1876, col. 104. It should be noted that between 1870 and 1877, the works of Vredeman de Vries were published in a facsimile edition in Brussels. Like the *Documents classés de l'art dans les Pays-Bas, du Xᵉ au XVIIIᵉ siècle* by Jules van Ysendijk (1886–1889), they were to constitute an inexhaustible source of motifs for the supporters of Flemish Neo-Renaissance.

4. V. Horta, *Extrait des Mémentos*, in *Mémoires*, Brussels, 1985, p. 313.

5. J. Puissant, *Revue de l'ULB*, 1984, no 4–5, pp. 109–118.

6. A. Giraud, *Pierrot Lunaire*, 1884, reprinted in "Théâtre", *Pierrot lunaire*, Paris, 1884, p. 1.

7. Ch. Baudelaire, *Pauvre Belgique!*, in *Œuvres complètes*, Paris, 1976, II, p. 879.

8. A. Giraud, "Hérésies artistiques", *La Jeune Belgique*, 1885, p. 255.

9. Y. Gilkin, "Les origines estudiantines de *La Jeune Belgique*", *La Belgique artistique et littéraire*, July 1909, p. 6.

10. M. Maeterlinck, "Réponse à l'enquête sur Lautréamont", *Le Disque vert*, III, p. 383.

11. A. Giraud, *Rondels bergamasques*, Brussels, 1884, pp. 59–60.

12. M. Waller, "C'est ainsi", *Parnasse de La Jeune Belgique*, Paris, 1887.

13. E. Verhaeren, *Quelques notes sur l'œuvre de Fernand Khnopff*, Brussels, 1887, pp. 22–23.

14. Y. Gilkin, "Le Mauvais jardinier", *Parnasse de la Jeune Belgique*, p. 89.

15. M. Maeterlinck, "Feuillage de cœur", *op. cit.*, p. 215.

16. *Id.*, *Serre chaude* (1889) reprinted in *Serres chaudes, Quinze Chansons, La Princesse Maleine*, Paris, 1983, p. 31.

17. Undated letter with no address, 1890 or 1891, quoted by Paul Gorceix, "Lecture" by Max Elskamp, *La Chanson de la rue Saint-Paul*, Brussels, 1987, p. 201.

18. M. Maeterlinck, quoted in C. de Grève, *Georges Rodenbach*, Brussels, 1987, pp. 41–44.

19. Ch. van Lerberghe, *La Chanson d'Eve* (1904), reprint, Brussels, 1982.

20. It was intended to be very simple; there were twenty artists, three of whom were to be in charge of organising the Salon each year, and a secretary responsible for the day-to-day running of the organisation. At the AGM, the members would draw up a list of Belgian or foreign guests who were to be invited to the next Salon. At the exhibition, each artist would hang their own work in a location that had been allocated at random.

21. O. Maus, *Letter to Eugène Boch of 1 November 1883*, Brussels, Archives de l'Art Contemporain. It was advisable however to moderate this revolutionary approach. Les Vingt was made up of many different temperaments and a number of conflicting tensions existed. Some of the members, like Delvin, Vanaise, Verstraete and Verhaert, formed the group's reactionary faction. They were progressively expelled after attacks fuelled by *L'Art moderne*. On the other hand, Ensor's excessive behaviour and provocative stance caused him no end of problems with his peers. However, despite the ostentatious slogans and declarations, Maus aimed to steer a steady course between conservatism and libertarianism.

22. In an article published on 17 February 1884, Picard repeated the gist of his lecture when defining the common denominator of this new avant-garde: "The study and direct interpretation of contemporary reality by artists who give free rein to their temperament, and are masters of a thorough technique." E. Picard, "L'art jeune", *L'Art moderne*, III, 17 February 1884, p. 49.

23. [E. Verhaeren], "Whistler à Bruxelles", *L'Art moderne*, VII, no 36, 7 September 1887, p. 310.

24. Quoted in *L'Art moderne*, no. 11, 16 April 1884.

25. *Loc. cit.*

26. [Anonymous], "A propos du Salon des XX: l'impressionnisme", *L'Art moderne*, VI, no. 8, 21 February 1886, pp. 57–59.

27. "[…] the Parisian Impressionists use pure colours, blue, red, and green, together, and this produces, at a distance, harmonious combinations, unlike our painters who endeavour to create the exact colour they want on the palette and only apply it to the canvas when they have succeeded." [Anonymous], "A propos du Salon des XX, II, L'impressionnisme", *L'Art moderne*, VI, no. 9, 28 February 1886, p. 66.

28. E. Demolder, *James Ensor*, Brussels, 1892, p. 18.

29. "If it were to be exhibited, there would be sudden cases of insanity and severe attacks of apoplexy" [O. Maus], "Les Vingtistes parisiens", *L'Art moderne*, VI, no. 26, 27 June 1886, p. 204.

30. As well as this article, there was a long theoretical essay entitled "Le néo-impressionnisme", published in *L'Art moderne* in May 1887. It was not until 1899 that this article was superseded by Signac's famous work, *De Delacroix au néo-impressionnisme*.

31. F. Fénéon, "Le néo-impressionnisme", *L'Art moderne*, VII, no. 18, 1 May 1887, p. 138. Fénéon's reading signalled to the reader that Seurat's contribution entailed transcending what Pissarro called "romantic Impressionism" in favour of a "scientific Impressionism" nurtured by the concept of the absolute and of perfection. The law of simultaneous contrast – each colour tinges its immediate surroundings with its complementary colour (when staring at a yellow dot, it will appear to have a violet halo) – precluded any mixing of paint on the palette so that the intensity of the light was preserved on the canvas by the juxtaposition of the colours. The image was produced in accordance with a scientific principle – inspired by the physicists Chevreul, Sutter and Rood – that gave rise to a strict technique which ensured the integrity of the

painting. This quest for perfection was matched in Seurat's work by a longing for the absolute, inspired by the psychology of lines developed by the physiologist Charles Henry and by the use of the golden mean held in affection by Puvis de Chavannes. Seurat defined his aesthetics in a letter to Jules Beaubourg: "Art is Harmony. Harmony is in the analogy of opposites, the analogy of similar things, of tone, colour, line, considered according to the dominant element and under the influence of light in gay, calm or sad combinations." G. Seurat, quoted from J. Rewald, *Seurat*, Paris, 1990, p. 168.

32. H. van de Velde, "Notes d'art", *La Wallonie*, V, no. 2–3, February–March 1890, pp. 92–93. In respect of van de Velde's critical vision, see two other articles published in *La Wallonie* in April 1890 and March–April 1891 entitled "Notes d'art: 'Chahut' and Georges Seurat".

33. [Anonyme], "Le Salon des XX. L'ancien et le nouvel impressionnisme", *L'Art moderne*, VIII, no. 6, 5 February 1888, pp. 41–42.

34. C. Berg, *Max Elskamp et le bouddhisme*, Nancy, 1969, pp. 9–14.

35. G. Rodenbach, *Les Vies encloses*, Paris, 1896, p. 13.

36. M. Maeterlinck, *Serres chaudes, op. cit.*, pp. 172–173.

37. E. Verhaeren in *La Wallonie*, May 1890.

38. C. Mauclair quoted in F. C. Legrand, *Le Symbolisme en Belgique*, Brussels, Laconti (Belgium, Art du Temps), 1970, p. 36.

39. A. Goffin. *Xavier Mellery. Etudes d'art contemporain*, Brussels, 1902, p. 2.

40. F. C. Legrand, *op. cit.*, p. 155.

41. E. Verhaeren, "Les XX", *La Nation*, 15 February 1892.

42. "The thing to do would be to become a naturalised Belgian, at least one can still fight for Art in your country", he wrote to Maus after the failure of *Lohengrin* at the Paris Opéra.

43. During this period of French supremacy, audiences were not easily converted to Brahms.

44. The other members of the quartet, apart from Ysaÿe, were Mathieu Crickboom, Ysaÿe's young disciple and a future friend of Chausson, Léon van Hout, the finest Belgian violist of his generation, and the cellist Joseph Jacob, a childhood friend of Ysaÿe.

45. He played piano duets with d'Indy, harmonium in the first performance of Franck's *Prélude, fugue et variation* in the version for piano and harmonium, and the celesta to flesh out Ernest Chausson's Shakespearean fantasies.

46. G. Lekeu, *Lettre à E. Ysaÿe*, 1 February 1893, in M. Lorrain, *Guillaume Lekeu, sa correspondance, sa vie et son œuvre*, Liège, 1923.

47. In 1887, Franz Servais attempted to found a concert organisation to rival the Concerts Populaires; the Concerts d'hiver lasted only two seasons. It was at this organisation, on 28 April 1889, that César Franck's *Symphony* was given its first performance.

48. *Esclarmonde* was to attract a great deal of attention and became the but of a very popular parody at the Alcazar, *Ex-clarmonde*, the first success to distinguish the career of Georges Garnir. Ex-clar-monde, Roland and King Phorcocasse fought over the lion's share of the limelight with two men, one representing the Stoumon-Calabresi faction and the other, the Dupont-Lapissida faction, with lines, as Garnir himself put it, "which one might say were started by Racine and finished by Richepin".

1893–1914 The avant-garde: modernity and conformism

1. In 1910, large companies represented 1% of the total number of industries, but 63% of the workforce. On the other hand, there continued to be a large number of very small operations: 92% of companies employed less than five employees and 69% did not have any. This increasing concentration did not affect all the sectors; the majority of companies were fairly small with regard to most activities connected with the textile, construction or metalwork industries.

2. A. Mockel, *Propos de littérature*, 1894, in *Esthétique du symbolisme*, Brussels, 1962, p. 93.

3. J. Delville quoted in F. C. Legrand, *Le Symbolisme en Belgique*, Brussels, 1970, p. 76.

4. J. Delville, *Dialogues entre nous. Argumentation kabbalistique, occultiste, idéaliste*, Brussels, n. d., and *La Mission de l'art, étude d'esthétique idéaliste*, Brussels, 1900.

5. J. Delville, *La Mission de l'art, étude d'esthétique idéaliste, op. cit.*, pp. 70–71.

6. This exhibition, which was held from 15 June to 15 October 1902 at the Conseil Provincial in Bruges, displayed works by Jan van Eyck, Petrus Christus, Rogelet de La Pasture, Hans Memling, Gérard David, Quentin Metsys and Pieter Bruegel.

7. E. Witte and J. Craeybeckx, *La Belgique politique de 1830 à nos jours. Les tensions d'une democratie bourgeoise*, Brussels, 1987, p. 136.

8. H. van de Velde, *Récit de ma vie. I. Anvers, Bruxelles, Paris, Berlin, 1863–1900*, Paris-Brussels, 1992, p. 189.

9. See F. de Crits (ed.), *Brussel en het fin-de-siècle, 100 jaar Van Nu en Straks*, Antwerp-Brussels, 1993, pp. 65–80.

10. E. Picard, in *Pro Arte*, 1886, p. 138.

11. E. Verhaeren, in *La Nation*, 1 November 1891.

12. E. Vandervelde, *Essais socialistes (l'alcoolisme, la religion, l'art)*, Paris, Alcan, 1906, quoted in R. Pirotte, *Art et société. Le POB et la culture*, Brussels, typewritten document, p. 9.

13. "The artist does not restrict himself to creating within an ideal world. He attends to everything that interests us and affects us. Our monuments, our houses, our furniture, our clothes, the smallest objects we use, are taken up again and again, transformed by Art which is therefore involved in all things and continually recreates our entire life to make it more elegant, more worthy, more cheerful and more social." *L'Art moderne*, no. 1, 1881, p. 2.

14. F. Khnopff, "L'Art anglais", *Annuaire de la Section d'art*, Brussels, 1893, p. 30.

15. H. van de Velde, *Récit de ma vie, op. cit.* p. 24. It is likely that Serrurier-Bovy had discussed with his wife-to-be, Maria Bovy, the possibility of opening a shop in Liège modelled on Liberty in London (founded in 1875) which he had visited. In his firm's first catalogue, published between 1884 and 1894, he confirmed, following the example of his British model, that he would not be manufacturing artistic furniture and offered his customers a range of objects imported directly from India and Japan. In England, he had also discovered William Morris and the guilds, particularly the Century Guild founded by Arthur Heygate Mackmurdo whose review *The Hobby Horse* – the first magazine distributed on the continent to bear witness to the importance of the English movement – was also to make a profound impression on Lemmen and van de Velde.

16. G. Lemmen, "Walter Crane", *L'Art moderne*, no. 9, 1 March 1891, pp. 67–69, and no. 11, 15 March 1891, pp. 83–86.

17. H. van de Velde, *Récit de ma vie, op. cit.*, p. 169.

18. Id., "Première prédication d'art", *L'Art moderne*, no. 53, 31 December 1893, p. 120.

19. Lemmen and van de Velde collaborated on other projects as well as *Van Nu en Straks*. In 1895, Lemmen produced a glass mosaic frieze for the smoking room designed by van de Velde for Bing's gallery L'Art Nouveau. The latter also commissioned the design of invitations, advertising inserts and letter-headed paper. See J. Block, *A Neglected Collaboration. Van de Velde, Lemmen and the Diffusion of the Belgian Style*, in G. P. Weisberg and L. S. Dixon, *The Document Image. Visions in Art History*, Syracuse, 1987, pp. 147–164.

20. H. van de Velde, *Récit de ma vie, op. cit.*, p. 175.

21. Consequently, in 1892, van de Velde acquiesced to the request of his childhood friend, the poet Max Elskamp, to design the cover of *Dominical*: a recollection of days when van de Velde ran "along the beach to capture the remains of linear arabesques left on the shore by the ebbing waves" [Id., unpublished manuscript FSX 39, Brussels, Bibliothèque Royale-Archives et Musée de la Littérature]. He was also approached by August Vermeylen who wanted to found an avant-garde Flemish literary review under the title of *Van Nu en Straks*. Van de Velde supplied ornamental capitals, vignettes and tailpieces, "all born of the same spirit, essentially abstract and linear" [Id., *Récit de ma vie, op. cit.*, p. 191], influenced by Japanese prints. As a result of his work, the review received contributions from the English artist Ricketts, the Dutch artists Thorn-Prikker, Toorop and Holst, as well as Lucien Pissarro.

22. [Anonymous], "Art et socialisme", *L'Art moderne*, IX, no. 27, 30 August 1891, p. 276.

23. [Anonymous], "La Libre Esthétique", *L'Art moderne*, XIII, no. 44, 29 October 1893, p. 345.

24. Over one hundred names were listed in this catalogue for La Libre Esthétique. Besides a large number of lawyers – Maus' former profession – and magistrates, there were industrialists, politicians, men of letters, university lecturers, and doctors. The calibre of this board of sponsors was a testimony to Maus' social standing and the reputation he had acquired after ten years of "vingtisme".

25. M. O. Maus, *Trente Années de lutte pour l'art. Les XX et La Libre Esthétique 1884–1914*, Brussels, 1980, p. 181. This work, published originally in 1927 (in Namur, by the publisher Oiseau Bleu), formed the first account, albeit partial and prejudiced, of the activity of Les Vingt and La Libre Esthétique. Drawing on Maus' archives, his wife, Madeleine, charted the sequence of events, focusing on their interdisciplinarity.

26. F. Khnopff, "Studio-Talk", *The Studio*, VIII, 1896, p. 119. From his early days, Serrurier – influenced, like Horta and Hankar, by the theories of Viollet-le-Duc – had forged close ties with the artistic circles in Liège which, with Auguste Donnay, Emile and Oscar Berchmans and Armand Rassenfosse, dominated the cultural scene in the *fin-de-siècle* period.

27. *L'Art moderne*, XIV, no. 11, 18 March 1894, p. 86.

28. G. Soulier, "Serrurier-Bovy", *Art et Décoration*, IV, 1898, pp. 78–85.

29. In 1925, Philippe Wolfers once again made artistic news with his exhibition of the *Gioconda* collection at the International Exhibition of Decorative Arts in Paris.

30. Two semi-detached houses on Rue des Douze Chambres are nevertheless worthy of note. The classical treatment of these buildings was enhanced by a liking for colour that reflected Beyaert's teachings: bare brick, a polychromatic frieze and bas-reliefs enlivened the façade.

31. E. Viollet-le-Duc, *X^e Entretien*, in *Entretiens ou l'Architecte*, Paris, 1872, I, p. 451.

32. Situated at 266, Chaussée de Haecht, Maison Autrique was distinctive for its use of carefully dressed freestone – not roughcasting as was customary for an ordinary house – and decorated with delicate mouldings. The size of the window openings, maximised by the use of thin metal posts and small columns, flooded the rooms with light. Horta also made the skylight into a window by placing the cornice on a central wooden prop.

33. G. Combaz, "Les arts décoratifs au Salon libre de la Libre Esthétique", *L'Art moderne*, XVII, no. 13, 23 March 1897, p. 98.

34. V. Horta, *Mémoires*, Brussels, Ministère de la Communauté française, 1985, p. 48.

35. E. Vandervelde, in *Le Peuple*, 3 April 1899.

36. With burgomaster Charles Buls, he campaigned in favour of "urban aesthetics", and entered competitions for façades and decorative signs (1894). He helped to found an artistic co-operative, volunteered to build an artists' colony in Westende on the Belgian coast, presided over the Société Populaire whose mission was to initiate people into the arts, became a member of the Brussels Société d'Archéologie in 1891 and, last but not least, wrote articles in *L'Emulation*, the mouthpiece of the Société Centrale d'Architecture in Belgium.

37. A. Crespin, "Le sgraffito", *L'Emulation*, 1895, col. 172–173.

38. [Anonymous], "Crespin, Duyck et Hankar", *L'Art moderne*, no. 6, 9 February 1896, p. 44.

39. Gouweloos house-cum-studio, Rue d'Irlande (1896), Ciamberlani studio, Boulevard de la Cambre (1897), Bartholomé studio, Avenue de Tervuren (1898), Janssens studio, Rue Defacqz (1898); plinths and display cases for works by his friend Philippe Wolfers exhibited in the main exhibition hall of the Tervuren exhibition in 1897 or at the Salon organised by the Société Nationale des Beaux-Arts in Paris in 1901.

40. H. van de Velde, *Formules de la beauté architectonique moderne*, Brussels, 1978, p. 63.

41. *Ibid.*, p. 65.

42. H. van de Velde, *Récit de ma vie, op. cit.*, p. 213.

43. This lecture, entitled "Die künstlerische Hebung der Frauentracht", was published in Krefeld (Druck und Verlag Kramer und Baum) in the form of a thirty-four page essay. It was supplemented by "Das neue Kunst-Prinzip in der modernen Frauenkleidung", published in the review *Deutsche Kunst und Dekoration* in 1902 (VIII-1, pp. 363–386).

44. The dining room, smoking room, collector's room and rotunda exhibited had made him the target of various gibes in the French press. He had even been described as "barbaric" by Rodin. Two years later, exhibiting at the Dresden exhibition of furnished interiors, Bing demanded that all the artists from his gallery should remain anonymous. The German press gave them a warm welcome and van de Velde's identity was soon revealed; the flamboyantly-decorated rest room that he had added to his Parisian designs was widely copied.

45. Horta was to be excluded from this project because his proposals were too expensive. Personal problems arising from Horta's irascible nature also played a part. It seems that he did not want to work with "interior designers". At that time, Horta already appeared to be deeply irritated by the techniques used by van de Velde, who was to have a decisive influence on the birth of Art Nouveau. In addition, he had quarrelled with Georges Hobé over the design of the Hôtel Deprez-van de Velde on Avenue Palmerston.

46. Wolfers was commissioned to produce a lavish bookbinding (leather, silver, ivory, baroque pearls and opals) for a commemorative album as well as a lectern, presented by the Congo Free State to the Baron of Béthune, the exhibition organiser. Wolfers selected animal motifs, the heron and the bat, which were to recur frequently in his jewellery and glass designs, perhaps after his discovery of the jewellery exhibited at the World Exhibition at the Parc du Cinquantenaire by the French designer René Lalique.

47. Even his treatment of mass recalls the Hôtel Aubecq built by Victor Horta on Avenue Louise. The curving base, on Avenue de la Jonction, supports the metal structure of the winter garden which contributes to the lighting of the stairwell, since Brunfaut did not conform to Horta's use of light shafts. The fluid arabesques described by the banisters unfurl in front of frescoes by the French painter Paul Baudouin, a disciple of Puvis de Chavannes. The entire decoration can be described as classicised Art Nouveau. The dynamism characteristic of Horta's forms is gentler here and more measured.

48. Adolphe Crespin, friend and collaborator of Paul Hankar, recalled that Otto Wagner had introduced Art Nouveau to Austria after his visit to the exhibition at Tervuren in 1897.

49. *L'Art moderne*, XXII, no. 5, 2 February 1902, pp. 35–36, XXII, no. 7, 16 February 1902, pp. 52–53.

50. P. Behrens, quoted in K. Frampton, *L'Architecture moderne. Une histoire critique*, Paris, 1985, p. 99.

51. J. Destrée, *Le Peuple*, 4 October 1905, p. 1, col. 2.

52. One noteworthy attraction at the Turin exhibition was a hall devoted to Ghent. Oscar van de Voorde showcased a collection of objects which were of Egyptian and Viennese inspiration; the polished surface of the wood was inlaid with metal rods that created attractive geometric patterns.

53. "Relation de la visite du palais Stoclet par des architectes belges, le 22 septembre 1912", *Tekhné*, no. 79, 28 September 1912, quoted in *Vienne-Bruxelles, La Fortune du palais Stoclet*, Brussels, 1897, p. 32.

54. J. S. Gibson, "Artistic Houses", *The Studio*, I, 1893, pp. 215–226.

55. In fact, the society continued to thrive in a similar format until after Ysaÿe's death in 1931, despite a long break due to the war and its aftermath.

56. It is worth noting that Maus' interpretation of the work of Les Fauves was completely in keeping with the Belgian tradition that has slowly asserted itself in these pages. He spoke of "ardent poems composed of colours and forms, of decorative surroundings imbued with fiery or tranquil rhythms, in which objective reality is subordinated to expression". O. Maus, *Préface au catalogue de La Libre Esthétique*, 1906.

57. F. Hellens, "A la Galerie Giroux. Exposition de M. Kandinsky", *L'Art moderne*, XXXIII, no. 23, 8 June 1913, p. 181.

BIOGRAPHICAL NOTES ON THE MAIN BELGIAN ARTISTS

Louis ARTAN de SAINT-MARTIN
(1837–1890)
Painter of maritime landscapes. Co-founder of the Société Libre des Beaux Arts in 1868. A member of the realist movement, both in his bold application of paint and his treatment of light. Most of his works were seascapes painted on the Belgian and Dutch coast.

Jean BAES
(1848–1914)
Architect and interior decorator. Professor at the Académie Royal des Beaux-Arts in Brussels and founder of the Ecole des Arts Décoratifs. One of the main exponents of Flemish Neo-Renaissance architecture.

Alphonse BALAT
(1818–1895)
Architect. Exponent of a classicising eclecticism. Responsible for the design of the Palais de Laeken and the Palais de Bruxelles. Buildings include the Musée d'Art Ancien in Brussels, the Royal Glasshouses at Laeken, and various town houses. Teacher of Horta.

Peter BENOIT
(1834–1901)
Composer. Prix de Rome in 1857. Studied in Germany and Paris. Championed the cultural emancipation of Flanders and wrote vast musical frescoes for choir and orchestra. In 1898, he obtained governmental permission to convert the Flemish Music School, founded previously by him in Antwerp, into the Royal Flemish Conservatory of Music.

Henri BEYAERT
(1823–1894)
Architect. Master of Flemish Neo-Renaissance style, characterised by his emphasis on picturesque appeal, colour and movement.

Hippolyte BOULENGER
(1837–1874)
Landscape artist. Founder and sole member of the Ecole de Tervuren. The Soignes forest, on the outskirts of Brussels, provided this expressive realist artist with his primary source of inspiration.

Gédéon-Nicolas-Joseph BORDIAU
(1832–1904)
Eclectic architect. Collaborated with Poelaert. His main projects included the plan for the development of the north-eastern district of Brussels, the exhibition halls in the Parc du Cinquantenaire and the Hôtel Métropole.

Louis BRASSIN
(1840–1884)
Pianist. Pupil of Liszt and a leading interpreter of Schumann. He helped to introduce Wagner to Brussels.

Fernand BROUEZ
(1861–1900)
Guiding force behind the socialist and anarchist review *La Société Nouvelle* from 1884 to 1897. Married the novelist Neel Doff.

Henri CASSIERS
(1858–1944)
Painter and watercolourist of landscapes, seascapes, cityscapes and genre scenes. Produced postcards and posters that provide picturesque views of the lower classes of Flanders and Zeeland.

Paul CAUCHIE
(1875–1952)
Painter, decorator and furniture designer. His sgraffiti decorated many Art Nouveau buildings in Brussels. His best-known work is his own house in Brussels (1905).

Albert CIAMBERLANI
(1864–1956)
Symbolist painter. Co-founder of the Pour l'Art group in 1892. From 1896, he participated in the idealist art exhibitions organised by Delville. Influenced by Puvis de Chavannes, he produced decorative art and vast mural paintings.

Émile CLAUS
(1849–1924)
Leader of the Belgian Luminist movement. Influenced by Monet, he used the impressionist technique in his sun-drenched Flemish landscapes. In 1904, he founded the Vie et Lumière group.

Gisbert (or Ghisbert) COMBAZ
(1869–1941)
Painter of landscapes, portraits and religious subjects. Sculptor, professor and art historian. Particularly renowned for his lithographs and posters.

Adolphe CRESPIN
(1859–1944)
Painter, decorator, poster artist. Became interested in Japanese prints early in his career. Met Hankar and perfected a sgraffito technique for decorating façades and exhibition halls. Worked with Edouard Duyck as a poster artist.

Henri DE BRAEKELEER
(1840–1888)
Realist painter. His work, influenced by the minor Dutch masters, was characterised by his Intimism and meticulous treatment of detail.

Charles DE COSTER
(1827–1879)
Writer. Presided with Rops over the weekly review *Uylenspiegel* (1856–1864) in which he published tales and narratives some of which were reprinted in *Contes brabançons* (*Brabant Tales*, 1861) or in *Légendes flamandes* (*Flemish Legends*, 1858). Also author of vituperative political articles. In 1867, he published his famous novel *La Légende et les aventures héroïques, joyeuses, et glorieuses d'Ulenspiegel et de Lamme Goedzak au pays de Flandres et ailleurs* (*The Glorious Adventures of Tyl Ulenspiegl*), a hymn to freedom of thought, written in artistically archaic language.

William DEGOUVE de NUNCQUES
(1867–1935)
Symbolist painter. Friendly with Toorop and de Groux, who pointed him towards Symbolism. In 1894, he married Juliette Massin, painter, Verhaeren's sister-in-law, and began frequenting the symbolist literary circle. Travelled widely, particularly to the Balearic Islands. After the death of his wife, he stopped painting for three years. Subsequently, he only produced Ardennes landscapes.

Charles DE GROUX
(1825–1870)
Pupil of Navez at the Brussels Academy. Co-founder of the Société Libre des Beaux-Arts in 1868. Precursor of Realism in Belgium. His work expressed his concern with social problems and frequently depicted scenes of rural life.

Henry DE GROUX
(1867–1930)
Symbolist painter, son of the above. Elected a member of Les Vingt in 1886, he was expelled in 1890 because of his violent temper. Friend of Degouve de Nuncques. His art was influenced by literary symbolism and he was fond of depicting religious themes in a somewhat grandiloquent manner.

Jean DELVILLE
(1867–1953)
Symbolist painter and writer. Disciple of Péladan, he exhibited in Paris at the Salons de la Rose+Croix. In 1892, the Pour l'Art association and in 1896 he founded the Salon d'Art Idéaliste

with the aim of perpetuating "the great tradition of idealist Art from old masters to modern masters".

Eugène DEMOLDER
(1862–1919)
Storywriter and art critic. Co-founder of the review *Le Coq rouge*. His books featured scenes taken from Flemish and Dutch painters whom he occasionally made his heroes, such as Rembrandt in *La Route d'emeraude* (*The Emerald Way,* 1899).

Isidore DE RUDDER
(1855–1943)
Sculptor. Designer of masks and decorative tiles. Worked for Wolfers' company. Built some funerary monuments.

Paul DE VIGNE
(1843–1901)
Sculptor. Widely travelled in Italy. Exponent of classicism and academism in sculpture.

Julien DILLENS
(1849–1904)
Sculptor and medallist. Prix de Rome in 1877. Famous for his figures in historical dress designed to embellish ancient monuments. Produced funerary statues and public monuments.

Auguste DONNAY
(1862–1921)
Landscape artist, engraver and illustrator. Made his debut in the symbolist review *La Wallonie.* Produced idealist drawings.

Charles DOUDELET
(1861–1938)
Painter, engraver and illustrator. Particularly noted for his illustration of several of Maeterlinck's books.

Fernand DUBOIS
(1861–1939)
Symbolist sculptor, engraver, medallist. Pupil of van der Stappen. Taught at the Ecole de Bijouterie in Brussels. Designed numerous decorative metal objects. Exhibited at the exhibitions mounted by Les Vingt and La Libre Esthétique.

Louis DUBOIS
(1830–1880)
Painter. Disciple of Courbet, he became a champion of Realism, both in his painting and in his writings in *L'Art Libre.* Founder member and leading theoretician of the Société Libre des Beaux-Arts.

Joseph DUPONT
(1838–1899)
Conductor. Conducted the Concerts Populaires for over twenty-five years. Conductor then director (1886–1889) of the Théâtre Royal de la Monnaie. Championed contemporary German music in Brussels.

Georges EEKHOUD
(1854–1927)
Novelist and naturalist storywriter. He was one of the first contributors to the review *La Jeune Belgique* which he left to found *Le Coq rouge* and champion a less elitist art. His novels centred around rebel heroes in conflict with an egotistical bourgeoisie (*La nouvelle Carthage*, 1888; *The New Carthage*). His books (*Kees Dorik*, 1884, *Kermesses* 1884, *Mes Communions*, 1895) made frequent reference to the seedy district around the port of Antwerp and the region of Kempenland (Campine).

Max ELSKAMP
(1862–1931)
Symbolist poet. Flemish folklore and legends were a source of inspiration for his poems which used the rhythm and images of litanies, laments and songs. Written in an archaic language, these works were given titles indicative of their author's sophistication: *Dominical* (1892), *Salutations* (1893), *Six Chansons de pauvre homme* (1896).

James ENSOR
(1860–1949)
Painter. Precursor of modern art. Founder member of Les Vingt. He first produced dark works tackling bourgeois subjects, characteristic for their application of rich, thick paint. In 1883, his palette grew lighter and he began using more aggressive and expressive pure colours to illustrate the artist's inner world, a fantastic universe peopled by skeletons and masks. After 1900, he immersed himself in his own work, repeatedly displaying the themes and motifs that eventually assured his fame.

Henri EVENEPOEL
(1872–1899)
Painter. Settled in Paris in 1892 where he became a pupil of Gustave Moreau. Influenced by Degas, Toulouse-Lautrec and Manet. He painted many portraits and Parisian landscapes. Travelled to Algeria from 1897–1898. Photographs often formed the basis of his works.

Émile FABRY
(1865–1966)
Idealist painter and lithographer. Co-founder of the group Pour l'Art in 1892. Exhibited at the Rose+Croix exhibitions in Paris. Painted some vast mural compositions.

François-Joseph FÉTIS
(1784–1871)
Composer and musicologist. Founder of the *Revue musicale*, director of the Brussels Conservatory (1833–1871). Ensured the prestige of the Concerts Populaires, which enabled him to educate the public. His collection of period instruments formed the basis of the Musée Instrumentale at the Brussels Conservatory.

Alfred William FINCH (alias Willy)
(1854–1930)
Painter, watercolourist, etcher and ceramicist. Founder member of Les Vingt. Initially influenced

by Ensor, his style developed towards Neo-Impressionism. Painter-decorator for the Boch ceramics firm, he devoted himself to that field and was employed by the Iris firm in Finland, where he became a teacher in 1897.

André FONTAINAS
(1865–1948)
Post-symbolist poet and friend of Mallarmé. He cultivated a sense of mystery in his unusually-titled collections such as *Les Vergers illusoires* (*The Illusory Orchards*, 1892).

César FRANCK
(1822–1890)
Composer and organist. Born and educated in Liège. In 1844, settled in Paris and studied the organ. Organist at the church of Sainte-Clotilde in Paris where he played the Cavaillé-Coll organ. Organ professor at the Paris Conservatoire (1872–1890). Many compositions for organ and a large-scale oratorio (*Les Béatitudes*). His compositions (chamber, orchestral, piano and organ) and his modern concepts influenced by Wagner, profoundly influenced Duparc, d'Indy, Chausson and Lekeu, who formed a school around him.

Léon FRÉDÉRIC
(1856–1940)
Painter. Travelled in Italy with the sculptor Dillens. His painting, initially naturalist in spirit through its concern for social inequality (circa 1882), developed towards an allegorical symbolism. The painter exhibited at the exhibitions of idealist art from 1896.

François-Auguste GEVAERT
(1828–1908)
Composer and musicologist. Career in Paris. Several successes as a composer (*Quentin Durward*, 1858). In 1871, appointed director of the Brussels Conservatory, he continued the educational work started by Fétis. His repertory extended as far as Wagner. He organised historical concerts on period instruments. He wrote many theoretical and historical articles.

Ywan GILKIN
(1858–1924)
Poet (*La Nuit*, 1897, *Prométhée*, 1899) and playwright (*Savonarole*, 1906, *Egmont*, 1926), a great lover of Baudelaire. One of the founders of *La Jeune Belgique* (1881).

Paul GILSON
(1865–1942)
Composer. Famous from 1892 for his symphonic poem *La Mer*. Prolific and uneven output. Renowned professor (Synthétistes group), music critic.

Albert GIRAUD (pseudonym of Albert Kayenbergh)
(1860–1929)
Poet, critic and journalist. Co-founder in 1881 of *La Jeune Belgique*. His poetical work was charac-

terised by a classical aesthetic and "*fin-de-siècle*" themes (*Pierrot Lunaire*, 1884, set to music by Schoenberg, *Hors du siècle*, 1888, *Les Dernières Fêtes*, 1891).

Paul HANKAR
(1858–1901)
Architect. Pupil and collaborator of Beyaert. Exponent of the rationalist style of Art Nouveau in Brussels. Masterpiece was his design of the colonial exhibition at Tervuren in 1897. He built many shops and artists' studios.

Édouard HANNON
(1853–1931)
Photographer. Founder member of the Association Belge de Photographie. In 1904, he commissioned an Art Nouveau town house.

Charles HERMANS
(1839–1924)
Realist painter. His work acquired an added social dimension when he exhibited, in 1875, *A l'Aube* (*At Dawn*), executed in the manner of a historical painting.

Adrien-Joseph HEYMANS
(1839–1921)
Landscape artist. Stayed in Paris. Initially in the tradition of the Barbizon school, his style began to develop, from 1863 onwards, towards Luminism. He participated in the activities of the Société Libre des Beaux-Arts, Les Vingt and La Libre Esthétique. Co-founder of the circle Vie et Lumière in 1904 with Claus.

Victor HORTA
(1861–1947)
Architect. Leading figure in modern Belgian architecture. He began his career under the influence of his teacher Balat, then became the originator and promoter of Art Nouveau. In particular, he built many houses, the Maison du Peuple in Brussels, and the department store Innovation. After 1918, his formal language began to bear similarities to Art Deco (Palais des Beaux-Arts in Brussels).

Joseph JONGEN
(1873–1953)
Composer. Director of the Brussels Conservatory (1929–1945). Prolific composer of well-made works in a variety of genres. Employed a Franckian language which showed the influence of Debussy and Ravel.

Fernand KHNOPFF
(1858–1921)
Principal Belgian symbolist painter. A pupil of Mellery. During his stays in Paris, he was fascinated by the work of Delacroix, Moreau and the English Pre-Raphaelites. Founder member of Les Vingt (1883). In Paris, he exhibited at the Rose+Croix exhibitions. He became an illustrator, collaborating with Belgian symbolist authors, and also produced polychromatic sculptures, decorative panels, costumes and stage sets for theatre and opera. In his

paintings, he used a wide variety of media, particularly photographs. He exhibited throughout Europe (Vienna, London, Munich, etc.).

Maurice KUFFERATH
(1852–1919)
Music critic and musicographer. Editor of the *Guide musical*. Director of the Théâtre Royal de la Monnaie (1900–1919). Champion and commentator of Wagner, Franck's disciples and Richard Strauss.

Eugène LAERMANS
(1864–1940)
Artist with a social calling. Took his subjects from rural and working life. Realist at the start of his career, his work developed towards a pre-expressionist Synthetism as his health worsened. Deaf and blind, he helped found the artistic group Voorwarts.

Jef LAMBEAUX
(1852–1908)
Sculptor. Lived in Paris from 1879–1881, then travelled in Italy. Lively style with voluptuous forms, epitomised by *Le Baiser* (*The Kiss*), exhibited at the Salon of 1881. He reached the height of his powers with the marble relief *Les Passion humaines* (*The Human Passions*).

Georges LE BRUN
(1873–1914)
Painter. With his farm interiors and landscapes showing various aspects of the Hautes Fagnes and the Ardennes, he displayed a subtle Symbolism combined with Intimism.

Guillaume LEKEU
(1870–1894)
Composer. Pupil of Franck and d'Indy. His works, whose structure was influenced by Franck, developed a powerful and original lyricism (*Sonate pour piano et violon*, *Adagio pour orchestre à cordes*).

Georges LEMMEN
(1865–1916)
Intimist painter, initially influenced by Neo-Impressionism, then by the Art Nouveau line. He participated in the exhibitions mounted by Les Vingt (of which he was a member in 1888) and by La Libre Esthétique. He exhibited at the Salon des Indépendants in Paris (1889–1892). Illustrator and poster artist. He made several forays into the field of applied arts.

Camille LEMONNIER
(1844–1913)
Naturalist then "naturist" novelist, storywriter and art critic. Champion of realist art versus academism. Founder of several reviews including *L'Art universel* (1873) and *L'Actualité*. Regarded as a master by the "Jeunes Belgique" and author of over seventy books including naturalist novels (*Un mâle*, 1881, *Happe Chair*, 1886, *La Fin des bourgeois*, 1892), children's stories, an important work on *La Belgique* (1888) and memoirs (*Une vie d'écrivain*, 1945).

Grégoire LE ROY
(1862–1941)
Poet, storywriter and art critic. Childhood friend of Maeterlinck and van Lerberghe. His *Chanson du pauvre* (*Song of the Poor Man*, 1907) resembles a reinterpretation of folk poetry.

Auguste LEVÊQUE
(1866–1921)
Idealist painter. Disciple of Delville and Péladan.

Privat LIVEMONT
(1861–1936)
Art Nouveau painter, interior decorator, poster artist and lithographer. Worked in Paris from 1883 to 1889. His first posters, whose central subject was often a woman, dated from 1890.

Maurice MAETERLINCK
(1862–1949)
Principal symbolist poet and playwright. From the start, he wrote symbolist poetry such as *Les Serres chaudes* (*Hothouses*, 1889), or *Douze chansons* (*Twelve Songs*, 1896). He settled in France, wrote claustrophobic plays that experimented with legends and the unconscious mind such as *La Princess Maleine* (1889), *Les Aveugles* (*The Blind*, 1890), *Pelléas et Mélisande* (1892). Also interested in scientific subjects with *Le Trésor des humbles* (*The Treasure of the Humble*, 1896), and *La Vie des abeilles* (*The Life of Bees*, 1901). His essays were to become famous throughout the world. Translated Ruysbroeck and Novalis. At the end of his life, he wrote his memoirs under the title of *Bulles bleues* (*Blue Bubbles*, 1948). Nobel Prize for literature in 1911.

Octave MAUS
(1856–1919)
Lawyer, artistic organiser, music critic and art critic. Collaborated with the review *L'Art moderne*. Founder, in 1884, of Les Vingt and in 1893 of La Libre Esthétique. Admirer of Wagner, great traveller, and author of assorted memoirs.

Xavier MELLERY
(1845–1921)
Painter, graphic artist, illustrator. Prix de Rome in 1870. On the one hand, he produced allegorical and decorative paintings against a gold background that were to remain at a preliminary stage and, on the other hand, a series of Intimist and symbolist drawings that brought out the inner poetry of everyday life. Exhibited at Les Vingt from 1885. Teacher of Khnopff.

Constantin MEUNIER
(1831–1905)
Realist sculptor, painter and graphic artist. Initially depicted religious and historical subjects. Around 1878, he discovered the working-class world and this then became the focus of his work, which either celebrated its heroic qualities or acquired the dimension of social criticism. Member of the Société Libre des Beaux-Arts, then Les Vingt. His success when he took part in the Bing exhibition in Paris (1895) led him to exhibit his work throughout Europe.

George MINNE
(1866–1941)
Symbolist sculptor and graphic artist. Exhibited at
Les Vingt in 1890 and frequented the symbolist
poets whose works he illustrated. A major figure in
the first group at Laethem-Saint-Martin, where he
settled in 1899. Symbolist because of the mood of
introspection, silence and asceticism that his works
exude. His angular and tortured visual vocabulary
prefigured Expressionism.

Léonard MISONNE
(1870–1943)
Self-taught photographer influenced by pictorial-
ism.

Albert MOCKEL
(1866–1945)
Poet. Founder of the symbolist review *La Wallonie*
(1886–1893). After 1892, he settled in Paris where
he wrote for the *Mercure de France*. Admirer of
Mallarmé. Poet (*Chantefable un peu naïve*, 1891).
With his *Propos de littérature* (*About Literature*,
1894), he made a name for himself as one of the
major theoreticians of symbolism.

Constant MONTALD
(1862–1944)
Symbolist painter, idealist. Prix de Rome, stayed in
Paris, Italy and Egypt. Produced vast matt, decora-
tive and allegorical mural paintings. Friend of Ver-
haeren whose portrait he painted on many occa-
sions.

George MORREN
(1868–1941)
Neo-impressionist, then luminist and intimist
painter. Pupil of Emile Claus with whom he organ-
ised the Vie et Lumière group.

Périclès PANTAZIS
(1849–1884)
Impressionist painter of Greek origin. Initially
studied in Paris, then came to Brussels around 1875
to work in the "Peinture et Décoration" firm owned
by Vogels, with whom he became friendly. Founder
member of Les Vingt.

Edmond PICARD
(1836–1924)
Writer, lawyer (Verhaeren and Maeterlinck did their
articles in law in his practice), professor, socialist
senator. Founder of the review *L'Art moderne* (1881).
A supporter of the concept of the "Belgian soul"
and national unity, he was opposed to the "Jeunes
Belgique" and advocated art with a social message.
Founder of the *Pandectes belges* and the *Journal des
Tribunaux*, journalist at *Le Peuple*, author of books
on law and literary works (*La Forge Roussel, L'Ami-
ral, Le Juré*). As a playwright, he was influenced by
the theatre of ideas (*Jéricho, Ambidextre*).

Joseph POELAERT
(1817–1879)
Architect. Appointed Municipal Architect of the city
of Brussels. Adopted an eclectic style that was occa-

sionally overbearing and excessive. He built among
others the Palais de Justice in Brussels, the Colonne
du Congrès, and the Eglise Notre-Dame in Laeken.

Antoine POMPE
(1873–1980)
Became a self-taught architect after devoting him-
self primarily to the industrial arts. Studied with
Horta. Modernist from the start, broke early
with the international movement to style himself
"pseudo-modernist". Produced garden-cities and
private houses.

Dario de REGOYOS
(1857–1913)
Landscape artist of Spanish descent. Lived in Bel-
gium from 1879 to 1890. Founder member of Les
Vingt, he was a friend of Vogels, van Rysselberghe,
Meunier and Verhaeren. He introduced Impres-
sionism and the divisionist technique to Spain.

Georges RODENBACH
(1855–1898)
Symbolist poet, novelist and playwright. Although
his early works showed the influence of the Par-
nassians and a deep respect for form, from 1884
onwards, his writing gradually developed an atmos-
phere of languid reverie tinged with mysticism and
fin-de-siècle pessimism. (*L'Hiver mondain*, 1884,
La Jeunesse blanche, 1885). His novels (*L'Art en exil*,
1889, *Bruges-la-Morte*, 1892) were among the first
symbolist novels.

Egide ROMBAUX
(1865–1942)
Sculptor, studied under van der Stappen, among
others. Collaborated with Lambeaux. Widely trav-
elled. Prix Godecharle in 1887 and Prix de Rome
in 1891.

Félicien ROPS
(1833–1898)
Painter, engraver, illustrator. Studied law at the
Brussels Free University and founded, in 1856, the
satirical weekly review *Uylenspiegel*. In 1874, he
moved to Paris where he worked primarily as an
engraver and illustrator, particularly for symbolist
authors (Péladan, Baudelaire). Landscape artist in
the realist style, he was better known for his works
tinged with Symbolism and Satanism and his erotic
compositions. He was elected a member of Les
Vingt in 1886.

Victor ROUSSEAU
(1865–1898)
Sculptor. Pupil of van der Stappen. Prix Gode-
charle in 1890. Travelled to London, Paris, Italy
and Greece. Proponent of idealism in sculpture.
Also painter and illustrator.

Adolphe SAMUEL
(1824–1898)
Composer and conductor. Pupil of Fétis and
Mendelssohn, then ardent Wagnerian. Founder of
the Concerts Populaires in Brussels (1865). Director
of the Ghent Conservatory (1871–1898).

Willy SCHLOBACH
(1865–1951)
Painter of landscapes and still lifes. Founder mem-
ber of Les Vingt (1883)

Gustave SERRURIER-BOVY
(1858–1910)
Architect and interior designer from Liège. He
was one of the first exponents of Art Nouveau in
Europe. He exhibited at La Libre Esthétique. Par-
ticipated in the design of the colonial exhibition at
Tervuren in 1897. Founded a chain of home decora-
tion shops, L'Art, in Liège, Brussels, Paris and
Nice, which sold his designs.

Fernand SÉVERIN
(1867–1931)
Poet (*Le Lys*, 1888, *Le Don d'enfance*, 1891). Friend
of Mockel and van Lerberghe, whose symbolist
tendencies he shared.

Léon SNEYERS
(1877–1949)
Architect and interior decorator. Deeply influenced
by the Viennese Secession. Founded a gallery called
L'Intérieur.

Léon SPILLIAERT
(1881–1946)
Self-taught painter from Ostend. He settled in Brus-
sels in 1935. Used mixed media (pastels, watercolour,
gouache, ink, crayon). His home town featured fre-
quently in his work. Symbolist artist, precursor of
Expressionism and Surrealism. Was a member of
various artistic circles (Sélection, Kunst van Heden).

Alfred STEVENS
(1823–1906)
One of the first painters keen to represent the
modernity of his times. After studying in Brussels
with the painter Navez, then in Paris with Roque-
plan, he settled in the French capital in 1852 and
won acclaim as a painter of women. A friend of
Manet, he was one of the first to display a liking
for Japonism in art. He combined technical mas-
tery with a sophisticated treatment of his subjects
to produce portraits of Parisian women of the Sec-
ond Empire.

Oscar STOUMON
(1835–1900)
Composer and mediocre musician. In 1875, he
was appointed Director of the Théâtre Royal de la
Monnaie with conductor Edouard Calabresi. He
held this position until 1900, except for an interval
between 1886 and 1889. Profoundly hostile to
Wagner but fairly receptive to new works; several
important premières (Reyer, Massenet, d'Indy).

Edgard TINEL
(1854–1912)
Composer. Director of the Malines Institute of
Religious Music, then of the Brussels Conservatory
(1908–1912). Prolific output influenced by Liszt
and biased towards the liturgical repertory (oratorio
Franciscus, 1888).

Jan TOOROP
(1858–1928)
Dutch painter. Studied at the academies in Amsterdam and Brussels. Exhibited at L'Essor in 1884. Member of Les Vingt from 1885. Through a protagonist of Dutch Art Nouveau, his work also illustrated the social problems of the 1880s and 1890s, as well as symbolist and religious themes. Great variety of styles (realist, neo-idealist).

Henry VAN DE VELDE
(1863–1957)
Painter, architect, interior designer, bookbinder, jeweller, typographer and designer. After studying painting in Antwerp and Paris, he adopted the neo-impressionist technique for a while before developing a style dominated by the ornamental line. In 1893, he abandoned painting to devote himself to the decorative arts and, later, to architecture. His work marked a move in Art Nouveau towards a style dominated by purity of line and functionalism. Director of the arts and crafts school in Weimar (1907–1914) and, in 1926, of the Institut Supérieur des Arts Décoratifs of La Cambre in Brussels. His numerous writings made him the principal theoretician of Art Nouveau and the modern movement.

Charles VAN DER STAPPEN
(1843–1910)
Sculptor. After travelling widely abroad and producing decorative work, he adopted a realist style tinged with idealism. Exhibited at Les Vingt and La Libre Esthétique.

Émile VANDERVELDE
(1866–1938)
Politician, socialist. Doctor of law, social sciences and political economics. Professor at the Brussels Free University and chairman of the Labour Party (1933–1938). Several ministerial terms of office.

Ernest VAN DYCK
(1861–1923)
Lyric tenor. The greatest Wagnerian tenor of his period (he was the perfect *Parsifal* at Bayreuth, from 1888–1901). Gave the first performance of Massenet's *Werther* in Vienna.

Charles VAN LERBERGHE
(1861–1907)
Symbolist poet and playwright. His extremely musical poetry revealed a yearning for purity that thinly disguised his heightened sensuality (*Entrevisions*, 1898, *La Chanson d'Eve*, 1907). *Les Flaireurs* (1889) introduced the genre of the Belgian symbolist drama.

Octave VAN RYSSELBERGHE
(1855–1927)
Architect. Brother of Théo van Rysselberghe. Started out as an eclectic architect (Neo-Greek style). Collaborated with van de Velde. His buildings, in several countries in Europe and in Peking, include the Conservatory in Uccle, the casino in Cherbourg, tourist hotels, town houses, the development of residential quarters and town-planning projects.

Théo VAN RYSSELBERGHE
(1862–1926)
Neo-impressionist painter and sculptor. Founder member of Les Vingt in 1883, he helped Octave Maus to organise this group as well as that of La Libre Esthétique from 1894. He settled finally in France in 1898. Principal exponent of Neo-Impressionism in Belgium, particularly in the field of portraiture.

Jules Jacques VAN YSENDIJCK
(1836–1901)
Architect. Built many Flemish Renaissance style buildings. In particular, he built several town halls, the Château Kunst et Kust and the grenadiers' barracks in Brussels, as well as restoration projects.

Émile VERHAEREN
(1855–1916)
Symbolist poet and playwright. Initially influenced by Parnassian literature, he suffered, at the end of the 1880s, a breakdown that was reflected in his symbolist trilogy *Les Soirs* (*The Evenings*), *Les Débâcles* (*The Debacles*), *Les Flambeaux noirs* (*The Black Flags*) in which he adopted free verse and a violent, fragmented language. After 1891, his poetry evolved, on the one hand towards a more Intimist style with *Les Heures claires* (*The Bright Hours*, 1896), and on the other towards a social engagement and an apologia of the modern world with *Les Campagnes hallucinées* (*The Hallucinated Countrysides*, 1893) or *Les Villes tentaculaires* (*The Sprawling Cities*, 1895). This vein reached its apogee in the poems "of energy" such as *Les Forces tumultueuses* (*The Tumultuous Forces*, 1902). Author of essays on Rembrandt, Ensor, Khnopff, and the plays *Les Aubes* (*The Dawns*, 1898) and *Le Cloître* (*The Cloister*, 1900).

Isidore VERHEYDEN
(1846–1905)
Painter, landscape artist, portraitist. Member of Les Vingt from 1885–1888. He belonged to the second generation of realists. His work also showed the influence of Impressionism in its emphasis on the effects of light.

Guillaume VOGELS
(1846–1896)
Painter. Member of La Chrysalide (1878), then founder member of Les Vingt (1883). He transcended Impressionism by his rich application of paint, his spontaneous technique and the bold patches of colour he laid in.

Victor VREULS
(1876–1944)
Composer. Pupil of d'Indy in Paris. Director of the Luxembourg Conservatory (1906). Influenced by Wagner and Franck, he composed a sound range of works, spanning all the genres.

Max WALLER (pseudonym of Maurice Warlomont)
1860–1889)
Writer. Founder and editor of *La Jeune Belgique* (1881) which he directed with courage and conviction in a spirit of enquiry. Poet (*La Flûte à Siebel*, 1887).

Philippe WOLFERS
(1858–1929)
Symbolist and Art Nouveau sculptor and jeweller. Excelled in the field of glass design. Influenced by Oriental arts. The female figure recurs like a leit-motiv throughout his work.

Eugène YSAŸE
(1858–1931)
Violinist, composer and conductor. One of the greatest virtuosi of his time. Gave first performance of sonatas by Franck, Lekeu, and Chausson, d'Indy's First Quartet, and Debussy's Quartet. Professor at the Brussels Conservatory (1886–1898). Founder of the Société Symphonique des Concerts Ysaÿe (1896). Compositions inspired by Franck, evolving later towards a sparser, more personal style (*6 Sonatas for Unaccompanied Violin*, 1924).

Bibliography

Art, Architecture, Literature, Music, History

A

ADAMS, B., "Ensor as a 1980's artist", *Print Collector's Newsletters*, XIX, 1, March–April 1988, pp. 10–12.

AKKERMAN, K., "De vijf zwaanhangers van de Brusselse goudsmid Philippe Wolfers" [The five swan pendants by the Brussels goldsmith Philippe Wolfers], *Antiek*, no. 9, April 1985, pp. 466–477.

ALHADEFF, A., "George Minne: Maeterlinck's Fin de siècle Illustrator", *Annales de la Fondation Maurice Maeterlinck*, XII, 1966, pp. 7–42.

ARON, P., *Les Ecrivains belges et le socialisme (1880–1913), l'expérience de l'art social: d'Edmond Picard à Emile Verhaeren*, Brussels, 1985.

ARON, P., "Le symbolisme belge et la tentation de l'art social: une logique littéraire de l'engagement politique", *Les Lettres Romanes*, XL, 1986, p. 316.

B

BAUDIN, F., "Books in Belgium", *Book Typography 1815–1965 in Europe and the United States of America*, Chicago, 1966, pp. 3–36.

BAUDIN, F., "La formation et l'évolution typographique d'Henry Van de Velde, 1863–1957", *Quarendo*, I, 1971, pp. 272–273; II, 1972, pp. 55–73.

BERG, Ch., "Dix-neuf lettres de Max Elskamp à propos des Six chansons imprimées par Henry Van de Velde", *Le Livre et l'Estampe*, XVI, 1970, pp. 155 ff.

BIERME, M., *Les Artistes de la pensée et du sentiment*, Brussels, 1911.

BLOCK, J., "What's in a name: The Origins of Les XX", *Jaarboek van het Koninklijke Museum voor Schone Kunsten Antwerpen* (Annual report of the Musées Royaux des Beaux-Arts in Antwerp], XXX, 1981–1984, pp. 135–141.

BLOCK, J., *Les XX and Belgian Avant-Gardism 1868–1894,* Ann Arbor, 1984.

BLOCK, J., "A Neglected Collaboration: Van de Velde, Lemmen and the Diffusion of the Belgian Style", *The Document Image: Vision in Art History*, Syracuse, 1987, pp. 147–164.

BLOCK, J., "A Study in Belgian Neo-Impressionist Portraiture", *Art Institute of Chicago Museum Studies*, XIII, 1987, pp. 36–51.

BORSI, F., *Victor Horta*, Brussels, 1990 (reprint).

BORSI, F. and WIESER H., *Bruxelles, capitale de l'Art nouveau*, Brussels, 1992.

BOYENS, P., *L'Art flamand. Du symbolisme à l'expressionnisme*, Tielt, 1992.

BRAET, H., *L'Accueil fait au symbolisme en Belgique 1885–1900,* Brussels, 1967.

C

CANNING, S. M., *A History and Critical Review of the Salons of 'Les Vingt': 1884–1893,* doctoral thesis, The Pennsylvania State University, 1980.

CANNING, S. M., "The Symbolist Landscapes of Henry Van de Velde, *Art Journal,* XLV, Summer 1985, pp. 130–136.

CARDON, R., *Georges Lemmen (1865–1916)*, Antwerp, 1990.

CELIS, M., "Door de oog van de naald: de Art Nouveau woning van Edouard Hannon [Through the eye of the needle: the Art Nouveau house of Edouard Hannon], *Monumenten en Landschappen*, IX, 1990, no. 1, pp. 41–55.

CHARTRAIN-HEBBELINCK, M. J., "Les Lettres de Théo van Rysselberghe à Octave Maus", *Jaarboek van het Koninklijke Museum voor Schone Kunsten Antwerpen*, XV, 1966, pp. 55–75.

CHARTRAIN-HEBBELINCK, M. J., "Les lettres de Paul Signac à Octave Maus", *Bulletin des Musées Royaux des Beaux-Arts de Belgique*, XVIII, 1–2, 1969, pp. 52–102.

CHLEPNER, B. S., *Cent ans d'histoire sociale en Belgique*, Brussels, 1972 (reprint).

CLARK, S., "Nobility, Bourgeoisie and Industrial Revolution in Belgium", *Past and Present,* CV, 1984, pp. 140–175.

CLOSSON, E. and VAN DEN BORREN, L., (ed.), *La Musique en Belgique du Moyen Age à nos jours,* Brussels, 1950.

"Constantin Meunier", *La Revue de Bruxelles,* special issue, December 1978.

COOLS, A. and VANDENDAELE, R., *Les Croisades de Victor Horta*, Brussels, n. d.

CROQUEZ, A., *L'Œuvre gravé de James Ensor*, Brussels-Geneva, 1947.

D

DAVIGNON, H., *L'Amitié de Max Elskamp et d'Albert Mockel (lettres inédites)*, Brussels, 1955.

DE BEULE, M., PUISSANT, J. and VANDERMOTTEN, *Itinéraire du paysage industriel bruxellois*, Brussels, 1989.

DELEVOYE, R. L., *Ensor*, Antwerp, 1981.

DELEVOYE, R. L., DE CROES, C., and OLLINGER-ZINQUE, G., *Fernand Khnopff catalogue de l'œuvre*, Brussels, 1987 (2nd ed.).

DELEVOYE, R. L., LASCAULT, G., VERHEGGEN, J.-P. and CUVELIER, G., *Félicien Rops*, Brussels, 1985.

DELHAYE, J. and DIERKENS-AUBRY, F., *La Maison du Peuple de Victor Horta*, Brussels, 1987.

DELSEMME, P. and TROUSSON, R. (ed.), "Le naturalisme et les lettres françaises de Belgique ", *Revue de l'Université Libre de Bruxelles*, 1984, 4–5.

DELVILLE, O. and LEGRAND, F.-Cl., *Jean Delville peintre*, Brussels, 1984.

De MAEYER, Ch., "Fernand Khnopff et ses modèles", *Bulletin des Musées Royaux des Beaux-Arts de Belgique*, XIII, 1964, pp. 43–56.

DEMOLDER, E., "La sculpture d'ivoire", *L'Art moderne*, no. 22, 1894, pp. 173–175.

De SADELEER, P., *Max Elskamp, Poète et graveur, Catalogue raisonné d'un ensemble exceptionnel de son œuvre littéraire et graphique*, Brussels, 1985.

DESAMA, C., CAULIER-MATHY, N. and GREVIN, P., (ed.) *1880, La Wallonie née de la grève?*, Brussels, 1990.

[DIERKENS]-AUBRY, F., "Henry Van de Velde ou la négation de la mode", *Revue de l'Institut de Sociologie*, 1977, pp. 293–306.

[DIERKENS]-AUBRY, F., "L'influence anglaise sur Henry Van de Velde. Autour du Bloemenwerf", *Annales d'Histoire de l'Art et d'Archéologie de L'Université Libre de Bruxelles*, 1, 1979, p. 83–92.

DIERKENS-AUBRY, F., "Victor Horta, architecte de monuments civiles et funéraires", *Bulletin de la Commission Royale des Monuments et des Sites*, XIII, 1986, pp. 37–101.

DIERKENS-AUBRY, F., *Musée Horta*, Brussels, 1990.

DIERKENS-AUBRY, F., "Une acquisition récente des Musées Royaux d'Art et d'Histoire: 'Les quatre Périodes du Jour' de Charles Van der Stappen (sellette de Victor Horta)", *Bulletin des Musées Royaux d'Art et d'Histoire*, vol. 64, 1993.

DIERKENS-AUBRY, F. and DULIERE, C., "L'hôtel Hannon, un exceptionnel ensemble de l'époque 1900", *La Maison d'Hier et d'Aujourd'hui*, no. 46, June 1980, pp. 14–25.

DIERKENS-AUBRY, F., and VANDENBREEDEN, J., *Art Nouveau en Belgique. Architecture et Intérieurs*, Louvain-la-Neuve, 1991.

DRAGUET, M., (ed.), *Irréalisme et art moderne. Les voies de l'imaginaire dans l'art des XVIII^e,*

XIX^e, et XX^e siècles, Mélanges Philippe Roberts-Jones, Brussels, 1991.

DRAGUET, M., (ed.) Rops et la modernité, Brussels, 1991.

DRAGUET, M., Khnopff ou la dissimulation, Brussels, 1994.

E

EISENMAN, S. F., "Allegory and Anarchism in James Ensor's Apparition: Vision Preceding Futurism", Records of the Arts Museum, Princeton University, XLVI, 1, 1987, pp. 2–17.

ELSKAMP, M., Chansons et enluminures, Brussels, 1980.

EMERSON, B., Léopold II. Le royaume et l'empire, Paris-Gembloux, 1980.

ENSOR, J., Mes écrits, Liège, 1974.

ELESCH, J. N., James Ensor. The Complete Graphic Work, The Illustrated Bartsch, New York, 1982, vol. 141.

F

FRIANGIA, M. L., Il simbolisme di Jean Delville, Bologna, 1978.

FRIEDMAN, D. F., An Anthology of Belgian Symbolist Poets, New York-London, 1992.

G

GERGELY, T., "La notion de naturalisme en Belgique francophone", Revue de l'Université de Bruxelles, 1984, pp. 89–108.

GILSOUL, R., La Théorie de l'art pour l'art chez les écrivains belges, Brussels, 1936.

GORCEIX, P., Les Affinités allemandes dans l'œuvre de Maurice Maeterlinck, Paris, 1975.

GORCEIX, P., "De la spécificité du symbolisme Belge", Bulletin de l'Academie royale de Langue et de Littérature française, LVI, 1978, pp. 77–100.

GORCEIX, P., "Y-a-t-il un symbolisme belge?", Cahiers roumains d'études littéraires, III, 1980.

GORCEIX, P., Le Symbolisme en Belgique, Heidelberg, 1982.

GOYENS DE HEUSCH, S., L'Impressionnisme et le fauvisme en Belgique, Antwerp, 1988.

GREGOIR, E. J. G., Les Artistes-Musiciens belges aux XVIII^e et XIX^e siècles, Brussels, 1885 (supplements and additions in 1887 and 1890).

GUIETTE, R., Max Elskamp, Paris, 1955.

H

HAMMACHER, A. M., Le Monde de Henry Van de Velde, Antwerp, 1967.

HANSE, J., Naissance d'une littérature, Brussels, 1992.

HAESAERTS, P., James Ensor, Brussels, 1957.

HASQUIN, H. (ed.), La Wallonie. Le pays et les hommes. Histoire, économies, sociétés, vol. 2, Brussels, 1976.

HEFTING, V., Jan Toorop, Een Kennismaking [Jan Toorop, a meeting], Amsterdam, 1989.

HERBERT, E., The Artist and Social Reform: France and Belgium, 1885–1898, New Haven, 1961.

HERMANS, G., Les Premières années de Maeterlinck, Ghent, 1967.

HOFFMANN, E., "Notes on the Iconography of Félicien Rops", Burlington Magazine, CXXIII, April 1981, pp. 206–218.

HOPPEN-BROUWERS, A., VANDENBREEDEN, J. and BRUGGEMANS, J., Victor Horta, architectonographie. Brussels, 1975.

HORTA, V., Mémoires, ed. by C. Dulière, Brussels, 1985.

HOWE, J. W., "The Sphinx and Other Egyptian Motifs in the Work of Fernand Khnopff: The Origins of 'The Caresses'", Arts Magazine, December 1979, p. 162.

HOWE, J. W., The Symbolist Art of Fernand Khnopff, Ann Arbor, 1982.

HOZEE, R., BOWN-TAEVERNIER, S. and HEIJBROEK, J. F., James Ensor, Dessins et estampes, Antwerp, 1987.

J

JACQUEMYNS, G., Histoire contemporaine du Grand-Bruxelles, Brussels, 1936.

L

LEBEER, L., The Prints of James Ensor, New York, 1971.

LEDENT, A., "Esquisse d'urbanisation d'une capitale, Bruxelles, son passé, son avenir", La Vie urbaine, XLI, pp. 321–349.

LEGRAND, F.-Cl., "Les lettres de James Ensor à Octave Maus", Bulletin des musées royaux des Beaux-Arts de Belgique, XV, 1966, 34–41.

LEGRAND, F.-Cl., Le Symbolisme en Belgique, Brussels, 1970.

LEGRAND, F.-Cl., Ensor cet inconnu, Brussels, 1971 reprint. in 1990.

LEGRAND, F.-Cl., Un Autre Ensor, Antwerp, 1994. Les Cahiers de la Fonderies, Revue d'histoire sociale et industrielle de la région bruxelloise, 1986–1993.

LEKEU, G., Correspondance, edited by L. Verdebout, Liège, 1994.

LESKO, D., James Ensor, the Creative Years, Princeton, 1985.

LIEBMAN, M., Les Socialistes belges 1885–1914, Brussels, 1979.

LORRAIN, M., Guillaume Lekeu, sa correspondance, sa vie & son œuvre, Liège, 1923.

LOYER, F. and DELHAYE, J., Victor Horta, Hôtel Tassel. 1893–1895. Brussels, 1986.

LOYER, F., Paul Hankar. La Naissance de l'Art nouveau, Brussels, 1986.

LOYER, F., Dix and d'Art nouveau. Paul Hankar. Architecte. Brussels, 1991.

LOZE, P. and F., Belgique Art Nouveau. De Victor Horta à Antoine Pompe, Brussels, 1991.

M

MABILLE DE PONCHEVILLE, A., Vie de Verhaeren, Paris, 1953.

Maison du Peuple, Architecture pour le peuple, Brussels, 1984.

MATHEWS, A. J., La Wallonie, 1886–1892. The Symbolist Movement in Belgium, New York, 1947.

MAUS, M. O., Trente années de lutte pour l'art, 1884–1914, Brussels, 1926 (reprint. 1980).

MAUS, O., "La sculpture en ivoire à l'exposition de Bruxelles", Art et Décoration, II, 1897, pp. 129–133.

MAUS, O., "La Lanterne magique" (1918), Revue des Belles-Lettres, Neuchâtel, 1927, pp. 195–227.

MERCIER, Ph. and WANGERMEE, R., La Musique en Wallonie et à Bruxelles – II – Les XIX^e et XX^e siècles, Brussels, 1982.

McGOUGH, S. C., James Ensor's 'The Entry of Christ into Brussels' in 1889, PhD thesis, Stanford University, 1981, New York, 1985.

N

NORTH. B., "Khnopff and Photography: Theory and Practice", Lecture, University of Kansas, 1990.

O

OLLINGER-ZINQUE, G., Ensor: un autoportrait, Brussels, 1976.

OLLINGER-ZINQUE, G., "Les artistes belges et la "Rose+Croix", Bulletin des Musées Royaux des Beaux-Arts de Belgique, 1989–1991, 1–3, pp. 433–464.

OOSTENS-WITTAMER, Y., L'Affiche belge 1892–1914, Brussels, 1975.

OOSTENS-WITTAMER, Y., Victor Horta. L'Hôtel Solvay, Louvain-la-Neuve, 1980 (2 vol.).

OTTEN, M., (ed.), "Centenaire du symbolisme en Belgique", Les Lettres romanes, vol. XL, no. 3–4, August-November 1986.

P

PAINDAVEINE, H., "Léon Sneyers et l'Intérieur moderne, 1877–1948", Vienne-Bruxelles, La fortune du palais Stoclet, special issue, Archives d'Architecture Moderne, 1987, pp. 47–57.

PIERRON, S., Etudes d'Art, Brussels, n.d., pp. 127–171.

PINCUS-WITEN, R., Occult Symbolism in France. Joséphin Péladin and the Salon de la Rose-Croix, New York-London, 1976.

PLOEGAERTS, L. and PUTTEMANS, P., L'Œuvre architecturale de Henry Van de Velde, Paris, Brussels-Quebec, 1987.

POWELL, K. H., "Xavier Mellery and the Island of Marken", Jaarboek van het Koninklijke Museum voor Schone Kunsten Antwerpen, 1988, pp. 343–367.

PUDLES, L., Solitude, Silence, and the Inner Life: A Study of Belgian Symbolist Artists, PhD thesis, University of California, Berkeley, 1987.

PUDLES, L., "Fernand Khnopff, Georges Roden-bach and Bruges, The Dead City", *The Art Bulletin*, December 1992, pp. 637–654.
PUISSANT, J., "Le naturalisme en Belgique, expression littéraire de la crise ou la prospérité", *Revue de l'Université de Bruxelles*, 1984, pp. 109–118.

Q

QUAGHEBEUR, M., *Lettres belges, entre absence et magie*, Brussels, 1990.

R

RANIERI, L., *Léopold II: urbaniste*, Brussels, 1973.
RAPETTI, R., "Un chef d'œuvre pour ces temps d'incertitude: 'Le Christ aux outrages' d'Henry De Groux", *Revue de l'Art*, 1992, no. 96 pp. 40–50.
Revue Belge de Musicologie, III–XLV, 1949–1991.
ROBERTS-JONES, Ph., *Du réalisme au surréalisme. La peinture en Belgique de Joseph Stevens à Paul Delvaux*, Brussels, 1969, reprint. 1994.
ROBERTS-JONES, Ph., *L'Alphabet des circonstances*, Brussels, 1981.
ROBERTS-JONES, Ph., *La Peinture irréaliste au XIXᵉ siècle*, Fribourg, 1982.
ROBERTS-JONES, Ph., *Image donnée, image reçue*, Brussels, 1989.
ROELANDTS, O., "Etude sur la Société Libre des Beaux-Art de Bruxelles", Brussels, 1935.
ROUIR, E., *Armand Rassenfosse. Catalogue raisonné de l'oeuvre gravé*, Brussels, 1984.
ROUIR, E., *Félicien Rops, catalogue raisonné de l'oeuvre gravé et lithographié. I, Les Lithographies; II, Les eaux-fortes, cat. 273–663; III, Les eaux-fortes, cat. 664–975*, Brussels, 1992.
ROUZET, A., "Les ex-libris Art nouveau en Belgique", *Revue de l'Université Libre de Bruxelles*, 1981–1983, pp. 87–92.

S

San NICOLS, J., *Dario De Regoyos*, Barcelona, n. d.
SARLET, Cl., *Les Ecrivains d'art en Belgique*, Brussels, 1992.
SCHOONBAERT, L. M. A. *et al.*, "Gazette des Beaux-Arts en The Studio als inspiratiebronnen voor James Ensor [*La Gazette des Beaux-Arts* and *The Studio* as sources of inspiration for James Ensor], *Jaarboek Koninklijk Museum voor Schone Kunsten Antwerpen*, 1978, pp. 205–221.
SEKLER, F., *Josef Hoffmann, Das architektonische Werk* [Josef Hoffmann, architectural work], Salzburg and Vienna, 1982.
SEMBACH, K. J., *Henry Van de Velde*, New York, 1989.
SEMBACH, K. J. and SCHULTE, B. (ed.), *Henry Van de Velde. Ein europäischer Künstler seiner Zeit* [Henry Van de Velde. A European artist of his time], Cologne, 1992.

SIEBELHOFF, R., "The Three Brides, a drawing by Jan Toorop", *Nederlands Kunsthistorisch Jaarboek* [Annual bulletin of the history of art in Netherlands], XXVII, 1976, pp. 221–261.
SIEBELHOFF, R., *The Early Development of Jan Toorop*, Utrecht-Toronto, 1973.
SMOLAER-MEYNAR, A. and STENGERS, J., (ed.), *La Région de Bruxelles. Des villages d'autrefois à la ville d'aujourd'hui*, Brussels, 1989.
SONCINI FRATTA, A., (ed.) *Le Mouvement symboliste en Belgique*, Bologna, 1990.
SPAANSTRA-POLAK, B., *De grafiek van Jan Toorop*, Amsterdam, Rijksprentenkabinet, Rijksmuseum, 1968.
STARK, D., *Charles de Groux and Social Realism in Belgian Painting, 1848–1875*, PhD thesis, Ohio State University, 1979.
STOCKHEM, M., *Eugène Ysaÿe et la musique de chambre*, Liège, 1990.
STENGERS, J., (ed.), *Bruxelles. Croissance d'une capitale*, Brussels, 1979.

T

TAVERNIER, A., *Het Ensor-drama in beeld, De aureolen van Kristus of de gevoeligheden van het licht* [Ensor's theatre of images, The Haloes of Christ or the Sensitivities of Light], Ghent, 1976.
THIERY, A. and Van DIEVOET, E., *Catalogue complet des œuvres dessinées, peintes et sculptées de Constantin Meunier*, Louvain, 1909.
TIBBE, L., *Art nouveau en socialisme, Henry van de Velde en de parti ouvrier belge* [Art Nouveau and socialism, Henry van de Velde and the Belgian Labour Party], Amsterdam, Kunsthistoriese Schriften V, 1981.
TIELEMANS, E. H., "Notes sur les ex-Libris dessinés par Fernand Khnopff", *L'Ex-libris*, I, November 1913, pp. 5–10.
TRICOT, X., *Ensoriana*, Ostend, 1985.
TRICOT, X., *Catalogue raisonné de l'œuvre de James Ensor*, Antwerp, 1992, 2 vol.
TROUSSON, R. and FRICKX, R., ed., *Lettres françaises de Belgique. Dictionnaire des œuvres*, Gembloux, 1988–1989.

V

VALLAS, L., *Vincent d'Indy*, Paris, 1946–1950, 2 vol.
VALLAS, L., *La Véritable histoire de César Franck (1822–1890)*, Paris, 1955.
VANDENBREEDEN, J., "Het huis Cauchie: een woning met 'een special karacter'" [Maison Cauchie: a house with 'special character'], *Monumenten en Landschappen* [Monuments and Landscapes], II, 1983, no. 6, pp. 20–23.
VANDENBREEDEN, J., "Wooncultuur of de cultus van het wonen. Het Stoclethuis in Brussel" [Housing culture or the cult of the house. The Palais Stoclet in Brussels], *Openbaar Kunstbezit in Vlaanderen* (Public heritage in Flanders), no. 3, 1987, pp. 84–100.

VANDENBREEDEN. J., "Van een stille dood gered" [Saved by a silent death], *Monumenten en Landschappen*, VI, 1989, no. 5, pp. 12–24.
Van De VELDE, H., *Récit de ma vie, Anvers, Bruxelles, Paris, Berlin. I. 1863–1900*, ed. by A. Van Loo and F. Van de Kerckhove, Brussels-Paris, 1992.
VANDER LINDEN, A., "Octave Maus et la vie musicale belge", *Mémoires, Académie Royale de Belgique, Classe des Beaux-Arts*, 1950, pp. 5–98.
Van LENNEP, J., *Catalogue de la sculpture. Artistes nés entre 1750 et 1882*, Brussels, 1992.
Van LOO, A., "Passé-futur, La Maison atelier de Fernand Khnopff", *Vienne-Bruxelles, la fortune du palais Stoclet*, special issue of the Archives d'Architecture Moderne, 1987, pp. 59–63.
Van MARIS, L., *Félicien Rops over Kunst, melancholie & perversiteit* [Félicien Rops about art, melancholy and perversity], Amsterdam, 1982.
VANNES, R. and SOURIS, A., *Dictionnaire des musiciens (compositeurs)*, Brussels, n. d.
Van PUYVELDE, L., *George Minne*, Brussels, 1930.
VANWELKENHUYSEN, G., "De l'Uylenspiegel à la Jeune Belgique", *Vocations Littéraires*, Paris-Geneva, 1959, pp. 9–24.
Van WEZEL, G. W. C., *Jan Toorop, 1858–1928*, Amsterdam, 1989.
VERNIERS, L., *Brussels et son agglomération de 1830 à nos jours*, Brussels, 1958.
VERVLIET, R., "Lever de rideau: les précurseurs", in F. Weisberger, *Les Avant-gardes littéraires en Belgique*, Brussels, 1991, pp. 27–88.
VICTOIR, J. and VANDERPERREN, J., *Henri Beyaert. Du classicisme à l'Art nouveau*, Sint-Martens-Latem, 1992.

W

WARMOES, J., "La jeunesse de Maeterlinck ou la poésie du mystère", *Annales de la Fondation Maurice Maeterlinck*, VI, 1960, pp. 5–59.
WARMOES, J., "Une amitié: Théo Van Rysselberghe et Emile Verhaeren", *Les Beaux-Arts*, 29 June 1962, p. 2.
WATELET, J. G., *Gustave Serrurier-Bovy, architecte et décorateur 1858–1910*, Brussels, 1975.
WATELET, J. G., *Gustave Serrurier-Bovy*, Brussels, 1986.
WATELET, J. G., Serrurier-Bovy au musée d'Orsay. Le constructivisme d'un décorateur Art Nouveau", *Revue du Louvre et des Musées de France*, October 1987, no. 4, p. 290–296.
WEISGERBER, J., "*La Jeune Belgique* et cent ans d'avant garde", *Bulletin, Académie Royale de Langue et Littérature française*, LIX, 1981, pp. 206–223.
WORTHING, E., *Emile Verhaeren 1855–1916*, Paris, 1992.

Y

YSAŸE, A., *Eugène Ysaÿe, sa vie, son œuvre, son influence*, Brussels-Paris, [1947].

Exhibition Catalogues

Emile Verhaeren: Exposition organisée pour le centième anniversaire de la naissance, Paris, Bibliothèque Nationale, 1955.

Rétrospective Anna, (1848–1936) & Eugène (1855–1941) Boch, La Louvière, Musée des Arts et Métiers, 1958.

Rétrospective Théo Van Rysselberghe, Ghent, Musée des Beaux-Arts de Belgique, 1962.

Les XX et leur temps, Brussels, Musées Royaux des Beaux-Arts de Belgique, 1962.

Henry Van de Velde, 1863–1957, Brussels, Palais des Beaux-Arts, 1963.

Le centenaire de Maurice Maeterlinck (1862–1962), Brussels, Académie Royale, Palais des Académies, 1964.

Tervuren 1897, Tervuren, Musée Royal de l'Afrique Centrale, 1967.

Antoine Pompe et l'effort moderne en Belgique 1890–1940, Brussels, Musée Communal d'Ixelles, 1969.

Anna Boch und Eugène Boch. Werke aus den Anfängen der modernen Kunst, Saarland Museum, Moderne Galerie Saarbrücken, 1971.

Peintres de l'imaginaire, symbolistes et surréalistes belges, Paris, Grand Palais, 1972.

Als ik Kan, Antwerp, Musées Royaux des Beaux-Arts, 1973.

Antoine Pompe ou l'architecture du sentiment, Brussels, Musée Communal d'Ixelles, 1974.

Ensor, New York, The Solomon R. Guggenheim Museum, 1976.

Le Symbolisme en Europe, Rotterdam, Museum Boymans-Van Beuningen; Brussels, Musées Royaux des Beaux-Arts de Belgique; Baden-Baden, Staatliche Kunsthalle and Paris, Grand Palais, 1976.

Félicien Rops, London, Arts Council of Great Britain, 1976–1977.

Jan Toorop 1858–1928, Impressionniste, Symboliste, Pointilliste, Paris, Institut Néerlandais, 1977.

J. Th. Toorop, De Jaren 1885 tot 1910, Otterlo, Rijksmuseum Kröller-Müller, 1978.

Philippe Wolfers juwelen, silver, ivoor, kristal (1858–1929), Ghent, Museum voor Sierkunst, 1979.

Fernand Khnopff 1858–1921, Paris, Musée des Arts Décoratifs, 1979.

William Degouve de Nuncques, Stavelot, Musée de l'Ancienne Abbaye, 1979.

150 ans de gravure en Belgique, Brussels, Galerie de la CGER, 1980.

Art et société en Belgique, 1848–1914, Charleroi, Palais des Beaux-Arts, 1980.

Belgian Art 1880–1914, New York, The Brooklyn Museum, 1980.

La Photographie en Wallonie, des origines à 1940, Liège, Musée de la Vie Wallonne, 1980.

Kunst en Camera/Art et photographie, Brussels, Galerie de la CGER, 1980–1981.

Belgique Art Nouveau, Brussels, Palais des Beaux-Arts, 1980–1981.

L'industrie en Belgique, Deux siècles de développement 1780–1980, Brussels, Crédit Communal, 1981.

George Minne en de kunst rond 1900, Ghent, Musée des Beaux-Arts, 1982.

Le symbolisme en Belgique, Tokyo, National Museum of Modern Art, 1982–1983.

James Ensor, Antwerp, Musées Royaux des Beaux-Arts, 1983.

James Ensor, Zurich, Kunsthaus, 1983.

Fernand Khnopff and the Belgian Avant-Garde, New York, Barry Friedman, 1984.

Aspecten van het symbolisme, Tekeningen en pastels, Antwerp, Musées Royaux des Beaux-Arts, 1985.

Dario de Regoyos, un Espagnol en Belgique, Brussels, Banque Bruxelles Lambert, 1985.

Félicien Rops 1833–1898, Brussels, Musées Royaux des Beaux-Arts de Belgique, 1985.

D'un livre à l'autre, Mariemont, Musée Royal de Mariemont, 1986.

La thématique religieuse dans l'art belge, 1875–1985, Brussels, Galerie de la CGER, 1986.

Autour de Jules Destrée, Charleroi, Institut Jules Destrée en centre culturel de la Communauté française de Wallonie, Brussels, 1986.

Dario de Regoyos 1857–1913, Madrid, Fundación Caja de Pensiones, 1987.

Ik James Ensor, Ghent, Musée des Beaux-Arts, 1987.

Philippe Wolfers 1858–1929. Drawings, Brussels, Musée Horta, 1987.

Henry Van de Velde (1863–1957), Schilderijen en tekeningen. Paintings and Drawings, Antwerp, Musées Royaux des Beaux-Arts and Otterlo, Rijksmuseum Kröller-Müller, 1988.

Pastelle und Zeichnungen des belgischen Symbolismus, Frankfurt-am-Main, Frankfurter Kunstverein, 1988.

Jan Toorop, The Hague, Gemeentmuseum, 1989.

Le Cercle des XX, Brussels, Tzwern-Aisinber Fine Arts, 1989.

Fernand Khnopff 1858–1921, Tokyo, Bunkamura Museum of Art, 1990.

James Ensor, Paris, Musée du Petit Palais, 1990.

James Ensor, Self-Portrait in Prints 1886–1931, New York, Neuberger Museum, State University of New York at Purchase, 1990.

L'impressionnisme et le fauvisme en Belgique, Brussels, Musée Communal d'Ixelles, 1990.

Fin de siècle, dessins, pastels et gravure belges de 1885 à 1905, Brussels, Galerie de la CGER, 1991.

Félicien Rops, Les Techniques de la gravure, Brussels, Bibliothèque Royale Albert 1er, 1991.

Rops et la modernité, Œuvres de la Communauté Française, Acquisitions récentes (1988–1990). Choix d'œuvres, Brussels, Musée Communal d'Ixelles, 1991.

Victor Horta, Architetto e Designer (1861–1947), Opere dal Musée Horta di Bruxelles, Ferrara, Gallerie Civiche des Palazzo dei Diamanti, 1991–1992.

A. W. Finch, 1854–1930, Brussels, Musées Royaux des Beaux-Arts de Belgique, 1992.

Homage to Brussels, The Art of Belgian Posters 1895–1915, New Brunswick, N. J., Jane Voorhees Zimmerli Art Museum, 1992.

Les Vingt en de avant-garde in België. Prenten, tekeningen en boeken ca. 1890, Ghent, Musée des Beaux-Arts, 1992.

Philippe et Marcel Wolfers. De l'Art Nouveau à l'Art Déco, Brussels, Musée Bellevue (Musées Royaux d'Art et d'Histoire), 1992.

Théo Van Rysselberghe, Ghent, Museum voor Schone Kunsten, 1993.

Les XX – La Libre Esthétique. Cent ans après, Brussels, Musées Royaux des Beaux-Arts de Belgique, 1993–1994.

Impressionism to Symbolism. The Belgian Avant-Garde 1880–1900, London, Royal Academy, 1994.

Rick Wouters, Ostend, Musée Provincial d'Art.

Index

Fernand Khnopff, *Brown Eyes and a Blue Flower* or *A Blue Flower*, 1905. Pencil and gouache on paper, ø 18.5 cm. Ghent, Museum voor Schone Kunsten.

PHOTOGRAPHIC CREDITS